Modernity in Black and White

Modernity in Black and White provides a groundbreaking account of modern art and modernism in Brazil. Departing from previous accounts, mostly restricted to the elite arenas of literature, fine art and architecture, the book situates cultural debates within the wider currents of Brazilian life. From the rise of the first favelas, in the 1890s and 1900s, to the creation of samba and modern carnival, over the 1910s and 1920s, and tracking the expansion of mass media and graphic design, into the 1930s and 1940s, it foregrounds aspects of urban popular culture that have been systematically overlooked. Against this backdrop, Cardoso provides a radical re-reading of Antropofagia and other modernist currents, locating them within a broader field of cultural modernization. Combining extensive research with close readings of a range of visual cultural production, the volume brings to light a vast archive of art and images, all but unknown outside Brazil.

Rafael Cardoso is a member of the postgraduate faculty in art history at Universidade do Estado do Rio de Janeiro (Instituto de Artes) and a research fellow at Freie Universität Berlin (Lateinamerika-Institut). One of the leading historians of modern art and design in Brazil, he has authored numerous books and essays and curated major museum exhibitions.

Afro-Latin America

Series editors

George Reid Andrews, *University of Pittsburgh*
Alejandro de la Fuente, *Harvard University*

This series reflects the coming of age of the new, multidisciplinary field of Afro-Latin American Studies, which centers on the histories, cultures, and experiences of people of African descent in Latin America. The series aims to showcase scholarship produced by different disciplines, including history, political science, sociology, ethnomusicology, anthropology, religious studies, art, law, and cultural studies. It covers the full temporal span of the African Diaspora in Latin America, from the early colonial period to the present and includes continental Latin America, the Caribbean, and other key areas in the region where Africans and their descendants have made a significant impact.

A full list of titles published in the series can be found at:

www.cambridge.org/afro-latin-america

Modernity in Black and White

Art and Image, Race and Identity in Brazil, 1890–1945

RAFAEL CARDOSO

Universidade do Estado do Rio de Janeiro &
Freie Universität Berlin

CAMBRIDGE
UNIVERSITY PRESS

CAMBRIDGE
UNIVERSITY PRESS

University Printing House, Cambridge CB2 8BS, United Kingdom

One Liberty Plaza, 20th Floor, New York, NY 10006, USA

477 Williamstown Road, Port Melbourne, VIC 3207, Australia

314–321, 3rd Floor, Plot 3, Splendor Forum, Jasola District Centre, New Delhi – 110025, India

79 Anson Road, #06–04/06, Singapore 079906

Cambridge University Press is part of the University of Cambridge.

It furthers the University's mission by disseminating knowledge in the pursuit of education, learning, and research at the highest international levels of excellence.

www.cambridge.org
Information on this title: www.cambridge.org/9781108481908
DOI: 10.1017/9781108680356

First published 2021

Printed in the United Kingdom by TJ Books Limited, Padstow Cornwall

A catalogue record for this publication is available from the British Library.

ISBN 978-1-108-48190-8 Hardback

Para minha Tierchen.

So is Brazil, of an ineffable grandeur in which civilization and savagery do not contrast but blend, mingle, become wedded in an active and troubling manner. It takes one's breath away, from admiration and often from terror or passion.

Blaise Cendrars, 1955[1]

[1] Blaise Cendrars, "Mort subite", *Trop c'est trop*, In: *Oeuvres complètes, tome VIII* (Paris: Denoël, 1987), 163. "*Tel est le Brésil, d'une grandeur ineffable où la civilisation et la sauvagerie ne contrastent pas mais se mêlent, se conjuguent, s'épousent d'une façon active et troublante. On reste le souffle coupé d'admiration et, souvent, de terreur ou de passion.*"

Contents

The plate section can be found between pp 140 and 141

Figures

Acknowledgements

Research for this book first began in 2007 when I was awarded a grant from Fundação Biblioteca Nacional, Rio de Janeiro, to study the relationship between art and bohemianism in Brazil, circa 1900–1930, especially with regard to graphic design and illustrated periodicals. The task proved to be much larger than originally envisioned and led to a dispersion of efforts in what often seemed to be opposing directions. The idea for a book began to take shape in 2015 when I was a guest scholar at the Getty Research Institute, Los Angeles, and subsequently a visiting researcher at the Institut National d'Histoire de l'Art, Paris. I am grateful to all three institutions for their receptivity and material support, without which the project would never have got off the ground.

A number of colleagues have played a vital role, over the years, as intellectual peers or in terms of advancing specific aspects of the research for this project. I wish to thank Caroline Arscott, Maria Berbara, João Brancato, Amy Buono, Lauro Cavalcanti, Roberto Conduru, Sérgio Costa, Pedro Duarte de Andrade, Joaquim Marçal Ferreira de Andrade, Uwe Fleckner, Lúcia Garcia, Paulo Herkenhoff, Hu Xudong, Jennifer Josten, Margit Kern, Paulo Knauss, Julia Kovensky, Anne Lafont, Aleca Le Blanc, Laura Karp Lugo, Marize Malta, Sérgio Bruno Martins, Andrew McNamara, Eric Michaud, Anders Michelsen, Valéria Piccoli, Paula Ramos, Kim Richter, Stefan Römer, Silviano Santiago, Alexa Sekyra, Elena Shtromberg, Vera Beatriz Siqueira, Michi Strausfeld, Nataraj Trinta Cardozo, Arthur Valle, Joan Weinstein, Marcus Wood, among others too numerous to list here, for their support, encouragement, advice or collaboration. I also wish to record, in memoriam, my debt to the irreplaceable Lélia Coelho Frota.

Images are a decisive component of any art historical study, and that is certainly the case here. A large part of the illustrations in this book derive from the superlative collections, physical and digital, of Fundação Biblioteca Nacional. The following individuals played a decisive role either in granting permissions to use images or helping to obtain them: Tarsila do Amaral, Ana Sueli Baldas, Noemia Buarque de Hollanda, Mônica Carneiro Alves, Eduardo Mendes Cavalcanti, Andrea Chambelland, Joel Coelho de Souza, Elisabeth Di Cavalcanti Veiga, Martha Fadel, Luciana Freire Rangel, Valéria Lamego, Matias Marcier, Alvaro Marins, Gustavo Martins de Almeida, Laura Nery, Christina Gabaglia Penna, Max Perlingeiro, Karin Philippov, João Cândido Portinari, Diana dos Santos Ramos, Heloisa Seelinger, Priscila Serejo, Julieta Sobral, Afrísio de Souza Vieira Lima Filho, Mônica Azevedo Velloso, Tobias & Isabel Visconti, Mônica F. Braunschweiger Xexéo. Thanks to all for generously making accessible the works of art included in this book.

Almost needless to say, this book would not exist without the interest of series editors Alejandro de la Fuente and George Reid Andrews. My heartfelt gratitude to them for casting a sympathetic gaze upon a topic that might otherwise have fallen between the boundaries separating disciplines. Thanks also to the anonymous peer reviewers whose suggestions have made the arguments here stronger. A final word of thanks to the many people at Cambridge University Press who produced this volume – especially, Thomas Haynes, Cecelia Cancellaro, Rachel Blaifelder and Vicki Harley. I hope you can follow William Morris in saying: "The books that I would like to print are the books I love to read and keep."

Notes on Usage of Brazilian Portuguese

Use of proper names is extremely variable in Brazil. Most people possess at least two family names, the mother's and the father's, and which one they embrace is determined by local custom and personal choice. Many people come to be known by a composite of family names. Others are usually referenced by a first name or names. Artists, musicians and athletes often adopt a nickname or sobriquet, by which they come to be universally designated. As far as possible, the present book follows historical usage in Brazil, rather than obeying a fixed rule, so that individuals may be cited by any of these nominal cases. Whenever necessary, full names and cross references are provided in the index.

Spelling of names is further complicated by several orthographic reforms enacted in Brazil over the twentieth century – most importantly, for the present study, that of 1943. The author has opted to spell proper names as they were used within a person's lifetime or in their published writings. This may give rise to minor discrepancies (e.g. Melo vs Mello, Luis vs Luiz) between the spellings adopted in this book and those encountered in other sources. The same criterion has been adopted for titles of periodicals, for which contemporary spellings have been preserved (e.g. Atheneida vs Ateneida).

All translations from Brazilian Portuguese are by the author, who is solely responsible for their accuracy and style.

Note on References: Footnotes refer to many periodicals in which pages either were not numbered or numbers are missing in the original. This is indicated by the abbreviation n.p. (no pagination).

Introduction

Ambiguous Modernities and Alternate Modernisms

São Paulo possesses the virtue of discovering tree honey in an owl's nest. Every so often, they send us some ancient novelties of forty years ago. Now, through the auspices of my congenial friend Sergio Buarque de Hollanda, they wish to impose upon us as their own discovery, São Paulo's, so-called 'futurism'.

Lima Barreto, 1922[1]

Upon receiving a copy of *Klaxon*, the seminal literary magazine produced by São Paulo's modernists around 1922, writer Lima Barreto famously penned the remark in the epigraph. The unusual turn of phrase "tree honey in an owl's nest" (*mel do pau em ninho de coruja*) suggests a wrong-headedness bordering on delusion. As a critique of pedantry in others, this ornate figure of speech disguised as colloquialism conceals more than it reveals. Certainly, the flippancy with which the author seeks to dismiss the young provincials is feigned. After accusing them, in the opening paragraph, of imposing novelties of forty years ago, the article reduces that accusation by half, subsequently affirming that everybody has known about the grandstanding of "*il Marinetti*" for over twenty years. Considering that F. T. Marinetti's "Manifesto of Futurism" was first published in 1909, even the lower figure proves that Lima Barreto's charge was either hyperbolic or else his mathematical abilities were atrocious. His resentment of the *paulistas*' claim to inaugurating modernism in Brazil is so patent, even to him, that the writer excuses

[1] Lima Barreto, "O futurismo", *Careta*, 22 July 1922, n.p.

I

himself with his readers for "what there is of sourness in this little article".[2]

Lima Barreto had every reason to be bitter. Five months later, in November 1922, he would pass away at the age of 41, twice committed to a mental asylum for complications stemming from chronic alcoholism, twice rejected in his ambition to become a member of the Brazilian Academy of Letters, essentially unable to find a publisher for his later works, several of which were destined to appear posthumously. An Afro-descendant writer of recognized talent but modest social standing, his acerbic criticism and radical politics did little to open doors for his career. As Berthold Zilly has observed, he occupied an ambiguous position, enough of an insider to aspire to become part of the establishment but too much of an outsider to know how to make the requisite concessions.[3] Nearly a century after his death, he is revered as one of the great names in Brazilian literature and his claim to modernity finally recognized as having preceded the young upstarts from São Paulo.[4] At the time, however, they were the rising stars; he was on his way out; and both sides were attuned to their respective destinies.

Over the latter half of the twentieth century, and even more recently in some quarters, the contention that Lima Barreto's oeuvre was modern was pointedly rejected. To call it modernist, then, was unthinkable. Rather, it was shoehorned into the category of *pre-modernism*, along with a hodgepodge of other writers active over the first decades of the twentieth century. That label is so meaningless in its historicist overdetermination that it is best jettisoned right away and altogether. Simply put, no one sets out to be *pre-* anything at the time they are doing something (unless, that is, the action is done in prophetic vein, à la John the Baptist, or is intended to reclaim a lost tradition, as in Pre-Raphaelitism). To cast Lima Barreto as a precursor of the group of young authors and poets around *Klaxon*, whom he testily dismissed, is to presume their work is somehow a fulfilment of stylistic or artistic qualities he failed to achieve.

[2] Ibid., n.p.

[3] Berthold Zilly, "Nachwort: das Vaterland zwischen Parodie, Utopie und Melancholie", In: [Afonso Henriques de] Lima Barreto, *Das traurige Ende des Policarpo Quaresma* (Zurich: Ammann, 2001), pp. 309–336. See also Renata R. Mautner Wassermann, "Race, nation, representation: Machado de Assis and Lima Barreto", *Luso-Brazilian Review*, 45 (2008), 84–106.

[4] See Lilia Moritz Schwarcz, *Lima Barreto: Triste visionário* (São Paulo: Companhia das Letras, 2017), pp. 430–461; and Irenísia Torres de Oliveira, "Lima Barreto, modernidade e modernismo no Brasil", *Revista Terceira Margem*, 11 (2007), 113–129.

One would be hard pressed, at present, to find a literary critic prepared to defend that position.

1.1 ALTERNATE MODERNISMS

In studies of Brazilian literature, the notion of *pre-modernism* began to be challenged in the late 1980s. Among others, Lima Barreto, Benjamim Costallat and João do Rio were subjected to revised critical readings and their reputations subsequently revived in the 1990s and 2000s.[5] The epistemological swamp in which they were mired, however, has yet to be drained. If rigid notions of periodization are accepted, how should the modernist inflections, both technical and stylistic, of works produced before the 1920s be categorized? Selective rehabilitation of a few noteworthy authors has so far proved insufficient to liberate others from the no-man's-land staked out between the feuding clans of 'modernists' and 'traditionalists' in the bygone culture wars of the mid-twentieth century. For the visual arts, it has done almost nothing. The few attempts in Brazil to address what Paulo Herkenhoff labelled "the modern before official modernism" have so far failed to shift the historiographical imbalance to any significant degree. Eliseu Visconti, Belmiro de Almeida and Arthur Timotheo da Costa, among other artists consigned by modernist histories to the tail end of the 'academic', are still pretty much in the same place where Gilda de Mello e Souza left them when she tried to draw attention to the injustice of their plight in the 1970s.[6]

The major obstacle hindering attempts to rehabilitate individual artists as precursors or pioneers is a conceptual one. If modernism is a radical break with the past, as many of its proponents have claimed, then

[5] See, among others, Flora Süssekind, *Cinematograph of Words: Literature, Technique and Modernization in Brazil* (Stanford: Stanford University Press, 1997 [1987]); Eduardo Jardim de Moraes, "Modernismo revisitado", *Estudos Históricos*, 1 (1988), 220–238; Centro de Pesquisas/Setor de Filologia, *Sobre o pré-modernismo* (Rio de Janeiro: Fundação Casa de Rui Barbosa, 1988). See also Beatriz Resende, "Modernização da arte e da cultura na Primeira República", In: Paulo Roberto Pereira, ed., *Brasiliana da Biblioteca Nacional: Guia das fontes sobre o Brasil* (Rio de Janeiro: Nova Fronteira/Fundação Biblioteca Nacional, 2001); and Silviano Santiago, *The Space In-between: Essays on Latin American Culture* (Durham: Duke University Press, 2001).

[6] Paulo Herkenhoff, "O moderno antes do modernismo oficial", In: *Arte brasileira na coleção Fadel* (Rio de Janeiro: Centro Cultural Banco do Brasil, 2002), pp. 22–29; and Gilda de Mello e Souza, "Pintura brasileira contemporânea: Os precursores", *Discurso*, 5 (1974), 119–130. See also Ana Paula Cavalcanti Simioni & Lúcia K. Stumpf, "O moderno antes do modernismo: Paradoxos da pintura brasileira no nascimento da República", *Teresa - Revista de Literatura Brasileira*, 14 (2014), 111–129.

anything short of that rupture belongs squarely on the other side of the divide, no matter how much it may tend in a modernizing direction. For all its clever rhetorical appeal, the formulation *modernity before modernism* falls short of dislodging the essential premise of teleological progress towards formal truth. The present book partakes of the belief that there is no such thing as evolution in the history of art. For all that artists borrow from each other and build upon the achievements of the past, which they undoubtedly do, this in no way entails a positive progression. Nor does the borrowing that takes place necessarily imply that some works are wholly original while others are derivative. Influence, as Partha Mitter has pointed out, does not operate in a single direction but, rather, is a process of mutual exchange, emulation and paradigm change.[7]

Neither does the author of this book subscribe to the orderly periodization of artistic styles through the pinpointing of major works and the dates they were produced. Continuity and rupture, canon and revolution, classic and modern, exist in a dialectical relationship, subject to continual hermeneutical analysis.[8] Like any other historical construct, the validity of stylistic categories must be reexamined in the light of documentary evidence and questioned at every turn. Thus, the impossibility of thinking about the significance of 'modern art' from within the parameters imposed by modernism's inflated conception of itself. Any historical evaluation worth its salt must reject the contention, all too often taken as an unspoken assumption, that what is or is not modernist can be determined by distinctive features within the works or aesthetic principles espoused by their makers.[9]

The present book is not the place for a full-blown discussion of modernism: what it was, when it was, whether to embrace it or bid it farewell. Rather, it aims to contribute one more case study to the larger investigation of cultural modernization as a diverse and dispersed historical phenomenon. Variations in what is meant by 'modern art' are not

[7] Partha Mitter, "Decentering modernism: art history and avant-garde art from the periphery", *The Art Bulletin*, 90 (2008), 538–540.

[8] Cf. Larry Silver, "Introduction: Canons in world perspective – definitions, deformations and discourses", In: Larry Silver & Kevin Terraciano, eds., *Canons and Values: Ancient to Modern* (Los Angeles: Getty Publications, 2019), pp. 1–21; and Hubert Locher, "The idea of the canon and canon formation in art history", In: Matthew Rampley *et al.*, eds., *Art History and Visual Studies in Europe: Transnational Discourses and National Frameworks* (Leiden: Brill, 2012), pp. 29–40.

[9] See Stephen Bann, *Ways around Modernism* (London: Routledge, 2007), pp. 58–61, 92–101, 107–111.

exclusive to Brazil. Discrepancies of form and style, political and cultural context are routinely glossed over in the unthinking wish to apprehend the concept as a stable and unified whole. The more national and regional histories are brought to bear upon one another in comparative vein, the less coherent the case for a single modernism becomes.[10]

Given the considerable variations occurring over time and place, it makes more sense to speak of "a multiplicity of modernisms", plural, as Perry Anderson proposed many decades ago, rather than giving in to selective criteria justifying some exclusive definition of the term, which are always based on more or less "open ideologizing", as Raymond Williams warned.[11] The evidence from a global perspective points to the existence of a series of *alternate modernisms*, overlapping and intersecting each other from at least the 1890s onwards and constituting a broader field of modernist exchanges. Each of the various components does not necessarily partake of all the formal qualities, theoretical underpinnings and sociological structures that characterize the rest; and any attempt to reduce the plurality of examples to one narrative thread will necessarily result in over-simplification.[12] The present book is premised on the assumption that the larger import of modernism in Brazil can only be understood by taking into account other competing currents of cultural modernization existing alongside the generally recognized one. That such alternate modernisms mostly stem from popular and mass culture, while the great names of the canon hail almost exclusively from the elitist

[10] Andreas Huyssen, "Geographies of modernism in a globalizing world", *New German Critique*, 100 (2007), 193–199. See also Arjun Appadurai, *Modernity at Large: Cultural Dimensions of Globalization* (Minneapolis: University of Minnesota Press, 1996); Geeta Kapur, *When was Modernism: Essays on Contemporary Cultural Practice in India* (New Delhi: Tulika, 2000); Laura Doyle & Laura Winkiel, eds., *Geomodernisms: Race, Modernism, Modernity* (Bloomington: Indiana University Press, 2005); Kobena Mercer, ed., *Cosmopolitan Modernisms* (London: International Institute of Visual Arts & Cambridge: MIT Press, 2005); Partha Mitter, *The Triumph of Modernism: India's Artists and the Avant-Garde, 1922–1947* (London: Reaktion, 2007); Tom Avermaete, Serhat Karakayali & Marion von Osten, eds., *Colonial Modern: Aesthetics of the Past – Rebellions for the Future* (London: Black Dog Publishing, 2010); and Harri Veivo, ed., *Transferts, appropriations et fonctions de l'avant-garde dans l'Europe intemédiaire et du nord* (Paris: L'Harmattan, 2012).

[11] Perry Anderson, "Modernity and revolution", In: Cary Nelson & Lawrence Grossberg, eds., *Marxism and the Interpretation of Culture* (London: Macmillan, 1988), 323; and Raymond Williams, *The Politics of Modernism* (London: Verso, 1989), pp. 31–35.

[12] On the possibilities of interpreting modernism as a unified concept, see Fredric Jameson, *A Singular Modernity: Essay on the Ontology of the Present* (London: Verso, 2002), pp. 1–13, 32–55, 94–99, 161–179; and Raymond Spiteri, "A farewell to modernism?: Re-reading T. J. Clark", *Journal of Art Historiography*, n.3 (2010), 1–13.

spheres of literature, fine art, architecture and classical music, says much about how the term has been construed in Brazil.

I.2 THE MYTH OF 1922

The real significance of artistic modernization in Brazil has been obscured by the dominance of a mythic narrative of 'modern art'. Ask any reasonably well-informed Brazilian when modernism began in Brazil, and the reply will invariably revolve around the date 1922. The reference is to the *Semana de Arte Moderna* (Modern Art Week), a cultural festival staged in São Paulo in February 1922, encompassing musical performances, lectures and poetry readings, as well as an exhibition of about one hundred works of art. Sponsored by prominent figures of the local elite – under the decisive leadership of coffee magnate and art collector Paulo Prado – and staged in the city's operatic Municipal Theatre, the *Semana*, as it is familiarly known and hereafter designated, assembled a cast that includes some of the most famous names in twentieth-century Brazilian culture: writers Oswald de Andrade and Mário de Andrade; visual artists Anita Malfatti, Di Cavalcanti and Victor Brecheret; composer Heitor Villa-Lobos, among many others. It also spawned a foundational myth that continues to proliferate in a vast secondary literature, largely of a celebratory nature.[13]

Despite its enshrinement by scholarship and safeguarding by institutions founded in its memory, the importance of the *Semana* resides largely

[13] Summaries in English and French include: Randal Johnson, "Brazilian modernism: an idea out of place?", In: Anthony L. Geist & José B. Monleon, eds., *Modernism and its Margins: Re-inscribing Cultural Modernity from Spain and Latin America* (New York: Garland, 1999),pp. 186–214; Ruben George Oliven, "Brazil: the modern in the tropics", In: Vivian Schelling, ed., *Through the Kaleidescope: the Experience of Modernity in Latin America* (London: Verso, 2000), pp. 53–71; Ana Paula Cavalcanti Simioni, "Le modernisme brésilen, entre consécration et contestation", *Perspective*, 2013–2, 325–342; and Saulo Gouveia, *The Triumph of Brazilian Modernism: the Meta-Narrative of Emancipation and Counter-Narratives* (Chapel Hill: University of North Carolina Press, 2013). Recent reappraisals in Portuguese include: Marcia Camargos, *13 a 18 de fevereiro de 1922: A Semana de 22: Revolução Estética?* (São Paulo: Companhia Editora Nacional/ Lazuli, 2007); Marcos Augusto Gonçalves, *1922: A semana que não terminou* (São Paulo: Companhia das Letras, 2012); Frederico Coelho, *A semana sem fim: Celebrações e memória da Semana de Arte Moderna de 1922* (Rio de Janeiro: Casa da Palavra, 2012); as well as the special edition of *Revista USP*, 94 (2012), edited by Lisbeth Rebollo Gonçalves and published to commemorate the ninetieth anniversary of the event, which contains a range of scholarly assessments.

in its legendary status.[14] At the time the event took place, its impact was limited to an elite audience in São Paulo, then a very prosperous but still provincial capital. What happened there hardly made a dent in national debates during the 1920s and 1930s. One of the few organs of the mainstream press to give it attention in Rio de Janeiro, then the nation's capital and cultural centre, was the magazine *Careta*, for which Lima Barreto wrote. The periodical was aware of the São Paulo group even before the event took place. In late 1921, it published a piece distancing writers Oswald de Andrade, Mário de Andrade, Menotti del Picchia and Guilherme de Almeida, among others, from the label 'futurism', under which they were often categorized, and emphasizing their claim to be considered 'modernist'.[15] A few months after the *Semana* took place, an article with a São Paulo dateline, titled "The death rites of futurism", concluded the event had been a flop and castigated the participants for their pretentiousness.[16] Over one year later, the magazine ran a strongly worded attack on the 'futurists' and defence of traditional values in art.[17] The editors were open-minded enough, though, to publish a poem by Mário de Andrade on the same page, under the title "Brazilian futurism in poetry", thus allowing readers the opportunity to judge for themselves.

Careta's reactionary stance was hardly typical of the mainstream press, which mostly ignored the goings-on in São Paulo. Contrary to the widely held belief that the *Semana* scandalized bourgeois Brazilian society – a myth propagated strategically, between the 1940s and 1960s, by the remnants of *paulista* modernism and their heirs – the truth is that the cultural milieu in the nation's capital had other things on its mind.[18] 1922 was a watershed year in Brazil, overshadowed by the centennial of independence from Portugal and filled with charged political

[14] See Monica Pimenta Velloso, *História e modernismo* (Belo Horizonte: Autêntica, 2010), pp. 22–30; and Rafael Cardoso, "Forging the myth of Brazilian modernism", In: Silver & Terraciano, *Canons and Values*, pp. 269–287.

[15] Y-Juca-Pirama, "A morte do futurismo", *Careta*, 5 November 1921, n.p. On the 'futurist' versus 'modernist' debate in the 1920s, see Annateresa Fabris, *O futurismo paulista: Hipóteses para o estudo da chegada da vanguarda ao Brasil* (São Paulo: Perspectiva, 1994), pp. 70–76, 139–153.

[16] Ataka Perô, "O mortorio do futurismo", *Careta*, 1 April 1922, n.p.

[17] Ildefonso Falcão, "A idiotice que pretende ser arte", *Careta*, 28 July 1923, n.p. For more on *Careta*, see Chapter 3.

[18] See Angela de Castro Gomes, *Essa gente do Rio...: Modernidade e nacionalismo* (Rio de Janeiro: Fundação Getúlio Vargas, 1999), pp. 12–13; Francisco Alambert, "A reinvenção da Semana (1932–1942)", *Revista USP*, 94 (2012), 107–118; and Cardoso, "Forging the myth of Brazilian modernism".

developments including the founding of the Brazilian Communist Party, the opening of the Catholic think-tank Centro Dom Vital and the failed military insurrection of July 1922 that came to be known as the *18 do Forte* revolt. If all that were not enough to put the *Semana* into perspective, the existence of competing claims to modernism has been grossly underemphasized by the historical literature, particularly in the fields of art and art history. The nature of what constituted 'modern art', its applicability to the Brazilian context or lack thereof, as well as divergent expressions of its aims, constituted topics of heated debate over the 1920s and 1930s.[19] The *Semana* group was one among many postulants to the prize and, by 1928, had itself split up into three divergent currents.

Modern has long been a term of aspiration in Brazil. As an adjective, it crops up occasionally in literary discourse from the late nineteenth century onwards and became a catchword in the Brazilian press during the early decades of the twentieth century, most often to qualify some activity or process as a technological novelty: cinema, airplanes, automobiles, electricity, skyscrapers. The wish to be perceived as modern was already widespread enough by the 1910s that it inspired the name and packaging of a brand of cigarettes called Modernos.[20] It is easy to imagine that they might have been smoked by the characters in João do Rio's 1911 short story "Modern Girls" (the original title was in English, that most up-to-date tongue in a country where French was still the norm of social grace). In another contemporary work by João do Rio, the armchairs in Rio's Automobile Club are described as partaking of "a modernism that asks no leave of Mapple".[21] The author's jazz-age, anything goes, conception of modernity only grew more prevalent after the First World War, but its presence as early as 1911 is not without significance.

References to technological modernity or changing social mores are not, of course, equivalent to artistic modernism. It is one thing to thrill in the experience of novelty, or even to condemn it, and quite another to reflect upon how those experiences relate to a historical condition. To develop the consciousness of modernity into an aesthetic creed is yet a further step. Such gradations were likewise present over the 1900s and

[19] See Rafael Cardoso, "Modernismo e contexto político: A recepção da arte moderna no Correio da Manhã (1924–1937)", *Revista de História (USP)*, 172 (2015), 335–365.

[20] See Rafael Cardoso, *Impresso no Brasil, 1808–1930: Destaques da história gráfica no acervo da Biblioteca Nacional* (Rio de Janeiro: Verso Brasil, 2009), p. 133.

[21] The reference is to British furniture maker, Maple & Co.; João do Rio, *A profissão de Jacques Pedreira* (Rio de Janeiro: Fundação Casa de Rui Barbosa & São Paulo: Scipione, 1992), p. 109.

1910s. The historiography of Brazilian modernism has long been aware of episodes in which some full-blown manifestation of modern art – in the restricted sense of the historical avant-gardes – was made available to Brazilian audiences before 1922. The most notorious example is Lasar Segall's 1913 exhibitions in São Paulo and Campinas. Coming straight from Dresden, where he was caught up in the ferment between the end of *Die Brücke* and the eventual rise of the *Dresdner Sezession (Gruppe 1919)*, in which he took part, Segall showed at least some works in Brazil that would today be classed as expressionist. These elicited polite applause and occasional misunderstanding from provincial critics who were baffled by how a painter of evident skill could commit such elementary 'mistakes'.[22] Segall's is not even the earliest example of links with German Secessionism, the influence of which was felt a decade earlier in Rio de Janeiro, as shall be seen in Chapter 2, through the auspices Helios Seelinger and José Fiuza Guimarães.

The impact of art nouveau, discussed in detail in Chapter 3, is another grossly underestimated aspect of artistic modernization in Brazil. Between circa 1900 and 1914, the craze for a 'new art' swept the cultural milieu of Rio de Janeiro at all levels, from cinema to music halls, from commercial advertising to fine art. As early as 1903, the concept of *modern art*, thus designated, was insightfully discussed by leading art critic Gonzaga Duque. His writings of the period – as well as those of his contemporaries Camerino Rocha, José Verissimo and Nestor Victor – repeatedly reference what were then considered modern styles and tendencies and, what is perhaps even more telling, purposefully oppose them to the *academic* output of the past. These critics were attuned to debates in Europe and hastened to align themselves with aesthetic and political currents they admired. 'The modern' figures for them as an outgrowth of the scientific and philosophical discoveries of the new century, an inexorable fact of existence that demanded new attitudes and novel responses. There can be no doubt their commitment to artistic modernization was both deliberate and self-aware.

The recurrence of terms like *modern art* and *modernism* in Brazilian discourses of the time can only be dismissed if one assumes that a critical

[22] Vera d'Horta Beccari, *Lasar Segall e o modernismo paulista* (São Paulo: Brasiliense, 1984), pp. 48–64. See also Jasmin Koßmann, "Will Grohmann, Lasar Segall und die Dresdner Sezession Gruppe 1919", In: Konstanze Rudert, ed., *Zwischen Intuition und Gewissheit: Will Grohmann und die Rezeption der Moderne in Deutschland und Europa 1918–1968* (Dresden: Staatliche Kunstsammlungen Dresden, 2013).

innovation of such import could not originate outside the linguistic spheres of French, German or English. Unfortunately, and despite the challenges posed by postcolonial critiques over the past decades, a propensity still exists to downplay the precocity of *modernismo* in the Latin American context, especially via the writings of Nicaraguan poet Rubén Darío, the author credited with coining the term in the 1880s.[23] Darío was the object of overt discussion in Brazilian literary circles and even visited Rio de Janeiro in 1906. The local writer who paid him the greatest attention, going so far as to author a brief volume on his work, was Elysio de Carvalho, poet and aesthete, militant atheist and anarchist, translator of Oscar Wilde, propagandist of Nietzsche and Max Stirner. A few years later, Carvalho would become a police criminologist and take a sharp ideological turn towards Catholic conservatism. A strange combination of qualities, to say the least; yet, this awkward concurrence of modernist and anti-modernist tendencies in a single biography is by no means uncommon among Brazilian intellectuals. The convoluted relationships, professional and personal, that allowed radically divergent positions to co-exist and even mingle in the context of turn-of-the-century Rio are more fully explored in Chapters 2 and 3. Suffice it to say, for now, that the small size and insularity that have long plagued artistic circles in Latin America also made them a prime breeding ground for the sense of alienation and restlessness associated with yearnings for modernity.

Monica Pimenta Velloso was perhaps the first author to formulate plainly the idea that modernism was already in place in Rio de Janeiro long before the *Semana*. Her 1996 book *Modernismo no Rio de Janeiro* argues for the recognition of an artistic modernity centred around the distinctive sociability of cafés, magazines and literary salons in the fast-changing urban scenario of the 1900s and 1910s, in which the major players were journalists, illustrators and humourists.[24] The core of her thesis has withstood the test of time; and the present book aims to support

[23] See Jameson, *A Singular Modernity*, pp. 100–101. Cf. Daniel Link, "Rubén Darío: la Sutura de los Mundos" In: Gesine Müller, Jorge J. Locane & Benjamin Loy, eds., *Re-mapping World Literature: Writing, Book Markets and Epistemologies between Latin America and the Global South* (Berlin: De Gruyter, 2018), pp. 81–90; and Alejandro Mejías-López, *The Inverted Conquest: the Myth of Modernity and the Transatlantic Onset of Modernism* (Nashville: Vanderbilt University Press, 2009), pp. 85–124. The first major work in English to recognize Darío's precedence was: Matei Calinescu, *Five Faces of Modernity: Modernism, Avant-Garde, Decadence, Kitsch, Postmodernism* (Durham: Duke University Press, 2006 [1977]), pp. 69–74.

[24] Monica Pimenta Velloso, *Modernismo no Rio de Janeiro: Turunas e Quixotes* (Rio de Janeiro: Ed. Fundação Getúlio Vargas, 1996), esp. ch.2.

and complement it with novel perspectives, based on a wealth of evidence that has come to light over the past two decades. Revealingly, the Carioca modernism she posits is unequivocally cosmopolitan and distinctly less primitivist than its more easily recognized *paulista* counterpart. From a Parisian standpoint, it was too familiar and therefore did not fulfil the craving for exoticism then prevalent among European modernizers. The younger generation of modernists in São Paulo – in particular, the group congregating around the *Revista de Antropofagia*, in 1928–1929 – was savvy enough to play the part of the savage, thereby making themselves more interesting to European observers. Wealthy and well-connected figures like Oswald de Andrade and Tarsila do Amaral knew how to make themselves look modern by Parisian standards and thereby managed to manipulate insider opinions more effectively. In turn, when they returned to Brazil, they carried the cachet of what was perceived locally as Parisian approval.[25]

The comparison between modernizing tendencies and groupings in Rio de Janeiro and São Paulo is instructive but should not be overstated. They were never completely distinct. João do Rio, the *dernier cri* of Carioca identity circa 1910 (to the point that he incorporated the city into his pseudonym), turned to São Paulo as often as possible in his quest not only for money but also for differing perspectives on Brazilian identity.[26] Painter Di Cavalcanti, another quintessential Carioca, was a prime mover of the *Semana*. When Oswald de Andrade launched his "Manifesto of Brazilwood Poetry" in 1924, he chose to publish it in one of Rio's leading dailies, *Correio da Manhã*, rather than burying it in a literary magazine. When Tarsila do Amaral decided to stage her first solo exhibition in Brazil, in 1929, the venue she chose was the Palace Hotel, on Avenida Rio Branco, then the fashionable heart of the Federal District (Rio's administrative and territorial status from 1891 to 1960). The history of Brazilian modernism between the 1920s and 1950s is better construed as a back and forth circuit between Rio and São Paulo – subordinating the rest of the country to their rivalry – than as the triumph of one over the other. Yet, the regional inflections of the *Semana* narrative should not be underestimated either. Part of its efficacy has to do with the decline of Rio

[25] See Rafael Cardoso, "White skins, black masks: Antropofagia and the reversal of primitivism", In: Uwe Fleckner & Elena Tolstichin, eds., *Das verirrte Kunstwerk: Bedeutung, Funktion und Manipulation von Bilderfahrzeugen in der Diaspora* (Berlin: De Gruyter, 2019), pp. 131–154.

[26] See Nelson Schapochnik, ed., *João do Rio: Um dândi na Cafelandia* (São Paulo: Boitempo, 2004).

and rise of São Paulo, especially after the national capital was moved to Brasília in 1960. Another important aspect is generational conflict, as many participants in the Carioca modernism identified by Pimenta Velloso were, on average, fifteen years older than the *paulista* modernists. Last but certainly not least, the comparison between the two movements is riddled with disparities of race and class.

The construction of a "Paulista Modern" identity, as Barbara Weinstein has labelled it, was accompanied by an enabling rhetoric of racial supremacy that posited São Paulo as separate from and superior to the rest of Brazil.[27] Though this antagonism only became patent in 1932 – with the so-called Constitutionalist Revolution, through which the state of São Paulo attempted to secede from the federal union – its existence can be traced back to the 1890s when prominent voices began to affirm the region as an alternative in racialized terms. Weinstein's assertions about how *paulista* ideals of modernity were inflected by colour is more than germane to the argument here. Her frank admission of glossing over the situation in Rio de Janeiro, with the intent of not diluting the thrust of her book's argument, should be complemented with an equal acknowledgement that the present book privileges the viewpoint from the Federal District.[28] In that sense, the discussion at hand is also about the difficulties of imparting a sense of unified nationhood in a country that has long struggled against centripetal tendencies. The tensions manifested in the Brazilian case by the contradistinction between Rio and São Paulo might usefully be compared to those between *criollismo* and *vanguardia* that Beatriz Sarlo identified as the driving force behind modernization in 1920s Buenos Aires.[29]

The title of the present book proposes a dialogue with Weinstein's conception of 'the colour of modernity'. The idea of a *modernity in black and white* refers not only to disparities of race, but also to the tensions between elite culture and a rising mass culture that found expression in media like photography, graphics and printed periodicals, traditionally (though inexactly) classed as 'black and white art'. The overlap between exclusions based on race and on class in the Brazilian context makes it difficult to examine one without taking the other into account. The

[27] Barbara Weinstein, *The Color of Modernity: São Paulo and the Making of Race and Nation in Brazil* (Durham: Duke University Press, 2015), pp. 27–68.

[28] Ibid., pp. 14–17.

[29] Beatriz Sarlo, *Una modernidad periferica: Buenos Aires 1920 y 1930* (Buenos Aires: Nueva Visión, 1988), pp. 15–18.

present study has no intention of separating them. On the contrary, attempts to affirm blackness and working-class identities at the turn of the twentieth century can be viewed as part of one and the same struggle to break the stranglehold of the old oligarchies on power. The discourses that canonized *paulista* modernism have sometimes cleverly played one off the other in order to ensure their own ascendancy. In doing so, they have managed to disguise the extent to which the movement around the *Semana* was itself an outgrowth of patriarchal dominance and privilege.

I.3 MODERNISM AND PRIMITIVISM

The loose and shifting construct of Brazilian identity before the 1930s is central to understanding what was at stake in debates about modernism. After the abolition of slavery in 1888, the question of how to incorporate the formerly enslaved population into the imagined community of the nation, from which they had been systematically excluded for centuries, became inescapable. Champions of *paulista* modernism have long credited the movement with providing an answer. According to a view still widely held but utterly false, the main players in the *Semana* and its aftermath reclaimed blackness from a cultural silence to which it had been relegated by the Francophile elites of the nineteenth century.[30] This misleading thesis rests on three mistaken assumptions, readily contradicted by examples: 1) that black subjects were not represented in Brazilian art and literature before 1922; 2) that the modernist movement put forward a unified and self-conscious discourse on race; 3) that the depictions of blackness it did produce are affirmative of Afro-Brazilian identities.[31]

The retrospective view of *paulista* modernism as defiant of colonialist hegemony is a specious historical construct. The movement's claims to indigenousness and authenticity are disingenuous, at best, and should certainly not be taken at face value. Regardless of the intentions of individual artists, their rendering of the subaltern into folklore and/or

[30] Perhaps the earliest and most explicit formulation of this argument occurred in a 1940 text by American historian Robert C. Smith; see Chapter 5. The endurance of its premises is exemplified in Jorge Schwartz, *Fervor das vanguardas: Arte e literatura na América Latina* (São Paulo: Companhia das Letras, 2013), pp. 30–31, 69–75.

[31] See Rafael Cardoso, "The problem of race in Brazilian painting, c.1850–1920", *Art History*, 38 (2015), 488–511; and Roberto Conduru, *Pérolas negras, primeiros fios: Experiências artísticas e culturais nos fluxos entre África e Brasil* (Rio de Janeiro: Ed. Uerj, 2013), pp. 301–313.

lampoon perpetuated stereotypes and ultimately had the effect of exclud-
ing the objects of their ethnographic incursions from the modernity to
which they themselves laid claim. The most celebrated example of this
procedure, one among many, is the infamous scene in Mário de Andrade's
1928 novel *Macunaíma* evoking a *macumba* session at Tia Ciata's
house.[32] The facetiousness with which it treats a juncture of critical
importance to the formation of Afro-Brazilian cultural identity compares
unfavourably with the seriousness attributed to the same topic by a
foreign commentator like poet Benjamin Péret.[33] The entitlement
with which many of the *Semana* group appropriated African and Amer-
indian heritage betrays a sense of prerogative not too distant from
the way European colonial authorities regarded the 'natives' under
their 'protection'.

The embrace of primitivism by writers Mário and Oswald de Andrade
or artists Tarsila do Amaral and Lasar Segall demands to be reassessed in
terms of what it meant within the context of its time. Should their claims
to speak for the subaltern be celebrated as a signifier of cultural modern-
ity? Or should they be dismissed, on the contrary, as one more example of
misplaced ideas, in the sense famously enshrined by Roberto Schwarz?[34]
Or, more problematically, does their real significance lie somewhere in
between? Esther Gabara has emphasized the importance of tracking the
movement and disruptions of key ideas out of place, which she sums up
under the concept of *errancy*.[35] The present book seeks to address the
errant nature – in the deepest sense in which territorial wanderings cross
over into epistemological ones – of primitivism as a site for reinterpreting
the Brazilian quest for modernity. Thus, the centrality attributed here to
themes like carnival and favelas, which have not traditionally been con-
sidered a part of the narrative of artistic modernization. Unless the
backdrop of archaism against which they acted is vividly detailed, the

[32] Mário de Andrade [E. A. Goodland, translator], *Macunaíma* (New York: Random
House, 1984), pp. 57–64. See also Bruno Carvalho, *Porous City: a Cultural History of
Rio de Janeiro (from the 1810s onwards)* (Liverpool: Liverpool University Press, 2013),
pp. 116–131. *Macumba* is a generic term for Afro-Brazilian religions, used today in a
largely pejorative sense.

[33] For more on Péret's writings on candomblé and macumba, see Chapter 4. On the specific
context, see Roberto Moura, *Tia Ciata e a Pequena África no Rio de Janeiro* (Rio de
Janeiro: Prefeitura da Cidade do Rio de Janeiro/Bilblioteca Carioca, 1995).

[34] Roberto Schwarz, *Misplaced Ideas: Essays on Brazilian Culture* (London: Verso, 1992),
pp. 19–32.

[35] Esther Gabara, *Errant Modernism: the Ethos of Photography in Mexico and Brazil*
(Durham: Duke University Press, 2008), pp. 13–15.

performative gestures of the modernist players are reduced to soundings on an empty stage.[36]

Florencia Garramuño has advanced the seemingly contradictory concept of 'primitive modernities' to explain how exoticism and self-exoticism intertwined in Latin America to produce an unstable equilibrium in which the autochthonous and the avant-garde mutually reinforced each other.[37] This vital point guides much of the discussion in the chapters that follow. The underlying thesis of the present book is that modern and archaic are not opposed in Brazilian culture, but rather wedded and enmeshed in an active and troubling fashion, as phrased forcefully by poet Blaise Cendrars in the quote that serves as epigraph to this volume. Contrary to common sense apprehensions of the subject, favelas and carnival are not out of place in a discussion of artistic modernization. Rather, the opposite must be asked: why have histories of modernism skirted such issues for so long? How is it possible to dissociate works of art, as well as their makers, from the social and political context in which they were produced? How far did artistic modernization operate as an emancipating project in the Brazilian context and to what extent did it collaborate with the age-old forces of oppression? These questions point to the fundamental disconnect that Néstor García Canclini identified as Latin America's conundrum of "an exuberant modernism within a faulty modernization", generating a situation in which modern art and architecture come "to be seen as a mask, a simulacrum of the elite and of state machinery", incongruent and unrepresentative of the deeper currents of collective existence.[38]

The art historical reception of Brazilian modernism has all too often been content to put a fig leaf on a bloody cadaver. The latter term is employed not only in a metaphorical sense but refers to literal bodies too. Under the dictatorship of the *Estado Novo*, modernist celebrations of the *folkloric* and *the people* often functioned as a cover for the very real suppression of regional difference and popular self-determination. As

[36] On the deeper historical sense of 'archaism' in the Brazilian context, see João Fragoso & Manolo Florentino, *O arcaismo como projeto: Mercado atlântico, sociedade agrária e elite mercantil em uma economia colonial tardia: Rio de Janeiro, c. 1790–1840* (Rio de Janeiro: Civilização Brasileira, 2001).

[37] Florencia Garramuño, *Primitive Modernities: Tango, Samba and Nation* (Stanford: Stanford University Press, 2011), esp. pp. 17–33.

[38] Nestor Garcia Canclini, "Modernity after postmodernity", In: Gerardo Mosquera, ed., *Beyond the Fantastic: Contemporary Art Criticism from Latin America* (London: Institute of International Visual Arts, 1995), pp. 20–23.

further discussed in Chapter 5, the example made of outlaw Lampião – whose band was massacred by army troops, their heads decapitated, the image of their desecration circulated publicly as a warning to others – is instructive of the Vargas regime's ruthless determination to enforce a unified national identity. The role played by artists in bolstering that regime is a subject largely skirted by existing histories of modern art. And yet, the modernist players themselves were fully aware of the dilemma. In a notorious lecture of 1942, titled "The modernist movement", Mário de Andrade registered a very public *mea culpa*, declaring: "I believe we the modernists of the *Semana de Arte Moderna* should not serve as an example to anyone. But we can serve as a lesson." He explained didactically that their sin had been to succumb to individualism and collusion with power instead of contributing to the "social-political bettering of mankind".[39] Mário's followers and admirers have been busy burying that statement ever since.

What does it mean to be modern? In a fundamental sense, much of what is generally recognized as *modernist* in Brazil, in aesthetic terms, is at odds with the social and political fabric that is an integral part of Western conceptions of modernity.[40] Ideals like improved social welfare, equality among peoples, class struggle and revolution, abundant or even taken for granted in the context of European avant-gardes, are thin on the ground in *paulista* modernism of the 1920s. On the contrary, the political affiliations of the major players in the *Semana* group were primarily conservative before 1930, intimately linked to the ruling oligarchies of the Partido Republicano Paulista (PRP) or the competing Partido Democrático. With the changing political winds, several came to embrace left-wing positions – among others, Di Cavalcanti, Oswald de Andrade and Tarsila do Amaral joined the Brazilian Communist Party or drew close to it. However, they paid a price for their dissenting opinions. The modernist currents that managed to survive under the Vargas regime were precisely those that knew how to steer clear of the difficult task of political opposition.

[39] Mário de Andrade, *Aspectos da literatura brasileira* (São Paulo: Martins, 1974), pp. 253–255. See also Rafael Cardoso, "O intelectual conformista: Arte, autonomia e política no modernismo brasileiro", *O Que Nos Faz Pensar*, 26 (2017), 179–201.

[40] For a discussion of political modernity, its relationship to Enlightenment thinking and applicability to non-European contexts, see Dipesh Chakrabarty, *Provincializing Europe: Postcolonial Thought and Historical Difference* (Princeton: Princeton University Press, 2008), pp. 4–6.

Under Vargas, affirmations of dissidence – including racial and ethnic difference – were routinely sacrificed to a populist nationalism that demanded absolute subservience to a unified Brazilian identity.[41] After his deportation from Brazil in 1931, further discussed in Chapter 4, Benjamin Péret had little to say about the efforts of his former modernist friends. His essay "Black and white in Brazil", published in Nancy Cunard's *Negro: Anthology* (1934), makes no mention of *Antropofagia*, a movement to which he contributed, nor any other artistic current. Instead, it directs bitter invective against the enduring racial inequality of Brazilian society and preaches the necessity of "a definitely Communist programme".[42] For the outside observer, especially a European one, the contradictions of Brazilian modernism could prove baffling. Blaise Cendrars, who played such a key role in awakening the interest of the *paulista* modernists to the supposed primitive essence in their own back-yards, later concluded that the whole enterprise was no more than a literary cabal with little enduring result. "As it was practiced, all this modernism was nothing more than a vast misapprehension," he wrote in 1955. No wonder he thought so. Compared to the real drama and savagery of Brazil's westward expansion, the "bluff of modernism", as he termed it, barely broke the surface to reach the deeper currents underneath.[43]

Few things are more revealing of the *Semana* group's contradictions than the trip they undertook in Cendrar's company, in April 1924, to the colonial towns of Minas Gerais with the professed intention of 'discovering Brazil'.[44] For Cendrars, who was visiting the country for the first time,

[41] Cf. Adauto Novaes, "Introdução", In: Enio Squeff & José Miguel Wisnik, *O nacional e o popular na cultura brasileira* (São Paulo: Brasiliense, 1983), pp. 9–11.

[42] Benjamin Péret [Samuel Beckett, translator], "Black and white in Brazil", In: Nancy Cunard, *Negro: Anthology* (London: Nancy Cunard at Wishart & Co., 1934), pp. 510–514.

[43] Blaise Cendrars, "Utopialand" & "La voix du sang", *Trop c'est trop*, In: *Oeuvres complètes, tome VIII* (Paris: Denoël, 1987), pp. 191–193, 235–237. Cendrars's abiding interest in Brazil eventually took other avenues through his contacts with artist Oswaldo Goeldi, who produced a series of illustrations for *La vie dangereuse* (1938) depicting diverse aspects of popular culture, including images of maxixe, macumba, and the bandit Lampião; see Roberto Conduru, "Feitiço gráfico – a macumba de Goeldi", In: Conduru, *Pérolas negras, primeiros fios*, pp. 25–35; and Eulalio, *A aventura brasileira de Blaise Cendrars*, pp. 504–512.

[44] See Aracy A. Amaral, *Blaise Cendrars no Brasil e os modernistas* (São Paulo: Ed.34/Fapesp, 1997), pp. 15–20; and Luciano Cortez, "Por ocasião da descoberta do Brasil: Três modernistas paulistas e um poeta francês no país do ouro", *O Eixo e a Roda*, 19 (2010), 15–37. On the enduring repercussions of the 1924 trip, see Renata Campello

the phrase might have been apposite. For the remaining members of the so-called modernist caravan – Mário de Andrade, Oswald de Andrade, Tarsila do Amaral, René Thiollier, Olívia Guedes Penteado, Gofredo da Silva Telles – a visit to the neighbouring state of Minas, travelling in comfort and welcomed by local authorities, was hardly an encounter with some remote and unfathomed cultural entity. Excepting Mário, all were members of the *haute bourgeoisie* of the great coffee-producing state, one of the richest places in the world in the 1920s. The notion that they were uncovering deep archaic truths only reveals how sheltered a life they led in São Paulo and underscores the cluelessness of their quasi-colonialist enterprise. That this episode continues to be transmitted, unironically, as a 'discovery' attests to the endurance of social structures that allow Brazilian elites to live out their lives with little experience of the majority culture in their own country.

I.4 MODERN ART AND MASS CULTURE

The material examined in this book suggests that artistic modernization in the Brazilian context is best understood as a field of competing discourses and attitudes that shaped each other over the half century that preceded the Second World War. By 1945, as the *Estado Novo* regime came to an end, a new generation of critics and scholars, mostly too young to have played any part in the historical events themselves, repackaged the names and dates and facts into a recognizable narrative that has since become enshrined as the *Semana* myth. The "modernist tradition" they founded, as Heloisa Pontes called it, was moulded by personal relationships to the subjects they studied, by the academic community to which they belonged and by their ideological drive to distance themselves both from the outgoing Vargas regime and its communist opposition.[45] The combined impact of these pressures skewed their readings in a direction that over-emphasized both the centrality of literature and of São Paulo as markers for understanding modernism in Brazil. There are many others. As Silviano Santiago pointed out, long ago, every attempt "to hack a path through the jungle of artistic output since 1922" has led to traversing only

Cabral & Paola Berenstein Jacques, "O antropófago Oswald de Andrade e a preservação do patrimônio: Um 'devorador' de mitos?", *Anais do Museu Paulista*, 26 (2018), 1–39.

[45] Heloisa Pontes, *Destinos mistos: Os críticos do Grupo Clima em São Paulo (1940–68)* (São Paulo: Companhia das Letras, 1998), esp. pp. 34–42. See also Cardoso, "Forging the myth of Brazilian modernism".

one of many possible critical routes and ignoring other potential readings.[46] Three decades on from that evaluation, the accumulation of paths trodden makes it easier to map the terrain in its entirety.

A fresh look at archival evidence indicates that greater experimentation and formal innovation were going on in previously neglected arenas of visual and material culture, such as graphic design, than in the heavily scrutinized domain of fine art.[47] As shall be seen in Chapter 3, illustrated magazines were producing vibrant expressions of artistic modernism at a time when most painters and sculptors were engaged in work that was timid, at best. That such objects managed to reach a mass audience and impact attitudes and behaviour beyond the restricted circle of Brazilian elites makes them more interesting, rather than less, from a historical perspective and raises the troubling question of why scholars have largely been unwilling to engage with them. Over the decades, students of modernism in Brazil have tended to focus so intently on erudite forms of expression that they have conditioned their gaze to exclude all else. The most telling recent example is a study of the impact of modernism on periodicals in 1920s Brazil that gives precedence to literary magazines of avowedly "low popularity and extremely short duration" and excludes, without further justification, "cultural magazines" such as *Kosmos*, *Fon-Fon!*, *O Malho* and *Para Todos*, which its author nonetheless acknowledges reached a broad readership and impacted influential modernist agents.[48] The very currency of the cultural objects is written off, puzzlingly, as somehow detracting from their importance.

Such unabashed elitism is nothing new to the cult of 1922 modernism. The same wilful blindness to the facts at hand can be identified in Mário de Andrade's appreciation of popular culture, which he studied under the rubrics of folklore and ethnomusicology, but without ever giving equal consideration to its ramifications in the rising urban culture of the day. The writer compiled a wealth of documentary evidence on rural musical

[46] Silviano Santiago, "Calidoscópio de questões", In: *Sete ensaios sobre o modernismo* (Rio de Janeiro: Funarte, 1983), pp. 25–26. See also Eduardo Jardim de Moraes, *A brasilidade modernista: Sua dimensão filosófica* (Rio de Janeiro: Graal, 1978).

[47] See, among others, Rafael Cardoso, ed., *O design brasileiro antes do design: Aspectos da história gráfica, 1870–1960* (São Paulo: Cosac Naify, 2005); Julieta Sobral, *O desenhista invisível* (Rio de Janeiro: Folha Seca, 2007); and Paula Ramos, *A modernidade impressa: Artistas ilustradores da Livraria do Globo - Porto Alegre* (Porto Alegre: UFRGS Editora, 2016).

[48] Ivan Marques, *Modernismo em revista: Estética e ideologia nos periódicos dos anos 1920* (Rio de Janeiro: Casa da Palavra, 2013), pp. 14–16. Cf. Aracy A. Amaral, *Artes plásticas na Semana de 22* (São Paulo: Perspectiva, 1970), pp. 27–28.

traditions, storytelling and legends, some of which he used to compose the novel *Macunaíma*. His writings in the press show he was also aware of contemporary developments in the burgeoning musical genre of samba. However, as José Miguel Wisnik denounced many years ago, he stopped short of making the link between these phenomena and thereby recognizing samba, carnival and other urban forms as cultural expressions of Brazilian identity.[49] On the contrary, as further discussed in Chapter 4, he tended to write them off as contributing to the degradation of the truly national.

Mário de Andrade's blinkered attitude towards the mass culture of his day was not restricted to music. In an exhibition review of 1930, he raves about "the fantastic state of perfection in which the graphic arts exist in Germany" but, throughout his career, remained oblivious to the achievements of graphic artists K. Lixto or J. Carlos, among many others, which he would have seen weekly in the periodical press.[50] Reproducing the high/low divide that often inflected modernist currents elsewhere, Mário was unable or unwilling to view such productions as worthy of consideration as art. Likewise, in a 1932 essay on the representation of bandit leader Lampião in *cordel* literature – published under a pseudonym – he shows himself to be a connoisseur of that popular form but makes no effort to situate the subject of his discussion as a cultural agent in his own right.[51] For the great modernist critic, Sinhô, Lampião and J. Carlos were objects to be studied and/or strategically ignored, but certainly not counterparts or peers. This failure to recognize the relevance of the majority culture reflects an intellectual snobbery that, with a few honourable exceptions, has long been a characteristic of Brazil's cultural elite.

Mário de Andrade's apprehension of the rural and the ethnic as legitimate objects of folkloric study was couched in Romantic notions of lost purity and was thus implicitly primitivist, in the European sense of appropriating the purportedly backward culture of the subaltern *other* for

[49] José Miguel Wisnik, "Getúlio da Paixão Cearense", In: Squeff & Wisnik, *O nacional e o popular na cultura brasileira*, pp. 131–133. Cf. Avelino Romero Pereira, *Música, sociedade e política: Alberto Nepomuceno e a República musical* (Rio de Janeiro: Ed. UFRJ, 2007), pp. 26–28.

[50] Mário de Andrade, *Taxi e crônicas no Diário Nacional* (São Paulo: Duas Cidades/ Secretaria de Cultura, Ciência e Tecnologia, 1976), p. 254.

[51] Leocádio Pereira, "Romanceiro de Lampeão", In: Mário de Andrade, *O baile das quatro artes*, pp. 85–119. For a brief introduction to *cordel* literature and further references, see Rafael Cardoso, "Cordel collection", *Getty Research Journal*, 9 (2017), 219–225.

purposes of affirming the transgressive energies of the modernist self.[52] The divergent uses of primitivism in the Brazilian context can be better understood by contrasting Mário's positions with those of the *Antropofagia* movement. The anthropophagists engaged openly with primitivism and were critical of European practices, a topic addressed more fully in Chapter 4. Contemptuous of intellectual pedantry, they made short shrift of Mário's professorial tone in his writings on folklore. They even went so far as to claim Lampião as one of their own, facetiously citing him in the *Revista de Antropofagia* as a member of the movement. Despite their boisterous antipathy towards all manner of intellectual snobbery, however, the anthropophagists had similar difficulties in recognizing the modernity of the urban culture that surrounded them. In an article for the journal, published October 1928, poet Antônio de Alcântara Machado made passing reference to a Mutt and Jeff cartoon drawn by J. Carlos.[53] Even though they were evidently aware of the illustrator's work, at no point were any of the movement's members attuned to its qualities as art, much less of a modern kind. The jazzy graphics of J. Carlos, the explosive rise of modern samba and carnival, the media-saturated saga of Lampião, were all phenomena that no one living in an urban centre in Brazil over the 1920s and 1930s could have failed to notice. Yet, to examine the evidence from the modernist movement, it is as if these things were irrelevant to artistic debates.

Mass culture can be construed as "the repressed other of modernism", as Andreas Huyssen memorably labelled it in the 1980s, and the effort by some modernist critics to downgrade its importance is equally conspicuous in Europe or the United States. Driven by anxiety about technology, industrialization and the changing attitudes they engendered, Huyssen contends, modernists "eagerly incorporated themes and forms of popular culture" as a means of resisting the imperatives of a mass culture they feared.[54] In the Brazilian context, a similar high/low divide existed within modernism and, arguably, ran even deeper. Given the gross economic inequalities and stark class divisions that mark Brazilian society, a shared assumption still prevails that decisions about what really matters in art

[52] Abilio Guerra, *O primitivismo em Mário de Andrade, Oswald de Andrade e Raul Bopp: Origem e conformação no universo intelectual brasileiro* (São Paulo: Romano Guerra, 2010), pp. 260–264.

[53] Antônio de Alcântara Machado, "Vaca", *Revista de Antropofagia*, I, n.6 (October 1928), 1.

[54] Andreas Huyssen, *After the Great Divide: Modernism, Mass Culture and Postmodernism* (London: Macmillian, 1986), pp. vii–ix, 16–18, 56.

and culture are the prerogative of a privileged few. Brazilian modernists did not feel a need to combat mass culture because, for the most part, they could simply afford to ignore it.

Unlike Paris or New York, where mass culture was increasingly responsible for pushing older traditions of popular culture out of existence and replacing pre-industrial forms with fashionable novelties, Rio de Janeiro is a city where the old and the new, the rural and the urban, the sacred and the profane, found unique and peculiar ways of co-existing. The shifting social geography of the city, during the early twentieth century, saw the rise of favelas as a model of urban residence and the concomitant evolution of a cultural dynamic in which separate spheres – divided by class, race, religion, education and income, as well as access to public services and civil rights – shaped each other mutually to form the modern Carioca identity.[55] As further discussed in Chapters 1 and 2, samba and carnival were the specific cultural forms born of contacts between Rio's European-minded elites and a booming population of immigrants, migrants and descendants of the formerly enslaved, the latter enjoying the freedom for the first time to celebrate their African roots, rites and rhythms. The urban culture they formulated was steeped in popular traditions but by no means averse to new media and technologies.[56]

The modern movement's lack of interest in mass culture can be plausibly excused by arguing that the phenomenon did not attain the same preponderance in 1920s and 1930s Brazil as in economically more developed societies, where commodification and spectacle were more conspicuous features. In his ground-breaking essay "Cultura e sociedade", Renato Ortiz proposed that the designation *mass popular culture* only really becomes applicable in Brazil during the 1940s, with the rise of radio as a medium.[57] Much new evidence has been produced in the three decades since that essay was written, and Ortiz's position needs to be revised accordingly. Firstly, there can be little doubt that the increasing presence of cinema, especially American films produced in Hollywood, significantly impacted the visual culture of Brazilian audiences and exercised direct influence on established forms of cultural production. The

[55] See Antônio Herculano de Lopes, ed., *Entre Europa e África: A invenção do carioca* (Rio de Janeiro: Topbooks/Fundação Casa de Rui Barbosa, 2000).

[56] See Hermano Vianna, *O mistério do samba* (Rio de Janeiro: Jorge Zahar/Ed.UFRJ, 1995); and Carlos Sandroni, *Feitiço decente: Transformações do samba no Rio de Janeiro, 1917–1933* (Rio de Janeiro: Jorge Zahar/Ed.UFRJ, 2001).

[57] Renato Ortiz, *A moderna tradição brasileira* (São Paulo: Brasiliense, 1988), pp. 38–76.

runaway success of Benjamim Costallat's 1923 novel *Mademoiselle Cinema* – running to three editions in its first year, spawning a sequel and a film adaptation, and establishing the author's own publishing house as a force on the book market – is metonymical proof that the combination of cinema, sex and modernity appealed to a much broader audience than the restricted reading public usually associated with literature.[58]

The second arena in which a new mass audience is discernible is recorded music. The careers of musical sensations like Sinhô, discussed in Chapter 4, or the group Oito Batutas, whose 1922 tour to Paris has been the subject of extensive academic scrutiny over recent years, confirm that urban popular culture was already a phenomenon of considerable reach and significance in the 1920s.[59] The third arena is illustrated periodicals and commercial advertising, media of even more central concern to the present book. Despite Nicolau Sevcenko's substantial contributions to thinking about how new modes of communication shaped the public imagination, their cultural import continues to be routinely underestimated.[60] By and large, with a few notable exceptions, historical evaluations of the period attribute much more weight to erudite discourses than popular ones. Illustrated magazines propounded a conception of modernity as style and entertainment that became widespread as early as the 1910s, particularly for the urban middle classes in which most of the leading modernists lived out their social lives. In this sense, Chapter 3 provides crucial evidence supporting the contention that the cutting edge of visual cultural production in the Brazilian context occurred outside the arena of high art.

[58] See Beatriz Resende, "A volta de Mademoiselle Cinema", In: Benjamim Costallat, *Mademoiselle Cinema: Novela de costumes do momento que passa* (Rio de Janeiro: Casa da Palavra, 1999 [1923]), pp. 9–27. See also Maite Conde, *Consuming Visions: Cinema, Writing and Modernity in Rio de Janeiro* (Charlottesville: University of Virginia Press, 2012). On the existence of a mass reading public even earlier, see Alessandra El Far, *Páginas de sensação: Literatura popular e pornografia no Rio de Janeiro (1870–1924)* (São Paulo: Companhia das Letras, 2004).

[59] See, among others, Micol Seigel, *Uneven Encounters: Making Race and Nation in Brazil and the United States* (Durham: Duke University Press, 2009), 104–115; and Marc A. Hertzman, *Making Samba: a New History of Race and Music in Brazil* (Durham: Duke University Press, 2013), pp. 109–125.

[60] See Nicolau Sevcenko, "A capital irradiante: Técnica, ritmos e ritos do Rio", In: Nicolau Sevcenko, *História da vida privada no Brasil 3. República: da Belle Époque à Era do Rádio* (São Paulo: Companhia das Letras, 1998), pp. 513–620. See also Nicolau Sevcenko, *Orfeu extático na metrópole: São Paulo, sociedade e cultura nos frementes anos 20* (São Paulo: Companhia das Letras, 1992).

By the time of the manhunt for Lampião and the media furore it provoked between 1930 and 1938, mass culture had undoubtedly galvanized the nation into awareness of its own modernity. Considering the pervasiveness of cinema, recorded music, graphic arts and their unequivocal relationship to urban conditions and technological change, the inescapable question is: why has the discussion of modernism in Brazil been centred almost exclusively on elite arenas of cultural production? Compared to Lampião's clever manipulation of the media through photography and cinema, Oswald de Andrade's strategies to promote *Antropofagia* resemble the antics of a naughty schoolboy. Compared to the raw power of a carnival parade, Mário de Andrade's ideas on music echo the emptiness of the ivory tower. Compared to the boldness of K. Lixto or J. Carlos, many artworks produced with the declared intention of being revolutionary appear hopelessly tame. Yet, scholars and journalists continue to propagate a modernist canon that is somewhat less than ground-breaking, even by the relatively modest artistic standards set by those who wrote it.

A point worth stressing before drawing this introduction to a close is how the prevailing paradigm on artistic modernism has side-lined Afro-descendant artists. In any other cultural context, a pioneering graphic artist like K. Lixto would probably be revered as one of the great names of his day. Instead, he has been largely forgotten. Arguably, that has only partly to do with race. The equally talented J. Carlos, who was not only white but blatantly racist, has also been mostly left out of histories of modern art in Brazil. The difficulty seems to have more to do with the divide between fine art and graphic art, high and low. Yet, the case of Arthur Timotheo da Costa, an academically trained painter, gives pause for thought. Arthur Timotheo died one month before Lima Barreto, in October 1922, just short of his fortieth birthday, also committed to a mental asylum.[61] The coincidence of their trajectories as talented Afro-descendant artists condemned to a grim fate is chilling. Timotheo's extraordinary contributions to Brazilian painting over the years between 1906 and his death remained mostly obscure until the inauguration of the Museu Afro Brasil, in São Paulo, in 2004. Though he is now recognized as a great Afro-Brazilian artist and a pioneer in the self-representation of blackness, his work has yet to be reconciled with the

[61] Adalberto Pinto de Mattos, "Bellas artes. O pintor que morreu", *O Malho*, 14 October 1922, n.p.

broader narrative of artistic modernization in Brazil.[62] He is left to stand apart, as an anomaly, still an outsider in his own culture.

The blind spot with which traditional interpretations of modern art have disregarded alternate modernisms and their histories is situated in Brazilian society's difficulty in looking critically at itself – in particular, looking long and hard at the inequities of race and class that are the enduring legacy of slavery. Modernity, in Brazil, is often confused with the desire to appear modern. Sometimes, deliberately so. Politics and policies geared to modernization result in a veneer of progress but systematically stop short of effecting real change. It is always less work to paint over a damaged wall than to rebuild it. Still, hope remains that this condition can be countered by greater awareness of the structural deficiencies that perpetuate it. The archaism inherent in Brazilian modernity does not derive from a biologically given condition or fate, but from social constructs subject to deconstruction through historical analysis and political education. Oppression continues to exist; the subaltern continues to resist; and the past has a stubborn way of coming back to haunt the present. This book is about some of the alternatives to the prevailing paradigm and why they have for so long been overlooked.

[62] Cardoso, "The Problem of Race in Brazilian Painting", pp. 501–505.

Heart of Darkness in the Bosom of the Modern Metropolis

Favelas, Race and Barbarity

> I gazed sadly at the houses of Mangue, the side streets of Cidade Nova; those of Morro da Favela, I could just barely glimpse . . . I thought to myself: why didn't they get rid of 'that'? Was such a *repoussoir* necessary to set off the beauty of the so-called chic neighbourhoods?
>
> Lima Barreto, 1921[1]

Between 1890 and 1930, the emergence of favelas, or shantytowns, that sprang up on the hillsides of central Rio de Janeiro, then the capital of Brazil, generated discourses associating blackness, barbarity and backwardness. Mediated through art and literature, in addition to the press, these discursive tropes drew on fears and anxieties deriving from the rapid demographic changes occurring in the city, as well as the larger political transformation of the nation from Empire to Republic, a development that cannot be dissociated from the legal abolition of slavery in 1888. The enduring legacy of social inequality and racial difference lurked in the background of many debates, especially those relating to urban reform and the need to beautify the nation's capital, often framed in terms of the discursive trope of 'civilizing Rio'.[2] The narrator in Lima Barreto's short story of 1921, cited in the epigraph, gazes in horror at the city's first favela and can come up with no better term to designate it than *that*. (His name, Dr Matamorros, translates loosely as 'kills hills'.) Metaphorically, he compares the view to a *repoussoir*, a figure used in the foreground of a

[1] LB [Lima Barreto], "O poderoso dr. Matamorros", *Careta*, 5 February 1921, n.p.
[2] See Teresa A. Meade, *'Civilizing' Rio: Reform and Resistance in a Brazilian City 1889–1930* (University Park: Pennsylvania State University Press, 1997).

painting to increase the illusion of depth, suggesting that its purpose was to serve as the obverse of elegance. He was not alone in his apprehension of the poorer reaches of the city as places of archaic squalor and blight, fit only to be razed in order to make way for a new and modern Brazil.[3] The present chapter will examine how depictions of favelas in writings, paintings, photographs and cartoons created a foil of alterity and subalternity against which the modernizing aspirations of Brazil's elites could be opposed.

The convoluted nature of this process, shaped by conflicting demands and hidden tensions, engendered a situation of such complexity that, by the 1920s, the rise of favelas could be made to bear the blame for no less than the decline of art. An anonymous commentator in the popular weekly magazine *Fon Fon* fumed that journalists lent greater weight to what he viewed as a spurious alliance between modernity and blackness than to traditional values of art and literature:

Art is something secondary to the contemporary journalist and those who read him. Literature, then, elicits nothing from him. Why report on a book when the horrendous feats of a thick-lipped negro from the Favela attract more, much more, attention from a modern public spoiled by jazz, automobile horns and futurism?[4]

This bizarre formulation demands to be unpacked. How did automobiles, jazz, futurism and favelas come to be lumped together in such rhetorical anger? To begin to answer that question requires stepping back and understanding the social and cultural forces at play in the historical evolution of Brazil and Rio de Janeiro.

Over the latter half of the nineteenth century, the great boom in pseudo-scientific racial theories in Europe and the USA exercised a powerful influence on the way Brazilians thought about themselves.[5] African

[3] For virulent condemnations of the old colonial city and the wish to erase the past physically, see "A avenida projectada", *A Avenida*, 1 August 1903, 7; and Olavo Bilac, "Inauguração da avenida" (1905), In: Olavo Bilac, *Melhores crônicas* (São Paulo: Global, 2005), p. 173. Cf. Marcia Cezar Diogo, "O moderno em revista na cidade do Rio de Janeiro", In: Sidney Chalhoub, Margarida de Souza Neves, & Leonardo Affonso de Miranda Pereira, eds., *História em cousas miúdas: Capítulos de história social da crônica no Brasil* (Campinas: Ed. Unicamp, 2005), p. 468.

[4] "Commentarios da semana", *Fon Fon*, 16 January 1926, 3.

[5] See Nancy Leys Stepan, *Picturing Tropical Nature* (London: Reaktion, 2001), esp. ch. 3 & 4; Marcos Chor Maio & Ricardo Ventura Santos, eds., *Raça, ciência e sociedade* (Rio de Janeiro: Fiocruz/CCBB, 1996); Lilia Moritz Schwarcz, *O espetáculo das raças: Cientistas, instituições e questão racial no Brasil 1870–1930* (São Paulo: Companhia das Letras, 1993); and Roberto Ventura, *Estilo tropical: História cultural e polêmicas literárias no Brasil, 1870–1914* (São Paulo: Companhia das Letras, 1991), pp. 46–66.

and Amerindian origins were widely judged as inferior and an impediment to achieving the accepted ideal of civilization along European lines. Racial admixture continued to be understood almost exclusively as a source of degeneracy and even as a hereditary curse, at least until the pioneering writings of Manoel Bomfim in the early years of the twentieth century.[6] Against such a backdrop of scientifically validated racism, favelas were perceived as an obstacle to civilization. Their presence constituted a heart of darkness – in the sense enshrined by Joseph Conrad's novella of 1899 – implanted into the bosom of the modern metropolis.

In the brief interim between 1890 and 1930, Rio's favelas came to symbolize and demarcate a portion of the city that was later christened 'little Africa'. The origin of that epithet has been attributed to Heitor dos Prazeres, one of the leading composers of the new style of samba that gained popularity over the 1920s, and he undoubtedly intended it as a positive designation.[7] As a site of resistance, *little Africa* is a powerfully charged term and still resonates today with those who struggle to affirm human and civil rights for all, regardless of colour or creed. The idea of an enclave of Africanness within the larger social body is also suggestive, however, of a segregation of territories and traditions at odds with the prevailing conception of Brazil as a place of cultural fusion – a 'melting pot' or 'kaleidoscope', as it is sometimes deemed.[8] On an even more profound level, any partition of the city into African and non-African territories bespeaks a mentality not too far removed from the colonialist fantasies of Europe, which sought to affirm itself as racially separate and superior over the nineteenth century. Brazilian identity can never be considered apart from the contributions of Afro-Brazilian culture that are an integral part of its formation. Positing the existence of a *little Africa* within Rio de Janeiro, even as a place of resistance, begs the question of exactly what constitutes the larger territory surrounding it.

[6] Manoel Bomfim, *A América Latina – Males de origem* (Rio de Janeiro: Topbooks, 2005 [1905]). See also Dain Borges, "The recognition of Afro-Brazilian symbols and ideas, 1890–1940", *Luso-Brazilian Review*, 32 (1995), 59–78.

[7] Roberto Moura, *Tia Ciata e a Pequena África no Rio de Janeiro* (Rio de Janeiro: Secretaria Municipal de Cultura/Coleção Biblioteca Carioca, 1995), pp. 120–154. See also Bruno Carvalho, *Porous City: a Cultural History of Rio de Janeiro (from the 1810s onwards)* (Liverpool: Liverpool University Press, 2013), pp. 1–15.

[8] See Octavio Ianni, *A idéia de Brasil moderno* (São Paulo: Brasiliense, 1992), 61. Cf. Vivian Schelling, ed., *Through the Kaleidoscope: the Experience of Modernity in Latin America* (London: Verso, 2000).

I.I RIO DE JANEIRO AT THE TURN OF THE TWENTIETH CENTURY

The 1890s were a time of profound upheaval in Brazil. After nearly half a century of comparative stability under the reign of Emperor Pedro II, a military coup on 15 November 1889 proclaimed the nation a Republic and set off a chain of events that soon took on catastrophic proportions. Deregulation of financial markets and monetary policies, especially under economy minister Ruy Barbosa, led to fevered speculation and a cycle of dodgy issues of currency, investments and inflation remembered in economic history under the term *Encilhamento*, one of the first financial crises of global proportions. When the bubble burst in November 1890 – following the near failure of Barings Bank, in London, and ensuing panic – the Brazilian economy entered a meltdown from which it would only recover over a decade later.[9]

The financial collapse made an already unruly political situation worse. Within two years of the new regime, a coup within the coup saw the first president, Generalissimo Deodoro da Fonseca, shut down Congress and attempt to increase his already substantial executive powers. A counter-coup, led by rebellious navy commanders, forced him to resign and ensured that the vice-president, army Marshal Floriano Peixoto, succeeded to the presidency in November 1891. The new government was faced with relentless political opposition, as well as another larger navy rebellion in 1893–1894 – the *Revolta da Armada*, in which vessels sporadically bombarded Rio de Janeiro over a period of five months – plus an outright civil war in the southern state of Rio Grande do Sul – the *Revolução Federalista*, which lasted from 1893 to 1895, straining public coffers and leaving many thousands dead. Floriano struck back with full military might, crushed the rebellions, and jailed and exiled oppositionists, actions that earned him the epithet 'the iron Marshal'. When he handed power over to his successor Prudente de Moraes, Brazil's first civilian president, in November 1894, the storm seemed set to abate.[10]

[9] John Schulz, *The Financial Crisis of Abolition* (New Haven: Yale University Press, 2008), pp. 8–9 & ch.6; Kris James Mitchener & Marc D. Weidenmier, "The Baring Crisis and the Great Latin American Meltdown of the 1890s", *Journal of Economic History*, 68 (2008), 462–500; Gail D. Triner & Kirsten Wandschneider, "The Baring Crisis and the Brazilian Encilhamento, 1889–1891: an early example of contagion among emerging capital markets", *Financial History Review*, 12 (2005), 199–225.

[10] An introduction to the political situation is available in: Renato Lessa, "A invenção da República no Brasil: Da aventura à rotina", In: Maria Alice Rezende de Carvalho, ed., *República no Catete* (Rio de Janeiro: Museu da República, 2001), pp. 11–58.

The second half of the decade was only slightly less turbulent, though. An attempt to resolve the ongoing financial crisis, via a refunding loan negotiated with the London-based house of Rothschild, resulted in a new round of bank failures and bankruptcies after 1898.[11]

Meanwhile, in the hinterland (*sertão*) of the state of Bahia, a self-styled holy man named Antônio Conselheiro began to preach against the Republic and attracted so many followers that, by 1896, the community they established at a place called Canudos numbered around 25,000 inhabitants.[12] Two detachments sent by the state government to quell the so-called 'fanatics' were rebuffed, in 1896–1897, after which the federal government took over, dispatching more than a thousand regular army troops under the command of an officer renowned for his suppression of rebels in the recent civil war in the south. When this expedition was likewise defeated by the professedly monarchist *conselheiristas*, the tiny rebellion took on national security proportions. A fourth expeditionary force, consisting of about 10,000 heavily armed troops, arrived at Canudos in June 1897. After considerable initial losses, the army finally crushed all resistance and burned down the settlement in early October. The barbarity with which they meted out punishment, including brutal mass executions that raised the death toll to between 20,000 and 30,000, prompted public concern and undermined confidence in the Republican regime as a standard-bearer of civilized values.[13]

This was the political and economic backdrop for life in 1890s Rio de Janeiro, a city struggling against a reputation as the 'tomb of foreigners', driven by surging rates of tuberculosis, smallpox, malaria and yellow fever.[14] The main sociological factor in this public health crisis was a shortage of adequate housing. After the abolition of slavery, migrants

[11] Gail D. Triner, "British banking in Brazil during the First Republic", *Locus: Revista de História*, 20 (2014), 157–159. See also Schulz, *Financial Crisis of Abolition*, ch.7 & 8.

[12] For more on ideas of *sertão* and *sertanejo*, see Chapter 5.

[13] See, among others, Robert M. Levine, *Vale of Tears: Revisiting the Canudos Massacre in Northeastern Brazil, 1893–1897* (Berkeley: University of California Press, 2006 [1995]). The trauma of Canudos inspired one of the great documents of twentieth-century Brazilian literature: Euclides da Cunha [Samuel Putnam, translator], *Rebellion in the Backlands* (Chicago: University of Chicago Press, 2010 [1902]).

[14] Despite the pithy epithet, proportionally fewer non-Brazilians perished than the city's urban poor, who were the population most at risk. See Sidney Chalhoub, "The politics of disease control: Yellow fever and race in nineteenth century Rio de Janeiro", *Journal of Latin American Studies*, 25 (1993), 441–463; and Thales Augusto Zamberlan Pereira, "Mortalidade entre brancos e negros no Rio de Janeiro após a abolição", *Estudos Econômicos*, 46 (2016), 439–469. See also Carvalho, *Porous City*, ch.1.

from rural areas began to stream into the capital, adding to the rising tide of immigrants from Europe, especially Portugal. According to the 1890 census, approximately 20 per cent of the city's residents consisted of Portuguese immigrants. Between 1890 and 1900, the population of Rio swelled from about half a million to just over 800,000 – a growth rate of over 55 per cent in one decade – with a severe imbalance between males and females.[15] Inadequate housing and underinvestment in waste and sewage treatment meant poor sanitary conditions. Local authorities became convinced that the way to combat the problem was to stamp out the multi-family lodging houses, called *cortiços*, in which much of the poorer population lived. From the early 1890s onwards, the municipal government began to implement a policy of demolishing tenements and ejecting their inhabitants onto the streets, often with tragic consequences in terms of social unrest.[16]

1.2 IMAGES OF THE FIRST FAVELAS

Squatter settlements sprang up in the 1890s, almost simultaneously, in two hillside locations in central Rio de Janeiro: Morro da Providência and Morro de Santo Antônio. Living conditions were semi-rural. Residents erected simple wooden shacks, planted gardens and raised animals, with little regard for municipal regulations and no public services. There are few hard facts about their early formation, but historians agree that many of those who built makeshift housing upon these hills, especially Morro da Providência, were dislodged from nearby tenements.[17] The most notorious of such establishments – known as *Cabeça de Porco*, the pig's

[15] See Lilian Fessler Vaz, *Modernidade e moradia: Habitação coletiva no Rio de Janeiro, séculos XIX e XX* (Rio de Janeiro: 7Letras/Faperj, 2002), pp. 26–27; and Sidney Chalhoub, *Trabalho, lar e botequim: O cotidiano dos trabalhadores no Rio de Janeiro da Belle Époque* (Campinas: Ed. Unicamp, 2001 [1986]), pp. 42–50.

[16] Fessler Vaz, *Modernidade e moradia*, pp. 32–36; José Murilo de Carvalho, *Os bestializados: O Rio de Janeiro e a República que não foi* (São Paulo: Companhia das Letras, 1987), ch.1; and Sidney Chalhoub, *Cidade febril: Cortiços e epidemia na Corte imperial* (São Paulo: Companhia das Letras, 1996), ch.1. For an English-language account, see Brodwyn Fischer, *A Poverty of Rights: Citizenship and Inequality in Twentieth-Century Rio de Janeiro* (Stanford: Stanford University Press, 2008), pp. 19–49.

[17] Maurício de Almeida Abreu & Lilian Fessler Vaz, "Sobre as origens da favela", *Anais do IV Encontro Nacional da ANPUR*, 4 (1991), 481–492; Maurício de Almeida Abreu, "Reconstruindo uma história esquecida: Origem e expansão das favelas no Rio de Janeiro", *Espaço & Debates*, 37 (1994), 34–46; Lilian Fessler Vaz, "Dos cortiços às favelas e aos edifícios de apartamentos – a modernização da moradia no Rio de Janeiro", *Análise Social*, 29 (1994), 590–592.

head, in reference to an ornament displayed over its gate – housed up to two thousand people in its heyday. It was demolished in January 1893, following a press campaign inflamed by the success of Aluizio Azevedo's naturalist novel, *O cortiço* (1890), which denounced the squalor of living conditions and fed perceptions of a link between bad housing and loose morals.[18] Public outcry provided a pretext for the city's mayor, Cândido Barata Ribeiro, to clear away what was widely regarded as a focus of disease and sordidness.[19] The *Cabeça de Porco* complex stood at the foot of Morro da Providência, a sparsely populated hill situated between the city's port to its north and the central train station directly to its south. It was a short climb, and former residents were reputedly granted permission to cart off building materials discarded from the demolished tenement. Roughly in parallel, the settlement on Morro de Santo Antônio derived from emergency measures to house military personnel there during the *Revolta da Armada*.[20]

Eliseu Visconti's painting *Uma Rua da Favela* (*A street in the Favela*) (circa 1890) (Fig. 1) is among the earliest depictions of favela life.[21] A black woman stands outside a shack, wash-basin in hand, smoking a small pipe and staring out at the viewer. Her facial features are partially obscured by shadow and her expression rendered uncertain by the loose finish the painter has chosen to apply. Her clothing and surroundings indicate she is poor. She is emblematic, in many ways, of the formerly enslaved population who found their way to Rio de Janeiro after 1888. Parts of the composition are sketchier than others. The brushstrokes that make up the woman's clothes and lush vegetation are more visible than those that constitute the wooden walls of the shanty, making the buildings seem more substantial than the rest. Visconti has left the woman's feet strategically blurred: loose brown blobs bleeding into shadow. The viewer

[18] Aluizio Azevedo [David Rosenthal, translator], *The Slum* (Oxford: Oxford University Press, 2000).

[19] Fischer, *A Poverty of Rights*, pp. 32–34; Richard Negreiros de Paula, "Semente de favela: Jornalistas e o espaço urbano da Capital Federal nos primeiros anos da República – o caso do Cabeça de Porco", *Cantareira*, 2 (2004), 1–23; Lilian Fessler Vaz, "Notas sobre o Cabeça de Porco", *Revista do Rio de Janeiro*, 1 (1986), 33.

[20] Abreu, "Reconstruindo uma história esquecida", 36; and Fessler Vaz, *Modernidade e moradia*, p. 55.

[21] The painting dates from Visconti's period as a student in the Escola Nacional de Belas Artes and is certainly prior to 1893, when he went to study in Paris. The title may have been added later. See Mirian Nogueira Seraphim, "A carreira artística", In: Tobias Stourdzé Visconti, ed., *Eliseu Visconti: A arte em movimento* (Rio de Janeiro: Hólos Consultores/Projeto Eliseu Visconti, 2012), pp. 64–140.

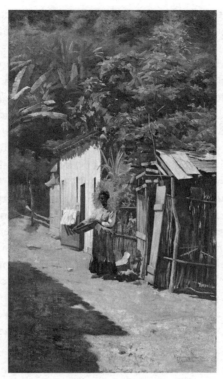

FIG. 1 Eliseu Visconti, *Uma Rua da Favela*, circa 1890, oil on canvas, 72 × 41 cm. For color version of this figure, please refer color plate section.
Brasília: collection of Tatiana and Afrisio Vieira Lima

is thus denied the crucial information of whether they are bare or shod. That would be a significant detail to the contemporary viewer since, in nineteenth-century Brazil, slaves were not allowed to wear shoes. A large area of shadow occupies the bottom left-hand corner of the composition. The length of rounded shapes along its right edge suggests roofing tiles on the cornice of a taller house. The woman is standing almost in the shadow of a *sobrado*, the typical two-story dwelling inhabited by families with proper housing. Visconti's pioneering depiction encapsulates the early history of the favela, casting a critical eye upon the plight of the black population recently delivered from slavery only to be flung out cruelly into a society that provided neither land nor opportunity.[22]

[22] This critique was most prominently voiced, at the time, in the writings of engineer André Rebouças advocating land, work and education for the newly freed. See Martha V. Santos Menezes, "A utopia agrária e democrática de André Rebouças", *Revista Três*

Received tradition has it that numerous soldiers returning from the Canudos campaign settled on Morro da Providência in late 1897, claiming compensation for a purported promise they would be given land by the government in exchange for their service in Bahia. According to this well-known account, they renamed the hill Morro da Favela in reference to a place near Canudos where the hearty favela plant (*Cnidoscolus quercifolius*), a species endemic to northeast Brazil, grew in abundance.[23] Whether or not this account is true, it has evolved into an "origin myth", as Licia Prado Valladares has termed it.[24] The designation caught on, and the community soon became known as *the* Favela, with a capital F, a name it retained during the first half of the twentieth century. Over subsequent decades, as self-built settlements on squatted land spread to other hills in Rio de Janeiro, they came to be referred to as favelas, plural. By 1930, the term had completed the transition from toponym to category.[25]

By the early 1900s, when journalistic accounts began to be published, the original Favela had already acquired a reputation as a breeding ground for crime and vice, where even the police were afraid to tread. Sensationalist newspaper reports became commonplace, describing Morro da Favela as a no-man's land ruled by criminals and home to the worst of the city's so-called dangerous classes.[26] A 1903 article on the

Pontos, 5 (2008), 131–140; and also Inoã Pierre Carvalho Urbinati, *Idéias e projetos de reforma agrária no final do Império (1871–1889): Uma análise do seu sentido político e social* (unpublished MA thesis, Universidade do Estado do Rio de Janeiro, 2008), ch.1.

[23] References to the heights of Favela, from which vantage point Canudos was bombarded, are common in press coverage of the military campaign during 1897. Exactly when the term began to be used as a designation for Morro da Providência is uncertain. In 1901, there is a mention of an "arraial da Favela" connecting to Morro da Providência via Ladeira dos Melões; see "Morro da Providência", *Gazeta de Notícias*, 10 May 1901, 2.

[24] Licia do Prado Valladares, *A invenção da favela: Do mito de origem à favela.com* (Rio de Janeiro: Fundação Getúlio Vargas, 2005), pp. 28–36. See also Romulo Costa Mattos, "Militares de baixa patente na Primeira República: Os primeiros moradores das favelas cariocas?", *Anais do XXVI Simpósio Nacional de História – ANPUH* (2011), 1–15.

[25] Abreu, "Reconstruindo uma história esquecida", 42. After *favela* became a generic appellation, and a pejorative one at that, the original Morro da Favela reverted to its earlier name, Morro da Providência, which it retains to this day. For more on this ongoing history, see Brodwyn Fischer, "A century in the present tense: Crisis, politics, and the intellectual history of Brazil's informal cities", In: Brodwyn Fischer, Bryan McCann & Javier Ayuero, eds., *Cities from Scratch: Poverty and Informality in Latin America* (Durham: Duke University Press, 2014), pp. 9–67; and Alba Zaluar & Marcos Alvito, *Um século de favela* (Rio de Janeiro: Fundação Getúlio Vargas, 2006).

[26] See Romulo Costa Mattos, "Heavenly heights, or reign of the dangerous classes? F. T. Marinetti's visit to the Morro da Favela (1926)", In: Marina Aguirre, Rosa Sarabia, Renée M. Silverman & Ricardo Vasconcelos, eds., *International Yearbook of Futurism Studies*, 7 (2017), pp. 288–306. See also Romulo Costa Mattos, "Shantytown dwellers'

front page of the daily *Gazeta de Notícias* – poised on the borderline between fiction and reportage – states: "On this Morro da Providência live the most terrible *malandros* [ruffians] in the world, with frightful wives and weekly murders."[27] The text goes on:

Morro da Providência has always been a place famed for its *capoeiragem* and murders. Long ago, the site where the cross built by the Santa Casa currently stands, at the summit of the mountain, is where the *capoeira* lessons took place. They called it *China Seco* and the royal police were never able to put a stop to this centre of horror. After the War of Canudos, the boldest evildoers returned to inhabit the apex of the hill, calling it *Favela*, because in this bastion no police go undefeated.[28]

Revealingly, the author forges a link between crime, the practice of *capoeira* – a martial art of Afro-Brazilian origin, widely practised by outlaws and agitators during the imperial epoch – and the tenacious rebels of Canudos who resisted all but the final army assault against their community. In these few lines, the slippage between lawlessness, blackness and insurgency is complete. As Nicolau Sevcenko pointed out, these tropes were subtly linked by notions of "errant activity" and "epiphanic experience" that were deeply threatening to the established order.[29]

The historical geography of Rio de Janeiro reinforced such connections. The side of Morro da Providência closest to the port is only a few minutes' walk away from the former slave market, located on what was once Rua do Valongo (today, Rua Camerino) and Cais do Valongo, the wharf where at least half a million enslaved persons were disembarked before Brazil's official prohibition of the transatlantic trade in 1830.[30] This region, just outside the old colonial city, had long been given over to

resistance in Brazil's First Republic (1890–1930): Fighting for the right of the poor to reside in the city of Rio de Janeiro", *International Labor and Working-Class History*, 83 (2013), 54–69; and Andrelino Campos, *Do quilombo à favela: A produção do "espaço criminalizado" no Rio de Janeiro* (Rio de Janeiro: Bertrand Brasil, 2005).

[27] "Na Favella. Trecho inédito do Rio", *Gazeta de Notícias*, 21 May 1903, 1–2. In 2015, the newspaper *O Globo* reprinted this text and attributed it to João do Rio, based on stylistic grounds, but this attribution is by no means certain. It is not included in the volume of the author's 1903–1904 chronicles written for the *Gazeta de Notícias*, edited by Julia O'Donnell & Lara Jogaib; see João do Rio, *A cidade* (Rio de Janeiro: Contra Capa/Faperj, 2017).

[28] "Na Favella", 1.

[29] Nicolau Sevcenko, "Peregrinations, visions and the city: from Canudos to Brasília, the backlands become the city and the city becomes the backlands", In: Schelling, *Through the Kaleidoscope*, pp. 78–98.

[30] See Rafael Cardoso, "Do Valongo à Favela: A primeira periferia do Brasil", In: Clarissa Diniz & Rafael Cardoso, eds., *Do Valongo à Favela: Imaginário e periferia* (Rio de Janeiro: Museu de Arte do Rio/Instituto Odeon, 2015), pp. 12–35.

shunned activities including not only the commerce of humans, but also cemeteries, a prison, a hospital for contagious diseases, as well as illicit pursuits related to the port, including prostitution.[31] In many ways, it was the dingy, dirty counterpart of the formal urban centre clustered around Morro do Castelo and Largo do Paço (today, Praça XV de Novembro), where the city had its origin and government. After Rio de Janeiro was elevated to colonial capital in 1763 and, even more importantly, to seat of the Portuguese empire in 1808, rapid growth ensued, and new districts were incorporated to the city. The area corresponding to the present-day neighbourhoods of Saúde and Gamboa – encompassing Morro da Providência – was relegated to purposes considered undesirable in the city centre. By the early twentieth century, this region was widely perceived as dangerous and infested with crime and vice. It became a focus for rebellion and played a dramatic role in the Vaccine Revolt of 1904, the largest popular uprising in the history of Rio de Janeiro.[32]

One of the first texts to give favelas serious consideration was part of a series of reportages by engineer Everardo Backheuser titled "Where the poor live", published in *Renascença* magazine in 1905, complete with photographs and even floor plans. Backheuser describes the Favela as "a thriving village of shacks and shanties in the very heart of the capital of the Republic, eloquently affirming by its mute contrast with the Great Avenue, a few steps away, what is the rest of Brazil in its millions of square kilometres".[33] The engineer was among the earliest to describe the favela as a separate enclave within the city and to consider it a vestige of

[31] Nina Rabha coined the term "*usos sujos*" [dirty uses] to refer to the territorial segregation that marked the urban development of the colonial city and relegated undesirable activities to the port area. See Augusto Ivan de Freitas Pinheiro & Nina Maria de Carvalho Elias Rabha, *Porto do Rio de Janeiro: Construindo a modernidade* (Rio de Janeiro: Andrea Jakobsson, 2004).

[32] On the Vaccine Revolt, see Nicolau Sevcenko, *A Revolta da Vacina: Mentes insanas em corpos rebeldes* (São Paulo: Cosac Naify, 2010 [1984]); Jane Santucci, *Cidade rebelde: As revoltas populares no Rio de Janeiro no início do século XX* (Rio de Janeiro: Casa da Palavra, 2008); and Leonardo Affonso de Miranda Pereira, *As barricadas da Saúde: Vacina e protesto popular no Rio de Janeiro da Primeira República* (São Paulo: Fundação Perseu Abramo, 2002). In English, see Jeffrey D. Needell, "The Revolta Contra Vacina of 1904: the revolt against modernization in belle-époque Rio de Janeiro", *The Hispanic American Historical Review*, 67 (1987), 233–269.

[33] Everardo Backheuser, "Onde moram os pobres", *Renascença*, March 1905, 92. Backheuser worked as a consultant on workers' housing for the Ministry of Justice and Interior Affairs and produced the first detailed report on their living conditions in 1906; see Abreu, "Reconstruindo uma história esquecida", 37; and Prado Valladares, *A invenção da favela*, pp. 36–39. He was also a contemporary of Lima Barreto during their mutual studies at the Escola Politécnica.

some undefined Brazilian essence embedded into the polished surface of modernizing aspirations. His mention of *the great avenue* is a reference to Avenida Central, a north–south axis cutting through the centre of the old city and showpiece of the major urban reforms of Rio de Janeiro undertaken between 1903 and 1910, the first phase of which under mayor Francisco Pereira Passos.[34] Construction of the avenue entailed tearing down thousands of residential buildings, and their former inhabitants swelled the numbers vying for an already short supply of adequate housing. The poorest among them ended up moving to the burgeoning favelas, thus fomenting a paradoxical correlation between efforts to modernize the city and the growth of informal settlements perceived as throwbacks to a more primitive condition.

The irony was not lost on municipal and federal authorities who soon devised plans to raze favelas to the ground, much as they had done with *cortiços* a few years earlier. A June 1907 cartoon (Fig. 2), titled "An indispensable cleansing" and published in the weekly magazine *O Malho*, shows the director-general of public health, Oswaldo Cruz, combing human figures out of the hair of an anthropomorphized Morro da Favela. Cruz's hygienist campaign to sanitize the city – which was successful in eradicating yellow fever – was also used as a pretext for the first attempts to eradicate favelas through forced removal of their inhabitants; and, indeed, the caption at the top of the image informs that residents have been given ten days to vacate the site. The neighbouring hills look on and comment, wondering where Cruz is going to dispose of what the longer caption underneath refers to as "parasites" and "pests". One of the hills, identified as Morro do Valongo, states they will provisionally be thrown out into the street and will eventually find their way to jail. The cartoonist endows Morro da Favela with facial features suggestive of prevailing conceptions about physiognomy and criminality.[35] The low brow, sunken

[34] These reforms included a refurbishment of the port as well as the opening of avenues and widening of streets. See, among others, Jaime Larry Benchimol, *Pereira Passos, um Haussmann tropical: A renovação urbana da cidade do Rio de Janeiro no início do século XX* (Rio de Janeiro: Secretaria Municipal de Cultura /Biblioteca Carioca, 1992); and Augusto Ivan Pinheiro de Freitas, *Rio de Janeiro: Cinco séculos de história e transformações urbanas* (Rio de Janeiro: Casa da Palavra, 2008). In English, see Meade, *"Civilizing" Rio*, ch. 3; and Carvalho, *Porous City*, pp. 75–83.

[35] Cesare Lombroso's ideas on criminal anthropology were influential in Brazil, at the time; see Marcos César Alvarez, "A criminologia no Brasil ou como tratar desigualmente os desiguais", *Dados*, 45 (2002), 677–704. Purportedly scientific notions about the physiognomy of criminals filtered out to a wider audience through the writings of Elysio de Carvalho; see Diego Galeano & Marília Rodrigues de Oliveira, "Uma história da

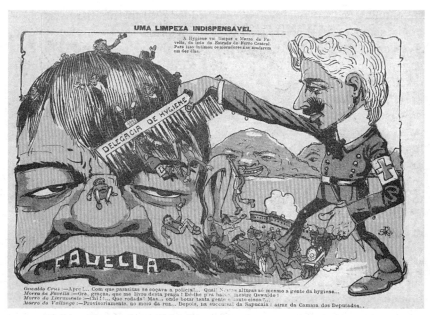

FIG. 2 Unidentified author, *O Malho*, 8 June 1907
Fundação Biblioteca Nacional (BN Digital/Hemeroteca Digital Brasileira)

eyes, protruding ears and broad rounded nose are all characteristic of
what would then be taken by readers as a criminal type. The huge gaping
mouth – in which the letters of the word *favella* stand in for crooked
teeth – is especially effective in conjuring a mean and mongrel appear-
ance, in stark contrast to the well-groomed Cruz.

The prevailing conception of favelas, over the first decades of their
existence, was as blight or scourge. They were an evil to be combated
through aggressive intervention, like the problems of crime and disease to
which they were routinely associated; and the designated agents for the
task were engineers, doctors and the police. However, the official threat to
clear the Favela and summarily evict its residents seems to have been a
tipping point in public perceptions. A little over a week after the above
cartoon was published, the illustrated weekly *Revista da Semana* featured
eight photographic views of Morro da Favela, including one showing a
large group of residents, all orderly and respectably dressed, posing in

História natural dos malfeitores", In: Elísio de Carvalho, *Escritos policiais* (Rio de
Janeiro: Contracapa/Faperj, 2017), pp. 15–27.

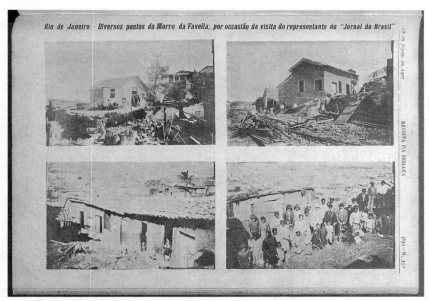

FIG. 3 Unidentified author, *Revista da Semana*, 16 June 1907
Rio de Janeiro: Fundação Biblioteca Nacional

dejection next to reporters from the magazine (Fig. 3).[36] In this image, favela dwellers are given a human face, and, unusually for the press coverage of the time, it was not a headshot of a criminal. A few pages later, a column expressed outrage at the prospect of turning thousands of families out onto the street, suggesting that the government should instead dislodge "the one hundred or so idlers who reap while doing nothing in the lugubrious and foul place that is the house of Congress".[37]

Revista da Semana was a Sunday supplement to the popular daily newspaper *Jornal do Brasil*, much read among the middle and even lower classes of Rio. It was certainly not averse to sensationalist coverage of crime and often featured stories about violence on Morro da Favela, complete with photographs of victims and perpetrators, even dead ones. The fact that it was widely read lent additional political weight to its criticism. In the following issue, the magazine hit back hard against the

[36] "Rio de Janeiro – diversos pontos do Morro da Favella, por occasião da visita do representante do Jornal do Brasil", 16 June 1907, 4839–4840. Further examples of photographic depictions of favela dwellers as ordinary people can be found in: *Careta*, 21 December 1912, n.p.

[37] "Chroniqueta", *Revista da Semana*, 16 June 1907, 4843.

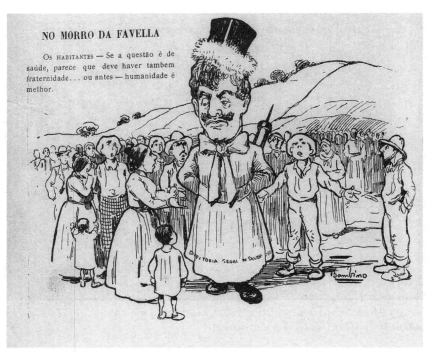

NO MORRO DA FAVELLA

Os HABITANTES — Se a questão é de
saúde, parece que deve haver tambem
fraternidade... ou antes — humanidade é
melhor.

FIG. 4 Bambino [Arthur Lucas], *Revista da Semana*, 23 June 1907
Fundação Biblioteca Nacional (BN Digital/Hemeroteca Digital Brasileira)

idea of clearing out the favela residents. A dramatic cover illustration by
Bambino (pseudonym of Arthur Lucas) titled "Exodus from the Favela"
shows a group of residents cast out into the street, with destitute mothers
clutching children in the foreground while hapless men and women look
on mournfully, all under the watchful eye of a policeman. Its style is more
akin to nineteenth-century Realism than to the standard fare of comic
illustration, and the caption is unambiguous: "This is the painful perspec-
tive that awaits the unhappy residents of the already ill-fated Morro da
Favela: the sky for a roof, the open expanse for a home!"[38] As if this
sentimental depiction were not enough, the inner pages of the issue
contain another illustration by Bambino registering a further appeal
(Fig. 4). It shows a sneering Oswaldo Cruz, ridiculously garbed in a frock
with a large bow and a top hat trimmed with fur. He is surrounded by
favela residents who plead with him: "If the issue is health, then it seems

[38] *Revista da Semana*, 23 June 1907.

that there should also be fraternity ... or rather, humanity is better." A large syringe juts out from behind his back, a reference bound to evoke memories of the bloody Vaccine Revolt, three years earlier.

Faced with opposition, the authorities lost their nerve, and the community remained in place. Gradually, as favelas survived plans to stamp them out of existence, a more sympathetic view of their inhabitants began to emerge. Among the best-known examples is a reportage by João do Rio, published on the front page of *Gazeta de Notícias* in November 1908, titled "The city of Morro de Santo Antônio. Nocturnal impression". The title of this text bolsters the idea of the favela as a separate city within the city. Its residents are presented as mostly unemployed working people, often up to no good but not necessarily criminals. Though the usual sensationalist tropes of vice and danger are present, João do Rio makes a point of explaining that not all the inhabitants are reprobates. There are "family homes, with decent girls", he notes, and most of the people he interviews lay claim to being "working men" (*operários*). The author evinces a grudging admiration for those "vigorous people, lounging in destitution instead of working, managing in the very centre of the great city the unprecedented construction of a camp of idleness, free from all laws".[39]

Under the pseudonym João do Rio, Paulo Barreto was then the most celebrated journalist in Brazil and a literary celebrity riding on the success of his volume *As religiões no Rio* (1904), compiled from a series of reports published a few years earlier in the same newspaper.[40] The 1908 article recounts a nocturnal visit to Morro de Santo Antônio, accompanied by a group of residents who escort the author to a musical gathering. It is narrated in the first person, intertwining description and dialogue, a format typical of João do Rio's reportage style. After introducing the characters and setting up the situation, the narrator chronicles the moment when they first enter the favela:

[39] João do Rio, "A cidade do Morro de Santo Antonio. Impressão nocturna", *Gazeta de Notícias*, 5 November 1908, 1. This text was later republished as "Os livres acampamentos da miséria" in the volume of collected essays, *Vida Vertiginosa* (1911).

[40] João do Rio [Anna Lessa-Schmidt, translator], *Religions in Rio* (Hanover, CT: New London Librarium, 2015). On these reportages and the author's career at the *Gazeta de Notícias*, see João Carlos Rodrigues, *João do Rio: Vida, paixão e obra* (Rio de Janeiro: Civilização Brasileira, 2010), pp. 50–57, 139–150; and Julia O'Donnell, "A Cidade em construção", In: João do Rio, *A Cidade*, pp. 13–29. In English, see Carvalho, *Porous City*, pp. 83–91.

I then saw that they were ducking into a sort of passageway concealed by high grass and some trees. I followed them and came out into another world. The lights had disappeared. We were in the countryside, the back country [*sertão*], far from the city. The path, winding in descent, was at times narrow, at times wide, but full of craters and holes. On either side, narrow houses made of boards from crates, with enclosures suggesting backyards.[41]

As in the earlier text by Backheuser, the favela is associated with the hinterland of Brazil. Again, as in both Backheuser's and the anonymous text of 1903 about Morro da Providência, João do Rio establishes a direct connection to the Canudos rebellion: "In the luminous darkness of the starry night, one had the impression of having entered the village of Canudos". The reference is most assuredly to the experience of reading about the rebellion in Bahia, since the elegant dandy Paulo Barreto never set foot in the *sertão*. In the journalistic imagination of the time, the favela seems to have evoked something of a frontier wilderness; and there is an unmistakeable ethnological inflection to the author's gaze upon the figures he encounters during his nocturnal adventure.

An even more sympathetic portrayal of favela life is manifested in a series of paintings exhibited by Gustavo Dall'Ara at the 1913 Salon of the Escola Nacional de Belas Artes (ENBA). Their titles were: *Climbing the Hill*, *Heavy Chore* and *The Favela Patrol*. The three paintings were exhibited together and, somewhat surprisingly, *Heavy Chore* was distinguished with an acquisition prize in the value of two *contos de réis*, the third highest attributed by the exhibition jury.[42] The artist was also awarded a large silver medal (something of a third place, after the large and small gold medals). The surprise derives from the fact that Dall'Ara was a popular painter but not particularly acclaimed by critics or peers. Specializing in street scenes, he was perceived as diligent and exact, if somewhat uninspired. A critic writing in the newspaper *O Paiz* damned him with faint praise for his "moderation, which is always pleasing" but did single out two of the favela pictures for their peculiar qualities, describing *Heavy Chore* as "a very well executed work" and *The Patrol* as possessing "a sincerity and reality that are seductive".[43] Given that Dall'Ara's paintings were slightly old-fashioned both in their naturalist

[41] João do Rio, "A cidade do Morro de Santo Antonio", 1.
[42] "Premios conferidos pelos jurys da Exposição Geral de Bellas-Artes", *Correio da Manhã*, 14 September 1913, 7; "Artes e artistas", *O Paiz*, 14 September 1913, 2.
[43] LF, "O Salão de 1913 (VI)", *O Paiz*, 3.

style and emphasis on narrative genre, it is likely that the jury's interest was sparked by the novelty of the theme the painter chose to portray.[44]

There are few depictions of favela themes in Brazilian art before the 1920s, which makes the presence of Dall'Ara's paintings in the 1913 Salon all the more intriguing.[45] *Tarefa Pesada: Favela* (*Heavy Chore*) (Fig. 5) provides an early representation of one of the enduring clichés of favela life: women carrying cans of water on their head.[46] The background sets the scene on a hillside, with tropical vegetation and similar visual markers to the painting by Visconti. In the middle ground stands a ramshackle house built of wattle and daub (*pau-a-pique*), old roofing tiles and other discarded materials. A small figure, possibly a child, sits on the ground next to it. On the right, white washing hangs out to dry on a clothesline. Two women approach the gate carrying cans of water on their heads. On the left, another woman sets washing out on the ground to bleach in the sun, a wash-basin at her side. In the foreground, a lone woman carrying a can of water stops to rest, left hand poised on her hip and posture slightly stooped. Her expression is downcast and weary, though her facial features remain less than distinct because of the shadow cast by the strong sunlight. Next to her, a small dog sniffs along the ground. Refuse – an old can, a rusty hoop, a piece of metal sheeting – is scattered at their feet. The image is of hard work, as the title suggests, far removed from the tropes of idleness and vice that prevailed in journalistic accounts of the time.

Dall'Ara's other painting, *Ronda da Favela* (*The Favela Patrol*) (Fig. 6), is even more remarkable in its portrayal of favela dwellers as victims rather than perpetrators. The far background shows a hillside and a mountain chain in the distance. In the nearer background, traffic can be seen circulating along a sunlit street bordering a wall, behind which the chimneys and smoke of trains can just be glimpsed. On the other side of the tracks, well-built houses stand regularly aligned. For an audience familiar with the geography of Rio de Janeiro, the location is clear. The viewer's standpoint is situated just behind the central train station, at the foot of Morro da Providência, looking south. The outcrop of rocks and

[44] Ten years later, in his obituaries, the painting is singled out as one of Dall'Ara's most important; Escragnolle Doria, "O pintor da cidade", *Revista da Semana*, 15 September 1923, n.p.; and "Dall'Ara", *Fon Fon*, 15 September 1923, n.p.

[45] The 1913 Salon was exceptional in many ways, as discussed further in Chapter 2.

[46] This became a stock image by the 1930s and was turned into a musical cliché in 1952 in the carnival *marchinha* "Lata d'água na cabeça", composed by Luís Antônio and Jota Júnior, and sung by Marlene; see José Ramos Tinhorão, *A música popular no romance brasileiro. Vol. III: Sec. XX (2ª parte)* (São Paulo: Ed. 34, 2002), pp. 354–355.

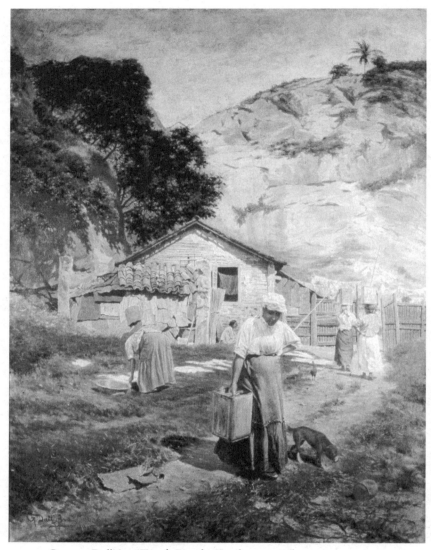

FIG. 5 Gustavo Dall'Ara, *Tarefa Pesada: Favela*, 1913, oil on canvas, 120.4 × 90 cm
Rio de Janeiro: Museu Nacional de Belas Artes/Ibram (photo: Museu Nacional de Belas
Artes/Ibram)

scrub, on the left, with the ubiquitous washing hung out to dry and laid
out to bleach, is the visual signifier of the favela's proximity. As in *Heavy
Chore*, the foreground is emptied of major incident. A fallen branch,
potholes in the cobbled street filled with puddled water, a hen leading a

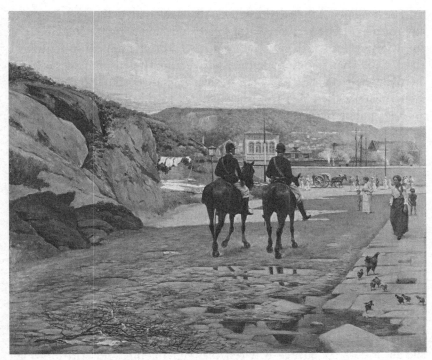

FIG. 6 Gustavo Dall'Ara, *Ronda da Favela*, 1913, oil on canvas, 74 × 88 cm. For color version of this figure, please refer color plate section. Rio de Janeiro: collection of Hercila and Sergio Fadel (photo: André Arruda)

brood of chicks along the broken pavement. Signs of neglect and a lack of modern amenities, contrasting with the streetlamp and utility poles visible in the sunny zone.

In the centre of the middle ground, two mounted policemen advance into the space of the composition, moving from the favela towards the centre of the city. The painter has depicted them strategically at the threshold between a zone of shadow that takes up the foreground and most of the right-hand side and a zone of intense sunlight that bathes the rest of the picture. Due to this careful positioning, the horses' legs and hooves are in the shade but the bodies of the policemen are thrust up into the sunny area. The mounted figures partake of both worlds: shadow and light. Otherwise, there is a rigid spatial division. The background figures, along the sunny street, are properly attired in the fashion of the day. The four figures in the area of shadow – two women and two children – are more shabbily dressed, hatless and, in the case of one child, even naked.

The meaning of the picture is given by the woman in the dark skirt who approaches the viewer, carrying a small parcel in her right hand. She casts an uneasy glance at the two policemen who do not appear to return the gaze. Dall'Ara's painting captures the relationship of mutual suspicion between police and Rio's poor residents that exists to this day. The policemen are there to patrol the shadowy world of the favela and keep it from spilling over into the sunny mainstream. The work is exceptional in the subtlety with which it evokes the favela without recourse to the visual tropes that have become stereotypes since that time. Not a shack or shanty in sight, nor a water can. It also stands out from more usual representations by placing the viewer within the space of the favela, looking out.[47] The policemen's backs are turned to us. The faces we do see, and with which we are meant to identify, belong to the denizens of the neglected margin of the composition. Both paintings by Dall'Ara further partake of a telling precedent: neither depicts male favela residents, only women and children.

1.3 THE FAVELA AS PLACE OF BLACKNESS

Up until the 1920s, surviving representations of favelas do not necessarily dictate a correspondence between their inhabitants and Afro-Brazilian identity. The figures depicted might be black, as in Visconti's painting, or they might remain ambiguous in terms of ethnicity, as in Dall'Ara's works. The same is true for journalistic and literary descriptions, though there was certainly no dearth of generic references to *pretos* (blacks) in newspaper accounts of crimes. As for illustrations and cartoons, favela dwellers might just as well be depicted as white, brown or even Jewish as black.[48] Perusing the illustrated periodicals of the 1910s and 1920s – *Revista da Semana*, *O Malho*, *Fon-Fon!*, *Careta*, *D. Quixote*, among others – numerous cartoons can be found pitting favelas as the ugly opposite of a civilized norm. Residents are routinely represented as dirty and uncouth, but most often left undefined in terms of racial attributes. An equivalence between favelas and blackness was not yet established as a visual cliché. One reason is that the population of the first favelas was far from homogeneous in terms of ethnic make-up.

[47] Dall'Ara lived nearby, in Rua da América, one of the streets most impacted by the growth of Morro da Favela; see Escragnolle Doria, "O pintor da cidade".

[48] See, among others, "No Morro da Favela", *Revista da Semana*, 23 June 1907, 4874; "Cantata na Cidade Nova", *O Malho*, 22 June 1907, n.p.

This fact is readily ascertained by examining the hundreds of photographs of favela life produced by Augusto Malta over the first decades of the twentieth century.

Employed as the city's official photographer from 1904 onwards and charged with documenting all aspects of urban existence, Malta frequently photographed Morro da Favela and Morro de Santo Antônio, generating some of the most extraordinary visual records of life in Rio's first favelas.[49] Though the original purpose of his mission was to chronicle the transformations the city underwent as a result of mayor Pereira Passos's urban reforms, the photographer seems to have taken a particular interest in including people in his images. A discreet and impassive observer, Malta's photographs document how distinct the real favelas were from the visual clichés prevalent, then and now, and transmit a sense of the actual experiences of residents with little in the way of editorializing or sermonizing. There is poetic justice in the fact that an employee of the very authorities engaged in combating the squatter settlements ended up contributing to the preservation of their memory.

Malta's photographs remained mostly hidden away in municipal archives during his lifetime and did not have much impact on contemporary ideas of how favelas should be depicted. They stand in instructive contrast to the visual stereotype of the favela constructed over subsequent decades in the realm of fine art. Beginning with Tarsila do Amaral's iconic *Morro da Favela* (1924) (Fig. 7), nearly every major name in the history of modern art in Brazil produced favela pictures, some multiple times like Lasar Segall, Di Cavalcanti or Livio Abramo. Favelas proved to be an amenable subject for artists seeking to explore formal contrasts of geometry, pattern and colour. Segall's *Brazilian Landscape* (1925) is a prime example, rendering the favela into a formal exercise through the depiction of conventionalized elements like hilly backgrounds, colourful houses stacked in wobbly perspective, plants and animals, faceless black or brown figures.[50] Later, in the 1950s, some artists even took the favela theme into the realm of abstraction, emptying their compositions of all reference to the people who lived there. This whimsical approach stands

[49] Nataraj Trinta, "O Rio maldito de Augusto Malta", In: Diniz & Cardoso, *Do Valongo à Favela*, pp. 80–101. On other early photographs of favelas, see Cláudia de Oliveira, "A iconografia do moderno: A representação da vida urbana", In: Cláudia Oliveira, Monica Pimenta Velloso & Vera Lins, *O moderno em revistas: Representações do Rio de Janeiro de 1890 a 1930* (Rio de Janeiro: Garamond, 2010), pp. 162–165, 170–175.

[50] The painting was featured under the alternate title *Brazilian Village* in: Robert C. Smith, "Lasar Segall of São Paulo", *Bulletin of the Pan American Union*, 74 (1940), 383.

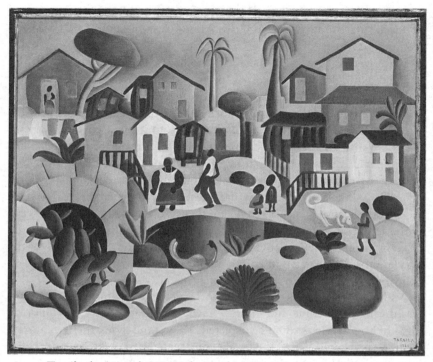

FIG. 7 Tarsila do Amaral, *Morro da Favela*, 1924, oil on canvas, 64 × 76 cm.
For color version of this figure, please refer color plate section.
Rio de Janeiro: collection of Hercila and Sergio Fadel (photo: André Arruda)

in contrast not only to Malta's photographs but also to the social concern
of older works like those by Visconti and Dall'Ara.[51]

Tarsila's *Morro da Favela* was painted in the same year as the publica-
tion of Oswald de Andrade's "Manifesto of Brazilwood Poetry".[52] The
image of the favela it depicts is strikingly analogous to that evoked in
the manifesto's opening lines: "Poetry exists in facts. The saffron and
ochre shanties on the green slopes of Favela, under the Cabralian blue, are

[51] Arthur Timotheo da Costa produced a painting in 1919 depicting Morro da Favela. Its
composition foregrounds a couple of shacks, on the right, and washing left out to bleach
in the sun, on the left, against an outcrop of rock in the background and a cloudless sky.
The palette, dominated by blue, yellow, pink and white, is light and airy. There are no
figures or incident. This little-known painting is presently in a private collection in Rio de
Janeiro. There is no conclusive indication whether it is a study or a finished work.

[52] For more on the relationship between Tarsila, Oswald and *Antropofagia*, see Chapter 4.

aesthetic facts."[53] To saffron and ochre, green and blue, the painter added judicious daubs of pink and red, yellow and white ... plus, a dog, a rare bird, an exotic cactus, a tunnel (that really does exist), a clothes-line and a smattering of tiny black figures. With its colourful palette and naïf treatment, Tarsila's composition provides a distinctively upbeat representation of favela life – one at odds both with the prevalent view of crime and danger, on the one hand, and with a critique of social injustice, on the other. Its pursuit of decorative effect begs numerous questions about what we might today consider an aestheticization or romanticizing of poverty.

Blinkered by their interest in aesthetic facts, Tarsila and Oswald seem to have been unable to apprehend that the favela was an actual place where people live. This flippant attitude is explained by social and geographical circumstances. Both were inordinately wealthy, came from São Paulo and were more familiar with the streets of Paris, where Tarsila lived at the time, than Rio de Janeiro. Their mutual interest in the favela was driven by a sort of primitivism in reverse in which they played up their links to subaltern identities in Brazil in order to make themselves more interesting in Parisian artistic circles and thereby more consummately modern.[54] Despite Oswald's nominal appeal to facts, even aesthetic ones, the favela depicted in the dialogue between their works is more pictorial motif and literary device than anything remotely linked to the concerns of real life.

Given that there was no automatic correlation, at the time, between favelas and Afro-Brazilian culture, it is worth pondering why Tarsila chose to represent all the figures in her *Morro da Favela* as black. The most prominent one – a rotund woman with a blue skirt, white top and red headscarf – is analogous to a similar figure in another painting of the same year, *Carnival in Madureira* (1924), standing directly under a colourful Eiffel Tower.[55] Tarsila's repeated recourse to such faceless effigies would seem to hark back to the use of black figures in

[53] Oswald de Andrade, *Do Pau-Brasil à antropofagia e às utopias* (Obras completas de Oswald de Andrade) (Rio de Janeiro: Civilização Brasileira, 1970), p. 5.

[54] See Cardoso, "White skins, black masks", pp. 131–154.

[55] A replica Eiffel Tower was actually erected in the working-class district of Madureira during the carnival festivities of 1924; see Felipe Ferreira & Roberto Conduru, "Carnaval à Madureira: Modernisme et fête populaire au Brésil", In: *Samba etc.: Carnaval du Brésil* (Binche: Musée International du Carnaval et du Masque, 2011), pp. 65–68. Cf. Rafael Sento Sé, "Torre Eiffel de Madureira: Instituto do Irajá desvenda mistério", *Veja Rio*, 25 February 2017. See also Michele Greet, *Transatlantic Encounters: Latin American Artists in Paris between the Wars* (New Haven: Yale University Press, 2018), ch.6.

nineteenth-century landscape paintings as a means of attributing scale and adding local colour. In any case, they are less representations of real people than of types and stereotypes. Such pictorial decisions are rarely taken deliberately, so it makes little sense to scrutinize the painter's intentions. A clue can be found, however, in a lecture delivered by Oswald de Andrade, the previous year in Paris, at the Sorbonne, on contemporary artistic production in Brazil, in which the writer suggests cryptically that "black blood" operates as an antidote to verbosity and literary excess in Brazilian culture and posits the outlandish aphorism: "the negro is a realist element".[56] Given the proximity, bordering on symbiosis, between Tarsila and Oswald in the years of courtship that led up to their marriage in 1926, it is likely that the painter's inclusion of black figures in these compositions derives from a wish to make the scenes more authentic – more *realist*, in the twisted sense proclaimed by Oswald. As white intellectuals from the upper classes of São Paulo, they may very well have convinced themselves that their exoticized gaze upon the poorest reaches of the capital was a genuine expression of empathy or identity. In all fairness to them, the very act of including the favela in erudite discourse was, at the time, still provocative. To affirm the favela as an expression of modernism, doubly so. For average middle-class observers, the existence of favelas was a source of national shame.[57]

Given her lack of first-hand knowledge of favela life, added to the fact she resided in Paris for much of the period 1923–1928, Tarsila must presumably have acquired at least some of her impressions of favela iconography from secondary sources. An immediate reference would be her artistic contemporary, Di Cavalcanti, one of the few veterans of the *Semana de Arte Moderna* group who hailed from Rio de Janeiro. Before becoming a successful painter in his own right, Di was better known as an illustrator, and his depictions of a recent squatter settlement – Morro do Querozene, in the neighbourhood of Catumbi – were featured in a July 1923 article in the Sunday edition of leading newspaper *Correio da Manhã* (Fig. 8). The tone of the text is lyrical, lamenting that favelas had not yet found due literary expression for their "rude and brutal poetry, the savage beauty of which blends the nostalgic refrains of the

[56] Oswald de Andrade, "L'effort intellectuel du Brésil contemporain", *Revue de l'Amérique Latine*, 2 (1923), 197–207. See also Alejandro de la Fuente & Rafael Cardoso, "Race and the Latin American Avant-gardes, 1920s–1930s", In: David Bindman & Alejandro de la Fuente, eds., *The Image of the Black in Latin America and the Caribbean* (Cambridge, MA: Harvard University Press, forthcoming, 2021).

[57] See, for example, João da Cidade, "Um sorriso para todas...", *Careta*, 5 June 1926, n.p.

FIG. 8 [Emiliano] Di Cavalcanti, *Correio da Manhã*, 22 July 1923
Fundação Biblioteca Nacional (BN Digital/Hemeroteca Digital Brasileira)

'sambas' and the bloody drama of the gangsters [*bambambãs*]".[58] The article goes on to name and categorize the various human types found in the favela – the ruffian [*malandro*], the hoodlum [*bamba*], the urchin [*moleque*], the old black woman [*preta velha*], the Portuguese shop-keeper, the samba dancer – describing each in terms of their particular physiognomy, local colour and expression. Significantly, it asserts that the *bamba* "perpetuates, in full civilization, the immortal traditions of the *cangaço* in the hinterland", again reinforcing the link between favelas and *sertão*.[59]

The unsigned article functions as a showcase for five illustrations by Di Cavalcanti, which dominate the page visually, achieving much greater immediate impact than the text. Two are sketches of landscapes with shacks and vegetation, framed conventionally within rectangular borders; the other three are caricatures of types – a *bamba*, a *moleque* and a *preta* – cut out against the white background and staggered along the central columns in such a way that they almost jump off the page. The text concludes with the assertion that the illustrations capture "the originality of this dirty neighbourhood" better than any text: "Di Cavalcanti offers, in these columns, marvellous instant views [*flagrantes*] of a stretch of this veritable unknown city that is the black carioca *bas-fond*. Admire them."[60] The emphasis on blackness is noteworthy, as is the repetition of the trope of a city within the city. The three types featured, all black, soon became mainstays of visual discourses surrounding favelas and favela life: the crafty and slick young tough, with his striped tee-shirt and hat perilously cocked; the broadly smiling and irrepressible street urchin; the hard-working and long-suffering woman with a can of water on her head. With his eye for significant detail, skill as a draughtsman and deep-rooted knowledge of working-class life in Rio, Di Cavalcanti is here engaged in devising and codifying archetypes.[61]

[58] "Na cidade da multidão turbulenta e soffredora", *Correio da Manhã*, 22 July 1923, 3. Cf. Abreu, "Reconstruindo uma história esquecida: Origem e expansão das favelas no Rio de Janeiro", 46. *Bambambã*, or *bambambam*, is a still current colloquialism for a powerful or important person (roughly akin to 'top cat'), but was also used at the time to refer to a hoodlum or tough. It is a variant of *bamba*, but higher up in the hierarchy. The expression was popularized by the book: Orestes Barbosa, *Bambambã!* (Rio de Janeiro: Secretaria Municipal de Cultura/Biblioteca Carioca, 1993 [1922]).

[59] "Na cidade da multidão turbulenta e soffredora", 3. For more on *cangaço*, see Chapter 5.

[60] Ibid.

[61] See Rafael Cardoso, "Ambivalências políticas de um perfeito modernista: Di Cavalcanti e a arte social", In: José Augusto Ribeiro, ed., *No subúrbio da modernidade – Di Caval-canti 120 anos* (São Paulo: Pinacoteca do Estado, 2017), pp. 41–53.

Another obvious wellspring for Tarsila's cartoonish figures would be cartoons. By 1920, as seen in a cover illustration featured for the weekly *Careta* [Fig. 9] – drawn by J. Carlos, Brazil's preeminent illustrator of the 1920s to 1940s – the conventional visual markers were all in place: steep climbs and lofty views, a stooped woman carrying a can of water on her head and another at her side, houses poised precariously on the hillside with stones used to weight down the flimsy roofing, washing hanging out to dry and bleach in the sun, garish contrasts of colour (including a red-white-and-blue colour scheme for the woman's outfit not too dissimilar from that of Tarsila's plump matron). With his acute graphic sensibilities, J. Carlos draws together various strands of a visual discourse, decades in the making, and assembles them into a composite that eventually came to prevail as stereotype.

The racist caricatures of the two favela inhabitants – thick-lipped, bare-footed and simian – are reinforced by their patched-up clothing and the equally patchy tenor of their conversation. In the caption, the man addresses the woman in words deliberately misspelled to evoke the patois of unedu-cated black people: "Have you heard, *Dona* Florência? They're going to beautify our hill. Now, we can partake in footing and morphine." *Footing*, in English, was the then fashionable term for a leisurely stroll, and the prime place to practice this activity was along the great new avenues, like Avenida Beira-Mar or Avenida Rio Branco (as Avenida Central was renamed in 1912). The artist pokes fun at the habits of the upper classes by using the favela as a foil to set up the joke. The only thing more ridiculous than the snobbery of Brazilians who wanted to act European, the cartoon suggests, was the farce of this black favela dweller's pomposity. Posing as man of the world, he pontificates to his stunned companion with an elegant gesture of his outstretched and outsized hand in which he delicately clasps a hand-rolled cigarette between thumb and index finger. Another trivial detail, but significant, is the handle of a knife jutting out from the waistband of his trousers, confirming his status as a potentially dangerous *malandro*.

J. Carlos's emphasis on blackness is characteristic of his oeuvre, fre-quently tainted by racial prejudice, but is something of a novel departure as regards depictions of favelas. One of the earliest cartoons depicting favela residents as black was drawn by Raul Pederneiras in 1911. It shows a washerwoman confiding to a seated man her wish to see a fashionable seaside avenue like Avenida Beira-Mar built near Morro da Favela [Fig. 10].[62] Though caricatures, the two figures are not stereotypes.

[62] "Doces aspirações", *Fon-Fon!*, 16 December 1911, n.p.

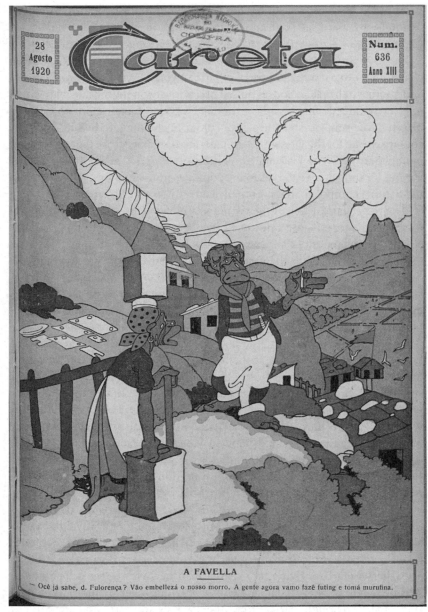

FIG. 9 J. Carlos [José Carlos de Brito e Cunha], *Careta*, 28 August 1920. For color version of this figure, please refer color plate section.
Fundação Biblioteca Nacional (BN Digital/Hemeroteca Digital Brasileira)

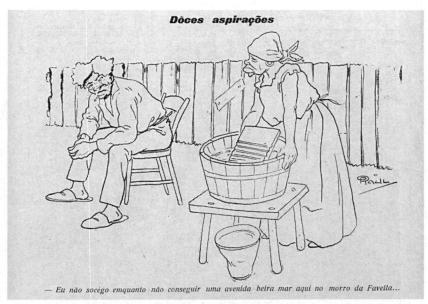

Dôces aspirações

— *Eu não socégo emquanto não conseguir uma avenida beira mar aqui no morro da Favella...*

FIG. 10 Raul [Pederneiras], *Fon-Fon!*, 16 December 1911
Fundação Biblioteca Nacional (BN Digital/Hemeroteca Digital Brasileira)

Rather, their facial features are individualized; their expressions, empathetic; and the caption is written in proper Portuguese. J. Carlos was among the first illustrators to move representations of black people in the direction of overtly racist stereotypes, which bear striking similarity to an iconography common in the USA but previously infrequent in Brazil.[63] An early example is a 1915 cartoon showing three grotesque black matrons discussing a carnival ball attended by one of them, who snootily informs the others the atmosphere was too mixed. One of the women balances a bucket on her head, and the shacks of a favela can be seen in the background. The dialogue is written in intentionally broken Portuguese. Another cartoon of 1920 verbalizes the association by referring to Morro da Favela as *"pretopolis"*, a pun on *preto* (black) and Petrópolis, the then fashionable summer resort in the mountains near Rio.[64]

[63] See Rafael Cardoso, "O moderno e o arcaico em J. Carlos", In: Cássio Loredano, Julia Kovensky & Paulo Roberto Pires, eds., *J. Carlos: Originais* (São Paulo: Instituto Moreira Salles, 2019), pp. 178–187.

[64] "Aristocracia de sabbado", *Careta*, 9 January 1915, n.p.; and "Quem é pobre também *véve*", *Careta*, 3 April 1920, n.p.

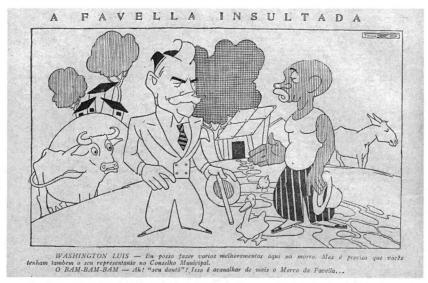

FIG. II Theo [Djalma Pires Ferreira], *O Malho*, 27 July 1927
Fundação Biblioteca Nacional (BN Digital/Hemeroteca Digital Brasileira)

By the late 1920s, the practice of representing favela dwellers as black became something of a convention. A cartoon of July 1927, titled "The Favela insulted" [Fig. II] and published in the satirical weekly *O Malho*, shows President Washington Luiz trying to convince a black resident to cooperate in the task of improving Morro da Favela. The president states as a precondition that the community must first appoint a representative to the City Council. The local man – identified as a *bambambã* – replies that doing so would be much too degrading for the favela, again turning the tables to humorous effect by casting politicians as lower than the lowest rung on the social ladder. Visually, the joke hinges on the contrast between the president's flashy bearing – coiffed hairdo, double-breasted suit, broad shoulders, thin waist – and the unimposing appearance of the local boss – bald, chinless, pot-bellied, dressed in his undershirt. Another cartoon on the same theme, by J. Carlos, shows Washington Luiz in dialogue with mayor Prado Junior against a backdrop composed of rickety houses on a hillside, clothes hanging on a line and four little black figures, outrageously stereotyped with thick lips and bulging eyes, dehumanized by the lack of noses or hair.[65]

[65] "Nunca mais", *O Malho*, 23 July 1927, n.p. Cf. "Na Favela", *D. Quixote*, 5 March 1924, n.p.

The same theme of a presidential visit to Morro da Favela prompted a very different cartoon in *Careta* magazine [Fig. 12]. "His Excellency in the Favela", by Alfredo Storni, shows a grumpy-looking Washington Luiz climbing the hill and being welcomed by an obsequiously bowing resident who asks if his excellency is there for a visit or merely a "tourist 'cruise'". A woman stands at his side in an upright, almost defiant posture. The expression on her face borders on smirking. The thick lips of both favela residents and the man's woolly hair are meant to indicate they are not white, but neither would the pinkish hue of their skin colour categorize them as black in the eyes of contemporary readers. In the foreground, a scrawny dog on a roof looks on in wide-eyed dismay. The president's position lower down on the hillside forces him to gaze upwards at the grinning pair. Despite his hat and the snazzy spats on his shoes, he looks less than imposing. The mention of a 'tourist cruise' in the favela may seem unusual, but the cultural reference would not be lost on readers in 1927.[66]

1.4 INNER FRONTIER AND OUTER REACHES

In May 1926, on the first leg of a South American journey that would take him further to Uruguay and Argentina, the Italian futurist leader F. T. Marinetti visited Brazil for a whirlwind lecture tour promoting futurism and fascism. In one of his first interviews in Rio de Janeiro, he expressed a wish to visit "places where the racial characteristic was strongest" in the city.[67] He was promptly taken on a nocturnal visit to Morro da Favela, chaperoned by several leading newspapermen and an escort of policemen and residents designated to guide their tuxedo-clad guests and accompanying ladies safely through the community. This expedition was accompanied by reporters and a photographer and widely publicized in the press, with opinions divided as to its suitability but most agreeing on its ridiculousness. *Fon Fon* magazine reported that the whole

[66] See "Looping the loop", *Careta*, 4 August 1923, s.p, on the trope of Argentinian tourists taking home photographs of the favela. The favela's potential as an embarrassment in comparisons with Buenos Aires is taken up in LB [Lima Barreto], "Leitura de jornaes", *Careta*, 19 March 1921, n.p.

[67] Rômulo Costa Mattos, "'Reino do céu' ou território das 'classes perigosas'?: O Morro da Favela no contexto da visita de Filippo Tommaso Marinetti (1926)", In: Diniz & Cardoso, *Do Valongo à Favela*, pp. 39–40. See also Orlando de Barros, *O pai do futurismo no país do futuro: As viagens de Marinetti ao Brasil em 1926 e 1936* (Rio de Janeiro: E-papers, 2010), pp. 52–68.

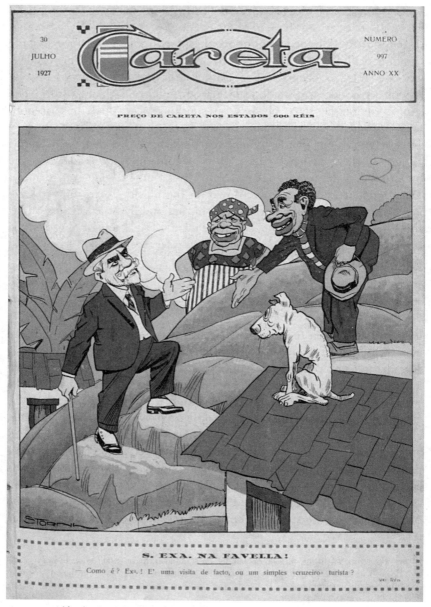

FIG. 12 Alfredo Storni, *Careta*, 27 July 1930
Fundação Biblioteca Nacional (BN Digital/Hemeroteca Digital Brasileira)

Recepção a Marinetti na 1ª Sociedade da Favella

FIG. 13 Unidentified author, *Careta*, 29 May 1926
Fundação Biblioteca Nacional (BN Digital/Hemeroteca Digital Brasileira)

adventure was a joke on Marinetti, stating that no one was remotely afraid but him.[68]

Some of the harshest criticism came from *Careta* magazine, which derided "the man of the future" for being stout, smelling of mothballs and coming to Brazil in bourgeois fashion on an ocean liner, "like any olive oil salesman who goes on holiday to Europe" and suffers from seasickness.[69] Underneath the scathing article, a photograph [Fig. 13] of Marinetti and his entourage visiting the seat of a carnival society on Morro da Favela.[70] The image is less dramatic than more widely circulated photographs of the group posing outdoors in front of shacks. Marinetti glowers triumphantly at the camera, arms crossed, head tilted

[68] "Marinetti e a Favela", *Fon Fon*, 29 May 1926, 58. See also "Uma caravana do papa mitrado do futurismo na Favela", *Correio da Manhã*, 19 May 1926, 3, 5, which closely details the tour, pointing out that the community was sound asleep, secured by a curfew imposed by local gangs.

[69] "Futura... acção", *Careta*, 29 May 1926, 29.

[70] This was the Sociedade Sujos e Limpos, run by community leader José da Barra, who was rudely awakened by Marinetti and friends after midnight; see "Uma caravana do papa mitrado do futurismo na Favela", 3; and Costa Mattos, "'Reino do céu' ou território das 'classes perigosas'?", p. 50.

back, like a hunter proudly posing with the game he has bagged. The two local guides, standing to his immediate right, appear distinctly less comfortable with their role as trophies. The prominent Brazilian companions – among whom Assis Chateaubriand, Afonso Arinos de Melo Franco, Rodrigo Melo Franco de Andrade – mostly look bored or uncomfortable. Only the two policemen appear alert. The following week, *Careta* returned to the topic, commenting sarcastically on the bad influence exerted on "our modern, overly complicated poets" by Marinetti, "who, thank God, has already gone".[71]

On the same date that *Careta* compared Marinetti to an olive oil salesman, competing weekly *O Malho* dedicated its cover to his visit [Fig. 14]. Illustrated by J. Carlos, it depicts the futurist leader standing, arms crossed, contemplating the sky, like a colossus atop Morro da Favela. At the foot of the page, three grotesquely caricatured black residents – two men and a woman – discuss the matter. Again, the dialogue between them is written in a style mimicking the broken speech of the poor and uneducated:

– It's that Marinetti so-and-so.
– Police?
– No, scout ['*gaforinha*']. He's come to examine the routes to lay down motor cars, railroads, electric trams; *porgress, porgress.*[72]

The middle character bends in close to catch the speaker's whisper, eyes closed, lighting his cigarette with a match. The ink-black woman on the right, with a red bandanna on her head, bulges her eyes and lets her mouth hang open, astonished at what she sees and hears. The disparity

[71] "Um sorriso para todos", *Careta*, 5 June 1926, 16. Marinetti's arrival was preceded by extensive discussion of futurism in the press. The term was loosely employed, often misinterpreted and misapplied, and became a sort of catch-all for anything modern or transgressive. It recurs in cinema advertisements as a form of hype for films as diverse as *The Cabinet of Dr Caligari* and an Esther Ralston picture suggestively titled *A epidemia do jazz* in Portuguese. Journalists were well aware that Marinetti's brand of futurism was passé in the artistic centres of Europe; see, for example, Luiz, "Para ler no bonde. Futurismo", *Correio da Manhã*, 13 May 1926, 2. For an overview of the tensions surrounding the term futurism and Marinetti's visit, see Annateresa Fabris, *O futurismo paulista: Hipóteses para o estudo da chegada da vanguarda no Brasil* (São Paulo: Perspectiva, 1994), pp. 219–236.

[72] "Favella!", *O Malho*, 29 May 1926, cover. The precise meaning of the term *gaforinha* here has been lost. The use of quotation marks indicates it was a colloquialism or slang; and the context makes clear that it refers to Marinetti's role as some sort of spy or scout for the purported road and transportation works. The literal meaning of the term *gaforinha* is quiff or forelock, and it possesses mildly racial undertones; see Chapter 3.

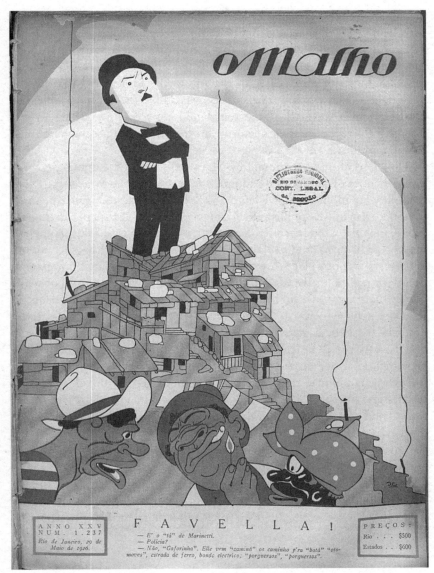

FIG. 14 J. Carlos [José Carlos de Brito e Cunha], *O Malho*, 29 May 1926
Fundação Biblioteca Nacional (BN Digital/Hemeroteca Digital Brasileira)

between their uncouth appearance and speech and Marinetti's distinctly un-stout figure epitomizes the contrast between European civilization and local barbarity. The futurist leader's whiteness is so extreme that his face is rendered as a white mask, disparate from the pinkish hue of the back of

his head. Though Marinetti is clearly ridiculed by the cartoon, its derogatory portrayal of the residents also provokes uneasiness in Brazilian viewers – a disquiet graphically captured in the exclamatory nature of the title, "FAVELA!". Both culturally and pictorially, readers would have found themselves nearer to the trio in the foreground than to the lofty Italian poet, whose bizarre stance was all but incomprehensible. His absurdity must have irked the sensibilities of a public baffled by the interest of a representative of European high culture in something most Brazilians considered the lowest of the low.[73]

The discomfiture occasioned by Marinetti's bout of slumming is intriguing. Echoes of the episode continued to well up in the press throughout the following months and well into 1927. The magazine *D. Quixote* ran a cartoon, previously published in the São Paulo newspaper *Folha da Noite*, in which a white-suited Marinetti, presides over shacks, dog, goat, ducks and a pigsty and exclaims: "Oh, how sublime! How enchanting! What a marvellous place to write a poem."[74] In that image, a companion in a dark suit holds his nose and clasps his belly, while a group of white intellectuals look on in bemusement and assorted black residents in bewilderment. A black male figure also appears, with cocked hat and a knife in his belt, a stereotype of the *bamba*. Informed opinions were divided between those embarrassed that a distinguished foreigner should be shown an aspect of the city most elite citizens preferred to hide and a few who championed the favela as a symbol of deepest Brazil. Recurring discursive structures already linked favelas to imagined tropes of the *sertão*, and the capital was in thrall to a vogue for all things *sertanejo* in the 1920s and 1930s. The coverage generated by Marinetti's visit thrust the favela into the epicentre of debates about what could be considered authentic or typical of a supposed 'real' Brazil.

With the new interest evinced by artists and intellectuals, especially a celebrity like Marinetti, some observers became alarmed that favelas might be glamourized. Augusto de Mattos Pimenta, a physician by

[73] Cf. I. Grego, "Belleza condicional", *Careta*, 25 June 1927, 12, which comments that no beauty is more conditional than "the futurist beauty of the Favella". Further in the same issue of *O Malho*, another cartoon by Fritz shows two ragged figures, towering over a minute favela, engaged in conversation. One bends in and whispers to the other that "This man of futurism understands nothing. He really came after some sort of *macumba*."; *O Malho*, 29 May 1926, 25.

[74] Romulo Costa Mattos, "A Brazilian cartoon about Marinetti's visit to a favela in 1926", In: Aguirre, Sarabia, Silverman & Vasconcelos, eds., *International Yearbook of Futurism Studies* (2017), pp. 384–387.

training, member of the Rotary Club, active in the real estate and construction sectors, led a concerted campaign over late 1926 and 1927 to combat this threat, lecturing, publishing articles in various newspapers and even producing a short film that was probably the first to document a favela in moving images.[75] Alongside the usual concerns with hygiene and crime, Mattos Pimenta took pains to couch his critique in aesthetic terms too, as evidenced in a lecture delivered at a Rotary Club luncheon and reprinted in the newspaper *Correio da Manhã*:

Gentlemen, deplorable and incomprehensible, pernicious and dangerous, is the habit some of our intellectuals have acquired of glorifying the favelas – through some unfathomable perversion of taste, discovering poetry and beauty in these agglomerations triply abject as anti-aesthetic, anti-social and anti-hygienic. Ridiculous and revolting is the tendency ever more pronounced among us, incited by certain bohemian spirits, of accepting favelas as a characteristic of ours, a happy and interesting institution, worthy of being bequeathed to coming generations as a national tradition.

No. To those extravagant intellectuals who make excuses for ruffianism [*malandragem*] and filth, who would exalt swindles and squalor, who celebrate the quarters of slavery [*senzalas*] and stench, and proclaim that this is Brazilian, that this is Carioca, we shall oppose the voice of common sense, the incorruptible rules of true Art, the legitimate precepts of true Science, saving from futurist demolition this masterpiece of nature that is Rio de Janeiro.[76]

Mattos Pimenta described the growth of favelas on Rio's hillsides as an "aesthetic leprosy", and the solution he proposed was three-pronged: to inhibit further expansion immediately, to construct adequate housing for workers and, eventually, to raze the favelas altogether. By the mid-1920s, the spread of unregulated settlements to other locations in the city – Morro da Babilônia, Morro do Salgueiro, Morro da Mangueira, Morro de São Carlos, among others – had unequivocally outstripped the ability of local authorities to deal with the ensuing problems.[77] An intriguing detail of Mattos Pimenta's 1926 speech is his claim that favelas display the worst and most squalid living conditions in the world,

[75] Prado Valladares, *A invenção da favela*, pp. 41–45. See also Américo Freire & Lucia Lippi Oliveira, eds., *Novas memórias do urbanismo carioca* (Rio de Janeiro: FGV Editora, 2008), pp. 172–174. The contents of the film are partially described in Jacintho, "Poeira das ruas. As favellas da cidade", *Fon Fon*, 5 February 1927, n.p.

[76] "Acabemos com as 'favellas'. Uma interessante exposição feita pelo dr. Mattos Pimenta ao Rotary-Club", *Correio da Manhã*, 18 November 1926, 3.

[77] Abreu, "Reconstruindo uma história esquecida", pp. 41–42. On the links between Mattos Pimenta and the urban renewal plan of Alfred Agache, see Fischer, *A Poverty of Rights*, pp. 38–44.

in support of which he enlists the authority of an unnamed "notable North American doctor" and which he couches in the following terms: "In the backlands [*sertões*] of Brazil, the huts have more art and more comfort. Kabylie, in Africa, renowned for possessing the densest and most sordid population in the world, revealed, when I visited there, greater hygiene and care in its constructions."[78] The favela is here compared, at once and unfavourably, to the remote interior of Brazil and to far-off Africa, the ultimate heart of darkness in the colonialist narrative propagated by European imperialism. It is posited as a symbol of both inner and outer shadow, of native barbarity and ethnological savagery. Yet, logically speaking, it could not be both interior and exterior, a part of Brazil but somehow foreign to the imagined community of the nation. Unless, of course, the speaker did not position himself within the same mental space that included *sertões* and favelas, in which case both would be as external to his discourse as the distant reaches of Algeria he cites as a metonym of Africanness. Like many members of the urban elite, Mattos Pimenta did not view the place he inhabited as qualitatively akin to the rest of Brazil, except in the narrowest sense of belonging to the same nation-state.

This discursive lapse bolsters contentions by early twentieth-century critics like Euclides da Cunha and Alberto Torres that a mental divide separated coastal elites from the 'real' Brazil of the interior. The key point is that Mattos Pimenta did not perceive himself as belonging to the *little Africa* that was taking shape around him but, rather, to what historian Afonso Carlos Marques dos Santos termed "the achievable Europe" that Brazilian elites imagined for themselves over the course of the nineteenth century in their pursuit of *civilization* and *progress*.[79] The brutalized existence of subaltern populations in the hinterland of northern Brazil or in the poorer districts of Rio de Janeiro was as alien to many members of the white establishment – be they business leaders, politicians or intellectuals – as the muted sufferings of exploited workers in the Congo Free State. In fact, given the international furore surrounding the Congo Reform Association during the early years of the twentieth century, it is entirely conceivable that someone as cosmopolitan as Mattos

[78] "Acabemos com as 'favellas', 3. Mattos Pimenta was not alone. Lima Barreto repeatedly approximated Rio's favelas to Africa in a pejorative sense. See, among others, Lima Barreto, "O prefeito e o povo", *Careta*, 15 January 1921, n.p.; LB, "Leitura de jornaes", *Careta*, 19 March 1921, n.p.; and LB, "Hospede illustre", *Careta*, 26 August 1922, n.p.

[79] The term "Europa possível" was coined in an essay of 1979; see Afonso Carlos Marques dos Santos, *A invenção do Brasil: Ensaios de história e cultura* (Rio de Janeiro: Ed. UFRJ, 1997), pp. 19–37. Cf. Ventura, *Estilo tropical:*, pp. 36–46.

Pimenta – who had lived in both France and Germany – would be more aware of the sins of European colonialism than those of his own social milieu.[80] No sense of common destiny bound these elites to their countrymen of other regions and backgrounds.

The discourse constructed between 1900 and 1930 associating favelas and blackness served the purpose of ensuring their alterity in the worldview of Brazil's ruling classes. The thought that men, women and children were obliged to live in degrading conditions, lacking any comfort and amenities, exposed to all manner of dangers, abandoned to the worst possible lot and essentially left to languish and perish, could only remain tolerable so long as the disadvantaged were not considered people on the same level as those who governed them. The inhumanity of their living conditions demanded to be understood as a product of their own lack of dignity and worth; otherwise, it would be unconscionable by the ethical standards of a society premised on Republican ideals, Catholic virtues and family values. For the authorities, favela dwellers did not need to be treated humanely, because they were less than human. Within the cultural mindset of the time, only one factor was powerful enough to determine such a perception of radical otherness – and that was racial difference, the cumulative force of four centuries of chattel slavery that systematically reviled and vilified anything of African origin.

For Brazil's establishment, favelas were part of the same dusky trappings of backwardness that also included the distant *sertão* and Europe's African colonies, to which modernization and modernity were counterposed. They were a separate enclave, a city within the city, a cyst in the tissue of the social body. As the nation's capital, Rio de Janeiro had to be maintained sound and virtuous, untainted by barbaric influences; thus, the emphasis on its pristine natural beauty as the ultimate measure of worth. Given such assumptions, nothing could be more threatening than to see white intellectuals enthusing about favelas as expressive of genuine Brazilianness, particularly if they happened to be European. Di Cavalcanti could be easily written off as a libertine, an agitator or an exemplar of lower-middle-class resentment. Oswald de Andrade and Tarsila do Amaral could be conveniently indulged or ignored, as rich and clueless *paulistas*. Marinetti was another matter. It was necessary to disown him publicly as a charlatan and a fool. The notion that favelas were to be considered anything other than a problem to be solved or a

[80] For a contemporary critique of French colonialism in Africa, see Mario Poppe, "Africa civilizada", *Fon Fon*, 23 February 1924, n.p.

disease to be cured was dangerous. Any appeasement of such an opinion imperilled the perverse mental operation that equated inner and outer, local and remote, as one and the same thing.

There was another possible way of looking at favelas – not as citadels of crime or hotbeds of infection, much less as Romantic fantasy, but as neighbourhoods where ordinary people lived and whose needs could be met by the same public services and policies applied elsewhere. This was the attitude prescribed, over the years, by observers as distinct as the technically minded Everardo Backheuser and the extravagant João do Rio, both of whom noted that favela residents were mostly workers living in straitened circumstances. This was the assumption implicit in socially critical works of art like those by Visconti and Dall'Ara. However, this seemingly simple conclusion took a long time to filter through to the mainstream of public opinion. By the late 1920s, there are signs that it had finally begun to do so.

A May 1929 article in the much-read magazine *Para Todos*, authored by journalist Barros Vidal, is an attempt to familiarize readers with the favela, coaxing them into a positive view of the residents of Morro de São Carlos, who are described as "poor but peace-loving folk". It begins: "May heaven pour its blessings upon the slandered hill and may all the higher forces that rule us enlighten the destinies of its residents, who struggle from sunrise to sundown to earn the bread that dwindles as the difficulties of procuring it increase."[81] It ends with a tale about a poor widower crying over his departed love. The sentimental text is hardly worth exploring further, but the lavish illustrations by J. Carlos display a completely different outlook compared to the artist's earlier representations of favelas. The main illustration [Fig. 15], which splits the text diagonally in two and occupies both pages of the spread, shows a procession of women and children of all colours and shapes descending a hillside to the cobbled street below. The visual markers of favela life are all there: shanties, clothes-lines, water cans. There is no mistaking the place, but the figures who occupy the scene are smiling and chatting and unthreatening. Even the women carrying cans on their heads appear graceful and carefree. Their progression is placid and orderly, with not a pig or goat in sight. There is a profusion of children and even babes in arms. Two of the women are black but are neither demeaned nor depicted as racist caricatures. Rather, their blackness serves to draw attention to

[81] Barros Vidal, "Morro de São Carlos", *Para Todos*, 11 May 1929, n.p.

the fact that the remaining figures are undefined in terms of race or ethnicity. This favela is a place like any other.

The woman in front, with a huge bundle on her head and a water can in each hand, has a ringlet of black hair curled into a hook. A little ways behind her, a blonde woman leads a child by the hand. They are indistinguishable from figures that would illustrate other cartoons by J. Carlos, unrelated to a favela theme. They are ordinary Cariocas. The boy with a dog, dragging a huge bundle, in the lower right, is just another cute kid, except that his short trousers are ragged and patched. Significantly, no grown men are depicted. Despite the fact that the main character in Barros Vidal's sob story is a widower, J. Carlos must have judged that images of women and children would be more effective in garnering the sympathies of middle-class readers. Notwithstanding the affirmative view of favelas revealed by both article and illustrations, the respectable public was perhaps not prepared to deal with the dangers attendant upon mingling with *malandros, bambas* and *bambambãs*. At this critical juncture in the visual discourse surrounding favelas, there was still no question of rehabilitating the 'dangerous class' of poor black men.

Public opinion of the time should not be underestimated in its ability to deal with the tangled discourses surrounding favelas. When French urban planner Alfred Agache was hired in 1928–1930 to develop a master plan for the city of Rio de Janeiro, one of the first measures he announced was the eradication of all existing favela settlements.[82] After decades of wavering, municipal authorities seemed set to move in the direction envisaged by Mattos Pimenta and other antagonists of the hillside settlements. Agache's authority as an expert imported from Europe endowed him with a pedigree that could easily eclipse Marinetti's outlandish utterances about Brazilian raciality. With the backing of Rio's political and economic elites, there was no reason why the proposals should not go ahead. Yet, even after it was finalized, Agache's plan was never fully implemented, and the favelas remained in place. One reason was the vocal reaction of the city's populace against their removal.

Soon after Agache's intentions first came to light, in 1927, composer Sinhô – then known as 'the king of samba' – wrote a song titled "*A Favela*

[82] José Teles Mendes, "O Plano Agache: Propostas para uma cidade-jardim desigual", *Revista Habitus: Revista eletrônica dos alunos de graduação em Ciências Sociais*, 10 (2012), 116–127. See also Maurício de Almeida Abreu, *A evolução urbana do Rio de Janeiro* (Rio de Janeiro: Instituto Pereira Passos, 2010 [1987]), pp. 76–79; and Carlos Kessel, *A vitrine e o espelho: O Rio de Janeiro de Carlos Sampaio* (Rio de Janeiro: Prefeitura da Cidade/Coleção Memória Carioca, 2001).

FIG. 15 J. Carlos [José Carlos de Brito e Cunha], *Para Todos*, 11 May 1929
Rio de Janeiro: Instituto Memória Gráfica Brasileira

FIG. 15 (*cont.*)

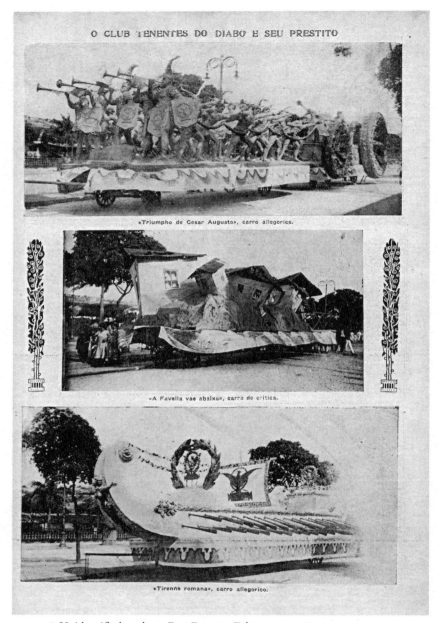

FIG. 16 Unidentified author, *Fon Fon*, 25 February 1928
Fundação Biblioteca Nacional (BN Digital/Hemeroteca Digital Brasileira)

vai abaixo" (the favela is coming down). It was recorded by the popular singer Francisco Alves and quickly became a hit. The lyrics speak tenderly of Morro da Favela, its special ambience, its place as home of samba and *malandragem*, and of how much it will be missed. The community's intended demise is attributed to the resentment and ingratitude of the money-grubbing powers who live in the city below, envious of the favela's music and moonlight.[83] Sinhô's lyrical defense of favela life struck a chord in the public imagination. During the 1928 carnival, Tenentes do Diabo – one of the three 'Great Societies' that still dominated carnival at the time – included a critical float called "*A Favela vai abaixo*" in its pageant [Fig. 16].[84] Public opinion, or at least a significant portion of it, had apparently tipped in favour of the favelas. The curious coalition between modernist attitudes and Afro-Brazilian identity, denounced by the likes of Mattos Pimenta, was no longer a sentiment restricted to the intellectual few. A wider public was ready and willing to rally around the favelas.

[83] Maria Clementina Pereira Cunha, "De sambas e passarinhos: As claves do tempo nas canções de Sinhô", In: Chalhoub, Neves & Pereira, *História em cousas miúdas*, 566; Fischer, *A Poverty of Rights*, pp. 15–16; and Carvalho, *Porous City*, 158. See also Marc A. Hertzman, *Making Samba: a New History of Race and Music in Brazil* (Durham: Duke University Press, 2013), pp. 121–123, 132–134.

[84] For more on carnival and the Great Societies, see Chapter 2. On Sinhô, see Chapter 4.

2

A Pagan Festival for the Up to Date

Art, Bohemianism and Carnival

Although eminently national, carnival has not encountered among our painterly and sculptural youth the comforting reception that was to be expected.

Terra de Senna, 1926[1]

The present chapter contends that the relationship between the visual arts, bohemianism and carnival was an important avenue for bridging the social chasm that separated elite and popular cultures in Rio de Janeiro over the early twentieth century. Previous evaluations of that cultural context have focused mainly on literature or music and have thereby failed to account for the transformations taking place in the visual arts. Jeffrey D. Needell's *A Tropical Belle Époque* – still an important reference – takes a superficial view of the history of Brazilian art, collapsing a century of painting into a single paragraph and writing off a dense and variegated tradition as derivative.[2] Closer scrutiny of the Escola Nacional de Belas Artes (hereafter, ENBA), and the lesser-known Liceu de Artes e Ofícios (literally, School of Arts and Crafts) demonstrates that artistic institutions of the early twentieth century operated as sites of exchange and assimilation, much more permeable to new currents than

[1] Terra de Senna [Lauro Nunes], "O carnaval na pintura brasileira contemporanea", *D. Quixote*, 10 February 1926, n.p.

[2] Jeffrey D. Needell, *A Tropical Belle Époque: Elite Culture and Society in Turn-of-the-century Rio de Janeiro* (Cambridge: Cambridge University Press, 1987), 179–180. In Needell's defense, it should be stated that Brazilian art historians had hardly begun to revise this view up to the time he was writing.

the later modernist canon cared to acknowledge in its successful drive to sweep all that preceded it into the bin of the 'academic'. Both individually and collectively, artists undertook efforts to break down the barriers that had previously kept artistic production insulated from wider society and, particularly, from the burgeoning urban culture of the time.

The task of the present chapter is to investigate the art world in Rio de Janeiro between around 1900 and 1920, paying special attention to its links with the realm of carnival. Though the picture that emerges is not without ambiguities, it leaves no doubt that the process of artistic modernization was more complex than has been previously assumed. The dominance of a cultural elite – heavily Francophile, often repelled by the customs and habits of the common people – is indisputable. Nonetheless, the caricature of that elite's cluelessness, established post-1922 by the rival cultural elite that took their place, tends to overstate the case. As Avelino Romero Pereira has noted, modernist claims to nationalism in music were directed against a preceding generation that, in its time, had striven to be both national and modern. Ironically, the new aesthetic they imposed as a substitute for the copying of European models was itself a European import.[3] The same argument can be made for fine art, an arena in which the modernists of 1922 were equally in thrall to Parisian models and guilty of ignoring vital expressions of contemporary life, like the budding culture of samba and carnival.

A tendency still exists to exaggerate the polarity between an imitative Eurocentric paradigm, pre-1890, and a modernizing nationalist one, post-1930. This dichotomy conceals and obscures anomalies at both ends. More distressingly, it leaves a no man's land in the middle, usually camouflaged by hollow concepts like *pre-modernism*. In the field of literature, revision of this label has been ongoing for over three decades; and literary historians no longer write off authors such as Benjamim Costallat, João do Rio, Julia Lopes de Almeida or Lima Barreto as undeserving of attention.[4] Rather, the tensions and contradictions arising from their works are viewed as illuminating the deeper nature of a society riddled with suppressed conflict. To make sense of the art produced during the interim between the openly Europhile ambitions of the Imperial period and the populist idyll of a 'Brazilian Brazil', propagated under

[3] Avelino Romero Pereira, *Música, sociedade e política: Alberto Nepomuceno e a ruptura musical* (Rio de Janeiro: Ed. UFRJ, 2007), pp. 22–28, 290–291.

[4] See Introduction.

the Estado Novo regime, requires addressing the works within the context of their own place and time.[5]

2.1 CULTURAL PROVISION IN RIO DE JANEIRO

The period of the so-called First Republic, 1889–1930, witnessed a boom in the various arenas of cultural provision, entertainment and leisure.[6] To an already flourishing world of theatres and theatrical revues were added the new and exciting possibilities of the cinematograph. No fewer than one hundred cinemas operated in Rio de Janeiro between 1907 and 1911.[7] With the advent of urban electrification, circa 1909, nightlife prospered as never before. Music halls, cabarets and dance venues multiplied in the district of Lapa, adjoining the city centre, and contributed to a culture of bohemianism that became legendary over the 1920s and 1930s.[8] The Municipal Theatre, inaugurated in 1910, endowed the city with a world-class concert and opera house. Isadora Duncan danced there

[5] The expression 'Brazilian Brazil' was coined in 1925 as title of Joaquim Inojosa's pamphlet in defense of modernism, "O Brasil brasileiro". Ary Barroso's hit song "Aquarela do Brasil" (1939) popularized the term. It begins with the line *"Brasil, meu Brasil brasileiro / meu mulato inzoneiro / vou cantar-te nos meus versos"* (Brazil, my Brazilian Brazil / my wily mulatto / I will sing you in my verses). First recorded by Francisco Alves, the song became an international success after its inclusion in the Walt Disney film *Saludos Amigos* (1942). Over the 1940s and 1950s, under the title "Brazil", it was covered by Xavier Cugat, Django Reinhardt and Frank Sinatra and is considered by many as a sort of unofficial anthem of Brazilianness.

[6] See Andrea Marzano & Victor Andrade de Melo, eds., *Vida divertida: Histórias do lazer no Rio de Janeiro* (Rio de Janeiro: Apicuri, 2010); Sidney Chalhoub, Margarida de Souza Neves & Leonardo Affonso de Miranda Pereira, eds., *História em cousas miúdas: Capítulos de história social da crônica no Brasil* (Campinas: Ed. Unicamp, 2005); and Rosa Maria Barboza de Araújo, *A vocaçao do prazer: A cidade e a família no Rio de Janeiro republicano* (Rio de Janeiro: Rocco, 1995).

[7] Alice Gonzaga, *Palácios e poeiras: 100 anos de cinemas no Rio de Janeiro* (Rio de Janeiro: Funarte/ Record, 1996), pp. 94–97. See also Maite Conde, *Consuming Visions: Cinema, Writing and Modernity in Rio de Janeiro* (Charlottesville: University of Virginia Press, 2012); Antônio Herculano Lopes, "O teatro de revistas e a identidade carioca", In: Antônio Herculano Lopes, ed., *Entre Europa e África: A invenção do carioca* (Rio de Janeiro: Topbooks/Fundação Casa de Rui Barbosa, 2000), pp. 13–32; and Flora Sussekind, *As revistas do ano e a invenção do Rio de Janeiro* (Rio de Janeiro: Nova Fronteira, 1986).

[8] Muza Clara Chaves Velasques, *A Lapa boêmia: Um estudo da identidade carioca* (unpublished MA thesis, Programa de Pós-Graduação em História, Universidade Federal Fluminense, 1994), pp. 27–28, 50–71. See also Nicolau Sevcenko, "A capital irradiante: Técnica, ritmos e ritos do Rio", In: Nicolau Sevcenko, ed., *História da vida privada no Brasil, 3. República: Da Belle Époque à Era do Rádio* (São Paulo: Companhia das Letras, 1998), pp. 513–619.

in 1916; Enrico Caruso sang there in 1917. Sports became a fashionable pastime, and the establishment of rowing and football clubs quickly mushroomed into a national obsession.[9]

Information circulated with a new and exciting immediacy. Diverse options arose for reading, including magazines about cinema or sports or fashion or automobiles. They were founded in growing numbers, most short-lived but some developing into staples of a thriving periodical press.[10] The book trade likewise underwent major transformations, with new publishers vying for a growing national audience. Best-selling authors like Monteiro Lobato or Benjamim Costallat broke sales records and achieved a level of celebrity that was distinct from the esteem accorded to writers of prior generations.[11] Though burdened with a more conservative institutional culture, the world of art kept up with the drive towards cultural modernization. ENBA's General Exhibition of Fine Art, or Salon – staged on an annual basis after 1894, always in September – became a fixture on the social calendar and attracted substantial interest from press and public.[12] In 1908, the school moved to a new building on Avenida Central, placing it at the heart of the city's elegant cultural scene. Commercial art galleries played an important role in making exhibition attendance a year-round activity. Galeria Jorge, the most important gallery of the period, opened in 1908 and remained active through the 1930s.[13] Other alternative exhibition spaces gained ground over the period, including the Liceu de Artes e Ofícios, particularly after its move in 1916 to a building on Avenida Rio Branco, close to ENBA. The Palace Hotel, located nearby on the Avenida, became a frequent location for exhibitions of modern art in the later 1920s and into the 1930s.

[9] See Leonardo Affonso de Miranda Pereira, *Footballmania: Uma história social do futebol no Rio de Janeiro, 1902–1938* (Rio de Janeiro: Nova Fronteira, 2000).

[10] See Ana Luiza Martins, *Revistas em revista: Imprensa e práticas culturais em tempos de República (1890–1922)* (São Paulo: Edusp, 2008); and Cláudia Oliveira, Monica Pimenta Velloso & Vera Lins, *O moderno em revistas: Representações do Rio de Janeiro de 1890 a 1930* (Rio de Janeiro: Garamond, 2010). See also Chapter 3.

[11] See Márcia Abreu & Nelson Schapochnik, eds., *Cultura letrada no Brasil: Objetos e práticas* (Campinas: Mercado de Letras, 2005); Rafael Cardoso, "O início do design de livros no Brasil", In: Rafael Cardoso, ed., *O design brasileiro antes do design: Aspectos da história gráfica, 1870–1960* (São Paulo: Cosac Naify, 2005), pp. 160–196; and Alessandra El Far, *Páginas de sensação: Literatura popular e pornográfica no Rio de Janeiro (1870–1924)* (São Paulo: Companhia das Letras, 2004).

[12] See Arthur Valle, "Ver e ser visto nas Exposições Gerais de Belas Artes", *19&20*, 8 (2013).

[13] Carlos Rubens, *Impressões de arte* (Rio de Janeiro: Typ. do Jornal do Commercio, 1921), pp. 39–43.

The spatial distribution of these pleasures and spectacles is important to making sense of how and by whom they were consumed. As seen in Chapter 1, the accelerated growth of the capital and the urban reforms it underwent during the first decade of the twentieth century drastically altered the geography of the city. During the latter half of the nineteenth century, the near totality of Rio's theatres, restaurants and amusements were located within the confines of the city centre, mostly on and around Praça da Constituição (today, Praça Tiradentes). Cafés, bookshops and newspaper offices, as well as purveyors of fashion and art, were mostly concentrated in Rua do Ouvidor. The boom in population caused the urban perimeter to radiate outwards and encompass a much larger territory. Between the 1910s and 1940s, whole new neighbourhoods were built in both the newly well-to-do districts near the seashore (*Zona Sul*) and the working-class ones of *Zona Norte*, putting in place the north/south divide that has marked the city's identities ever since.[14] Stratified by hierarchies of class and income, the city's dwellers sought increasingly to reside outside the old city, following the routes opened by a growing network of tram and train lines.

The renovated city centre continued to congregate the major institutions of cultural provision. In fact, the reforms instigated by mayor Pereira Passos served to agglomerate them further, as ENBA, the Municipal Theatre and National Library were assembled in grand buildings at the southern end of the Avenida.[15] The National School of Music and Brazilian Academy of Letters, among other notable public institutions and private organizations, likewise took up new premises near what is today's Cinelândia area. Codes and conventions, mostly unwritten, ensured that these spaces of cultivation and leisure were kept apart from a populace perceived as uncouth. Yet, it should be borne in mind that this thriving hub of the capital was located within a half hour's walk from the surrounding arc of Lapa, Cidade Nova, Morro da Favela and Saúde.

[14] For more on Rio's territorial divisions by class, see Bruno Carvalho, *Porous City: a Cultural History of Rio de Janeiro (from the 1810s onwards)* (Liverpool: Liverpool University Press, 2013), ch. 3; and Conde, *Consuming Visions*, pp. 105–111.

[15] See André Nunes de Azevedo, "A grande reforma urbana do Rio de Janeiro: A modernização da cidade como forma de sedução estética a serviço de um horizonte de integração conservadora sob a égide da civilização", In: Carmem Negreiros, Fátima Oliveira & Rosa Gens, eds., *Belle Époque: Crítica, arte e cultura* (Rio de Janeiro: Labelle/ Faperj & São Paulo: Intermeios, 2016), pp. 293–304.

It was in these marginal locations that the musical culture of samba, in its present urban style, came into being between the 1910s and 1930s.[16]

It is often presumed that the two sides of *Belle Époque* Rio de Janeiro did not mix or even meet. A Eurocentric elite culture is thought to have remained aloof from contemporary developments in popular culture. Though there is much truth to allegations of elitism, the situation was never quite so clear-cut.[17] Given Rio de Janeiro's peculiar geography and rapidly changing demographics, some sort of coexistence had to be hammered out. Police oppression of the urban poor was part of the picture, as has been seen in Chapter 1; and the Republican period is renowned for repressive measures against the 'dangerous classes' of society, a category routinely taken to include religious and cultural traditions of Afro-Brazilian origin like *candomblé* and *capoeira*. At the opposite end of the equation, historians have long recognized an undercurrent of resentment against the Republic and its values among segments of the working classes, along with a residual survival of monarchist sentiments.[18] These tensions occasionally boiled over into overt hostility and even outright rebellion, as in the Vaccine Revolt and other lesser instances of popular protest. Direct confrontation, however, was the exception and not the rule. An ability to sidestep conflict, accommodate contradictions

[16] Lira Neto, *Uma história do samba: As origens* (São Paulo: Companhia das Letras, 2017), pp. 27–82; Marc A. Hertzman, *Making Samba: a New History of Race and Music in Brazil* (Durham: Duke University Press, 2013), ch. 4; Magno Bissoli Siqueira, *Samba e identidade nacional: Das origens à era Vargas* (São Paulo: Ed. Unesp, 2012), pp. 144–155; Carlos Sandroni, *Feitiço decente: Transformações do samba no Rio de Janeiro, 1917–1933* (Rio de Janeiro: Jorge Zahar/Ed.UFRJ, 2001), pp. 90–97, 131–142; Hermano Vianna, *O mistério do samba* (Rio de Janeiro: Jorge Zahar/Ed.UFRJ, 1995), ch. 6; and; Roberto Moura, *Tia Ciata e a Pequena África no Rio de Janeiro* (Rio de Janeiro: Secretaria Municipal de Cultura/Biblioteca Carioca, 1995).

[17] See Micol Seigel, *Uneven Encounters: Making Race and Nation in Brazil and the United States* (Durham: Duke University Press, 2009), pp. 98–101; Pereira, *Música, sociedade e política*, pp. 286–287; Maria Alice Rezende de Carvalho, "O samba, a opinião e outras bossas... na construção republicana do Brasil", In: Berenice Cavalcante, Heloisa Starling & José Eisenberg, eds., *Decantando a República: Inventário histórico e poético da canção popular moderna brasileira* (Rio de Janeiro: Nova Fronteira & São Paulo: Fundação Perseu Abramo, 2004), pp. 37–68; Vianna, *O mistério do samba*, pp. 44–51, 111–117.

[18] José Murilo de Carvalho, *Os bestializados: O Rio de Janeiro e a República que não foi* (São Paulo: Companhia das Letras, 2011 [1987]), pp. 30–41; Ricardo Salles, *Nostalgia imperial: Escravidão e a formação da identidade nacional no Brasil do Segundo Reinado* (Rio de Janeiro: Topbooks, 1996), ch. 1; and Júlio Braga, "Candomblé da Bahia: Repressão e resistência", *Revista USP*, 18 (1993), pp. 54–59. See also Sidney Chalhoub, *Trabalho, lar e botequim: O cotidiano dos trabalhadores no Rio de Janeiro da Belle Époque* (Campinas: Ed.Unicamp, 2005 [1986]); and Lúcio Kowarick, *Trabalho e vadiagem: A origem do trabalho livre no Brasil* (Rio de Janeiro: Paz e Terra, 1994 [1987]).

and contain seemingly impossible pressures emerged as a hallmark of the Carioca identity forged over the period under scrutiny in this book.

The importance of carnival as a mechanism of social cohesion can hardly be overstated. Dating back to colonial times, in the form of the antics known as *entrudo*, carnival has long provided an opportunity for subverting established relationships of power and propriety. As a collectively authorized suspension of social mores, it is the highlight of the annual calendar of events in Rio de Janeiro to this day.[19] During carnival celebrations, the fantasy prevails that anything goes and that everything is acceptable in the name of fun. Though venues and groupings are stratified by location and social class, the event's festive culture is premised on a loosening of restrictions and a propensity towards unwarranted encounters. Over many generations, carnival has proved its power to defuse tensions, construct alternate social relationships and institute a compelling imaginary.[20] During the period under consideration in this chapter, the present-day *escolas de samba* (literally, 'samba schools') – the groupings that have dominated carnival since the 1930s – had not yet come into being. Before then, Rio's carnival revolved around the competition between the three so-called *Grandes Sociedades* (Great Societies): Democráticos (Democrats), Fenianos (Fenians) and Tenentes do Diabo (The Devil's Lieutenants). As shall be seen, they played a crucial mediating role between the art world and other strata of society.

Perhaps the least considered aspect of cultural provision is those forms of recreation accessible to the unlettered and destitute, including religious festivities and popular entertainments.[21] Given its history of entrenched patriarchy and pervasive urban slavery, Rio de Janeiro developed a street

[19] For an anthropological appreciation of Brazilian carnival, see Maria Laura Cavalcanti, *Carnaval, ritual e arte* (Rio de Janeiro: 7Letras, 2015); and Maria Laura Viveiros de Castro Cavalcanti, *O rito e o tempo: Ensaios sobre carnaval* (Rio de Janeiro: Civilização Brasileira, 1999).

[20] On the history of carnival, see Felipe Ferreira, *Inventando carnavais: O surgimento do carnaval carioca no século XIX e outras questões carnavalaescas* (Rio de Janeiro: Ed. UFRJ, 2005); Maria Clementina Pereira Cunha, ed., *Carnavais e outras f(r)estas: Ensaios de história social da cultura* (Campinas: Ed. Unicamp, 2002); Maria Clementina Pereira Cunha, *Ecos da folia: Uma história social do carnaval carioca entre 1880 e 1920* (São Paulo: Companhia das Letras, 2001). The former book has been published in French as: Felipe Ferreira, *L'invention du carnaval au XIXe siècle: Paris, Nice, Rio de Janeiro* (Paris: L'Harmattan, 2014).

[21] See Monica Pimenta Velloso, *A cultura das ruas do Rio de Janeiro (1900–1930)* (Rio de Janeiro: Fundação Casa de Rui Barbosa, 2014); and Monica Pimenta Velloso, *As tradições populares na Belle Époque carioca* (Rio de Janeiro: Instituto Nacional do Folclore, 1988). On the role of the *botequim* as a meeting place, see Sandroni, *Feitiço decente*,

culture starkly segregated from the settings of family and domesticity. Over the nineteenth century, the lives of women were often restricted to home and church, with only a few public venues for amusement considered respectable.[22] The barriers separating private from public spheres began to be worn down during the period under discussion here. As a form of expression easily transported between indoors and outdoors, music served as a crucial conduit for such exchanges. Festive musical gatherings held in private residences, known as *saraus*, were important arenas for bridging the gap between street and salon. Despite a greater permeability, however, restrictions regarding what was or not appropriate for 'good society' remained in place. The popular musical form called *maxixe* – considered the most typically Brazilian dance style before the reinvention of samba – took decades to reach elite audiences.[23] As late as 1914, when Brazil's first lady Nair de Teffé dared to introduce it into a musical programme at the presidential palace, political uproar ensued.[24] Though less well known, such border crossings between elite and popular, high and low, were equally at play in the domain of visual art.

pp. 143–146. See also Martha Abreu, *O império do divino: Festas religiosas e cultura popular no Rio de Janeiro , 1830–1900* (Rio de Janeiro: Nova Fronteira, 1999).

[22] See Valdeci Rezende Borges, "Em busca do mundo exterior: Sociabilidade no Rio de Machado de Assis", *Estudos Históricos*, 28 (2001), 49–69; Rachel Soihet, *A subversão pelo riso: Estudos sobre o carnaval carioca da Belle Époque ao tempo de Vargas* (Rio de Janeiro: Fundação Getúlio Vargas, 1998), ch. 6; and Barboza de Araújo, *A vocaçao do prazer*, pp. 63–96. On urban slavery in Rio de Janeiro, see Luis Carlos Soares, *O 'povo de Cam' na capital do Brasil: A escravidão urbana no Rio de Janeiro do século XIX* (Rio de Janeiro: 7Letras, 2007).

[23] *Maxixe* was already a phenomenon in the 1890s, became ubiquitous by the time of the hit revue *O maxixe* (1906) and sparked a dance craze in Paris and New York, circa 1912–1915. On its importance and complex history, see Luís Carlos Saroldi, "O maxixe como liberação do corpo", In: Lopes, *A invenção do carioca*, pp. 35–48; Antonio Herculano Lopes, "Da tirana ao maxixe: A 'decadência' do teatro nacional", In: Antonio Herculano Lopes, Martha Abreu, Martha Tupinambá de Úlhoa & Monica Pimenta Velloso, eds., *Música e história no longo século XIX* (Rio de Janeiro: Fundação Casa de Rui Barbosa, 2011), pp. 239–262; and Marcelo Balaban, *Estilo moderno: Humor, literatura e publicidade em Bastos Tigre* (Campinas: Ed. Unicamp, 2016), ch. 6. On the origins and musical structure of *maxixe*, see Sandroni, *Feitiço decente*, pp. 62–83. On the reception of *maxixe* in Europe and the USA, see Monica Pimenta Velloso, "A dança como alma da brasilidade: Paris, Rio de Janeiro e o maxixe", *Nuevo Mundo, Mundos Nuevos* (Colloques 2007); and Seigel, *Uneven Encounters*, ch. 2.

[24] Rafael Nascimento, "Catete em ré menor: Tensões da música na Primeira República", *Revista do Instituto de Estudos Brasileiros*, 67 (2017), 38–56; Rezende de Carvalho, "O samba, a opinião e outras bossas", pp. 41–42; Saroldi, "O maxixe como liberação do corpo", pp. 36–42; and Enio Squeff & José Miguel Wisnik, *O nacional e o popular na cultura brasileira: Música* (São Paulo: Brasiliense, 1983), pp. 156–157.

2.2 BOHEMIANISM AND THE UNITY OF ART

The key to understanding the slippages between art, music and carnival is the imaginary construct of bohemianism. The term *boemia* (or, *bohemia*, as it was spelled before the rules were changed in 1943) possesses a resonance all its own in the Brazilian context, distinct from European or North American conceptions.[25] Though equally rooted in the nineteenth-century fantasies of Henri Murger's novel *Scènes de la vie de Bohème*, the ideal of bohemianism acquired a peculiar inflection in early twentieth-century Rio de Janeiro that moved it in a more down-to-earth direction. Between the 1900s and 1930s, repeated usage of the term in the titles and lyrics of popular songs ended up equating bohemianism to nightlife, drinking and music.[26] As a consequence, the noun *bohemia* became a euphemism for nocturnal carousing and the adjective *bohemio* (*boêmio*, in current spelling) for anyone who habitually engages in such pleasures. In Brazil, bohemianism is not necessarily associated with the lifestyle of artists or with any countercultural stance. The term has acquired a much wider valence, and even otherwise conventional people may lay claim to it.

Although diluted to some extent by subsequent popularization, the original sense of *bohemia* in Brazil was more akin to usage elsewhere. Already known from French literary references, the term crops up more frequently after Giacomo Puccini's opera *La Bohème* (1896) was

[25] See Arthur Valle, "Sociabilidade, boêmia e carnaval em ateliês de artistas brasileiros em fins do século XIX e início do XX", In: Arthur Valle, Camila Dazzi, Isabel Sanson Portella & Rosangela de Jesus Silva, eds., *Oitocentos – tomo IV: O ateliê do artista* (Rio de Janeiro: Cefet, 2017), pp. 43–55; Marcelo Balaban, *Estilo moderno*, ch. 5; Conde, *Consuming Visions*, ch. 2; Marcelo Balaban, "Memória de um demônio aposentado: Literatura e vida literária em Bastos Tigre", In: Sidney Chalhoub, Margarida de Souza Neves & Leonardo Affonso de Miranda Pereira, eds., *História em cousas miúdas* (Campinas: Ed. Unicamp, 2005), pp. 379–387; Berenice Cavalcante, "A República às avessas: Boemia carioca e crítica literária", In: Cavalcante, Starling & Eisenberg, *Decantando a República*, pp. 117–132.

[26] Uelba Alexandre do Nascimento, "'Deus me deu essa vida por prêmio, serei o boêmio enquanto ele quiser': Música e boemia nas primeiras décadas do século XX", *Anais do XXVIII Simpósio Nacional de História – Anpuh*, 39 (2015), 14. See also Elton Nunes & Leonardo Mendes, "O Rio de Janeiro no fim do século XIX: Modernidade, boemia e o imaginário republicano no romance de Coelho Netto", *Soletras*, 16 (2008), 82–97. The term is used in this broad sense by Vagalume, legendary chronicler of Rio's nightlife in 1904, who divides *bohemios* into three classes – Vagalume [Leonardo Affonso de Miranda Pereira & Mariana Costa, eds.], *Ecos noturnos* (Rio de Janeiro: Contracapa, 2018), pp. 331–335.

performed in Rio under the Brazilian title *Bohemia* in 1901. The following year, presumably riding on the opera's success, Murger's and Théodore Barrières's 1849 theatrical version of *La vie de Bohème* was belatedly staged in Rio, also under the title *Bohemia*.[27] From there, the term slipped into contemporary usage and soon became a way of describing a certain class of artists, as well as the wannabes and hangers-on who wished to pass for artists. In a 1908 text, leading art critic Gonzaga Duque made a point of contradicting the "regrettable confusion" that mistook mere sponging and carousal for bohemianism. Real bohemian identity was something altogether different:

The word *bohemianism* [*bohemia*], acclimated in our midst, partakes of a cheerful irony with which those who are averse to gregariousness, to the passive consensus of the multitudes guided by the rod of a falsely established morality and a supinely hypocritical order, qualify themselves.[28]

The accepted appearance of a bohemian is reflected in this 1902 evocation of writer and journalist João Luso:

In the agreeable manner of the bohemia of the spirit, he dressed in the decent dishevelment of light-coloured clothing with a fine cravat, knotted loosely and carelessly, and an expressive floppy hat, its broad-brimmed shadow casting upon his physiognomy the serene features of the Contemplative and the Artist.[29]

The trope of the broad-brimmed floppy hat is recognizable to anyone familiar with the image of French cabaret star Aristide Bruant, immortalized in the posters of Toulouse-Lautrec, or else with the 1882 photographic portraits of Oscar Wilde in hat and cape, by Napoleon Sarony. It became an accessory of the artist figure at the *fin-de-siècle*, its looseness contrasting with the stiff top hats more likely to cover bourgeois heads. One of the first cartoons ever published by J. Carlos – barely eighteen years old, in 1902 – satirizes "the art nouveau artist", depicted in just such a hat and a droopy cravat.[30]

A similar hat appears in the painting *Bohemia* (1903) (Fig. 17), by Helios Seelinger, not crowning the head of João Luso – who nonetheless

[27] "Chronica do Lyrico. Bohemia", *Correio da Manhã*, 27 July 1901, 2 and "Correio dos theatros", *Correio da Manhã*, 26 July 1902, 2 & advertisement on 6.

[28] Gonzaga Duque, "Chronica da saudade", *Kósmos*, October 1908, n.p.

[29] Sancho, "Vida airada", *Tagarela*, 10 May 1902, 7. Cf. Camerino Rocha, "A grande arte nos pequenos ateliers", *Atheneida*, April 1903, 55–56, where Seelinger's bohemianism is discussed in light of his connections to German culture.

[30] J. Carlos, "O artista art-nouveau", *Tagarela*, 11 October 1902, 4. On the implications of the term art nouveau, see Chapter 3.

FIG. 17 Helios Seelinger, *Bohemia*, 1903, oil on canvas, 103 × 189.5 cm.
For color version of this figure, please refer color plate section.
Rio de Janeiro: Museu Nacional de Belas Artes/Ibram (photo: Jaime Acioli)

emerges on the far left of the composition – but rather that of Raul
Pederneiras (hereafter, Raul), the tall figure in a high collar standing in
front of the window in the background. Flanking him, on either side, are
Calixto Cordeiro (hereafter referenced under the pseudonym K. Lixto),
on the right, and, on the left, a discreet self-portrait of the painter. At the
time the painting was produced, all three men were active primarily as
illustrators and caricaturists and were regular contributors to a satirical
weekly titled *Tagarela*.[31] From the rear of the picture, tucked away in half
shadow, they eye the agitated goings-on and talk amongst themselves.
They are depicted as observers – by far, the least active participants in the
overall merrymaking – and, yet, the fact that the author has placed
himself among them casts the trio into the role of bearing witness to the
veracity of the scene. The position of Seelinger's tilted head and the
direction of Raul's gaze suggest they are aware of the female figure in
the centre of the composition. The painter identified this personage as
Bohemia herself, the presiding spirit of the gathering. Right arm out-
stretched in a gesture almost of benediction, she is seated on an ambigu-
ous perch, more pedestal than armchair, and draped in a costume that
exposes her shoulder, more akin to classical mythology than to the
fashions of 1900. Yet, she remains sufficiently undifferentiated that the

[31] Raul and K. Lixto were also artistic directors of another weekly, *O Malho*. Seelinger, in
turn, was artistic director of the short-lived *Atheneida*. For more on these magazines and
the sociability surrounding them, see Chapter 3.

viewer might plausibly interpret the figure as a real woman, of flesh and blood. Her mouth, slightly agape, even suggests she might be singing.

This mixture of reality and unreality should alert the viewer to the allegorical nature of the composition. Even by the standards of allegory, though, it is a strange picture. Excepting lady Bohemia, the remaining eighteen figures depicted are portraits of contemporaries who would have been recognizable to a substantial portion of the viewing public.[32] It is necessary to know who they are in order to understand the artist's intentions. Starting from the left, writers João Luso, profile half cropped by the edge of the canvas, and Paulo Barreto (João do Rio) enter the room and glance inwards. Seated in the foreground, in relaxed intimacy, both gazing contemplatively, actress Plácida dos Santos reclines against architect Gelabert Simas, who holds a coffee cup. Around a table littered with cups, glasses, a bottle, painters Lucilio de Albuquerque and João Timotheo da Costa laugh and converse warmly. Just above them, painter Rodolpho Chambelland leans in to light his cigarette in the flame of a lamp on the table. This light source draws attention to the three painters' faces, rendered garish and almost mask-like by its luminosity. Standing a little further behind the table are journalist Trajano Chacon, hatless, and noted writer and art critic Gonzaga Duque, wearing a high light-coloured fedora. The two men are engaged in reading a newspaper. Completing the left-hand side of the composition, journalist Cezar Lima Campos stands in the far background, leaning against the wall and smoking a cigarette. To his right, Araújo Vianna plays the piano, Bohemia's outstretched arm hovering weirdly over his head.[33]

The female allegory divides the composition into two distinct halves. The only other figure who crosses the imaginary central axis running vertically through her torso is sculptor Honório Cunha Mello, in the right foreground, in vest and shirtsleeves, hat tilted back, playing a guitar. The slight inclination of his body and head suggest a gaze that seeks out his

[32] The portraits are identified from a sketch in which the painter listed them by name – see Américo de Almeida Gonçalves Neto, "Seelinger: Um pintor da 'nossa belle époque'", *Boletim do Museu Nacional de Belas Artes*, 7 (1988), 19, 20, 21. See also Rafael Cardoso, *A arte brasileira em 25 quadros (1790–1930)* (Rio de Janeiro: Record, 2008), pp. 132–140. Judging from contemporary photographs, not all the portraits appear to correspond to the names indicated on the list, which was likely composed in retrospect.

[33] The precise identification of Araújo Vianna is complicated by the fact that two different public figures used the same name around this time. One was Ernesto da Cunha Araújo Vianna, architect, art critic and professor at ENBA. The other was pianist and maestro José de Araújo Vianna, who is presumably the one depicted in *Bohemia*.

fellow musician in the back of the room, almost craning his neck to glimpse around the figure of Bohemia. Again, this reinforces her ambiguous presence – part spiritual allegory, part flesh and blood. To the sculptor's right, three men engage in conversation: journalist Luiz Edmundo, young and tall, looking to the right; painter Heitor Malagutti, sporting a large moustache and facing the viewer; and painter and scenographer José Fiuza Guimarães, practically invisible along the right-hand edge of the canvas.[34] Behind them, in the background, the trio of illustrators rounds out the composition.

To an untutored eye, the picture is a chaotic depiction of a bunch of artist types engaged in late-night camaraderie. The mixed company, with women given wantonly to amusement among men, would have been morally dubious by prevailing social standards.[35] The various states of dress – some in formal evening apparel, others in day suits, all manner of hats worn indoors – betray a disregard for social convention. Alcohol, coffee and cigarettes mingle with music, papers and playing cards. Everything seems to be going on at once, and no one is at all concerned with decorum or propriety. This disorderliness is apparent not only in what the work represents but also in how the artist chooses to depict it. By the prevailing artistic criteria of 1903, the painting appears sketchy and unfinished, the composition agitated and jumbled. Quite apart from the issue of whether the central figure is intended as real or allegorical, the different degrees of pictorial finish and the unconventional way individual portraits are staggered in position and size might suggest to a censorious eye that the painter was less than proficient in draughtsmanship and composition. Indeed, contemporary critics said as much, describing the painting as incurring in errors of proportion and perspective, albeit

[34] Fiuza's presence is impossible to detect in photographs of the painting. However, he is clearly indicated and named in the artist's sketch. His figure is just barely discernible in the painting itself.

[35] Cf. Valle, "Sociabilidade, boêmia e carnaval em ateliês de artistas brasileiros", pp. 46–47. Placida dos Santos was no ordinary woman, but rather one of the better-known actresses and singers of the day, renowned for having performed at the Folies Bergères in Paris. See Monica Pimenta Velloso, "A invenção de um corpo brasileiro", In: *Música e história no longo século XIX*, pp. 281–283 and Luiz Edmundo, "O Rio de Janeiro do meu tempo", *Correio da Manhã*, 10 May 1936, "Supplemento de domingo", 1–2. She was also known, in carnival circles, as the 'queen of Democráticos' see "Chronica de Momo", *Correio da Manhã*, 5 January 1910, 3; "Correio dos Theatros", *Correio da Manhã*, 7 January 1910, 3; and Vagalume, *Ecos Noturnos*, 230.

enthusing about its originality as well as the freedoms they imagined were permitted in artists' studios.[36]

Both in terms of subject and stylistically, *Bohemia* breaks radically with the tradition of Brazilian painting up to that time; and it is this freshness of approach that led critics and jury to attribute qualities of boldness and brilliance to its author, regardless of what might be understood as technical imperfections. The supposed deficiencies were part of its appeal. The painting's looseness of handling endows it with a lack of distinctness – a formlessness that infers informality. The uneven distribution of figures and details over the composition suggest immediacy, as if the work had been painted in haste, hurrying to capture an instant like a snapshot. The sketchiness of several of the portraits adds to this sense of urgency and impetuosity, although it contradicts any claim to photographic realism. Brushstrokes are left visible, and effects of colour and chiaroscuro heightened, endowing the scene with a sombre appearance that contrasts with the gaiety it depicts. The artist lovingly deployed painterly technique to subvert the established pictorial order.

Given that *Bohemia* is an unusual work for its place and time, problematic in many senses, it is surprising that the jury of the 1903 ENBA Salon, where it was exhibited, chose to reward Seelinger with the highest accolade available to a young artist: the travel prize to study in Europe. That decision is even more remarkable given the artist had only recently returned to Rio de Janeiro after nearly five years abroad, between 1896 and 1901.[37] Seelinger was reputed as something of an outlier to the artistic currents prevailing in Brazil. The tropes that most often crop up in critical appraisals of his work revolve around adjectives like bizarre, extravagant and even demonic. He was routinely compared to Arnold Böcklin, James Ensor, Felicien Rops and Franz von Stuck.[38] Indeed, Seelinger laid claim to having studied under the latter painter during his first sojourn in Europe, and his status as a pupil of the Munich

[36] A. Morales de los Rios, "Exposição de Bellas-Artes", *O Paiz*, 2 September 1903, 2 and "Notas de arte", *Jornal do Commercio*, 9 September 1903, 3. See also "No vernissage", *Atheneida*, July 1903, 149.

[37] See Arthur Valle, "Helios Seelinger: Um pintor 'salteado'", *19&20*, 1 (2006).

[38] G. Deo, "Helios Seelinger", *Correio da Manhã*, 31 January 1908, 3; José Marianno Filho, "Helios Seelinger", *Correio da Manhã*, 2 February 1908, 1; Gonzaga Duque, "Helios Seelinger", *Kósmos*, March 1908, n.p.; Elysio de Carvalho, *Five o'Clock* (São Paulo: Antiqua, 2006 [1909]), 62–66; and "A nossa capa", *Fon-Fon!*, 12 December 1908, n.p.

Secessionist was taken for granted in the Brazilian press.[39] The distinct-
ness of his work was partly credited to this influence. A few months before
Bohemia was exhibited, a leading daily newspaper referred to him as a
"disciple of the modern German pictorial spirit".[40] A decade later, in
1914, another magazine still considered him "the most original of our
modern painters".[41] There was no doubt in anyone's minds that he
was attempting something new, different and quite apart from the Paris-
ian *Beaux-arts* influences that prevailed in the Brazilian painting world
at the time.

Though more than one critic situated *Bohemia* as a studio scene, there
is little visual evidence to support that contention.[42] Nowhere in the
image are any studio props depicted; nor is any actual work, artistic or
otherwise, taking place. Rather, the picture shows numerous artists and
writers pointedly not working, having a good time instead. *Bohemia* is
not readily classifiable into any of the then accepted genres of painting. At
103 × 190 cm, it is larger than a conventional genre scene and distinctly
lacking in narrative. As portraiture, it is erratic in the attention devoted to
its subjects, some of whom are hardly visible. It could be considered an
allegory, in the sense enshrined by Gustave Courbet's 'real allegory' in
The Painter's Studio (1855), with which it shares the characteristic of
including portraits of living artists, but no contemporary source made this
connection. More than an allegory, *Bohemia* is akin to a visual manifesto,
announcing a new artistic spirit unbound by conventions, moral or

[39] Although Gonzaga Duque asserted categorically that Seelinger was von Stuck's pupil,
there is no record of his passage through the Academy in Munich. See Horst Ludwig,
"Franz von Stuck als Lehrer an der Akademie von 1895–1928 und das breite Spektrum
seiner Schüler", In: Gabriele Fahr-Becker et al., *Franz von Stuck und die Münchner
Akademie von Kandinsky bis Albers* (Milan: Mazzotta, 1990), pp. 38–46. Archival
evidence does suggest Seelinger studied under Anton Ažbe, particularly photographs
contained in a scrapbook titled "München Rio de Janeiro Paris 1896–1914" currently
in possession of his granddaughter, Heloisa Seelinger. For a detailed account of Brazilian
artists in Munich, see Arthur Valle, "'A maneira especial que define a minha arte':
Pensionistas da Escola Nacional de Belas Artes e a cena artística de Munique em fins
do oitocentos", *Revista de História da Arte e Arqueologia*, 13 (2010), 109–144 and
Arthur Valle, "Bolsistas da Escola Nacional de Belas Artes em Munique, na década de
1890", *Artciencia*, 7 (2012), 1–16.

[40] "24 horas", *Gazeta de Noticias*, 3 July 1903, 1. Cf. "Notas de arte", *Jornal do Com-
mercio*, 1 September 1903, 2.

[41] *Fon-Fon!*, 10 October 1914, n.p.

[42] Cf. João Carlos Rodrigues, *João do Rio: Vida, paixão, obra* (Rio de Janeiro: Civilização
Brasileira, 2010), p. 39, which posits that the painting is a depiction of Seelinger's studio
in Catete, known as 'a Furna' [the cave]. See also Carvalho, *Five o'Clock*, 64, 121 and
Chapter 3.

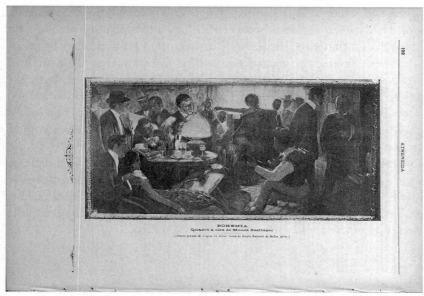

FIG. 18 Unidentified author, *Atheneida*, [October/November/December] 1903
Rio de Janeiro: Fundação Biblioteca Nacional

pictorial, an ethos of looseness and liberty, pleasure and vivacity. It also registers concretely the existence of a cohesive artistic grouping. Of the eighteen people portrayed in Seelinger's canvas, no fewer than ten (Trajano Chacon, Gonzaga Duque, João do Rio, Luiz Edmundo, Lucilio, Fiuza, Malagutti, Raul, K. Lixto and Seelinger himself) were directly involved in producing the magazine *Atheneida* – published in parallel to the painting's execution and display, during 1903 – as authors or illustrators. It is no coincidence that the work was reproduced and discussed in the pages of that magazine (Fig. 18).[43]

If the work is to be taken as a visual manifesto, the logical question is: a manifesto in favour of what? Certainly, of camaraderie, informality, freedom, revelry, lust for life, the flouting of bourgeois convention and all the other traits usually associated with the ideal of bohemianism. For all that, it makes a much more specific claim in terms of the artistic

[43] "No vernissage", *Atheneida*, July 1903, 149. This review of the Salon in the nominal July issue (no. 7) indicates that the latter edition could not have been published before September, when the Salon took place. The photographic reproduction of the work appears in the enlarged final issue of *Atheneida* (no. 8, 9, 10), which was published without a date. For more on *Atheneida*, see Chapter 3.

context in which it was painted. For over a century, the Brazilian art world had been dominated by an establishment that placed a premium on hierarchy and imposed distinctions between fine art and other forms of artistic expression. *Bohemia* takes a stand in favour of the unity of art and artists – a consummately modern proposition around 1900. It shows painters and illustrators, sculptors and architects, writers and journalists, poets and musicians, all mingling together in companionship, bonded by music and drink and laughter. The painter's decision to depict himself among the illustrators is perhaps the most pointed expression of the equivalence made between fine and graphic arts. The mere admission of such a painting to the Salon was a shrewd challenge to the pecking order that ENBA was supposed to enforce. The fact that it was singled out for praise and approval by an ENBA jury suggests that perhaps the establishment was not so averse to becoming disestablished.

2.3 PERFORMING MODERNITY

Judging from the way they are depicted in Seelinger's *Bohemia*, standing discreetly in the background, an uninformed viewer would hardly guess that Raul and K. Lixto were more than just cartoonists, but rather celebrities in Rio de Janeiro.[44] Together, from January 1903 onwards, they were employed as art directors of the weekly *O Malho*, which grew to become one of the most influential magazines in twentieth-century Brazil, and their work also featured prominently in other periodicals like *Tagarela*, *Kósmos*, *Fon-Fon!* and *D. Quixote*. Between the 1900s and 1920s, they performed together in cabaret acts and comedic entertainments, to great acclaim, often in collaboration with writers and humourists like Bastos Tigre (D. Xiquote), Baptista Coelho (João Phoca) and Paulo Barreto (João do Rio).[45] Seemingly indefatigable, K. Lixto designed

[44] See Rogério Souza Silva, *Modernidade em desalinho: Costumes, cotidianos e linguagens na obra humorística de Raul Pederneiras (1898–1936)* (Jundiaí: Paco, 2017), esp. ch. 2; Giovanna Dealtry, "Margens da Belle Époque carioca pelo traço de K. Lixto Cordeiro", *Alceu*, 9 (2009), 117–130; Laura Nery, "Cenas da vida carioca: O Rio no traço de Raul Pederneiras", In: *História em cousas miúdas*, pp. 435–458 and Laura Nery, "Nostalgia e novidade: Estratégias do humor gráfico em Raul Pederneiras", In: Isabel Lustosa, ed., *Imprensa, humor e caricatura: A questão dos estereótipos culturais* (Belo Horizonte: Ed. UFMG, 2011), pp. 225–249.

[45] "Fête cabaretière", *Revista da Semana*, 30 September 1906, 3939; "Conferencia do Fon Fon", *Fon-Fon!*, 10 August 1907, n.p. "Exequias artisticas de Chrispim do Amaral", *Revista da Semana*, 27 January 1912, n.p.; "Humoristas em Petropolis", *Revista da Semana*, 9 March 1912, n.p.; "A festa do Boqueirão do Passeio", *Revista da Semana*,

sets and costumes for the stage; authored popular plays, like *Pierrots e Colombinas* (1911) and *Podre de Chic* (1915); and even starred in a comedy film titled *Amor e Bohemia* (1918), the cast of which included other real-life bohemians like Raul, Seelinger, João Luso, J. Carlos and illustrator Fernando Correia Dias. In 1906, K. Lixto decorated the headquarters of the carnival society Tenentes do Diabo and, in 1913, was charged with designing their carnival pageant, which increased his already considerable celebrity.[46] Raul was equally active in theatre and, in 1917, became one of the founding members and vice-president of the Brazilian Society of Theatrical Authors.[47]

K. Lixto and Raul were among the most recognizable figures in Rio during the first decade of the twentieth century. In an age when the culture of celebrity around film stars, musicians and athletes was in its infancy, they were as famous as could be, and their portraits featured regularly in the press. Seelinger, though less well known to the general public, achieved notoriety in his own way, as a sort of *peintre maudit*, and was celebrated within the group for the audacity of his exploits. All aged between 25 and 29 when *Bohemia* was painted, united by their professional activities and passion for nightlife, the three men came from distinct backgrounds. Raul (born 1874) was the best positioned in terms of social class. He was schooled at the respected Colégio Pedro II and completed a law degree at the age of 22. This formal education later allowed him to teach at ENBA, from 1918 to 1938, and at the law college of the University of Brazil after 1938. K. Lixto (born 1877) came from a working-class background, having trained at the National Mint and subsequently ENBA and worked as a lithographer at the National Press before achieving fame as an illustrator. Seelinger (born 1878) followed a

1 May 1912, n.p.; "O jornal falado", *Correio da Manhã*, 30 July 1914, 2; "Horas alegres", *Correio da Manhã*, 24 July 1915, 4; "A festa da canção regional, no Recreio", *Correio da Manhã*, 20 March 1917, 5; *Para Todos*, 19 December 1925, 23. On Bastos Tigre, see Balaban, *Estilo moderno*, esp. ch. 2 and Balaban, "Memória de um demônio aposentado", esp. pp. 379–392.

46 *Correio da Manhã*, 5 December 1906, 3; *Correio da Manhã*, 10 September 1911, 16; "Notas, impressões e novidades sobre o glorioso carnaval de 1913", *Correio da Manhã*, 6 February 1913, 2; *Correio da Manhã*, 25 September 1918, 10. Cf. Conde, *Consuming Visions*, 74–75.

47 Nery, "Cenas da vida carioca", 436 and Mônica Pimenta Velloso, *Modernismo no Rio de Janeiro: Turunas e Quixotes* (Rio de Janeiro: Fundação Getúlio Vargas, 1996), pp. 65–74.

more conventional route artistically, studying at both ENBA and in the private studio of Rodolpho and Henrique Bernardelli, before heading to Germany, where his family had roots, at the age of nineteen.[48]

All three were known to enjoy carnival. A cover illustration by K. Lixto for *O Malho*, in February 1904 (Fig. 19) – showing two costumed revellers locked in an ecstatic dancing embrace – has become enshrined as a timeless representation of carnival pleasure. Significantly, it is inscribed with a dedication to Lima Campos, the cigarette-smoking journalist from Seelinger's *Bohemia*. An earlier illustration by Raul, enigmatically titled *"La mort sans phrases"* and published in *Atheneida* in 1903, is also dedicated to Lima Campos, confirming their mutual proximity at the time. In the following issue of *O Malho*, a cartoon self-portrait (Fig. 20) depicts its author K. Lixto and partner Raul hunched over a drawing table, heads in hands, trying to hide from phantasms that hover all around them. The caption informs that they are fresh out of ideas, since all the good ones were used up by the Democráticos and the Fenianos for their carnival pageants. Earlier in 1903, Seelinger painted a work titled *Samba*, an intriguing choice of subject matter, given the limited use of that term before the 1910s; and his acclaimed one-man show of 1908 included a carnival frieze.[49]

During the early years of the twentieth century, Seelinger was certainly more renowned for his bohemian lifestyle than for his painting. His ability at dancing, especially the cakewalk, became the subject of repeated lampoons in the periodical press, including one drawn by K. Lixto in 1908 (Fig. 21).[50] Illustrating a 1906 article in *Kósmos* magazine about dancing in Rio de Janeiro, K. Lixto likewise caricatured Raul doing the cakewalk – a high-stepping figure complete with floppy hat

[48] Herman Lima, *História da caricatura no Brasil* (Rio de Janeiro: José Olympio, 1963), III, pp. 988–1048.

[49] A. Morales de los Rios, "Fiuza, Ribeiro e Seelinger", *Correio da Manhã*, 3 January 1903, 1–2; G. Deo, "Helios Seelinger", 3; and Gonzaga Duque, "Helios Seelinger", *Kósmos*, March 1908, n.p. The whereabouts of the painting *Samba* are presently unknown. On origins and usage of the term samba, see Lira Neto, *Uma história do samba*, pp. 51–53; Hertzman, *Making Samba*, ch. 4; Bissoli Siqueira, *Samba e identidade nacional*, pp. 17–33; and Sandroni, *Feitiço decente*, pp. 84–97.

[50] "Helios Seelinger", *Gazeta de Notícias*, 7 March 1904, 2; K. Lixto, "A linha na dança ou a dança na linha", *Fon-Fon!*, 5 December 1908, n.p. "Berliques e berlóques", *Revista da Semana*, 12 August 1916, n.p.; Má Lingua, "Vida Alheia", *Careta*, 30 April 1921, n.p. Cf. Carvalho, *Five o'Clock*, 64.

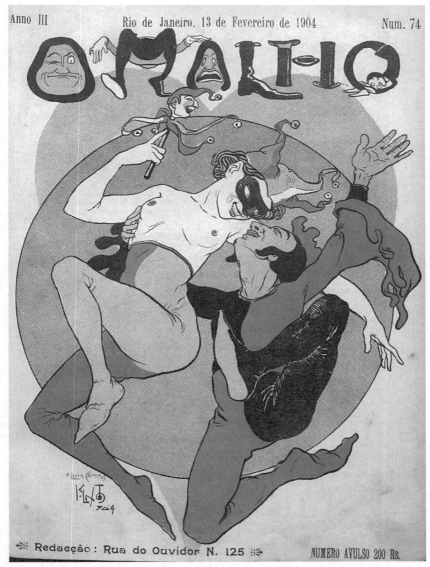

FIG. 19 K. Lixto [Calixto Cordeiro], *O Malho*, 13 February 1904
Fundação Biblioteca Nacional (BN Digital/Hemeroteca Digital Brasileira)

in hand. Raul returned the favour, further in the same article, caricaturing
K. Lixto as a high-collared, hip-thrusting dancer of samba – a foulard
wrapped multiple times around his neck, long fingernails, rings on both
little fingers, a skull-shaped trinket dangling from his watch chain

FIG. 20 K. Lixto [Calixto Cordeiro], *O Malho*, 20 February 1904
Fundação Biblioteca Nacional (BN Digital/Hemeroteca Digital Brasileira)

A "linha" na dança ou *A dança na linha*

Comecemos pelo gênero *smart*, chamado tambem salão e reservado á sociedade *up-to-date*, onde a *valsa* é a infallivel procurada fonte do *flirt*.

Depois, na ordem natural das.... danças, segue-se endiabrado, o vigoroso e elegante *cake-valk*, de uso exclusivo do *Café-Concerto* da *jeunesse dorée*, e uma das maiores paixões choreographicas do Luiz Edmundo e do Helias Seelinger.

Ainda no mesmo terreno (terreno é no sentido figurado, porque não ha ninguem que dança em.... terrenos) temos o afamado *pas-de-quatre*, excellente para a exhibição de mesuras e reverencias dos segundos secretarios de legação e moças casadeiras.

Finalmente, como bons patriotas, não podemos deixar de cahir no dengoso, no requebrado *maxixe*, que é o symbolo querido da dança nacional.

FIG. 21 K. Lixto [Calixto Cordeiro], *Fon-Fon!*, 5 December 1908
Fundação Biblioteca Nacional (BN Digital/Hemeroteca Digital Brasileira)

(Fig. 22).[51] Both artists' images were, by then, sufficiently well-known that readers would have recognized the caricatures, even though K. Lixto's face is hidden.

Big hats, high collars and long moustaches became something of a visual trademark for both Raul and K. Lixto. The latter, especially, was known to cultivate an outré appearance that advertised his skills as a dancer and master of *capoeira*.[52] K. Lixto's practice of drawing attention to himself through flamboyant fashion decisions deserves greater scrutiny.

[51] Fantasio, "A dansa no Rio de Janeiro", *Kósmos*, May 1906, n.p. See also Martha Abreu & Carolina Vianna Dantas, "Música popular e história, 1880–1920", In: *Música e história no longo século XIX*, 49. A 1908 cartoon by J. Carlos depicting K. Lixto and Raul as cut-out silhouettes, identified only by their high collars and big hats, is reproduced in Cássio Loredano, *O bonde e a linha: Um perfil de J. Carlos* (São Paulo: Capivara, 2002), p. 28.

[52] Dealtry, "Margens da Belle Époque carioca", 121. See also Balaban, *Estilo moderno*, 72; Ricardo Martins Porto Lussac, *Entre o crime e o esporte: A capoeira em impressos no Rio de Janeiro, 1890–1960* (unpublished doctoral dissertation, Programa de Pós-graduação em Educação, Universidade do Estado do Rio de Janeiro, 2016), pp. 301–306; and Cláudia de Oliveira, "A iconografia do moderno: A representação da vida urbana", In: Oliveira, Pimenta Velloso & Lins, *O moderno em revistas*, p. 188.

FIG. 22 K. Lixto [Calixto Cordeiro] & Raul [Pederneiras], *Kósmos*, May 1906
Fundação Biblioteca Nacional (BN Digital/Hemeroteca Digital Brasileira)

Though not always evident behind the accoutrements, he was the only
Afro-descendant member of the trio of illustrators.[53] This fact was subtly

[53] Though light-skinned, as evidenced in photographs, K. Lixto was perceived as a 'man of
colour' by the social standards of his time and place; see "O anniversario de Fon-Fon!",

inscribed in the humour of his double act with Raul due to the contrast between the two men in terms of class, complexion and height.[54] Their role as entertainers opened the doors of elegant salons and high society that might otherwise have remained closed to someone of his modest background.

K. Lixto's affirmation of a street-smart urban identity – mixing elements of high and low, black and white – demands to be understood as performative. In a society riddled with racial tensions and prejudices, it set him apart as artist and celebrity.[55] As far as the press was concerned, his eccentric self-presentation conveyed him from the status of mere illustrator, one who portrays and represents others, to that of someone worth depicting in his own right. Even these depictions often carry a performative dimension, made visible in his trademark signature. K. Lixto was by no means shy about caricaturing himself or his friends. The line dividing the illustrator from the performer was effectively indistinct. In fact, drawing caricatures in front of an audience was one of the performances for which the Raul and K. Lixto double act was most in demand.[56]

The multiple references to the cakewalk are evidence of how music and dance served as sites for defusing tensions and mediating between the private salons of the upper classes and life on the streets.[57] Lima Campos published an article drawing attention to the new dance craze in 1904.

Fon-Fon!, 19 April 1913, n.p. A newspaper column of 1925 posits him as authoring the statutes of a hypothetical "centre for the resistance of coloured men" and pits him against a racist senator Orozimbo – a recurring character in the column – who refuses even to address anyone of colour; see Luiz, "Para ler no bonde. Os inimigos de Cham", *Correio da Manhã*, 12 December 1925, 2. In 1901, Gonzaga Duque provided the following physical description of K. Lixto: "He was, around that time [1898], a youth of about twenty, sprouting the fine fuzz of a skimpy moustache, short in stature, smooth skin the colour of a light ochre watercolour and beautiful teeth of the translucent white of white pearls"; Gonzaga Duque, "Dos caricaturistas novos. III Calixto Cordeiro", *O Paiz*, 5 June 1901, 1.

[54] Pimenta Velloso, *Modernismo no Rio de Janeiro*, pp. 97–98.

[55] The creative use of apparel and trappings as a means of overcoming racial prejudice harks back to the experience of Dom Obá II d'África during the imperial period; see Eduardo da Silva, *Prince of the People: the Life and Times of a Brazilian Free Man of Colour* (London: Verso, 1993).

[56] See Maria Odette Monteiro Teixeira, "Raul Pederneiras entre Compadres e Bocós", *Anais ABRACE*, 18 (2017); see also de Oliveira, Velloso & Lins, *O moderno em revistas*, p. 88.

[57] See Pimenta Velloso, "A invenção de um corpo brasileiro", 263–285. A cartoon lampooning residents of a working-class district opposes the cake walk (mispronounced as *carque varque*) to the 'national dance' maxixe; "Na Gambôa", *Tagarela*, 1 September 1904, n.p.

It begins with a strikingly visual statement, a nod to his illustrator friends: "The cakewalk is a bustling caricature of Dance, such as would be traced in living lines by a choreographic [Paul] Gavarni, [André] Gill or [Jean-Louis] Forain, mixing the morbid twists of the African *jongo* with the quick steps of the Scottish solo, the voluptuous turns of the Aragonese *jota* and the disarray of the cancan."[58] The author goes on to argue that the cakewalk originated in the plantations of the American South as a recreation among enslaved workers and was appropriated by white Americans who exported it to the world. His description of how its rhythms take hold of a ballroom is worth citing at length, for its over-blown lyricism and ethnological flavour:

From the first sudden bursts of the orchestra, a strong and swaying [*sambante*] shiver of voluptuousness, of thrilling sensation, moves through the medulla of the audience, spurs the volition, hisses through the senses and does a fandango through one's desires. [. . .] Bodies move in place, as if dancing too; some among the assembled nervously tap their canes; and sometimes cries arise from the scattered spectators, like the simian shrieks of fauns who might have invaded the room, racing with the sharp clicks of their goats' hooves along the red morocco leather of the banisters, frolicking and swinging through the air, hanging by one arm from the metal arabesques of the ornaments, like lustful chimpanzees, peering from above into the triangular necklines of women, sucking up into their dilated nostrils the full exhalation, tepid and aphrodisiac, rising from the swell of breasts, wafting up from bosoms . . .[59]

Inverting the usual North Atlantic perspective that attributed animalesque and highly sexualized qualities to Latin Americans, the author contrives an experience of sensual delirium – complete with monkeys, erotic smells and heaving breasts – from a dance style imported from the USA. Lest his readers confuse the issue and conclude that the exhilaration of the cake-walk was purely a product of its purported African origins, Lima Campos makes clear that its magic lies in the mixture of primitive and civilized:

And to the sound of that music, at once savage and cancan-like [*cancanista*], through which pass, at times, shadows of African lands and, at others, sparkles the spangled and tart mischief of the *chansonettes*, the room roars and applauds, raves and cheers, feet stomp, mouths cry out, desires well up! . . . It's the cakewalk! It's the cakewalk![60]

This vision of the dance floor as a territory capable of breaking down inhibitions and promoting mixture through raw sexuality was to prove decisive to the artistic modernity arising in Rio de Janeiro over the 1910s.

[58] Lima Campos, "Cake-walk", *Kósmos*, August 1904, n.p. [59] Ibid. [60] Ibid.

João do Rio's 1910 short story, "*O bebê de tarlatana rosa*" (The baby in pink tarlatan) has rightly gained notoriety for its daring narrative structure and sexual ambiguity. It tells the tale of a romantic encounter at a masked carnival ball between the protagonist and a character dressed as a baby whose gender identity is purposefully left unclear through strategic shifts between masculine and feminine articles and pronouns.[61] The story is sometimes taken as an anomaly, a one-off product of the author's propensity for literary extravagance as well as his own homosexuality. Yet, other contemporary sources bear out that masked carnival balls were cherished precisely for a blurring of identities that facilitated unconventional and even illicit encounters. The question "*você me conhece?*" (do you know me?), posed by masked revellers to one another, often in a falsetto voice, became a narrative convention for recounting same-sex liaisons in barely disguised terms.[62] In one journalistic account of 1921, the male narrator falls asleep in a theatre box during a ball and awakens to find "a Pierrot in black satin" bent over him, caressing his hand and staring into his eyes:

Through the small mask that covered half the face, I could see he was young and beautiful. For five minutes, he stood in the same position. The ether on his hot breath scorched my face. His mouth, however, was fresh and healthy.[63]

A few lines later, the Pierrot – a popular carnival costume at the time and invariably a male figure in the Commedia dell'Arte – effortlessly metamorphoses into a woman, though the author continues to shift back and forth between 'she' and 'he', as in João do Rio's story, and to keep the use of pronouns as ambiguous as possible.[64] Behind the masks, literal and literary, the identity of the other person could be obscured, not least of which in terms of gender, class and race.

[61] Rodrigues, *João do Rio*, 82–88. See also Anna Carolyna Ribeiro Cardoso, "A ambiguidade e o fantástico em O bebê de tarlatana rosa", *Caletroscópio*, 5, 9 (2017), pp. 114–127.

[62] João da Avenida, "Um sorriso para todas...", *Careta*, 5 February 1921, n.p. See also "O carnaval nos clubs. Você me conhece?", *Fon-Fon!*, 1 February 1913, n.p; Garcia Margiocco, "Pamphletos... uma aventura reveladora", *Careta*, 12 February 1921, n.p. Cf. Pereira Cunha, *Ecos da folia.*, 26–40 and Soihet, *A subversão pelo riso*, p. 154.

[63] João, "Um sorriso para todas... O Pierrot dos olhos cinzentos", *Careta*, 5 February 1921, n.p.

[64] This is easily done in Latin languages, in which the gender of the possessive pronoun is determined by the object, rather than the subject. For instance, in the quotation above, "o seu hálito" could be variously translated as *his* or *her* breath; likewise, "a sua boca" as *his* or *her* mouth.

Significantly, in many such references over the 1920s, the masked ball where such encounters take place is the *Baile dos Artistas,* or Artists' Ball. The first such ball was held in Rio de Janeiro in 1917, modelled on the Parisian *Bal des Quat'z'Arts,* and organized by a group of young artists.[65] Like most outlets for celebrating carnival, it started out small and inconspicuous but grew to outsize proportions as word of mouth spread. The second ball, held at the Teatro Fênix in 1918, marks the occasion when it started to garner photographic coverage in the press, which became abundant over the course of the 1920s in magazines like *Fon-Fon!* and *Careta.* A page from *Revista da Semana* (Fig. 23) shows two group photographs of the event, the bottom one flanked by enlarged figures of Seelinger dressed as a Roman wrestler, on the left, and K. Lixto as a pharaoh, on the right. The two artists were mainstays in the festivities, and Seelinger was instrumental in providing information about similar festivities in Europe.[66] Their interest in carnival, as has been seen, antedated the Artists' Ball. An article of 1916, in the popular *Revista da Semana,* singles out Seelinger as a proud exception to the presumed rule that fine artists disliked carnival. K. Lixto's involvement with carnival ran even deeper, culminating in his role as scenographer for the society Tenentes do Diabo in 1913–1915.[67] The fact that Seelinger and K. Lixto appear prominently in this photograph of the Artists' Ball of 1918 may seem circumstantial, but it is a token of an entrenched relationship between the bohemian milieu of artists/illustrators and the wider conviviality of the carnivalesque.

[65] "Bilhetes brancos", *Fon-Fon!,* 10 February 1917, n.p. See also "O baile dos 'quatz'arts'", *Revista da Semana,* 9 February 1918, n.p.; "Vultos que passam. (O baile dos artistas)", *Careta,* 3 January 1920, n.p.; "O baile dos artistas", *Careta,* 29 January 1921, n.p.; and Dégas, "O baile dos artistas", *Careta,* 25 February 1922, n.p.

[66] Seelinger took part in both the *Bal des Quat'z'Arts* in Paris and the *Lumpen Fest* in Munich, as documented in the scrapbook preserved by his granddaughter (see note 39). On these experiences, see Valle, "Sociabilidade, boêmia e carnaval em ateliês de artistas brasileiros", pp. 52–55. Over many decades of existence, the *Baile dos Artistas* mutated into different shapes and forms, becoming noticeably more conventional after 1930, by which time it was organized by other groups, not necessarily of artists, though it retained the name.

[67] "A semana elegante. Carnaval!", *Revista da Semana,* 4 March 1916, n.p. See also "Notas, impressões e novidades sobre o glorioso carnaval de 1913", *Correio da Manhã,* 6 February 1913, 2; "Ultimas do carnaval", *Correio da Manhã,* 25 February 1914, 2. See also Carlos Frederico da Silva Reis, *Os Tenentes do Diabo: Carnaval, lazer e identidades entre os setores médios urbanos do Rio de Janeiro (1889–1932)* (unpublished master's thesis, Programa de Pós-graduação em História Social da Cultura, Pontifícia Universidade Católica do Rio de Janeiro, 2012), pp. 114–116.

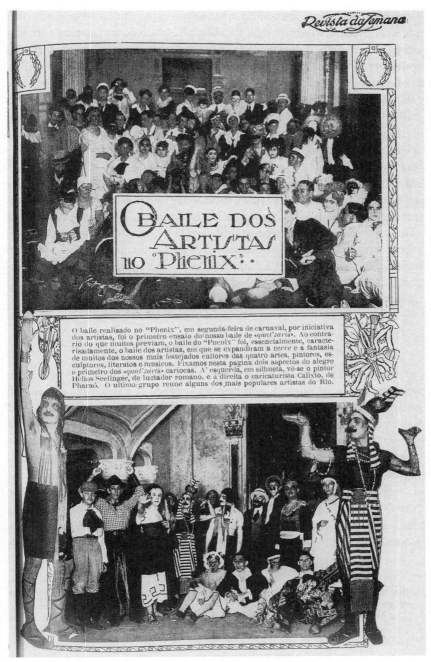

FIG. 23 Unidentified author, *Revista da Semana*, 23 February 1918
Fundação Biblioteca Nacional (BN Digital/Hemeroteca Digital Brasileira)

In February 1913, *Revista da Semana* ran a page titled "The Caricaturists", featuring an illustration by Bambino that shows a fat grinning man in a clown suit, reminiscent of the Pulcinella character, the word *carnival* emblazoned across his collar. Behind him is a masked woman in a low-cut bodice, choker, long gloves, striped breeches and a pointed hat. Further back are other figures, loosely sketched, and a cityscape including a man with a megaphone. Just the sort of illustration magazines would run to salute the start of carnival festivities. Its peculiarity lies in the fact that the page is specifically dedicated to caricaturists. A humorous poem cites several illustrators by name – including K. Lixto, Raul and J. Carlos – indicating what costumes they will wear for carnival. A strangely androgynous figure peeks up from an insert at the bottom, reinforcing the idea of masquerade and interchanged identities that the stanzas of the poem playfully posit.[68] This association between caricaturists and carnival – by no means self-evident – would have made perfect sense to contemporary audiences. More than just an inside joke among illustrators and their editors, it reflects a distinctive sociability that Monica Pimenta Velloso has identified as characteristic of ideas of modernity and modernism taking shape in Rio de Janeiro at the time.[69]

2.4 ART FOR CARNIVAL'S SAKE

Neither K. Lixto's demeanour nor his eccentric fashion sense precluded him from the milieu of fine art, and he even deigned to exhibit the occasional painting at the ENBA Salon, as in 1916.[70] The fact that he, Raul and Seelinger crossed seamlessly back and forth between the bohemian world of comedy, theatre, dance and the salons of fine art casts doubt upon the presumption that elite and popular culture were distinct and did not mingle. Just as in Europe or North America, such boundaries were being tested in the changing urban dynamics of Rio de Janeiro in the 1900s and 1910s. The "cross-class sociality" that Micol Seigel attributes to Rio's leisure spaces was also present in the artistic bohemianism with which it intersected, especially around the passion for carnival that united Cariocas of very different

[68] "Os caricaturistas", *Revista da Semana*, 1 February 1913, n.p. The second stanza states that in the court of His Majesty the Pencil, grand-duke K. Lixto will this year dress up as prince Raul. The third stanza suggests that the thin J. Carlos will use a borrowed body to pass himself off as Julião Machado, an older and more heavy-set illustrator. The fourth stanza affirms that Luiz Vianna will celebrate carnival disguised as himself.

[69] Pimenta Velloso, *Modernismo no Rio de Janeiro*, ch. 2.

[70] "Na Escola de Bellas Artes. O vernissage da exposição geral", *Correio da Manhã*, 13 August 1916, 5.

backgrounds.[71] It was hardly unusual for artists to engage with the festivities; and even established and relatively conventional names – like Rodolpho Amoedo, deputy director of ENBA – were known to design banners and pennants for carnival societies.[72] K. Lixto's involvement with carnival was, nonetheless, precocious and particularly intense. An illustrated elegy (Fig. 24) published in *Fon-Fon!* in 1910 – with drawing by Raul (under the pseudonym O.I.S.) and verse by K. Lixto – is one of the earliest printed tributes to samba as a phenomenon of black urban culture, providing a glimpse of the style at its inception and preserving some of its vivid period jargon, of which K. Lixto evidently was a master.[73]

K. Lixto was not the only artist to work as scenographer for a carnival society. His debut in that capacity, on behalf of theTenentes do Diabo, rounded out a trio of pageant directors who came to personify the three Great Societies and brought the rivalry between them to a head in the press between circa 1913 and 1919. The longest-serving was Publio Marroig, employed by the Democráticos over many years and, paradoxically, about whom the least is known.[74] The most successful during the

[71] Seigel, *Uneven Encounters*, 98. See also Antônio Herculano Lopes, "Vem cá, mulata!", *Tempo*, 13 (2009), 80–100.

[72] A selection of banners is reproduced as photos in: "Rio de Janeiro – estandartes das sociedades carnavalescas", *Revista da Semana*, 18 March 1906, 3283; and "Estandartes de sociedades carnavalescas", *Revista da Semana*, 25 March 1906, 3307.

[73] "Samba", *Fon-Fon!*, 10 December 1910, n.p. The poem is untranslatable, especially as many of the words are used in a colloquial or slang sense, no longer current. Roughly, it reads: "Casting aside the yoke of honest labour / Chico Bastião, after the yada–yada / Of style, plunges into the samba and makes his speech of greeting while knotting his thong. / The *batuque* is boiling hot inside, and next to the joint a *crioula*, joyous and coquettish, wiggles / her rigid hips. Next enters a stumbler / wobbling and teetering rolls up his sleeve / and next to the *crioula* prances and saunters / a grand strident dance step of *conga* / while in back some are sampling a taste of *pinga*. / Then comes a mulatto and sings in coarsest lewdness / Belting out the voice in his breast, he juts his thick lip / and drools and cries and laughs and spits and dances and snorts."

[74] Remarkably little has been published on these forerunners to the current profession of *carnavalesco* – the artistic directors who conceive, plan and direct the annual pageants of the *escolas de samba*. On carnavalescos, see Nilton Silva dos Santos, *"Carnaval é isso aí. A gente faz para ser destruído!": Carnavalesco, individualidade e mediação cultural* (unpublished doctoral dissertation, Universidade Federal do Rio de Janeiro, Programa de Pós-Graduação em Sociologia e Antropologia, 2006); Renata de Sá Gonçalves, *Os ranchos pedem passagem: O carnaval no Rio de Janeiro do começo do século XX* (unpublished master's thesis, Universidade Federal do Rio de Janeiro, Programa de Pós-Graduação em Sociologia e Antropologia, 2003); and Helenise Monteiro Guimarães, *Carnavalesco, o profissional que "faz escola" no carnaval carioca* (unpublished master's thesis, Universidade Federal do Rio de Janeiro, Programa de Pós-Graduação em Artes Visuais, 1992).

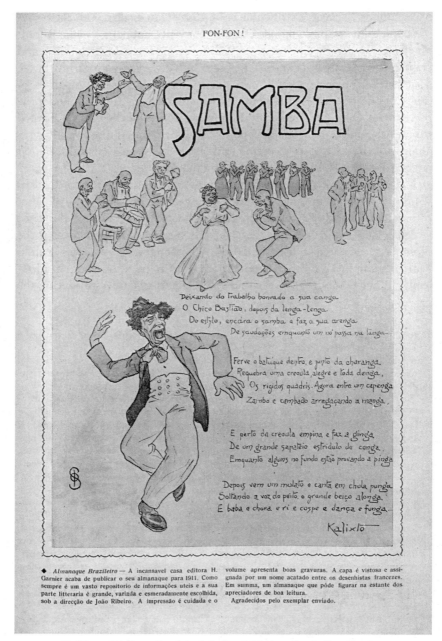

FIG. 24 K. Lixto [Calixto Cordeiro] & Raul [Pederneiras], *Fon-Fon!*, 10 December 1910
Fundação Biblioteca Nacional (BN Digital/Hemeroteca Digital Brasileira)

1910s was Fiuza Guimarães – the artist almost unseen on the right-hand side of Seelinger's *Bohemia* – who led the Fenianos to repeated triumphs from at least 1908 until his retirement in 1921, when he was succeeded by André Vento, a disciple and painter who decorated the club's facilities in 1920.[75] K. Lixto's tenure at the Tenentes do Diabo was shorter-lived, as were the careers of other noted carnival scenographers like Alexandre de Concilis, Jayme Silva and Angelo Lazary.[76] Before discussing the role played by these artists, a brief word is in order regarding the relevance of the pageants they directed.

The historiography of Rio's carnival has long been premised on the notion that the heyday of the Great Societies, between the 1850s and 1920s, represents an attempt by elites to tame the anarchical nature of the older *entrudo* festivities and impose an artificial veneer of European 'civilization' upon them. According to this view – put forward by pioneering carnival historian Eneida de Moraes in the 1950s – the advent of the *escolas de samba*, after 1928, marked a return to the authentic Afro-Brazilian roots of carnival. Several foundational histories of carnival establish a teleology that progresses from the "infancy" of *entrudo* to the "maturity" of the *escolas de samba*, after overcoming "the conceited and snobbish adolescence of Venetian corteges of the Frenchified oligarchs".[77] Though still widely repeated, the claim that the Great Societies were restricted to elite membership is unsubstantiated. During the 1910s, they appear to have enjoyed immense popularity, at least if their

[75] "Pelos clubs", *Gazeta de Notícias*, 9 December 1920, 4; "O que ouvimos hontem nos Democraticos, nos Fenianos e nos Tenentes", *Gazeta de Notícias*, 17 January 1921, 3.

[76] "Carnaval", *Gazeta de Notícias*, 31 January 1908, 4; "Carnaval de 1908. O dia de hontem", *Gazeta de Notícias*, 3 March 1908, 1; *Revista da Semana*, 7 March 1909, 1368; "Os que fazem os prestitos carnavalescos deste anno", *Revista da Semana*, 17 February 1912, n.p.; "Os prodromos do carnaval", *Fon-Fon!*, 25 January 1913, n. p.; "Carnaval. Fallam os tres scenographos K. Lixto, Fiuza e Marroig", *Fon-Fon!*, 1 February 1913, n.p.; "Carnaval", *Correio da Manhã*, 19 March 1916, 5– "Columna de Momo", *Correio da Manhã*, 24 January 1917, 4; "O carnaval de 1917. O que foram os tres grandes prestitos de hontem", *Correio da Manhã*, 21 February 1917, 1; "O carnaval levado a serio", *A Noite*, 17 February 1919 [page "Ultima Hora"]; "O carnaval de 1919. Fenianos", *Fon-Fon!*, 1 March 1919, n.p.; "Carnaval", *A Noite*, 18 January 1921, 3; "Carnaval", *Correio da Manhã*, 8 February 1921, 1.

[77] Pereira Cunha, *Ecos da folia*, 15. Cf. Cristiana Schettini Pereira, "Os senhores da alegria: A presença das mulheres nas grandes sociedades carnavalescas cariocas em fins do século XIX", In: Pereira Cunha, *Carnavais e outras f(r)estas*, pp. 311–339; Hertzman, *Making Samba*, p. 56– Lira Neto, *Uma história do samba*, esp. pp. 33, 46, 56; and Soihet, *A subversão pelo riso*, ch. 3.

ubiquitous presence in the press is to be believed.[78] As Felipe Ferreira has argued convincingly, the partial interpretation that discounts them derives from disputes between groups vying for control of carnival and its definition. Between the 1930s and 1950s, a mythical past was invented by the agents and authors who redefined modern carnival, through which they sought strategically to discredit their predecessors as a means of legitimating their own ascendancy. There were, Ferreira posits, "many carnivals" coexisting simultaneously; and "the practicable encounter" between elite and popular forms over the late nineteenth and early twentieth centuries, with all its inherent tensions, must be understood as a complex, multi-layered and multidirectional process.[79]

Following unusually lukewarm proceedings in 1912, carnival festivities of 1913 were a resounding success.[80] With no central planning and no clearly defined hierarchy of events, the magnitude of celebrations varied starkly from year to year and could be affected by political events, economic constraints or even weather. Typically, festivities included balls and corteges promoted by the many hundreds of carnival societies, of all shapes and sizes, existing throughout the city. The high point was the pageants (*préstitos*) staged by each of the three Great Societies, following different routes through the streets of the city on the same day, most often Shrove Tuesday. These pageants were elaborate processions of costumed revellers, musical and dancing groups, organized into subordinate sections (e.g. the lead delegation, or *comissão de frente*) and distributed around an assortment of floats, usually between half a dozen and a dozen. Each float had a theme, either allegorical or critical, and was embellished with sculptures and decorations. One was designated the leading float

[78] Pereira Cunha's *Ecos da folia* contains the most in-depth study of the subject, but its discussion is heavily weighted towards the nineteenth century and does not account for transformations undergone after 1900, which appear to have been considerable. References to Democráticos and Fenianos recur constantly in Vagalume's 1904 column on Rio's nightlife; see Vagalume, *Ecos noturnos*. Their popularity circa 1900 is confirmed by other press sources; see, for instance, J. Reporter, "Carnavalescos", *O Paiz*, 14 February 1904, 2. On the perception of their decline, see Mario Pederneiras, "Tradições", *Kósmos*, February 1907, n.p. See also Silva Reis, *Os Tenentes do Diabo*, pp. 101–108.

[79] Ferreira, *Inventando carnavais*, pp. 16–19, 156–161, 170–173.

[80] Following the death of Barão do Rio Branco, Brazil's leading statesman of the time, the 1912 carnival was overshadowed by debates about whether or not it should be staged at all and even attempts to prohibit the festivities; see Hertzman, *Making Samba*, pp. 53–54. See also "O carnaval vai correr frio", *A Noite*, 3 February 1912, 2; and "As festas da Paschoa promettem tomar extraordinario brilhantismo", *Correio da Manhã*, 14 February 1913, 5. The success of the 1913 edition continued to echo fifty years later: Sousa Rocha, "O carnaval da Carabu", *Correio da Manhã*, 24 February 1963, "3° Caderno", 1.

(*carro-chefe*) and represented the crowning achievement of the society's pageant.[81]

The job of the scenographer was to conceive and design the floats, as well as supervising their execution by a team of sculptors, decorators and costume-makers.[82] Among the prominent sculptors who worked for carnival societies were José Octavio Correia Lima, Modestino Kanto, Paulo Mazzuchelli and Armando Magalhães Corrêa.[83] Competition among the societies was fierce, and each jealously guarded its themes, concepts and designs from the others. Scenographers and their associated sculptors and decorators usually worked for one society exclusively, though there were instances of switching from one to another or, more rarely, of working for two societies (one larger and one smaller, or one in Rio and another in São Paulo) at once. The importance of the scenographers can be gauged by the prominence with which their names were highlighted in press coverage as well as in the advertisements each society would take out in newspapers laying claim to victory in that year's carnival and announcing a victory ball.[84] As the best known among the carnival scenographers, Fiuza was regularly singled out for breathless praise. An account of the 1910 carnival, on the front page of the leading daily *Correio da Manhã*, sets a scene that would be remarkable even by the standards of today, when *carnavalescos* have become media celebrities: "The people, assembled along the Avenue, open ranks, become agitated, awed by the majesty of the Fenianos pageant, and in a frenzy of enthusiasm, applaud the good art of Fiuza Guimarães."[85]

In the 1 February 1913 issue, *Fon-Fon!* published a three-page reportage on the activities of that year's scenographers of the Great Societies – K. Lixto, Fiuza and Marroig – featuring photographic portraits and interviews (Fig. 25). K. Lixto is given the most prominence, and the article was presumably motivated by his ties to the magazine, invoked as an excuse for interviewing him first. Some of the discursive tropes

[81] Many aspects of this pageant organization were subsequently appropriated by the *escolas de samba*.

[82] For photographic depictions, see, among many others, "Carnaval", *Revista da Semana*, 7 March 1909, 1369–1378; and "O carnaval no Rio", *Revista da Semana*, 28 March 1914, n.p.

[83] "O carnaval levado a serio", *A Noite*, 1919; Terra de Senna, "Bellas-artes", *D. Quixote*, 18 February 1920, n.p.

[84] See, for example, *Correio da Manhã*, 8 February 1913, 6; and *Correio da Manhã*, 22 March 1916, 7. See also "Carnaval. Fallam os tres scenographos K. Lixto, Fiuza e Marroig", *Fon-Fon!*, n.p.

[85] "Os prestitos de hontem", *Correio da Manhã*, 9 February 1910, 1–2.

Carnaval

FALLAM OS TREZ SCENOGRAPHOS CALIXTO, FIUZA E MARROIG

Fon-Fon que se preza em ser muito autorizado em questões carnavalescas e que, modestia á parte, tambem concorre annualmente com o seu prestito para a alegria sem peias dos tres dias de Momo, não podia deixar escapar mais esta opportunidade de salientar o verdadeiro valor do nosso carnaval, que os senhores todos estão fartos de saber — é o mais appreciavel exponente da nossa civilisação latino americana. . .

E como, principalmente, o enthusiasmo carnavalesco dependa da riqueza e da felicidade de concepção dos prestitos que os *Democraticos, Fenianos* e *Tenentes do Diabo* fazem sahir na terçafeira gorda, *Fon-Fon* pôz de banda o

CALIXTO

seu programma blaguista e foi ouvir a sério os tres scenographos, responsaveis pelo successo dos tres clubs que se disputam as glorias carnavalescas — Calixto *(Tenentes do Diabo)*, Fiuza *(Fenianos)* e Marroig *(Democraticos)*.

Attendendo aos laços que o ligam mais de perto a Calixto, *Fon-Fon* que havia muito tempo não exercitava a sua actividade entrevistadora, resolveu ouvil-o em primeiro lugar, fazendo assim mais á vontade o seu *entrenaiment* de reporter curioso e perspicaz... em disponibilidade.

Devidamente uniformisado *Fon-Fon* saltou da sua *barata* (120 H. P.) e dirigindo-se ao porteiro do *barracão*, entregou-lhe o seu cartão, pedindo que o levasse ao Calixto.

Abraços, cumprimentos, conversa fiada e nada do intimo amigo de *Fon-Fon* convidal-o a entrar.

Fon-Fon percebeu desde logo a manobra, mas fez-se de desentendido.

— Então, como vamos de prestito?

— Muito mal... Falta de tempo e tudo por fazer. Nem idéas a gente tem ! Um horror, meu caro !

Fon-Fon mais uma vez comprehendeu a sua situação de *raseur*, mas não desistiu. *Fon-Fon* nunca desiste...

— Deves estar atrapalhado...

— Muito.

— Pois não serei eu que te hei de roubar o tempo. O que tenho para te dizer não tem importancia, extremos e assim conversaremos sem prejuizo do teu trabalho.

— Ah ! ah ! ah ! ah !...

O Calixto não acabava mais de rir, parecia uma mocinha em primeira phase de *chilique*, ria... *p'ra burro*.

— Mas então queres entrar, hein ?... Ah ! ah ah !.,. Impossivel !

— Neste caso, peior p'ra ti... Pede dous banquinhos como aquelle do porteiro e vamos conversar um pouco, aqui mesmo á chuva...

* * *

Não è a primeira vez que Calixto toma o encargo de organizar um prestito carnavalesco. Annos atraz um grupo de rapazes fundou o club dos *Paladinos do Cattete* e um anno depois resolvia «botar o seu prestito na rua». Não havia muito dinheiro, mas fez-se o que se poude. A chuva porém estragou tudo e quando passàmos de volta, na Gloria, restavam apenas as ossadas dos carros. Nunca mais tratei disso. Este anno os Tenentes confiaram a mim o seu prestito e o resto já sabes... falta de tempo, tudo um horror !

— Ora o tempo ! Lá diz o inglez, é verdade, que *time is money*, mas e a reciproca — *money is time* — não é igualmente verdadeira ?

— Talvez, mas é que tambem esse...

— Tambem ha falta de dinheiro ?

— Nem tanto... Ouve lá : os clubs, em geral, não teem dinheiro sufficiente para as despezas do carnaval e sempre o conseguem do commercio, por meio de subscripção. Ora dá-se o caso que este anno o carnaval cahe logo nos primeiros dias de Fevereiro, o que quer dizer, não deu tempo dos clubs angariarem dinheiro, porque, como sabes, o commercio ainda está atrapalhado com os balanços e liquidações. Esse dinheiro devia estar em caixa pelo menos no dia 1 de Janeiro, isto é, um mez antes do carnaval e entretanto... Basta te dizer que por esse tempo o club que maior deposito tinha, não ia além dos... *oito contos de reis.*

— Só ?

— Apenasmente, meu caro *Fon-Fon.*

Vês tu portanto a lucta que ha para a gente conseguir alguma cousa assim, sem dinheiro e sem tempo...

— E o Governo, não ajuda ?

— O Governo... Espera... (Calixto pensou

FIUZA

uns cinco minutos e depois disse): O Governo ajuda assim : manda a Prefeitura dar *cinco contos*, a Policia *cinco* e a Estrada de Ferro outros *cinco*. Uma miseria como vês. Mas não é tudo : esse mesmo Governo que dá esse auxilio é o primeiro a tolher a acção dos clubs.

FIG. 25 Unidentified author, *Fon-Fon!*, 13 February 1913
Fundação Biblioteca Nacional (BN Digital/Hemeroteca Digital Brasileira)

emphasized are quintessential of carnival pageants and crop up in inter-
views with *carnavalescos* even today: rushing against the clock to get
everything ready in time; insistence on secrecy of preparations, even to the
point of not allowing visitors into the depot (*barracão*) where the floats
are being built; complaints about lack of funds and financial support; the
impression that Rio's carnival is not sufficiently appreciated by local
authorities even though its cultural value is widely recognized abroad.
Fiuza and Marroig are both adamant about the latter point, and Fiuza
tells the reporter: "I have seen the carnival in Munich, Nice and Brussels.
You may write that ours is superior to any of them."[86]

Other discourses are less predictable. Upon being asked whether the
pageant he was designing would be artistic, K. Lixto was surprisingly
disparaging about the relationship between carnival and art. He made
sarcastic reference to the vogue for historical and archaeological subjects
(e.g. Egyptian temples and Chinese pagodas); decried the tawdriness of
popular taste that thrilled to flashy ornaments and cheap special effects;
and bemoaned the fact that a Japanese-themed float was *de rigueur* for
any pageant. Carnival and archaeology were both worthy of appreci-
ation, he pondered, but should be kept separate: "For me, carnival should
be altogether different, that is to say, I believe carnival should be a pagan
festival, disjointed, made up of much laughter and much joy."[87] His
scepticism as to the relationship between art and carnival was premised
not on a rejection of the carnivalesque, but rather on a perception that the
public expected banal representations of timeworn themes and would
therefore not allow scenographers the freedom to innovate as much as
they might have liked. K. Lixto's disdainful comments do not imply he
considered carnival as inferior to art but, rather, suggest an insolent
impatience with mainstream attitudes, characteristic of bohemian sens-
ibilities. They were, after all, uttered by someone who was both a
carnavalesco and an artist.

K. Lixto's repudiation of the relationship between carnival and art can
be readily misinterpreted as an elitist and conservative position.[88] Yet, it
was not a criticism emanating from outside the carnival system – from a
defender of high art, for instance – but rather from within, by one of its

[86] Ibid. The claim would not have rung hollow. Fiuza was widely known for having studied
in Munich. See "Notas sobre arte. Exposição de Bellas Artes", *Jornal do Commercio*,
12 September 1901, 3; and "José Fiuza", *Gazeta de Notícias*, 14 December 1902, 2.

[87] "Carnaval. Fallam os tres scenographos K. Lixto, Fiuza e Marroig", *Fon-Fon!*, n.p.

[88] Pereira Cunha, *Ecos da folia*, 115.

rising stars. As a newcomer to the role of carnival scenographer, the veiled target of his criticisms was his veteran competitors and their pandering to conventional taste. As if to underscore the difference, the reporter made a point of asking Marroig whether he intended to include a Japanese-themed float in the Democráticos pageant, to which the elder scenographer replied: "I don't know yet. But why are you smiling like that? Japanese exoticism is perfectly worthy of admiration. It would be wonderful if we could organize an entire pageant in Japanese style!"[89] *Fon-Fon!*'s savvy and up-to-date readers would recognize the goading nature of the question. They would certainly be aware, too, of K. Lixto's position as celebrity and bohemian, of his working-class and Afro-descendant background, of the fact that he was pointedly not a member of the establishment. If anyone possessed the credibility to criticize carnival without sounding elitist, it would be K. Lixto.

Fiuza's sustained involvement with carnival derives its authority from the opposite pole: that of institutional insider. As an academically trained painter, winner of the Salon's travel prize in 1896, known for "having frequented the classes and museums of Europe", he became a regular exhibitor at ENBA and even an occasional member of the Salon jury.[90] With such artistic credentials, the fact that he dedicated much of his career to carnival is worthy of note, reinforcing the contention that fine art circles were more permeable to popular culture than has previously been granted. On the other hand, his relationship to ENBA over the years was not always smooth, raising the possibility that his reputation as a carnival scenographer may have been perceived negatively by more conservative segments of the art world.[91] Without a doubt, his role in Fenianos was highly prized by the society's members, as evidenced by the eminence attributed to his name in their advertisements and publications. He was already a member of their carnival commission in 1905 and was

[89] "Carnaval. Fallam os tres scenographos K. Lixto, Fiuza e Marroig", *Fon-Fon!*, n.p.

[90] Morales de los Rios, "Fiuza, Ribeiro e Seelinger", 2. Fiuza was a member of the Salon jury at least three times – in 1903, 1907 and 1911 – always filling one of the two slots elected by the exhibiting artists. Revealingly, he was on the jury that awarded the travel prize to Seelinger.

[91] In 1916, both Fiuza and Belmiro de Almeida, a painter long active as a caricaturist, were disqualified from competing for the post of professor of painting at ENBA; see "Escola Nacional de Bellas-Artes", *Correio da Manhã*, 10 June 1916, 2. The motives for this development remain unclear. The jury composed of Lucilio de Albuquerque, Modesto Brocos and José Octavio Correia Lima would not have been particularly hostile to carnival or bohemianism. In 1916, Fiuza took up a position teaching drawing at the Escola Normal, or teacher training school, which he held for many years.

promoted, by 1914 at latest, to the society's directorate.[92] His popularity as a *carnavalesco* vastly outstripped anything he might have achieved as a painter. Even the most successful fine artists of the day featured nowhere nearly as often or as prominently in the press, much less could claim to be beloved by the urban masses.

Coming from opposite sides of the art world, K. Lixto and Fiuza met at the intersection that was carnival. For them, as well as for Seelinger, Raul and other artists referenced in this chapter, the bohemian culture of theatre, dance, cafés and carnival was a way around the rigid social distinctions that segregated Carioca life by class and race, gender and sexuality, kinship and territory. Crossroads and meeting ground, carnival provided an alternate reality, breaking down hierarchies and divisions, and skewing the directionality of everyday relations. Within the parallel universe of a carnival society, a manual labourer could hold the rank of treasurer and a petty clerk that of president. A respectable family man could achieve renown as a dancer or musician. An undistinguished painter could be hailed an artistic genius. Unlike older forms in which the festivities lasted only a day or a few days, carnival societies in early twentieth-century Rio grew increasingly into a year-round phenomenon. By the 1910s, their culture had become so rich and varied that its sway over the daytime world of family and business undermined the established order and, at times, threatened to invert it.[93]

By the 1920s, the cult around carnival scenographers became something of a media convention. A front-page article in the evening newspaper *A Noite*, in 1921, hails them as "heroes of a magic world":

The soul that animates the pageants is born of the breath of the scenographers. The multitude that follows the onward march of each one with deafening applause, opening enchanted eyes to gaze upon those figures from a magical world, often ignores what hands worked the miracle of that spectacle, and remains oblivious to the fact that there, in the margins of the parade, diluted in the mass of people, swept by the triumphal wave are its greatest heroes.[94]

[92] [Fenianos advertisement], *Gazeta de Notícias*, 18 March 1905, 5 and [Fenianos advertisement], *Correio da Manhã*, 17 January 1913, 6. For a photograph of the directors of Fenianos, including Fiuza, see *O Malho*, 7 March 1914, n.p.

[93] See Leonardo Affonso de Miranda Pereira, "E o Rio dançou. Identidades e tensões nos clubes recreativos cariocas (1912–1922), In: Pereira Cunha, *Carnavais e outras f(r)estas*, pp. 419–444. See also Leonardo Affonso de Miranda Pereira, "A dança da política: Trabalhadores, associativismo recreativo e eleições no Rio de Janeiro da Primeira República", *Revista Brasileira de História*, 37 (2017), 1–26.

[94] "Os heróes de um mundo magico", *A Noite*, 4 February 1921, 1.

André Vento, Jayme Silva and Publio Marroig became household names, their photographs gracing front pages, their caricatures appearing in illustrated magazines. Like *Fon-Fon!* had done, over a decade earlier, the satirical weekly *D. Quixote* undertook a visit to the depots of the three Great Societies in 1924.[95] The tropes of secrecy, insider knowledge and assurances of victory for all three societies remained in place, but the tone is markedly more sarcastic. The author was probably Lauro Nunes, who wrote in the magazine under the pseudonym Terra de Senna, authoring a regular column on the art world titled "Bellas-artes". The relationship between art and carnival was a frequent theme, and the columnist's attitude to it far from unambiguous. Although he regularly featured artists engaged with carnival, the treatment dispensed to them was mostly satirical.[96] A column of January 1920 contains the cryptic note: "André Vento told an evening newspaper that Carnival does not need Art. Nor does Art need Carnival, someone remarked, remembering the 1919 Salon."[97]

While Terra de Senna considered carnival important enough to focus on the topic repeatedly, his text begrudges the artists their success and often insinuates they are wasting their talents on something of lesser value. This is most openly formulated in a 1921 column that begins:

If Arthur Timotheo, instead of painting *The Day After* or the curtain for the São Pedro Theatre, had dedicated himself to the art of Mardi Gras, his name would be acclaimed in the streets like that of André Vento, which was, by the way, always his only ambition in life.[98]

The phrasing of the text is slightly ambiguous as to whose ambition it refers: Timotheo or Vento. Either way, the comparison between the two artists is revealing. Timotheo was probably the leading Afro-descendant painter of his day, well known and considered for the seriousness of his work. When the column was published, he was already interned in the mental asylum where he would die the following year, just short of his fortieth birthday. As a journalist specializing in art-world gossip, Terra de Senna would certainly have been aware of that fact and also of the

[95] "D. Quixote nos grandes clubs. Uma visita aos Fenianos, Democraticos e Tenentes", *D. Quixote*, 27 February 1924, n.p.

[96] See, among others, Terra de Senna, "Bellas-artes", *D. Quixote*, 20 August 1919, 3 September 1919, 28 January 1920, 18 February 1920, 16 February 1921, 2 March 1921, n.p.

[97] Terra de Senna, "Bellas-artes", *D. Quixote*, 28 January 1920, n.p.

[98] Terra de Senna, "Bellas-artes", *D. Quixote*, 16 February 1921, n.p.

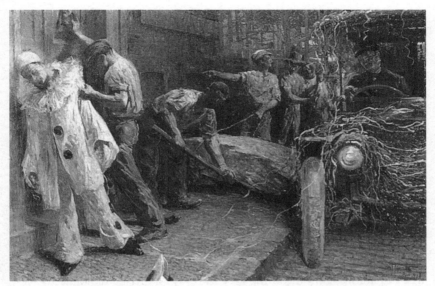

FIG. 26 Arthur Timotheo da Costa, *O Dia Seguinte*, 1913, oil on canvas, 85 × 120 cm. For color version of this figure, please refer color plate section. Rio de Janeiro: private collection

strategic choice of *O Dia Seguinte* (*The Day After*) (Fig. 26), a carnival-themed painting, as a foil to the success of fine artists who worked producing carnival festivities. Later, in 1926, when he authored the piece "Carnival in contemporary Brazilian painting", cited in epigraph to this chapter, Terra de Senna still did not seem to be sure about the relationship. He laments that Brazilian artists were not interested in carnival, yet, at the same time, lists several who did represent carnival themes and castigates them for their shortcomings. Interestingly, the latter article made no mention of Timotheo da Costa.

2.5 BRINGING CARNIVAL INTO THE SALON

The enthusiasm displayed by K. Lixto, Fiuza, Seelinger and other artists for Rio's most popular festivities helps situate their efforts in terms of elitism and class relationships. Carnival was clearly an avenue for art practitioners to explore society outside the restricted milieu of the art world. Yet, its relevance to artistic modernization went beyond thrill-seeking amusements or even issues of social mobility. By 1913, carnival had become such a central concern to some artists that it was ready to be

addressed head-on as a driving force in their art. That year, two painters, both in their early thirties and both familiar to the bohemian social circle described above, presented carnival-themed pictures to the ENBA Salon. The elder of the two, Rodolpho Chambelland, is the figure depicted in Seelinger's *Bohemia* lighting his cigarette in the flame of the lamp. The other, Arthur Timotheo, was the younger brother of João Timotheo da Costa, seated at the table in the 1903 painting. Besides their age and interests, Chambelland and Timotheo shared the peculiarity of both belonging to pairs of artist brothers. Carlos Chambelland, Rodolpho's younger brother, was a painter too. The four men engaged in a convivial relationship that dated back to student days at ENBA and was reinforced by work and projects in common over many years.[99] Their proximity makes it likely that the simultaneous presentation of Chambelland's *Masked Ball* and Timotheo's *The Day After* to the 1913 Salon was a concerted decision on both men's parts. Despite their discrepancy in size – the former is almost twice as large as the latter – the paintings can be read as companion pieces or, at the very least, as an artistic dialogue.[100]

It would be tempting to situate the scene in *Baile à Fantasia* (*Masked Ball*) (Fig. 27) as a depiction of one of the Artists' Balls described above, but the work was painted four years before the first edition in 1917. The relationship in this instance is likely the opposite, with life imitating art. In any event, the painting was a success. It was awarded one of the highest accolades, an acquisition prize – in the value five *contos de réis*, the largest sum paid out that year – and thereby entered the collection of ENBA. The extremely dynamic composition is structured around revellers in fancy dress taking turns on the dance floor. The position of their bodies – tightly enlaced, strongly diagonal, thrusting back and forth rhythmically – suggests they are dancing the *maxixe*.[101] The range of costumes is

[99] See, among others, *Revista da Semana*, 7 October 1906, 3958; "Fon-Fon em Turim", *Fon-Fon!*, 18 February 1911, n.p.; "Um quadro histórico", *O Malho*, 10 January 1914, n.p.; "Cine Palais", *Fon-Fon!*, 25 July 1914, n.p.; "Os nossos artistas fundam sua cidade", *A Noite*, 9 April 1915, 1.

[100] At least one contemporary critic interpreted the works as a pair: Ant., "Pintura. O 'Salon' de 1913 – J. Baptista da Costa – Arthur Timotheo – Rodolfo Chambelland", *O Imparcial*, 10 September 1913, p. 3; and another drew comparisons between them: MP, "O Salão de 1913", *Fon-Fon!*, 13 September 1913, n.p. See Arthur Valle, "*Baile à fantasia*, de Rodolpho Chambelland: A figuração do frenesi", *19&20*, 3 (2008) and Cardoso, *A arte brasileira em 25 quadros*, pp. 160–171.

[101] One contemporary critic identified the dance as such: Gonçalo Alves, "Notas do 'Salon'", *A Noite*, 8 September 1913, 2. On the contradistinctions between forms of dancing *maxixe*, *lundu*, samba and tango, see Sandroni, *Feitiço decente*, pp. 62–83.

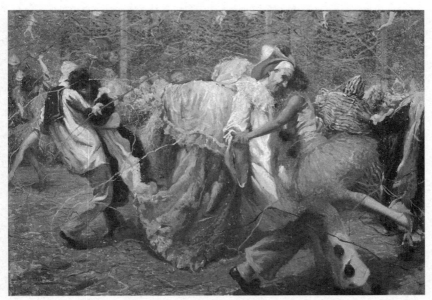

FIG. 27 Rodolpho Chambelland, *Baile à Fantasia*, 1913, oil on canvas, 149 ×
209 cm. For color version of this figure, please refer color plate section.
Rio de Janeiro: Museu Nacional de Belas Artes/Ibram (photo: Jaime Acioli)

characteristic of carnival at the time. The couple in the right foreground
consists of a man dressed as a Pierrot and a woman as a reddish-pink
ballerina. Just behind them, to the left, so close that their bodies overlap
on the canvas, a figure draped in a hooded cream-coloured cape trimmed
with pink frills leans into the right. Its height and size suggest it might be a
man, but it is impossible to say for sure. This figure's dance partner is
hardly visible, except for a greenish, ghoulish mask peeking over its
outstretched arm. Further to the left, a masked woman all in black leans
her head against the shoulder of a man in a sailor suit. Behind them, in the
background, with her foot kicking out of the left side of the frame, a bare-
legged woman raises a tambourine in her left hand. On the other side of
the composition, behind the pink ballerina, another couple leans to the
right. The back of a figure in a hooded zebra cloak is clearly discernible,
but the remaining figures to its right are painted in such broad strokes as
to become nearly abstract. The whole painting, in fact, seems to dissolve
into a jumble of patches and pigment. The artist has judiciously used the
motifs of streamers and confetti to cover the painted surface in a flurry of
spots and spurts of colour.

The thematic boldness and technical bravura of Chambelland's painting were not lost on critics. The venerable daily *Jornal do Commercio* affirmed:

Indisputably, the picture that most promptly draws and grips the attention is titled *Masked Ball*, by the young artist Rodolpho Chambelland. It is a powerful note of colour, a magnificent specimen of colourist technique executed with singular taste and ability. The theme possesses great local character and lends itself perfectly to the treatment dispensed by the artist, who has managed to interpret with great success its popular spirit. Nor is it lacking in the sentiment of amorous and somewhat erotic expression of the dance.[102]

Writing in the newspaper *O Paiz*, another critic enthused:

Lively, animated, full of tones and light, the first impression is of something fantastical and decorative. Soon enough, however, one sees that it is an ensemble of admirable effects. It is a work that pulsates and causes pulsations and, throbbing in intensity of colours, leaves the viewer in a corresponding intensity of emotions.[103]

The emphasis on technique is revealing, insofar as it indicates that the painting was perceived as straying from the established norm. On the same page of *O Paiz*, another article written entirely in French scrutinizes the nature of the admirable effects praised by the critic. Formulated as a dialogue between a male connoisseur and a female companion less than knowledgeable about art, it posits Chambelland as a *divisionist* and proceeds to explain the meaning of the term. It is worth citing the text at length and in the original, both to underscore its didacticism and the stylistic quirks that suggest the author may have been Brazilian:

– Tu ne sais pas, mignonne. C'est la méthode, la théorie, qui consiste dans la dissociation des tons en observant les mouvements et les transformations des points lumineux du spectre solaire, sur les objets, aussi bien que sur les personnes, dans le paysage comme dans le portrait ; ce travail exige une sureté absolue de l'œil et de la main. On divise les tons, on ne les mêle pas. Un peintre de mes amis apporta il y a six ans des pastels exécutés selon la théorie divisionniste. Bleu, vert, jaune, orange et quelques tons complémentaire[s] ; du bleu de Prusse à la place du noir. Un autoportrait aujourd'hui dans un musée d'art moderne, une tête de maçon portugais, et autres études faites à Paris et à Lisbonne.
– Je voudrais bien voir un peintre divisionniste quand il travaille!
– Regarde le tableau de Chambelland, que beaucoup n'ont pas compris et d'autres n'ont pas voulu comprendre. Admire les jolis tons de chair!

[102] "Notas de arte", *Jornal do Commercio*, 5 September 1913, 6.
[103] LF, "O Salão de 1913 – VI", *O Paiz*, 20 September 1913, 3.

– C'est vilain, il y a du bleu, du jaune, du vert ; les figures sont zébrées de bleu et de rose et de vert ; je n'ai jamais vu cela!
– C'est un travail très difficil[e]. Éloigne-toi, tu les verras harmonisées et fraiches, tandis que dans le tableau d'en face, académique et archaïque, les tons sont sales.[104]

There are multiple takeaways from this strange dialogue. Firstly, the effort to explain divisionism in technical terms implies that readers (even those capable of reading French) might not have been familiar with the concept. The female companion finds the picture ugly (*vilain*) and exclaims: "I've never seen anything like it!" Secondly, the assertion "that many misunderstood and others did not wish to understand" Chambelland's painting suggests the work was the object of dispute and negative appraisals. Thirdly, the counterpoint between a similar work hanging "in a museum of modern art" and the painting in front, described as "academic and archaic", reveals that the opposition between *modern* and *academic* was already operative in discussions of art in Rio de Janeiro in 1913. The sum of these three points is that *Masked Ball* was perceived by its audience as much more innovative in formal terms than it may appear in retrospect, over a century later.

The coincidences between Chambelland's and Timotheo's paintings are not only thematic but also stylistic, with distinct visual echoes between

[104] Bolognese, "Arte e artistas. Salon 1913", *O Paiz*, 20 September 1913, 3. This was not the first article signed by Bolognese to appear in French in *O Paiz*, but part of a recurring feature.

　　– You don't know, my dear. It's the method, the theory, that involves separating hues by observing the movements and transformations of luminous points of the solar spectrum upon objects as well as people, both in landscapes and in portraiture; such work demands absolute certainty of eye and hand. One divides the hues, as opposed to mixing them. Six years ago, a painter friend of mine brought me some pastels executed according to divisionist theory. Blue, green, yellow, orange and a few complementary hues; Prussian blue instead of black. A self-portrait that today hangs in a museum of modern art, the head of a Portuguese mason, and other studies done in Paris and Lisbon.
　　– I should very much like to see a divisionist painter at work!
　　– Look at Chambelland's painting, which many misunderstood, and others did not wish to understand. Admire the pretty flesh tones!
　　– It's ugly, there is blue, yellow, green; the figures are striped with blue, pink and green; I've never seen anything like it!
　　– It's a difficult work. Stand away from it, and you will see them harmonious and fresh, while in the work across from it, academic and archaic, the tones are dingy.
　　[Author's translation]

them. *The Day After* likewise features a man dressed in a Pierrot outfit, very similar in its details to the figure in *Masked Ball*, with two differences: his hat has fallen to the ground and is just visible along the lower edge of the composition, and the whiteface is distinctly more pronounced. He is being propped up by a sturdy labourer who knocks on the door of a house, one of a group of men working on the pavement, another of whom points out the incident. From the right-hand side of the composition, a uniformed driver looks on watchfully from a car covered in colourful streamers. The narrative structure of the image is conventional. After a night of revelry, Pierrot is being dropped off at home but is so exhausted, or drunk or both, that he can hardly stand. It is certainly a more critical, and even moralistic, depiction of the theme of carnival than Chambelland's. While those with money to ride in chauffeured automobiles can drink and party, others must get up early to work. Given that the painter was Afro-descendant and prone to provocative representations of black subjects, the whiteface mask is further susceptible to reading as a veiled critique of racial inequalities.[105]

As regards the painterly dialogue with Chambelland's *Masked Ball*, two crucial points emerge. Firstly, the relative paucity of facial features discernible in either painting reflects a shared understanding of the carnivalesque. In both works, the most visible physiognomy is that of the Pierrot, and even his face is reduced to a painted mask, to differing degrees in one and the other. Both painters have gone to great lengths to hide or shade the faces of the remaining figures in their respective compositions, suggesting a blurring of identities. This reinforces the idea of carnival as a site for reversing social roles and transgressing prohibitions, particularly through drunkenness and sexuality. The second point is to do not with the subject of the works but with painterly handling. The mutual use of streamers as a pretext for painting almost abstract patterns of pure chromatism indicates that both artists were exploring the relationship between representation and vision. Which is to say: they were engaged in experimenting with techniques contemporary viewers would have regarded as 'modern'. Furthermore, both elected the theme of carnival as an appropriate pretext to try out such innovations – largely absent from other works produced by either of them around the same time – evincing an intent to apply up-to-date treatment to a subject pertaining to modern life.

[105] For more on this, see Rafael Cardoso, "The problem of race in Brazilian painting, c.1850–1920", *Art History*, 38 (2015), 502–505.

There are a couple of tantalizing visual sources for such representations of streamers in the contemporary periodical press. The first is a cover of *Fon-Fon!* drawn by K. Lixto two years earlier, in February 1911 (Fig. 28). The second appears in an edition of the same magazine published just seven months before the ENBA Salon. The 1 February 1913 issue, largely devoted to carnival, contains a photographic reproduction titled "*As serpentinas*" (the streamers) (Fig. 29), retouched to depict the image of a smiling young woman enveloped in a cloud of carnival streamers.[106] The illustration bears no relationship to the editorial content of the prior or following pages and, in fact, is placed within the section at the start of the magazine devoted to advertisements. Only it does not advertise anything. It was apparently an experiment, a printed gift to the readership. From the timing of its appearance and the fact that *Fon-Fon!* was widely read by artists, whose works it often showcased, it is entirely plausible that Chambelland and Timotheo might have come across the image while developing their respective pictures. Though circumstantial, this coincidence of pictorial efforts is suggestive of yet another level at which the interplay between fine and graphic arts contributed to a process of modernization in the visual culture of the time.

As both theme and treatment, carnival provided a locus for the formal expression of ideas of modernity. Its presence on the walls of the Salon represents a challenge to approved ideas of what was acceptable as high culture. Another innovation of the 1913 Salon was the staging of three performative events that drew great crowds into ENBA for purposes other than viewing art. The first was a "Literary Hour" with writers Bastos Tigre, Luiz Edmundo and Goulart de Andrade. The second, one week later, was a "Musical Hour" organized by maestro Araújo Vianna. The third was a "Humoristic Hour" featuring K. Lixto, Raul and J. Carlos.[107] The inclusion of these entertainments, especially the latter,

[106] The image was produced using a typographic cliché produced from a retouched photograph, possibly airbrushed. It is signed J. Garcia, an engraving workshop that advertised its services – including photogravure, zincography, photozincography and phototyping – in *Atheneida* magazine, for which it produced several plates. For more on this, see Chapter 3. It is worth noting that K. Lixto was art director of *Fon-Fon!* at the time.

[107] "O que foi a festa de hontem no Salão deste anno", *Correio da Manhã*, 9 September 1913, 3; Bueno Amador, "Bellas-artes", *Jornal do Brasil*, 9 September 1913, p. 6; "A hora musical no palácio das belas-artes", *Correio da Manhã*, 16 September 1913, 3; Bueno Amador, "Bellas-artes", *Jornal do Brasil*, 16 September 1913, p. 6; and Bueno Amador, "Bellas-artes", *Jornal do Brasil*, 22 September 1913, p. 4. For photographs of these events, see *Revista da Semana*, 13 September 1913 & 20 September 1913 – and *Careta*, 13 September 1913.

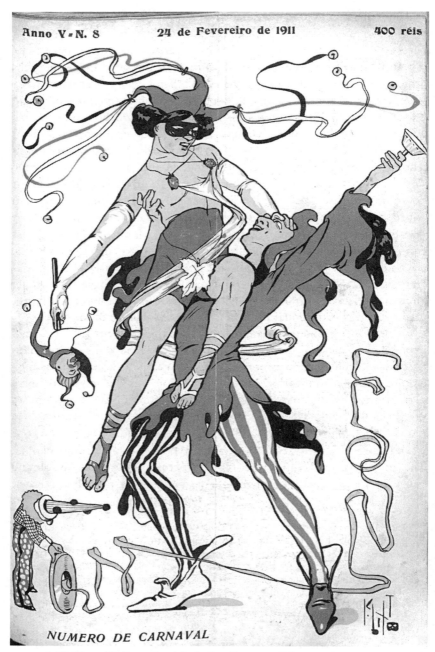

FIG. 28 K. Lixto [Calixto Cordeiro], *Fon-Fon!*, 24 February 1911
Fundação Biblioteca Nacional (BN Digital/Hemeroteca Digital Brasileira)

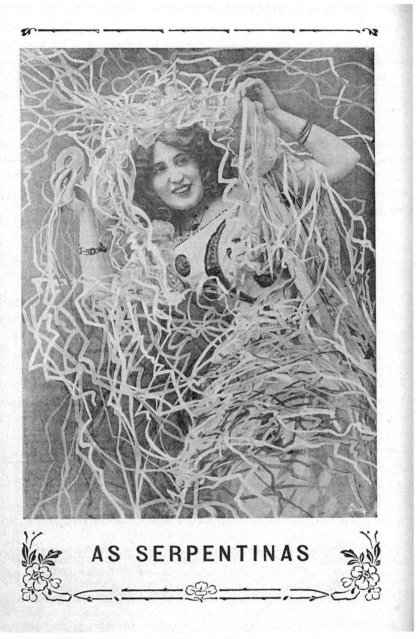

AS SERPENTINAS

FIG. 29 J. Garcia, *Fon-Fon!*, 13 February 1913
Fundação Biblioteca Nacional (BN Digital/Hemeroteca Digital Brasileira)

indicates a loosening of hierarchies that belies the modernist caricature of ENBA as a space of priggishness and elite exclusivity. The youthful vitality depicted in Chambelland's *Masked Ball* appears to have spilled out into the space in which it was exhibited. Indeed, the critic of *Correio da Manhã* had no doubt in affirming that the 1913 Salon belonged to the "new generation", echoing his counterpart in *Fon-Fon!*[108] This assertion is confirmed by the remaining prizes awarded by the jury, the majority of which went to younger artists, such as Angelina Agostini (only the second woman to win the travel prize), Pedro Bruno, the brothers Adalberto and Antonino Pinto de Mattos, Mário Navarro da Costa and Carlos Oswald.[109] A changing of the guard was underway in the artistic establishment, and the embrace of carnival was symbolic of the tastes of the new generation.

2.6 BOHEMIANISM, FROM INTERSECTIONAL TO INSTITUTIONAL

ENBA's capacity for assimilating novelty and reconciling generational shifts may seem surprising, given the narrative that situates Brazilian modernism as a rupture with a hopelessly retrograde 'academic' establishment. Yet, the decade of exhibitions that begins with the success of Seelinger's *Bohemia*, in 1903, and ends with the triumph of Chambelland's *Masked Ball*, in 1913, demonstrates that the institution was not averse to artistic experimentation and even managed to embrace it at critical junctures. The opposite pole of resistance to change was present too, of course. Like all institutions, ENBA contained competing groupings and conflicting opinions and cannot be taken as embodying a single unified position.[110] The fact that it was even somewhat permeable may help explain why proponents of artistic modernization in Rio de

[108] "O Salão de 1913. São seis os candidatos à medalha de prata", *Correio da Manhã*, 11 September 1913, 5; Jack, "Chronica", *Fon-Fon!*, 6 September 1913, n.p.

[109] "Artes e artistas", *O Paiz*, 14 September 1913, 2; and LF, "O Salão de 1913 – V", *O Paiz*, 18 September 1913, 7. The jury was composed of João Baptista da Costa, Henrique Bernardelli, Modesto Brocos, Alberto Delpino, Pedro Peres, Carlo de Servi and João Timotheo da Costa.

[110] Among the major institutional struggles of the period were the reorganization of its statutes in 1890 and the controversy around Modesto Broco's polemical *A questão do ensino das bellas artes* (1915). See Camila Dazzi, "Pôr em prática a reforma da antiga Academia: Dificuldades enfrentadas pela Escola Nacional de Belas Artes (1891–1895)", *Visualidades*, 15 (2017), 171–198; and Heloisa Selma Fernandes Capel, "Entre o riso e o desprezo: Modesto Brocos como crítico na 'Terra do Cruzeiro'", *19&20*, 11 (2016).

Janeiro never took up the aggressively oppositional stance characteristic of secessions and avant-gardes in other historical contexts. Writing about the Salon in 1905, one critic pondered as much:

At first sight, in this epoch of conflicting schools, it is surprising that works do not appear there [ENBA] that set into relief such differences, such demonstrations of revolutionary objectives, that reveal opposition and insurrection against the established principles.[111]

The author of the text posits that this would not happen, "without a great national occurrence that strongly impacts the sensitive nature of the people or a profound social revolution that intimately modifies the prevailing sentiment".[112] Instead, he suggested, change would continue to be processed piecemeal, on an individual basis. This canny observation was borne out by developments over the following years. Instead of undermining the system, challenges to prevailing norms were co-opted through conviviality, in keeping with the Carioca culture of sidestepping conflict and channelling it into humour and divertissement. Significantly, the paintings singled out here as examples of formal innovation take as their subject nocturnal pleasures.

The free and easy sociability among artists of all sorts – anticipated in Seelinger's *Bohemia* – evolved over the 1910s into broader networks and even managed to establish itself on an organizational level. Fine artists and graphic artists increasingly frequented the same spaces of exhibition and education; and the crossover between the two fields, which had been a constant trickle over the latter half of the nineteenth century, flowed more freely after 1916. The main institutional locus for these exchanges was the Liceu de Artes e Ofícios. Inaugurated 1858 as a school of arts and crafts, with the express purpose of training workers for manufacturing industry, the Liceu gradually encroached into the arena of fine art and came to function almost as a preparatory school for ENBA, with which it shared numerous personnel. From 1882 onwards, it also began promoting art exhibitions independently of the Salon.[113] Two interrelated

[111] Rapin, "A exposição de 1905", *Renascença*, October 1905, 174–182.
[112] Ibid., 174.
[113] See Alba Carneiro Bielinski, "O Liceu de Artes e Ofícios - sua história de 1856 a 1906", *19&20*, 4, (2009); and Rafael Cardoso, "A Academia Imperial de Belas Artes e o Ensino Técnico", In: *180 Anos de Escola de Belas Artes: Anais do Seminário EBA 180* (Rio de Janeiro: Universidade Federal do Rio de Janeiro, 1997). In 1906, the Liceu obtained one of the best lots on the new Avenida Central and began erecting a building that would only be inaugurated in 1916. This real estate transaction ultimately proved a boon to the institution's finances, as the ground floor of the building became a

groupings that congregated around the Liceu during the latter half of the 1910s are significant for fleshing out the social networks engaged in Rio's artistic modernization: namely, the Centro Artístico Juventas and the Salão dos Humoristas.

In 1910, a group under the leadership of twenty-four-year-old painter Annibal Mattos (brother of printmaker Adalberto Pinto de Mattos and sculptor Antonino Pinto de Mattos) established an art students' league named Juventas to exhibit the work of younger artists.[114] Other painters like Henrique Cavalleiro, Galdino Guttmann Bicho, José Marques Júnior, Sylvia Meyer and Navarro da Costa, almost all in their twenties, were among the early members; and their first group exhibition was held in August 1911 on the premises of ENBA.[115] The league's fifth exhibition, in 1916, represented a breakthrough in size and scope. Held in the newly inaugurated building of the Liceu, it showed 217 works, including not only artists of the "new generation", so-called, but also recognized masters like João Baptista da Costa (then, director of ENBA), Henrique Bernardelli and Belmiro de Almeida.[116] Several of the artists depicted in Seelinger's *Bohemia* also took part: Malagutti, Fiuza Guimarães and Cunha Mello, as well as Arthur Timotheo. Held in October, immediately after ENBA's annual exhibition in September, the Juventas show elicited favourable comparisons with the official Salon across the Avenida.

In 1913, artists linked to Juventas and Liceu were singled out for awards at the ENBA Salon. That same year, Carlos Oswald was hired to set up a printing workshop at the Liceu which became a focal point for encounters between fine and graphic artists. Several of the names featured in this chapter – Seelinger, Arthur Timotheo, Mazzuchelli, Raul and

sought-after location for shops and cafés. The rents paid by these businesses financed the activities of the Liceu until the late 1930s, when the building was expropriated under the *Estado Novo* regime.

[114] For more on Annibal Mattos, see Rodrigo Vivas, "Aníbal Mattos e as Exposições Gerais de Belas Artes em Belo Horizonte", *19&20*, 6 (2011); and Rodrigo Vivas Andrade, "Análise da produção do pintor Aníbal Matos em Belo Horizonte – 1917–1944", *III Encontro de História da Arte* (CHAA/Unicamp, 2007), pp. 66–75.

[115] *Fon-Fon!*, 12 August 1911, n.p. See also *Fon-Fon!*, 25 May 1912, n.p.; *Fon-Fon!*, 3 August 1912, n.p.; *Fon-Fon!*, 14 September 1912, n.p.; "Comissão organizadora da 3ª Exposição Juventas", *Revista da Semana*, 26 July 1913, n.p.; "Juventas", *Revista da Semana*, 23 August 1913, n.p.

[116] "Bellas-artes. Inauguração da exposição do Centro Juventas", *Correio da Manhã*, 5 October 1916, 3; "A exposição do circulo Juventas", *Gazeta de Notícias*, 22 October 1916, 2; and "Exposições de arte. Centro Artistico Juventas", *Correio da Manhã*, 25 October 1916, 2. See also "Centro Artistico Juventas", *Careta*, 14 October 1916, n.p.

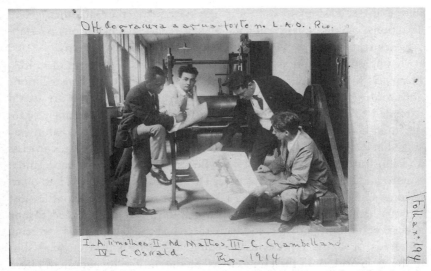

FIG. 30 Unidentified photographer, 1914 (from left to right: Arthur Timotheo da Costa, Adalberto Pinto de Mattos, Carlos Chambelland, Carlos Oswald, in the printing workshop of the Liceu de Artes e Ofícios)
Rio de Janeiro: Fundação Biblioteca Nacional

K. Lixto, among others – printed their work there or took part in related exhibitions, over the 1910s (Fig. 30).[117] Oswald's initial contact with the Liceu occurred through Adalberto Pinto de Mattos, printmaker and later art critic.[118] A network of sociability developed around these and other artists who shared an interest in printmaking which crossed over, via personal contacts, into the fine arts milieu of ENBA. A group photograph at the 1913 Salon shows both Chambelland and both Timotheo brothers, posing together with younger artists, Adalberto Mattos, Guttmann Bicho and Navarro da Costa. Other photographs of 1916 and 1919, published

[117] Born, raised and trained in Italy, son of the Brazilian composer Henrique Oswald, Carlos Oswald moved to Brazil in 1913. In 1911, he worked with the Chambelland and Timotheo brothers designing the Brazilian pavilion for the Turin International. See Maria Isabel Oswald Monteiro, *Carlos Oswald, 1882–1971: Pintor da luz e dos reflexos* (Rio de Janeiro: Casa Jorge, 2000), pp. 85–102.

[118] Ibid., 85. See also João Brancato, "Um mestre da arte da gravura: Adalberto Pinto de Mattos", *Anais da XXX Semana de História – Universidade Federal de Juiz de Fora* (2013), 348–362; and João Brancato, *Crítica de arte e modernidade no Rio de Janeiro: Intertextualidade na imprensa carioca dos anos 20 a partir de Adalberto Mattos (1888–1966)* (unpublished master's thesis, Programa de Pós-Graduação em História, Universidade Federal de Juiz de Fora, 2018).

in the press, cast many of the same names together in other group situations, as colleagues or allies.[119] Their recurrence in various overlapping contexts points to the permeability between artists' groups.

Though the institutions may have existed apart, key figures of ENBA, Liceu and Juventas are frequently cited together, in varying constellations and contexts. This porosity between different parts of the art world extended to illustrators and caricaturists, as well. In November 1916, one month after the Juventas exhibition, the first Humourists' Salon was staged in the Liceu. On show were 518 works by well-known caricaturists and illustrators like Raul, K. Lixto, Belmiro de Almeida, Luiz Vianna, Amaro and Nemesio, plus newcomer Di Cavalcanti, who would go on to become a key player in the Modern Art Week of 1922 and one of the most famous names in Brazilian modernism.[120] In a city accustomed to one general exhibition per year, suddenly three back-to-back shows featuring hundreds of artists represented nothing less than a gravitational shift in the art world. Both the Humourists' Salon and the Juventas exhibition continued to be staged over the following years, pointing to a segmentation of the art world but also indicating greater room to manoeuvre in contact zones and intermediate spaces. Encounters between individuals in the informal arenas of carnival and bohemianism facilitated exchanges that may remain barely perceptible from examining only the daytime evidence.

In 1919, Centro Artístico Juventas was renamed Sociedade Brasileira de Belas Artes (SBBA). The decision was taken at a general assembly of league members held on 1 July, at the Liceu, and the motion was proposed by an odd couple: Raul Pederneiras and Rodolpho Chambelland. Aged 45 and 40 respectively, they were senior representatives of a membership that apparently no longer identified with the youthfulness of the former name. At the time, the celebrated Raul was just beginning to take on teaching duties at ENBA. Chambelland had already been employed as a professor of life drawing there since 1916. Between them,

[119] "A Sociedade de Aquarellistas", *Fon-Fon!*, 23 September 1916, n.p.; and *Fon-Fon!*, 5 July 1919, n.p. The Timotheo brothers also shared a studio with Seelinger, as evidenced by photographs in the scrapbook referenced in note 39. For further links between Seelinger and Timotheo, see also Niclo, "Artistas e arteiros", *Fon-Fon!*, 16 July 1910, n.p.

[120] "O 'vernissage' do 'Salão' dos Humoristas", *Correio da Manhã*, 14 November 1916, 2. See also "Salão dos Humoristas", *Revista da Semana*, 30 September 1916, n.p.; and "Nem só do pão vive o homem", *O Malho*, 2 December 1916, n.p. Cf. Lima, *História da caricatura no Brasil*, II, pp. 430–448.

they represented a noteworthy intersection of groupings and interests: ENBA and Liceu, painters, sculptors and illustrators. The list of artists present at that assembly reinforces the sense that an ample cross-section of the worlds of graphic and fine arts in Rio de Janeiro was gathered in the room – among others, Seelinger, Arthur Timotheo, Cavalleiro, Navarro da Costa, Mazzuchelli, Modestino Kanto, Rubem Gil, Alberto Delpino, Ernesto Francisconi, and Lucilio and Georgina de Albuquerque. For that brief moment, it must have seemed that the various factions of the art world in Rio were coming together to form a unified force. The feeling did not last long. By 1921, the first internal signs of conflict became public. After 1922, the renamed SBBA was granted a government subsidy and began to take on additional duties, which only served to heighten tensions and disputes. After a near split of the organization in 1929, it took a more conservative turn and became stridently anti-modernist over the 1930s and 1940s.[121]

By the 1920s, the youthful bohemians of 1903 had aged. The sense of humour and style they shared were no longer current, much less innovative. The First World War proved a bitter turning point. Even for those who might be less concerned about the conflict in Europe, its deadliness was brought home in late 1918 when the epidemic of Spanish flu hit Brazil, killing tens of thousands including the newly re-elected president, Rodrigues Alves. Though distant, the War's moral impact was keenly felt in Francophile Rio de Janeiro. Both Seelinger and Raul produced repeated covers for *Fon-Fon!* depicting its horrors. From the transformations perceptible in his drawings of the period, Seelinger seems to have been hit particularly hard. A magazine cover of October 1914, titled "*Gott mit uns*" is harshly critical of his own German background, depicting a wrathful God unleashing destruction on a ruined Europe. Over 1914, the artist produced a series of sombre illustrations for the inner pages of *Fon-Fon!* indicative of his evident despair and perplexity. By the end of

[121] The best source of information on the early history of Juventas is a rare pamphlet housed in the Fundação Biblioteca Nacional (Seção de Iconografia, 109.1.5) which bears no bibliographical information (location, publisher, date) but was printed around 1935: *A Sociedade Brasileira de Bellas-Artes, no seu primeiro jubileu. 1910–1935*. See also Nogueira da Silva, "Na exposição do Centro Artistico Juventas", *Gazeta de Notícias*, 6 June 1914, 1; FM, "A exposição do circulo Jeventas", *Gazeta de Notícias*, 25 October 1916, 5; Adalberto Pinto de Mattos, "Bellas artes. Intercambio artistico", *O Malho*, 22 August 1922, n.p. In 1931, Raul and Chambelland teamed up again to depose Lúcio Costa as director of ENBA; see Maria Lucia Bressan Pinheiro, "Lúcio Costa e a Escola Nacional de Belas Artes", *Anais do 6º Seminário Docomomo-Brasil* (2005).

the war, his art changed noticeably. Between mid-1917 and late 1918, Seelinger produced several colourful covers for *Fon-Fon!* and *O Malho* on patriotic themes, depicting Brazilian flags and effigies of the Republic, in a cartoonish and hardly recognizable style.

Like many artists of his generation, Seelinger was little attuned to the new artistic currents taking hold in Europe. Their reflexes would soon be felt in Brazil and particularly in São Paulo. Nonetheless, however dated or even reactionary the members of the group depicted in his *Bohemia* may have become after 1918, that does not alter the significance of their actions before that date. To deny them recognition of what they accomplished in their own time and place is not only historicist, but also colonialist in its fixation with Paris-centred categories of modernism. Between around 1903 and 1916, in Rio de Janeiro, the conjunction between carnival and theatre, art and illustration engendered unique and vibrant expressions of visual culture. These were avowedly modern in the Baudelaireian sense – transient, fleeting, contingent – and unequivocally attuned to an urban experience of rapid modernization. They were perceived as timely and contemporary by the public that experienced them. No matter what others may have made of them in retrospect, the artists who created them conceived of themselves as consummately modern. Significantly, this carnivalesque Carioca modernism was also permeable to Afro-descendant artists, such as K. Lixto or Arthur Timotheo. The *paulista* modernism that succeeded it – and to a great extent, erased its memory – possessed a very different relationship to themes of blackness, as shall be seen in Chapter 4.

3

The Printing of Modern Life

A New Art for a New Century

> Leave out the sermonizing, because those days are gone. The country is transformed; everything now is art nouveau.
>
> *Fon-Fon!*, 1907[1]

The relationship between bohemianism, carnival and art, explored in the preceding chapter, is suggestive of a distinctively Brazilian experience of modernity. However, the mere fact that modernizing networks existed falls short of constituting a conscious recognition of *modernism* as a conceptual category. The task of the present chapter is to demonstrate that such a conception did indeed exist. One reason it has not been generally recognized as such is that its formulation was disjointed and erratic. There is no great statement of Carioca modernism, and its plural nature was a constituent part of its contemporary appeal. In a city with stark divisions of race and class, territories and communities, those practices and discourses applicable across varying conditions were more likely to prosper. The second reason a Brazilian conception of modernism has struggled to achieve acceptance is precisely that it was home-grown – cobbled together from discrete strands of thought, rather than imported readymade from some authorized critic, movement or manifesto. Distinctly cosmopolitan and not a little eclectic, the alternate conception of 'the modern' posited here does not necessarily resemble modernism as it took shape in Paris or New York. For past observers on the lookout for mirrors of their own metropolitan modernities in the Brazilian periphery,

[1] "A successão", *Fon-Fon!*, 22 June 1907, n.p.

it has been very hard to notice because it blends in so well with its surroundings.

The present chapter will focus on three interrelated aspects that shed light on the conception of modernity existing in Rio de Janeiro over the first two decades of the twentieth century: 1) the conceptual categories and ideological premises that underpinned it; 2) the artists and intellectuals who constituted its core; 3) the extensive oeuvre they produced in the domain of illustrated periodicals. The last topic is examined in detail because it is crucial to understanding the extent to which the modernization in question was bound up with the rise of new media and technologies. The Brazilian modernism that took shape over the first two decades of the twentieth century is fascinating because it blossomed directly out of commercial practices and urban culture, rather than as critical commentary by elite observers. This is consistent with the circumstances of a country in which literature and fine art were traditionally restricted to a privileged few. As seen in the preceding chapter, no painter could hope to achieve the level of societal impact readily available to a carnival scenographer.

Vibrant and original expressions of modernity were produced, over the 1910s and 1920s, in the domain of graphic arts and design. Many works by K. Lixto (Calixto Cordeiro) and J. Carlos (José Carlos de Brito e Cunha) rival analogous productions anywhere in the world in terms of novelty and inventiveness. Cutting-edge where more erudite forms of expression faltered, they exemplify the erosion of hierarchies subordinating 'lesser' forms of artistic labour to 'higher' ones. This inversion of categories makes historical sense, considering that some of the earliest articulations of European modernism – such as the Belgian group *Les XX* or the Franco-German network around *La Maison Moderne* in Paris – were committed to breaking down barriers artificially erected between fine and applied arts. Ideas that held artistic modernity to be the unification of craft and industry, style and purpose, spread out from a few hotbeds in 1890s Europe and gained currency throughout the world over the period 1900 to 1914. In Brazil, they largely arrived under the epithet art nouveau – new art – via the Francophile intellectual groupings that dominated academies, galleries, publishers and press.

The reception given to such ideas of modern art – mostly northern European in origin – was further complicated in Brazil by the existence of a competing conception of *modernismo* in the Spanish-speaking context. Nicaraguan poet and essayist Rubén Darío's work was known and admired in early twentieth-century Rio de Janeiro, and he visited the city

in 1906 as a delegate to the Third Pan-American Conference. Unlike those thinking about art in English, French or German, who could conveniently ignore the precedence of Darío's interpretation of modernism, Brazilian observers were obliged to take it into account in formulating their own thoughts on what constituted the modern in aesthetic terms.[2] The common ground they found between Darío's vision of literary modernity and art nouveau expressions of artistic modernity was, perhaps surprisingly, social and ideological. Gonzaga Duque, the greatest art critic of his day, reconciled his refined aesthetic tastes with a vision of 'art for the people' that harked back to John Ruskin and William Morris.[3] His contemporary Elysio de Carvalho, principal Brazilian interpreter of Darío, took this further to wed decadentism with anarchism.

Over the first fifteen years of the twentieth century, an idea of *modernism*, purposefully thus called, was present in Rio de Janeiro. It found its boldest visual expression in the new culture of mass-circulation periodicals. Empowered by rapidly advancing technologies of printing and photographic reproduction, graphic artists were able to experiment and explore fresh possibilities. Their achievements were recognized, at least by some contemporaries. A critic of 1905 – writing in *Renascença*, perhaps the outstanding magazine of its time in terms of graphic design – wrote approvingly of illustrator Raul's participation in the ENBA Salon:

[2] On the precocious use of the term modernism in the Spanish-speaking context and its relations to European modernism, see Andrew Reynolds, "The Enduring Scholarly and Creative Legacies of Rubén Darío and *Modernismo*", *Review: Literature and Arts of the Americas*, 51 (2018), 175–179; Andrew Reynolds & Bonnie Roos, eds., *Behind the Masks of Modernism: Global and Transnational Perspectives* (Gainesville: University Press of Florida, 2016), pp. 11–15; Alexandra Ortiz Wallner & Werner Mackenbach, "Escribir en un contexto transareal: Rubén Darío y la invención del modernismo como movimiento", In Jeffrey Browitt & Werner Mackenbach, eds., *Rubén Darío: Cosmopolita arraigado* (Managua: IHNCA-UCA, 2010), pp. 350–382; and Alejandro Mejías-López, *The Inverted Conquest: the Myth of Modernity and the Transatlantic Onset of Modernism* (Nashville: Vanderbilt University Press, 2009), esp. ch.3.

[3] Luiz Gonzaga Duque Estrada gained early prominence with *A arte brasileira* (1888), the first book on Brazilian art to take a decidedly historical approach. He was also active as a writer, with close ties to the symbolist movement over the 1890s, culminating in his novel *Mocidade morta* (1899). See Vera Lins, *Novos pierrôs, velhos saltimbancos: Os escritos de Gonzaga Duque e o final do século XIX carioca* (Rio de Janeiro: Ed. Uerj, 2009); and Vera Lins, *Gonzaga Duque, a estratégia do franco-atirador* (Rio de Janeiro: Tempo Brasileiro, 1991). See also Elaine Durigam Ferreira Pessanha, *Gonzaga Duque: Um flâneur brasileiro* (unpublished master's thesis, Programa de Pós-graduação em Estudos Linguísticos e Literários em Francês, Universidade de São Paulo, 2008).

Another new name in the catalogue, with a new and characteristic oeuvre, is that of Raul Pederneiras; and, if there were space enough, now would be the occasion to bear witness to the important role of the illustrators and caricaturists of the nineteenth century, bringing modern life into the domain of art and how, through the direct, immediate and constant observation of daily life which they are obliged to undertake as caricaturists, they translate and better represent the life and customs of the epoch in which they live.[4]

The critic had evidently been reading Charles Baudelaire's "The Painter of Modern Life" (1863), which famously argued that a caricaturist, Constantin Guys, provided the model for the role of the artist in capturing and defining modernity. The inclination to view graphic art on a par with fine art was not a quirk of the critic hiding behind the pseudonym Rapin. Rather, it reflects the outlook of a whole contingent of enthusiasts seeking a new art for the new century.

3.1 ART NOUVEAU AND THE 'MANIA OF MODERNISM'

As a style, art nouveau became a rage in Rio de Janeiro over the first few years of the twentieth century. Its vegetable sinuousness, asymmetrical curves and characteristic ornaments abound in the printed periodicals discussed in this chapter, and even a cursory examination of magazines and newspapers circa 1903 to 1909 – the height of the fashion – will turn up hundreds of examples of Mucha-inspired female allegories, whip-lashes, floral decorations and borders (Fig. 31).[5] From the printed page, its traits and mannerisms spilled out into fashion and jewellery, architecture and decoration, fine and applied arts. With its explicit conjunction of tropes of newness and art, added to the implicit association to all things

[4] Rapin, "A exposição de 1905", *Renascença*, October 1905, 182. In French, *rapin* is a term for an artist's apprentice or a bohemian artist of dubious talent.

[5] Despite the profusion of *art nouveau* graphics over the period, surprisingly little has been published on the subject. See Maurício Silva, "Da *fièvre ornamentale* ao estilo floreal: A estética *art nouveau* no grafismo e na literatura pré-modernistas brasileiras", In: Carmem Negreiros, Fátima Oliveira & Rosa Gens, eds., *Belle Époque: Crítica, arte e cultura* (Rio de Janeiro: Labelle/Faperj & São Paulo: Intermeios, 2016), pp. 69–84; and Rafael Cardoso, ed., *Impresso no Brasil, 1808–1930: Destaques da história gráfica no acervo da Biblioteca Nacional* (Rio de Janeiro: Verso Brasil, 2009), pp. 142–145. See also Michele Bete Petry, *Revistas como exposições: Arte do espetáculo e arte nova (Rio de Janeiro, 1895–1904)* (unpublished doctoral dissertation, Programa de Pós-Graduação em Educação, Universidade Federal de Santa Catarina, 2016); and Ligia Cosmo Cantarelli, *A Belle Époque da editoração brasileira: Um estudo sobre a estética art nouveau nas capas de livros do início do século XX* (unpublished master's thesis, Programa de Pós-Graduação em Ciências da Comunicação, Universidade de São Paulo, 2006).

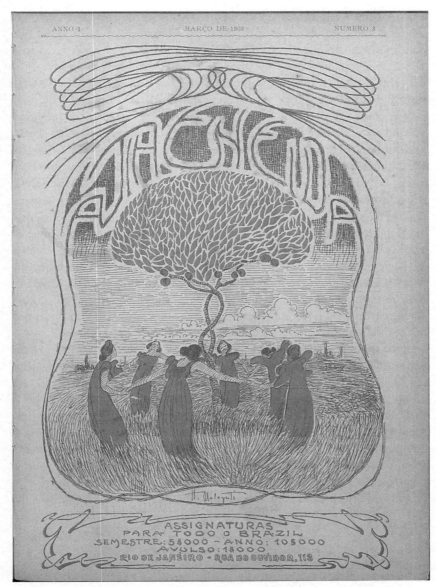

FIG. 31 Heitor Malagutti, *Atheneida*, March 1903. For color version of this figure, please refer color plate section.
Rio de Janeiro: Fundação Biblioteca Nacional

chic that the French language evoked for Brazilian audiences of the time, the term summed up an aspiration towards modernity.[6] In fact, the two concepts were frequently conjoined in contemporary discourse, as in a 1901 critic's mention of "the modern French artists of art nouveau".[7] Moreover, because of its modishness and ready availability, the modernization it stood for was of an alarmingly democratic kind.

The term art nouveau found its way into the Brazilian imagination around 1900. Before that date, there are few references to it. Afterwards, and for well over a decade, it was seemingly everywhere. The timing of this shift is attributable to the influence of the Universal Exposition of 1900, in Paris, which popularized the style internationally. Nonetheless, the inflection it gained in Brazilian usage is unique. Alongside the usual mentions of art nouveau as stylistic label, the term came to signify anything novel or new-fangled or faddish. Thus, a political columnist of 1901 discussing the recent assassination of US president William McKinley speaks of "a sort of art nouveau holy alliance" among the peoples of the world to combat anarchism. In 1904, another article in *Revista da Semana* bears the unusual title "Art nouveau police".[8] That same year, roving reporter Vagalume, of the newspaper *Tribuna*, defined his popular column on Rio's nightlife as "art nouveau reportage".[9]

Even more perplexingly, the term also took a pejorative turn. In 1902, yet another newspaper chronicler, discussing the education provided to girls at Rio's Escola Normal, comments favourably on their ability to talk about art and literature "without malice, without effort, without pursing their lips and rolling their eyes like any art nouveau darling".[10] A few months later, the editors of satirical magazine *Tagarela* registered a complaint about the sluggishness of "the art nouveau paving men" engaged in repair work on Rua do Ouvidor.[11] The following year, a theatre critic reproached a character in a play for sitting on a table, a "habit revealing an art nouveau upbringing".[12] In 1904, when the

[6] See Angela de Castro Gomes, *Essa gente do Rio. . .: Modernismo e nacionalismo* (Rio de Janeiro: Fundação Getúlio Vargas, 1999), pp. 39–40.
[7] Souza Bandeira, "Immortalidade pelo bronze", *Correio da Manhã*, 10 November 1901, 1.
[8] "Chronica", *Revista da Semana*, 29 September 1901, 596; and "Policia art nouveau", *Revista da Semana*, 18 December 1904, 1877.
[9] Vagalume [Leonardo Affonso de Miranda Pereira & Mariana Costa, eds.], *Ecos noturnos* (Rio de Janeiro: Contracapa, 2018), pp. 47, 168.
[10] Jacques Bonhomme, "Chronica", *Revista da Semana*, 30 March 1902, 98. In the original: "*revirar os olhos como qualquer preciosa art nouveau*".
[11] "Tagarelando", *Tagarela*, 11 October 1902, 2.
[12] "Theatrices", *O Malho*, 2 May 1903, n.p.

magazine *Renascença* published the score of a piano toccata that could be played backwards, from end to beginning, as well as forwards, it asked rhetorically what readers might make of this uncommon "new art" [*arte nova*] method of playing.[13] How and why did art nouveau come to connote this peculiar blend of affectation and contrariness?

A 1906 article in the up-market monthly magazine *Kósmos* provides a clue. Writing under the pseudonym Fantasio, poet Olavo Bilac penned a humorous text on the vogue for after-dinner speeches and attempted to classify the various types of speakers. The sort who addresses certain carnival groups [*grupos*] and associations [*ranchos*] is singled out for the author's greatest contempt:

This is the most 'uppity' [*'pernóstico'*] and most 'art nouveau', in dress and speech, both as a fop [*janota*] and an orator. It flourishes in the neighbourhood of Praça Onze de Junho, in that marvellous Cidade Nova, which is the paradise of the 'people of the lyre'. He is the orator of the merry fetes [*funçanatas alegres*], in which the piano alternates with the guitar and the military polka with the popular tune [*modinha*]. He is the Lucifer of the Eloás with frizzy hair and a flower behind their ear. He is the Don Juan of the Elviras in chintz dresses and patchouli oil in their hair... His immense red silk cravat, tied in a 'butterfly' knot, is a poem in itself; his lustrous quiff [*gaforinha*], divided into 'pleats' [*'pastas'*] is an entire programme.[14]

The elaborate language and arcane references are difficult to decipher today but would have been easily recognized by contemporary readers. Praça Onze and Cidade Nova situate the musical goings-on in the part of Rio de Janeiro that engendered modern samba and carnival over the 1900s and 1910s – a proletarian neighbourhood where recently arrived migrants and immigrants of all colours and creeds lived side by side.[15] The Eloás and Elviras – common female first names – with chintz print dresses suggest a working-class to lower-middle-class ambience, and the mention of frizzy hair is a strategic nod to the mixed racial composition of the audience. The specific term *gaforinha*, chosen to describe the orator's forelock instead of the more usual *topete*, possesses mildly racial

[12] "Theatrices", *O Malho*, 2 May 1903, n.p.
[13] B. Mol. "Maestro Arthur Napoleão", *Renascença*, July 1904, p .189.
[14] Fantasio, "A eloquencia de sobremeza. Oratoria e estomago", *Kósmos*, June 1906, n.p. The article was reprinted in *Careta*, 26 September 1959, 6–7, 34; and, more recently, in: Lúcia Garcia, *Para uma história da Belle Époque: A coleção de cardápios de Olavo Bilac* (São Paulo: Imprensa Oficial, 2011).
[15] See Bruno Carvalho, *Porous City: a Cultural History of Rio de Janeiro (from the 1810s onwards)* (Liverpool: Liverpool University Press, 2013), ch. 4.

O ORADOR DOS GRUPOS
«SENHORES! O BELLO SEXO É O ENCANTO D'ESTA VIDA!»

FIG. 32 K. Lixto [Calixto Cordeiro], *Kósmos*, June 1906
Fundação Biblioteca Nacional (BN Digital/Hemeroteca Digital Brasileira)

undertones.[16] Accompanying the text, an illustration by K. Lixto (Fig. 32) confirms the ambiguity of the figure, gazing out superciliously, high hairdo, right hand in pocket, the other thumb pressing down on the table. The caption quotes him as saying: "Gentlemen, the fair sex is the great delight of this life!".[17]

Judging from these and other references, art nouveau's capital crime seems to have been that it became too trendy too quickly. It was welcomed into the homes of the select few but equally appealed to the many who wanted to emulate their tastes. Without a doubt, the idea of art nouveau captured the popular fancy. During the first decade of the twentieth century, Rio de Janeiro boasted a lodging house called Pensão Art Nouveau (Praça José de Alencar) and a jeweller called Joalheria Art Nouveau (Rua do Ouvidor). In 1902, one purveyor of dentifrice, who promised "a breath of roses and white teeth", insistently peddled his product in the newspaper *O Paiz* under the unrelated header "Art Nouveau". Between 1904 and 1905, Art Nouveau was used as a title for a song and for a theatre play, as well as appearing in that of the short film *O chimico art nouveau* (the art nouveau chemist). An advertisement for a

[16] For a sampling of racialist connotations in usage of the terms *gaforinha* and *pernóstico*, cf. Vol-Taire, "Almanach das glorias. XXV J. Carlos", *Careta*, 8 October 1910, n.p.; Alfio, "Em columna de pelotões", *Fon-Fon!*, 15 September 1917, n.p.; João Pitanga, "A Ritinha", *Careta*, 22 October 1921, n.p.; Simeão Pechisbeque, "Jequi", *Careta*, 14 February 1925, 29.

[17] For more on K. Lixto's relationship to samba and carnival, see Chapter 2.

performance at Rio's Moulin Rouge theatre in 1907 announced the *"nec plus ultra* of art nouveau acrobatics".[18] The term became so ubiquitous that it even lent itself to deliberate parody. In 1902, *Tagarela* published a humorous piece announcing a new model of "art nouveau cane" which could be used by readers to strike their adversaries' heads. "The manner of use in this case is also extremely art nouveau [*art nouveausissima*]", the article assures, providing as hypothetical example a scuffle between journalist Paulo Barreto (the butt of many homophobic jokes in the magazine) and an imaginary rival.[19]

Within the visual arts, the label was far from being the object of unanimous approval. A 1906 article by poet Thomaz Lopes denounces "hideous art nouveau" as a purely commercial innovation, designed to sell art "like coloured shirts and Panama hats":

In Painting, Sculpture and Architecture, the mania of modernism has reached the point of inventing the most absurd, most impersonal, most anti-aesthetic, most angular, most garish thing, that goes by the name of Art Nouveau. New art! As if Art were a creation, a remodelling, an adaptation of fashion [. . .].[20]

This characterization of the style as a commercial fad, impersonal and garish, supports the contention that art nouveau was descending the social ladder too quickly for the comfort of those who considered themselves refined. The fact that this critique was published in *Kósmos* – one of the most deliberately art nouveau magazines – is not without significance. It points to a tension within the art world between differing conceptions of just what was acceptable in terms of artistic modernization. At the time he wrote the article, Lopes was serving as a diplomat in Spain. Most of the text is dedicated to analysing works of art in Madrid's Museo de Arte Moderno; and the gibes against art nouveau and *modern style* are a counterpoint to other productions of modern art towards which the author displays a more sympathetic disposition.

Art nouveau had its defenders too, and they were well-positioned within the art world. Not only up-and-coming artists Eliseu Visconti and Helios Seelinger embraced the style, but also writer and critic Gonzaga Duque, the most respected authority on art in Brazil, threw his

[18] *Correio da Manhã*, 20 October 1901, 6; *O Paiz*, 29 September 1902, 3; *O Paiz*, 30 October 1904, 6; *O Paiz*, 8 December 1905, 6; *O Paiz*, 22 July 1907, 6. On the Moulin Rouge, see Elysio de Carvalho, *Five o'Clock* (São Paulo: Antiqua, 2006 [1909]), pp. 41–43.
[19] "Bengalas 'Art nouveau'", *Tagarela*, 22 March 1902, 3.
[20] Thomaz Lopes, "Pintura", *Kósmos*, May 1906, n.p.

considerable weight behind their efforts. Other intellectuals like Paulo Barreto and Elysio de Carvalho – both linked to the enduring legacy of decadentism and dandyism – were supportive in strategic ways. Not coincidentally, these authors and artists were active in the periodicals highlighted in this chapter. The domain in which the art nouveau aesthetic was most fruitfully promoted and publicized was graphic arts. Particularly important are a handful of short-lived magazines of the 1900s, among which: *Atheneida* (1903), *Renascença* (1904–1908) and *Kósmos* (1904–1909). Their experimental efforts over the first decade of the century found direct continuity in more mainstream magazines over the 1910s and 1920s, including: *O Malho* (1902–1959), *Fon-Fon!* (1907–1958), *Careta* (1908–1960) and *Para Todos* (1919–1958). Produced by an overlapping network of writers and journalists, artists and illustrators, graphic and printing firms – some of whom worked on more than one of them at once – they represent a loose coalition gravitating around an aspiration towards modernity.

3.2 MODERNISM IN RIO DE JANEIRO, CIRCA 1900S

When Eliseu Visconti returned to Rio de Janeiro from Paris in November 1900, the atmosphere was very different from the city he had left behind seven years earlier. Despite the political and economic crises of the intervening years, the population had swelled; and the favela depicted in his pioneering images of 1890–1893 had become an integral component of the urban imaginary.[21] Instead of the upheavals that rocked the Republic in its early years, the new century ushered in a period of relative stability and prosperity, driven in part by the Amazon rubber boom. Opinions on cultural and artistic matters were also shifting in significant ways. New influences from abroad were welcomed, distinct from the well-worn axis that led from ENBA to the training grounds of Paris and back. Between 1901 and 1902, two other artists with whom Visconti was acquainted – Fiuza Guimarães and Seelinger – also returned from Europe after years in Munich, where both had been present at the height of the pioneering Secessionist movement there and the accompanying stir over the magazine *Jugend*, launched 1896.[22]

[21] See Chapter 1.
[22] See Arthur Valle, "'A maneira especial que define a minha arte': Pensionistas da Escola Nacional de Belas Artes e a cena artística de Munique em fins do oitocentos", *Revista de*

Within ENBA, momentous changes were taking place in terms of who could become an artist. After decades of attempting to wear down obstacles and barriers, women artists were finally being taken seriously. Just before Visconti's return, sculptor Julieta de França became the first woman to be awarded the travel prize and subsequently departed for Paris in 1901.[23] Afro-Brazilian artists likewise managed to achieve new levels of recognition, particularly the works of brothers João and Arthur Timotheo da Costa, both painters. The latter burst onto the scene, at the 1906 Salon, with *Portrait of a Black Man*, an intensely psychological portrait of a man in a hat smoking a cigarette, as well as a reclining nude knowingly titled *Free from Prejudice*.[24] Critics took notice of both pictures. Gonzaga Duque made mention of the latter's audacious composition, calling it a "note of rebellion in this midst". An anonymous critic, writing in *Correio da Manhã*, enthused that the portrait admirably captured "the expression of the impudent negro of our cities: an expression of audacity and deceitfulness". Bueno Amador, of *Jornal do Brasil*, described the painter as "a talented mestizo".[25] Despite the uphill nature of the black artist's struggle, Arthur Timotheo was awarded the travel prize to Europe at the following year's Salon.

Stylistically too the mood had changed. Audiences in Rio were more attuned to current tendencies coming out of Europe. Impressionism, naturalism and symbolism had all been duly processed, and art nouveau was the order of the day. A new generation, aged under forty, of artists and amateurs, enthusiasts and collectors was beginning to assert itself, epitomized by the private salon of Julia Lopes de Almeida and her husband Filinto de Almeida, both writers, or by the *Centro Artístico*, active between 1893 and 1902, which sought to bring together musicians, artists and writers sympathetic to tendencies then perceived as

História da Arte e Arqueologia, 13 (2010), 109–144; and Arthur Valle, "Bolsistas da Escola Nacional de Belas Artes em Munique, na década de 1890", *Artciencia*, 7 (2012), 1–16. See also Chapter 2.

[23] See Ana Paula Simioni, "*Souvenir de ma carrière artistique*. Uma autobiografia de Juleita de França, escultora acadêmica brasileira", *Anais do Museu Paulista*, 15, 1 (2007), 249–278; and Ana Paula Simioni, *Profissão artista: Pintoras e escultoras acadêmicas brasileiras* (São Paulo: Edusp/Fapesp, 2008).

[24] Both paintings are reproduced in *Revista da Semana*, 7 October 1906, 3954–3958.

[25] Gonzaga Duque, "Salão de 1906", *Kósmos*, September 1906, n.p.; CN, "O Salão de 1906", *Correio da Manhã*, 9 September 1906, 5; Bueno Amador, "Belas artes. O Salão de 1906", *Jornal do Brasil*, 26 September 1906, 2. See also "O Salão de 1906. A inauguração", *O Paiz*, 2 September 1906, 2; "Notas de arte", *Jornal do Commercio*, 23 September 1906, 4.

modernizing.[26] Their aesthetic tastes were different from the preceding generation, and they took particular interest in media that had long been devalued or ignored like prints and watercolours, increasingly to be found both in the ENBA Salon and elsewhere. Though it was still a far cry from anything that could be construed as modern, the art world in Rio was on the cusp of momentous change.[27]

Visconti too had changed as an artist. In Paris, he studied not only at the École des Beaux-Arts and Académie Julian, like so many of his contemporaries, but also and quite exceptionally under leading decorative artist Eugène Grasset at the École Normale d'Enseignement du Dessin, better known as École Guérin. Grasset's influence transformed the nature of his pupil's artistic output. Alongside painting, Visconti began to develop a body of work in decorative and applied arts. Schooled at the very heart of the Parisian art nouveau in the 1890s, the artist went on to take part in the Universal Exposition of 1900, where he was awarded a silver medal for the paintings *Mélancolie* (1898) – better known under the alternate title *Gioventù* – and *Les Oréades* (1899). Upon his return to Rio de Janeiro, he staged a solo exhibition at ENBA, in May 1901, in which 60 paintings were shown alongside 28 works of "decorative art applied to artistic industries", as stated in the catalogue, the cover of which was designed by the artist.[28]

The reception given to Visconti's 1901 exhibition was less triumphant than hoped.[29] Press coverage, though positive, was limited; and there were misunderstandings of key issues. Critic Araújo Vianna praised the

[26] See Michele Asmar Fanini, "Júlia Lopes de Almeida: Entre o salão literário e a antessala da Academia Brasileira de Letras", *Estudos de Sociologia*, 14 (2009), 320–324; Avelino Romero Pereira, *Música, sociedade e política: Alberto Nepomuceno e a República musical* (Rio de Janeiro: Ed. UFRJ, 2007), pp. 131–136; and Hilda Machado, *Laurinda Santos Lobo: Mecenas, artistas e outros marginais em Santa Teresa* (Rio de Janeiro: Casa da Palavra, 2002), pp. 66–69. On other intellectual salons of the time, see Carvalho, *Five o'Clock*, 35–41.

[27] An illuminating perspective on the art market at around this time is available in: Domicio da Gama, "O 'Salão' de Petrópolis", *Renascença*, April 1904, 77–81.

[28] Rafael Cardoso, "Dois ramos do mesmo tronco: Arte e design na obra de Eliseu Visconti", In: *Eliseu Visconti – Arte e Design* (Rio de Janeiro: Holos Consultores/Caixa Cultural, 2007), pp. 17–26. On Brazilian artists in Paris, see Ana Paula Cavalcanti Simioni, "A viagem a Paris de artistas brasileiros no final do século XIX", *Tempo Social*, 17 (2005), 343–366.

[29] Years later, Visconti complained that the exhibition went unnoticed; see Angyone Costa, *A inquietação das abelhas* (Rio de Janeiro: Pimenta de Mello & Co., 1927), pp. 77–81. This recollection is imprecise. Besides the reviews referenced here, the exhibition was noticed in the British magazine *The Studio*, which included two photographic reproductions; CAS "Studio-talk", *The Studio*, 26, 111 (June 1902), 70–71. The

artist's work effusively but went out of his way to distance it from the likes of Victor Horta or Hector Guimard, pontificating that it was by no means linked to:

the mercantile industrialism which, labelled *Modern style* or *Art nouveau* [terms written in English and French, in the original], goes about the world impinging debasements of the baroque with mangled mixtures of *japonisme*, the byzantine and banalities of a supposed *new*, as a *modern style* in art.[30]

Another critic, writing in the staid *Jornal do Commercio*, proved more knowledgeable about recent developments in design. He correctly identified Visconti's works with Grasset and art nouveau and explained, with propriety, the movement's debt to William Morris's philosophy of "an art made by the people, and for the people, as an element of happiness for those who make it and those who use it".[31] Displaying greater enthusiasm for Visconti's decorative works than for his paintings, the anonymous critic closed the review by recommending the exhibition to directors and workers of industries, who would find there, he writes, new ideas and broader horizons for the manufacture of their products. The advice was taken up by Americo Ludolf, a ceramics manufacturer, who hired the artist to produce a series of prototypes, later exhibited in the Salon of 1903 (Fig. 33).[32]

The divergence of critical opinions on Visconti's relationship to art nouveau underscores disputes around the term in its entry into the Brazilian art world. Such misgivings provide the backdrop for a front-page article championing the artist in *O Paiz*, over a month after the end of the exhibition. Its author was the influential critic Gonzaga Duque. The text begins by lamenting that Visconti's recent show had met with indifference and incomprehension, despite being "one of the most important exhibitions of art here made available to the public". Most of the article is devoted to painting, but it concludes with an appeal to manufacturers and government to support Visconti's efforts in the decorative arts. Invoking the "spectre of Ruskin", the author argues: "It is requisite to lessen the

exhibition was even visited by Epitácio Pessoa, then Minister of Justice and Internal Affairs and future President of Brazil; *A Notícia*, 16/17 May 1901, 1.

[30] Araújo Vianna, "A pintura decorativa", *A Noticia*, 24/25 May 1901, 3. This was presumably Ernesto da Cunha de Araújo Vianna; see chapter 2, note 33.

[31] "Notas sobre arte. Exposição E. Visconti", *Jornal do Commercio*, 16 May 1901, 2–3.

[32] "Salão de 1903", *Gazeta de Noticias*, 2 September 1903, 2; A. Morales de los Rios, "Exposição de Bellas Artes", *O Paiz*, 5 September 1903, 1; and "Ceramica aristica nacional", *Atheneida*, no. 8/9/10 [December 1903], 195.

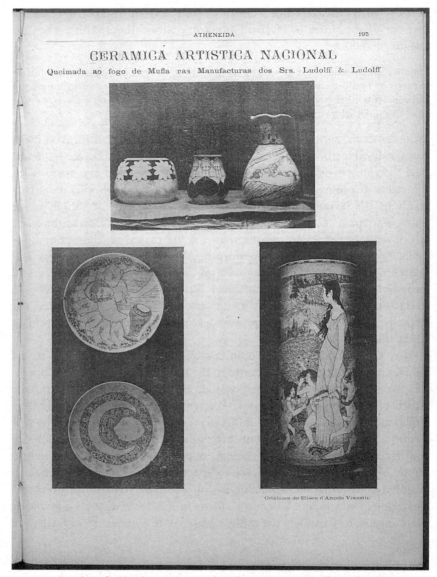

FIG. 33 Unidentified author, ceramics by Eliseu Visconti, *Atheneida*, [October/November/December] 1903
Rio de Janeiro: Fundação Biblioteca Nacional

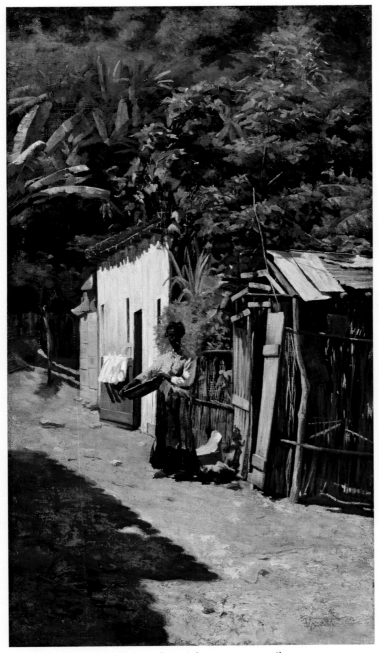

FIG. 1 Eliseu Visconti, *Uma Rua da Favela*, circa 1890, oil on canvas, 72 × 41 cm
Brasília: collection of Tatiana and Afrisio Vieira Lima

FIG. 6 Gustavo Dall'Ara, *Ronda da Favela*, 1913, oil on canvas, 74 × 88 cm
Rio de Janeiro: collection of Hercila and Sergio Fadel (photo: André Arruda)

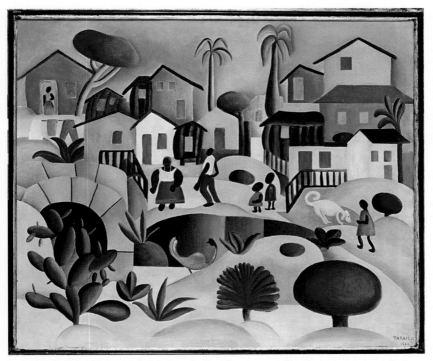

FIG. 7 Tarsila do Amaral, *Morro da Favela*, 1924, oil on canvas, 64 × 76 cm
Rio de Janeiro: collection of Hercila and Sergio Fadel (photo: André Arruda)

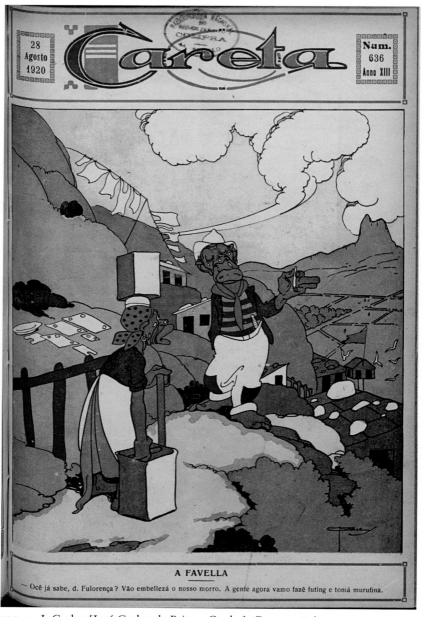

FIG. 9 J. Carlos [José Carlos de Brito e Cunha], *Careta*, 28 August 1920
Fundação Biblioteca Nacional (BN Digital/Hemeroteca Digital Brasileira)

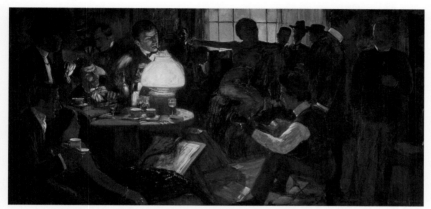

FIG. 17 Helios Seelinger, *Bohemia*, 1903, oil on canvas, 103 × 189.5 cm
Rio de Janeiro: Museu Nacional de Belas Artes/Ibram (photo: Jaime Acioli)

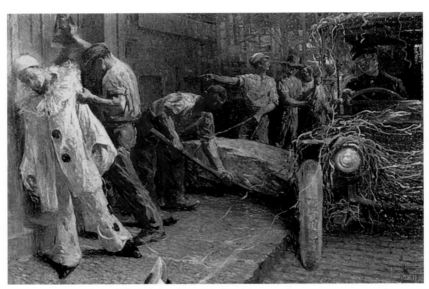

FIG. 26 Arthur Timotheo da Costa, *O Dia Seguinte*, 1913, oil on canvas, 85 ×
120 cm
Rio de Janeiro: private collection

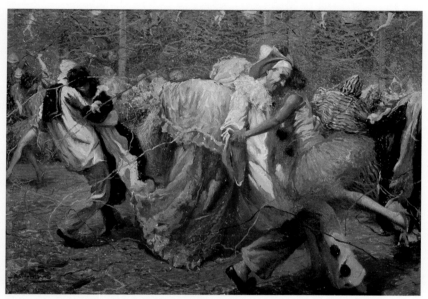

FIG. 27 Rodolpho Chambelland, *Baile à Fantasia*, 1913, oil on canvas, 149 ×
209 cm
Rio de Janeiro: Museu Nacional de Belas Artes/Ibram (photo: Jaime Acioli)

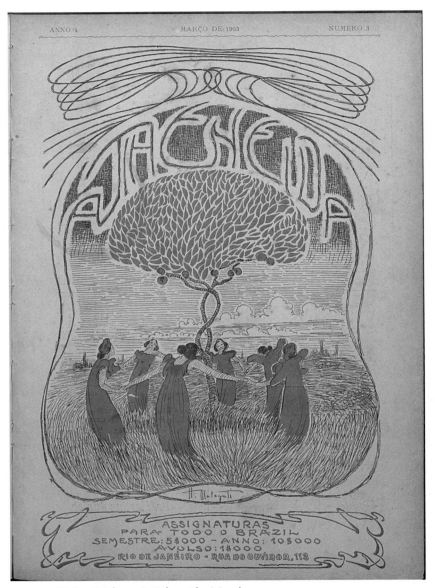

FIG. 31 Heitor Malagutti, *Atheneida*, March 1903
Rio de Janeiro: Fundação Biblioteca Nacional

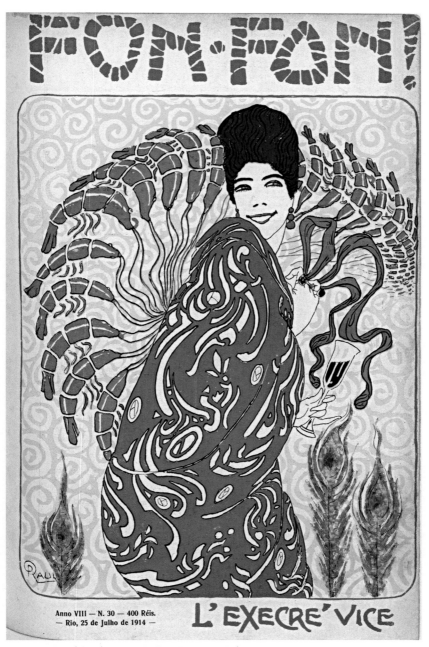

FIG. 41 Raul [Pederneiras], *Fon-Fon!*, 25 July 1914
Fundação Biblioteca Nacional (BN Digital/Hemeroteca Digital Brasileira)

FIG. 42 K. Lixto [Calixto Cordeiro], *Fon-Fon!*, 3 September 1910
Fundação Biblioteca Nacional (BN Digital/Hemeroteca Digital Brasileira)

FIG. 45 [Emiliano] Di Cavalcanti, *O Malho*, 9 August 1919
Fundação Biblioteca Nacional (BN Digital/Hemeroteca Digital Brasileira)

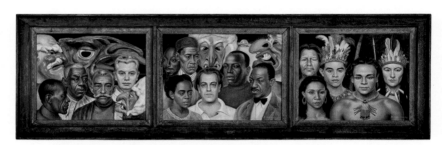

FIG. 56 Dimitri Ismailovitch, *Sodade do Cordão* (triptych), 1940, oil on canvas, 60.5 × 224.9 cm
Rio de Janeiro: Museu Nacional de Belas Artes/Ibram (photo: Museu Nacional de Belas Artes/Ibram)

violent effects of our civilization, to diminish the crassness of utilitarianism with the soft and gentle hand of gracefulness." His immediate practical suggestion was the creation of a course on decorative arts to be entrusted to Visconti who could thereby pass on the knowledge acquired in "the famous atelier of Grasset".[33] The reference to John Ruskin is not devoid of significance. Though Ruskin's spectre, as the critic calls it, was omnipresent in the months following his demise in January 1900, Gonzaga Duque's interest in the great theoretician of unity between arts and crafts would prove to be enduring.

The first issue of the magazine *Atheneida*, in January 1903, includes an article by Gonzaga Duque titled "Remodelling of the applied arts".[34] It is a spirited defence of "the new Art of the twentieth century" and represents a departure in aesthetic debates in Brazil. Citing the teachings of Ruskin and Grasset, among others, the text expounds on the role of art "in this turbulent bad time in which we live". The author enthuses about the "collective housing" built by Victor Horta in Brussels, numbering it among "the first triumphs of Socialism", with a capital S. He commends sculpture and painting for bursting out of their former constraints and coming "to cooperate with modern industry through the concourse of [their] thoughtful application". He thrills in "the marvels of this predicated *modern style*" – the latter term in English, in the original – the "reforming spirit" of which he credits with refashioning the applied arts and generating a "renaissance in the direct intervention of the arts of design [*desenho*] in industry".[35] Gonzaga Duque was clearly attuned to discussions in Britain and France surrounding the relationship between art and industry – so much so that he even advances what is likely one of the first Portuguese-language definitions of the concept of fitness for purpose. Reflecting on what he terms the "character of integrity [*probidade*]" that marks the "art of the useful object [*utensílio*] today", he ponders that their decoration and ornamental features "possess strict coherence with the particular purpose of each object and the most perfected relationship to the material of which it is made".[36]

With its explicit reference to socialism, Gonzaga Duque's text further illuminates the discursive tensions surrounding art nouveau and *modern style*. Already redolent of lower-class aspirations to mimic the lifestyle enjoyed by the rich, the 'new art' was further capable of encroaching

[33] Gonzaga Duque, "Elyseu Visconti", *O Paiz*, 2 July 1901, 1.
[34] Gonzaga Duque, "A remodelação das artes applicadas", *Atheneida*, January 1903, 3–6.
[35] Ibid., 4. [36] Ibid., 4, 6.

upon the dangerous terrain of insurgency against the established political order. Gonzaga Duque's enthusiasm for social housing and industrial design may surprise those familiar only with his reputation as a dandy or his ultra-refined prose style. Yet, the contradiction is only apparent. The critic was not alone in amalgamating a taste for symbolism and decadentism in the arts with a propensity towards radical politics. Writer and literary critic Elysio de Carvalho was one of the leading exponents of anarchism in Brazil over the early years of the twentieth century.[37] His 1907 collection of essays *Modern Aesthetic Currents in Brazilian Literature* – probably the first book dedicated to the discussion of "modern philosophical and aesthetic ideas" in Brazil – was brazenly enthusiastic about anarchism, socialism and communism.[38] If nothing else, the existence of that book is proof that the intention of defining modernism in aesthetic terms was already a concern during the first decade of the twentieth century.

Elysio de Carvalho's is an extreme example of a militancy more broadly shared. Among the writers featured in his 1907 book were Fabio Luz and João do Rio. The former was a leading anarchist, praised by Elysio for his success in explaining "the revolutionary aspirations that aim to achieve pure communism".[39] João do Rio had previously underscored the link between symbolism and socialism in a newspaper survey of contemporary writers, published 1905. In prefacing the opinions of Elysio, for instance, the author pointedly remarks that the tremendous young visionaries [*"tremendos jovens nephelibatas"*] of 1897 had become "today socialists".[40] The two writers drew close; and, in 1909, Elysio

[37] Elysio performed an about-face on anarchism after 1909. His writings turned deeply conservative and increasingly aligned with Catholicism, as well as occasionally anti-Semitic. He subsequently became a specialist in police forensics and criminal anthropology. He also went on to edit the nominally modernist magazine *America Brasileira* (1923–24), in proximity with members of the *Semana* group. See Lená Medeiros de Menezes, "Elysio de Carvalho: Um intelectual controverso e controvertido", *Revista Intellectus*, 4 (2004); Luiz Edmundo Bouças Coutinho, "O diário de um esteta decadentista", In: Carvalho, *Five o'Clock*, 7–15; Maria Vânia de Souza, *Modernismo e modernidade: A trajetória literária do alagoano Elysio de Carvalho* (Maceió: Edufal, 2013); and Diego Galeano & Marília Rodrigues de Oliveira, "Uma história da *História natural dos malfeitores*", In: Elísio de Carvalho, *Escritos policiais* (Rio de Janeiro: Contracapa/Faperj, 2017), pp. 15–27.

[38] Elysio de Carvalho, *As modernas correntes esthéticas na literatura brazileira* (Rio de Janeiro: H. Garnier, 1907), pp. vii, 20, 77–87, 239–245, 260–261.

[39] Ibid., 83.

[40] João do Rio, "O momento litterario. Elysio de Carvalho", *Gazeta de Noticias*, 28 May 1905, 4. This survey of contemporary writers originally appeared in instalments between

dedicated his bizarre diary of an aesthete, *Five O'Clock*, to Paulo Barreto. Fabio Luz, who was also included in João do Rio's 1905 survey, was later recalled by Gonzaga Duque for his "power of fascination". This reference occurred in a memoir dedicated to their fellow decadentist Camerino Rocha. Among the latter's claims to aesthetic refinement, Gonzaga Duque credits him with having read Pyotr Kropotkin, Elisée Reclus and all the authors of Italian socialism.[41] Over the first decade of the twentieth century, this small band of writers and artists in Rio de Janeiro saw no contradiction in amalgamating revolutionary politics, literary symbolism and decadentist dandyism.

The turn of phrase employed by João do Rio, referring to the young visionaries of 1897, is worthy of greater scrutiny. *Nefelibata* (in today's spelling) is an uncommon word, meaning literally someone who has their head in the clouds. It was often used in Brazil and Portugal to refer to the literati of the *fin-de-siècle*, especially in a pejorative sense. It recurs repeatedly in João do Rio's survey to evoke a group of young writers that formed around Gonzaga Duque, journalist Lima Campos and poet Mario Pederneiras in the 1890s. The latter described them in the following terms: "It was the time of the rebellious bohemianism of the 'new generation' [*dos 'novos'*] with its long train of ephemeral magazines and an extraordinary waste of talent and energy."[42] Among the magazines he must have had in mind was *O Mercurio*, a sporadic illustrated periodical aiming to revolutionize commercial advertising in Rio through the

March and May 1905. It was published in book form in 1909, with added material. See João Carlos Rodrigues, *João do Rio: Vida, paixão, obra* (Rio de Janeiro: Civilização Brasileira, 2010), pp. 53–57. For analogous references, see João do Rio, *O momento literario* (Rio de Janeiro: H. Garnier, [1909]), pp. 119, 206, 256, 260–262.

[41] Gonzaga Duque, "Chronica da saudade", *Kósmos*, October 1908, n.p. On Fabio Luz, see Alex Brito Ribeiro, "Entre a literatura e a história: Fábio Luz e o *Ideólogo*", *Veredas da História*, 8 (2015), 41–68. To some extent, the contention that radical politics had roots in the literary world is further applicable to José Oiticica, who went on to become a leading figure in the Brazilian anarchist movement. See Antonio Arnoni Prado, "Elucubrações dramáticas do professor Oiticica", *Estudos Avançados*, 14 (2000), 267–297; and Antonio Arnoni Prado, "Boêmios, letrados e insubmissos: Nota sobre cultura e anarquismo", *Revista Iberoamericana*, 70 (2004), 721–733. See also F. Luizzetto, "Letras rebeldes: Escritores brasileiros e o anarquismo no início do período republicano", *Teoria e Pesquisa: Revista de Ciência Política*, 1 (1992).

[42] João do Rio, *O momento literario*, p. 217; see also pp. 81, 256. Mario Pederneiras recalled being labelled the "*dernier cri do nephelibatismo*" by a critic in the 1890s and taking it as an "insult". For more on the trio and their impact on the literary scene around 1900, see Rodrigo Octavio (Filho), *Velhos amigos* (Rio de Janeiro: José Olympio, 1938), pp. 55–65.

promotion of posters as vehicles of publicity.[43] The experiment was short-
lived, lasting less than a year in 1898, but helped consolidate a network of
authors and intellectuals that would remain active over the following
decade and go on to shape a series of much more influential periodicals
like *Kósmos* and *Fon-Fon!*[44] In hindsight, *O Mercurio* was perhaps most
important for including two artistic contributors into the group: illustra-
tors Raul, Mario's brother, and K. Lixto.[45]

In the decade between 1898 and 1908, a loose coalition of like-minded
artists and writers took shape in Rio de Janeiro around a common project
of artistic modernization, the main outlet of which was the periodical
press. Its intellectual sponsor was Gonzaga Duque, a figure who strategic-
ally bridged the worlds of art, literature and journalism until his prema-
ture death in 1911, at the age of forty-seven.[46] His 1908 portrait by
Visconti (Fig. 34) – contemplating the unseen through the bluish lenses
of the dark glasses he habitually wore – is the picture of a deep and subtle
thinker, a man whose insight is precise as the grip with which he elegantly
pinches his cigarette between thumb and forefinger. Though they were
subdivided into smaller groups, virtually all the participants in this net-
work professed allegiance to the great critic; and his name recurs in the
various editorial projects they pursued – including crucially the three

[43] *O Mercurio*, June 1898, 1–2. See Petry, *Revistas como exposições*, pp. 242–269; Leticia
Pedruzzi Fonseca, *Uma revolução gráfica: Julião Machado e as revistas ilustradas no
Brasil, 1895–1898* (São Paulo: Blucher, 2016), pp. 252–277; and Mônica Pimenta
Velloso, *Modernismo no Rio de Janeiro: Turunas e Quixotes* (Rio de Janeiro: Fundação
Getúlio Vargas, 1996), pp. 60–63.

[44] "A familia de 'Fon-Fon!'", *Fon-Fon!*, 10 April 1909, n.p. See also Vera Lins, "Em
revistas, o simbolismo e a virada de século", In: Claudia de Oliveira, Monica Pimenta
Velloso & Vera Lins, *O moderno em revistas: Representações do Rio de Janeiro de
1890 a 1930* (Rio de Janeiro: Garamond, 2010), pp. 18–26; and *Fon-Fon! Buzinando a
modernidade* (Cadernos de Comunicação, Série Memória, 22) (Rio de Janeiro: Secretaria
Especial de Comunicação Social, 2008).

[45] Gonzaga Duque, "Dos caricaturistas novos. III Calixto Cordeiro", *O Paiz*, 5 June 1901,
1. Cf. Gonzaga Duque, *Contemporaneos (pintores e esculptores)* (Rio de Janeiro: Typ.
Benedicto de Souza, 1929), pp. 236–237, 241–242.

[46] Suggestively, Gonzaga Duque's novel *Mocidade morta* (1899) revolves around the clash
between a group of young artists and writers, described as rebels [*insubmissos*], and the
established powers of the academy. The rebels organize themselves into a group called
Zut but fail in their challenge to upend the system and eventually succumb to the
contradictions of their own bohemianism. See Lins, "Em revistas, o simbolismo e a virada
de século", 30–34; and Castro Gomes, *Essa gente do Rio*, 33–38. See also Peregrino,
"Um sorriso para todas", *Careta*, 1 February 1930, 28–29, which credits Gonzaga
Duque with having been the gravitational centre of Rio's literary youth at the turn of
the twentieth century.

FIG. 34 Eliseu Visconti, *Retrato de Gonzaga Duque*, 1908, oil on canvas, 92.5 ×
65 cm
Rio de Janeiro: Museu Nacional de Belas Artes/Ibram (photo: Jaime Acioli)

magazines *Atheneida*, *Renascença* and *Kósmos*, which together represent
the zenith of art nouveau graphics in Brazil.

It was in the pages of *Kósmos*, in 1907, that Gonzaga Duque again
took up the subject of art nouveau in the article "Remodelling of furni-
ture", the title of which echoes the text on applied arts published in
Atheneida, four years earlier. Tracing the evolution of furniture design
since 1789, the piece culminates in a spirited defence of art nouveau as
more than just a style of ornament but, rather, an expression of modern
life based on the meticulous study of nature and its analytical transform-
ation into constructed forms.[47] Alongside a third article, of 1904 – in which
the critic published part of a planned book on the history of caricature in
Brazil, which was to remain unfinished – these two texts constitute a core
of reflections on the centrality of design and applied art which help flesh
out Gonzaga Duque's spirited defence, in 1901, of Visconti's efforts to

[47] Gonzaga Duque, "Remodelação do mobiliário", *Kósmos*, February 1907, n.p.

unite art and industry.[48] Consistently over the first decade of the twentieth century, the critic put forward a vision of modernity in art as the application of aesthetic principles to the practical necessities of life and the transformation of social relationships. Yet, this politically committed vision was never utilitarian. True to his symbolist sensibilities, he advocated stylistic refinement alongside revolutionary ideals.

If Gonzaga Duque provided an abstract model for the modernizing spirit of a generation, at least a part of the following he inspired manifested its concrete existence in more mundane spaces of coexistence. Most of them were writers or artists, and several are portrayed, along with their aesthetic mentor, in Seelinger's painting *Bohemia*.[49] Many were engaged in producing the three art nouveau magazines – *Atheneida*, *Renascença* and *Kósmos* – that refashioned the graphic arts scenario in Rio between 1903 and 1909. They congregated at the Café Paris (Largo da Carioca), a location notorious in the early years of the twentieth century for its debauchery and raucous nocturnal carousal – including drunken disturbances, knife fights and even gunshots – amply reported in the police and crime pages of the newspapers.[50] Although it appears to have been more respectable during the daytime, it became a "focus of disorders" after the doors closed at one a.m. and, later still, when customers spilled out into the street in the early morning.[51] By 1904, its reputation was such that the police reportedly responded to a call to an incident there with the reply: "We have better things to do!"[52] The other location where the inner sanctum of the *Bohemia* group could meet in private was Seelinger's

[48] Gonzaga Duque, "A caricatura no Brasil. Os caricaturistas de costumes", *Renascença*, March 1904, 36–39. Cf. Gonzaga Duque, *Contemporâneos*, in which other texts constituting this study were published posthumously.

[49] See Chapter 2. This group was remembered as *"os promptos do Café Paris"* by Luiz Edmundo in his memoirs of 1938. *Pronto* (in current spelling) means *ready*, but its slang use at the time referred to having no money. The term appeared in the magazine *A Avenida*, in 1903, to designate a series of portraits of artists and writers; cf. Domingos Ribeiro Pinho, "O Gil", *Renascença*, March 1906, 138–141. See Marcelo Balaban, *Estilo moderno: Humor, literatura e publicidade em Bastos Tigre* (Campinas: Ed. Unicamp, 2016), pp. 183–192; and Pimenta Velloso, *Modernismo no Rio de Janeiro*, pp. 44–56.

[50] See, among others, *O Paiz*, 29 March 1901, 2; *Gazeta de Noticias*, 2 June 1901, 2; *O Paiz*, 3 June 1901, 2; "Roubado", *Correio da Manhã*, 17 June 1901, 2; "No Café Pariz", *Gazeta de Noticias*, 22 October 1901; "Na policia e nas ruas", *Correio da Manhã*, 2 September 1902, 2; "Crime?", *Gazeta de Noticias*, 27 November 1902, 1; *Gazeta de Noticias*, 1 January 1903, 3; "Na policia e nas ruas", *Correio da Manhã*, 15 June 1903, 2; "Na policia e nas ruas", *Correio da Manhã*, 13 December 1903, 2; "Na policia e nas ruas", *Correio da Manhã*, 3 May 1904, 2; *O Paiz*, 15 April 1905, 2.

[51] "Reclamações", *Correio da Manhã*, 3 November 1901, 3.

[52] "No Café Paris", *Correio da Manhã*, 14 November 1904, 2.

studio, in the neighbourhood of Catete, a place known by the name *A Furna* [the cavern] among the initiated.[53] According to the account of Elysio de Carvalho, writing in 1909, artists including Araújo Vianna, Camerino Rocha, Fiuza Guimarães, Heitor Malagutti, K. Lixto, Raul and Seelinger would meet there during the day, where they might partake in luncheons "that always ended in a fantastic cakewalk" and then move on in the evening to the restaurant G. Lobo and finally the "celebrated nights of the Café Paris".[54] The list of participants and mention of the cakewalk are redolent of the bohemianism discussed in Chapter 2.

The existence of an insurgent bohemian coterie in Rio de Janeiro, over the first decade of the twentieth century, is of decisive importance to fleshing out conceptions of modern art within that historical context. Elysio de Carvalho wrote approvingly of a "refined modernism" in 1909, and there can be little doubt that he meant by it the *modernismo* of Rubén Darío, whom he cited and whom he met upon the occasion of the latter's visit to Rio de Janeiro in 1906.[55] In fact, Elysio authored a small book introducing Darío to Brazilian audiences and hailed him for revolutionizing poetry by introducing "free verses, freed from all convention, emancipated from the fixed rules of ancient metre".[56] Elysio's friend Camerino Rocha – the bohemian aesthete and member of the *Furna* clique to whom a major section of *Five O'Clock* is dedicated – preceded him by several years in discussing the relationship between "modern art" and a "new conception of life".[57] That the vehicle for

[53] A contemporary description of the studio and its owner is available in: Camerino Rocha, "A grande arte nos pequenos ateliers", *Atheneida*, April 1903, 55–56.

[54] Carvalho, *Five o'Clock*, pp. 63–64, 121. Cf. Rodrigues, *João do Rio*, p. 39. By 1906, the Café Paris group had become dispersed and its heyday was consigned to memory; see Jayme Guimarães, "Theorias", *Correio da Manhã* (Supplemento Illustrado), 17 June 1906, 2; and Oswaldo Shondali, "Um pintor", *Correio da Manhã*, 7 July 1908, 1. The group recurs, in sanitized terms, in the memoirs of Luiz Edmundo, *O Rio de Janeiro do meu tempo* (Brasília: Senado Federal, 2003 [1938]), p. 345. Cf. Rodrigues, *João do Rio*, pp. 37–38.

[55] Carvalho, *Five o'Clock*, pp. 30, 32–35, 69.

[56] Elysio de Carvalho, *Rubén Darío* (Rio de Janeiro: Imprensa Nacional, 1906), pp. 15, 35–36.

[57] Camerino Rocha, "Sympathia humana na arte moderna", *Atheneida*, January 1903, 1–3. This essay was rediscovered and reprinted by Lima Barreto in 1919 in a text titled "As pequenas revistas" which, in its turn, was included in the anthology *Feiras e mafuás*, first published in 1953. It is possibly the only writing by Camerino Rocha to have achieved any sort of posterity, after his death from tuberculosis in 1906. Although he was revered by his contemporaries, like Gonzaga Duque and Elysio de Carvalho, Lima Barreto affirms that Camerino was already forgotten in 1919. See Beatriz Resende & Rachel Valença, eds., *Toda crônica: Lima Barreto* (Rio de Janeiro: Agir, 2004), pp. I, 505–510. See also

doing so was *Atheneida* magazine, in the same inaugural issue that contains Gonzaga Duque's essay on art nouveau, confirms the currency of such debates beyond the anecdotal memories of the Café Paris. The photographic reproduction of Seelinger's painting *Bohemia* in the same magazine is further proof of the group's self-perception as a movement. The short-lived *Atheneida* is possibly the closest thing to a manifesto that it produced.

3.3 ART NOUVEAU MAGAZINES OF THE EARLY 1900S

Considering that Helios Seelinger is almost forgotten as an artist today, the level of his renown over the first decade of the century is nothing short of astonishing. Besides numerous reviews and articles by less prominent critics, his work attracted the attention of three outstanding literary personalities of the day: Paulo Barreto, who rarely wrote about art but dedicated an article to him in *Atheneida* in 1903; Gonzaga Duque, whose four-page essay in *Kósmos* in 1908 anointed Seelinger as the great hope of a Brazilian painting at once modern and decorative; and Elysio de Carvalho, who singled him out as practically the only visual artist worthy of notice in his 1909 aesthetic diary of Rio de Janeiro.[58] The concurrence of these three endorsements, all coming out of the *Furna* coterie noted in the preceding section, is itself a historical anomaly that merits further investigation.[59] The posthumous obliteration of Seelinger's reputation can be traced to two main factors: firstly, the dispersal of his early work, largely missing from major collections and therefore hidden from public view, and secondly, his adoption of a conservative – literally, reactionary – position against modern art after the 1930s and into his old age.[60] A third factor that hampers proper historical evaluation of Seelinger's influence is the almost exclusive preoccupation with fine art within the historiography of artistic modernism in Brazil. Despite his abundant activity as a painter, Seelinger's greatest achievements were, arguably, in

Gonzaga Duque, "Chronica da saudade"; and Carvalho, *Five o'Clock*, pp. 43–47. Cf. Balaban, *Estilo moderno*, pp. 187–189.

[58] Paulo Barreto, "O ideal de Helios Seelinger", *Atheneida*, January 1903, 7–8; Gonzaga Duque, "Helios Seelinger", *Kósmos*, March 1908, n.p.; Carvalho, *Five o'clock*, 62–66.

[59] Although Paulo Barreto was the only one openly identified as homosexual in contemporary gossip, a residual undercurrent of animosity against the dandyism shared by all three authors has tended to obscure the importance of their artistic opinions. Cf. Rodrigues, *João do Rio*, pp. 65–69.

[60] See Arthur Valle, "Helios Seelinger: Um pintor 'salteado'", *19&20*, 1 (2006).

FIG. 35 Helios Seelinger, *Atheneida*, April 1903
Rio de Janeiro: Fundação Biblioteca Nacional

the domain of illustration and graphics, as well as in the performative dimension of his notorious bohemianism – the aspect for which he was best known during his years of early success.

Along with journalist Trajano Chacon, the magazine's founder and editor, Seelinger was the driving force behind the monthly magazine *Atheneida*, a small publication lasting only eight issues, over 1903 (Figs. 35–36).[61] He is the illustrator most present in its pages, which also feature artwork by Lucilio de Albuquerque, Rodolpho Amoedo, J. Arthur, Henrique Bernardelli, José Correia de Lima, Fiuza Guimarães, K. Lixto, Adolfo Morales de los Rios and Raul. The magazine is profusely illustrated and contains many high-quality photographic reproductions. Among its advertisers is J. Garcia, an engraving workshop offering services including photogravure, zincography, photozincography and

[61] Confusingly, the issues are numbered 1–10, but the final one is a composite of three (nos. 8, 9, 10) and was published without a date. The first seven issues are dated consecutively January to July 1903 but were not necessarily published on time. The July issue, for instance, contains coverage of the 1903 Salon, which only took place in September. Fundação Biblioteca Nacional houses a complete collection.

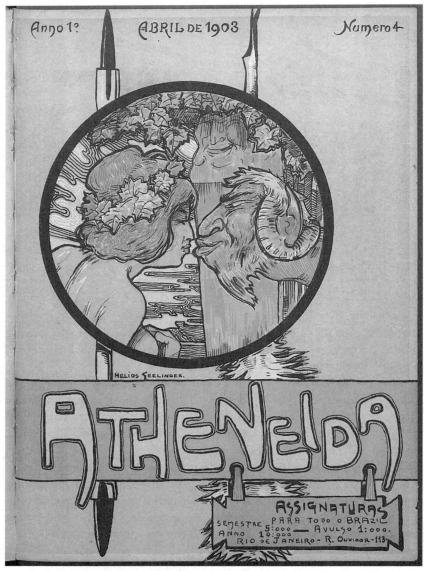

FIG. 36 Helios Seelinger, *Atheneida*, April 1903
Rio de Janeiro: Fundação Biblioteca Nacional

photo-typing. Three other printing firms also advertised in *Atheneida* over its brief existence, most likely in exchange for free or discounted services. The results are visible in the pages of the magazine. Its covers were printed in up to four colours, with occasional colour printing in the

inner pages too. This quality is also reflected in the price: one issue of *Atheneida* cost one *mil-réis*, ten times the price of competitors like *Tagarela* or *A Avenida*, still produced using simpler techniques of combined lithographic and typographic printing, typical of nineteenth-century periodicals.[62]

Although *Atheneida* was short-lived, its influence was outsized among the bohemian coterie who went on to produce two other monthly magazines that followed in its wake in 1904: *Kósmos* and *Renascença*. Writing in the former in 1908, Gonzaga Duque recalled "the gorgeous magazine" with utmost sympathy: "*Atheneida* holds for me the sweetness of longing [*saudade*]."[63] Yet, if *Atheneida* laid the foundations in terms of graphic arts, *Kósmos* and *Renascença* represent the complete built edifice. In the inaugural editorial of the former, poet Olavo Bilac dwelt on its material perfection:

Kósmos [...] would not be novel in Europe or North America, where the illustrated *magazine* [in English, in the original] is today a marvel, in the variety of literary and artistic matter, in the perfection of its graphic processes, and in its affordability. But, in Brazil, I believe it represents major progress.[64]

Excepting the remark on affordability – a single issue cost two *mil-réis* – Bilac's boast is no exaggeration. The quality of paper and printing of *Kósmos* remained practically unsurpassed until the 1920s; and the magazine experimented with novelties including metallic inks and coloured photographic plates.[65] Like *Atheneida*, one of its major advertisers was a printing firm, Augusto Niklaus & Cia., specializing in technical processes and supplies for graphic arts. The magazine's proprietor, Jorge Schmidt, was owner of the typographic workshop J. Schmidt, the name of which appears in a colophon at the back of the early issues and was subsequently changed to Kósmos. A third printing firm, Companhia Typographica do Brazil, specializing in printing presses, machinery and supplies, was also a frequent advertiser.

[62] *Atheneida* does not appear to have relied on sales and subscriptions for income. The magazine possessed an abundance of advertisers which grew to a proportion of almost half the edition in its bumper 72-page final issue. The motives for its demise were probably not financial. Trajano Chacon was deeply involved in political disputes, especially in his native Pernambuco, and actually died in a politically motivated assassination in 1913.

[63] Gonzaga Duque, "Chronica de uma saudade", n.p.

[64] OB, "Chronica", *Kósmos*, January 1904, n.p.

[65] Cardoso, *Impresso no Brasil*, 144–145.

Kósmos was undoubtedly a luxury magazine, intended for an elite audience. Its contributors represented an ample cross-section of the country's literary scene, and, in this sense, it was both more conservative and less cliquish than *Atheneida*.[66] Among its most frequent authors were Gonzaga Duque, Lima Campos, João Luso and Paulo Barreto, names that had graced the pages of its predecessor, to which were added others like Bilac, Mario Pederneiras and Mario Behring, the magazine's editor-in-chief.[67] The list of contributing artists and illustrators similarly mixed *Atheneida* regulars – K. Lixto, Raul, Malagutti – with established names from the fine arts milieu like Visconti and Amoedo. Unusually, *Kósmos*'s table of contents frequently billed the names of its artistic collaborators alongside authors of texts, attesting to the premium its editors placed on the visual. Though sober, its design was subtly playful and given to frequent experimentation with headers, borders and titles. In terms of content, *Kósmos* was ostensibly concerned with literature and society but frequently made room for visual art. In 1904, it published a pioneering article on 'negro sculpture', by ethnologist Nina Rodrigues, probably the first text in Brazil to consider Afro-Brazilian culture as 'fine art' (*belas-artes*), in so many words.[68]

An equal, if not greater, preoccupation with visual excellence is apparent in *Renascença*, the third of the great art nouveau magazines of the 1900s. Its first issue was published in March 1904, two months after the appearance of *Kósmos*, and it quite unabashedly vied for the same reading public, with the competitive edge of costing slightly less – one and a half *mil-réis*. Its full name was *Renascença: Monthly Magazine of Letters, Science and Art*, almost an exact counterpart to *Kósmos: Artistic, Scientific and Literary Magazine*.

[66] For more on the magazine's textual content, see Antonio Dimas, *Tempos eufóricos: Análise da revista Kósmos 1904–1909* (São Paulo: Atica, 1983). Brazilian literary historians traditionally emphasize disputes between parnassianism and symbolism as the dominant stylistic debate of the period. The group around *Kósmos* is strongly aligned with symbolist currents, but the leading parnassianist Olavo Bilac was among the magazine's frequent contributors.

[67] Mario Behring was employed in the manuscripts department of the National Library, in Rio de Janeiro, and served as that institution's director from 1924 to 1932. After his time as editor-in-chief of *Kósmos*, he went on to direct the magazines *Careta* and *Para Todos*, the latter alongside Alvaro Moreyra. In 1926, he founded the cinema magazine *Cinearte*, which he edited together with Adhemar Gonzaga, until his death in 1933. In addition, he was extremely active as a Freemason and is regarded as one of the modernizers of Masonic rites in Brazil. See "Dr. Mario Behring", *Cinearte*, 1 July 1933, p. 5. Cf. *Para Todos*, 6 October 1923, 22; and *Para Todos*, 22 March 1924, n.p.

[68] Nina Rodrigues, "As bellas-artes nos colonos pretos do Brazil. A esculptura", *Kósmos*, August 1904, n.p. See Roberto Conduru, *Pérolas negras, primeiros fios: Experiências artísticas e culturais entre África e Brasil* (Rio de Janeiro: Ed. Uerj, 2013), pp. 315–325.

In fact, the newer publication's first editorial cited *Kósmos* as a forerunner in the "effort towards the development of the graphic arts in Brazil" and explained that the name *Renascença* aimed to underscore "the tendency of outright aesthetic renaissance" that its authors perceived was at hand.[69] The list of its contributors contains many names familiar from the other two periodicals, including Araújo Vianna, Elysio de Carvalho, Gonzaga Duque, Luiz Edmundo, João do Rio, Lima Campos and Mário Pederneiras. Among the illustrators, Malagutti and Seelinger both published in the magazine, though less frequently than in *Atheneida*. The topics discussed in *Renascença* cover a wide range, but art and music were at the forefront of its concerns. The magazine's outlook was broad enough to encompass a long and enthusiastic article on anarchist philosopher Max Stirner, by Elysio de Carvalho, as well as the first ever text to give serious consideration to the development of favelas, by engineer Everardo Backheuser.[70]

Renascença's attention to the visual arts was considerably more pronounced than *Kósmos*. Unlike its rival, the newer magazine had two chief editors: author, lawyer and professor Rodrigo Octavio and painter Henrique Bernardelli.[71] The latter's co-equal status must certainly have meant that he was responsible for supervising the visual content, and indeed his drawings and paintings are frequently reproduced in its pages, as are the works of his brothers Rodolpho and Felix Bernardelli.[72] Much older than the majority of artists under consideration in this chapter, Henrique had been perceived as a modernizer in his youth, particularly by Gonzaga Duque who was among his earliest supporters, labelling him "a revolutionary in art" and comparing his role in Brazil to that of Manet in France.[73] Over the 1890s and 1900s, he exercised considerable influence on a generation of younger artists through

[69] *Renascença*, March 1904, 1–2. The use of the term "renaissance" echoes Gonzaga Duque's affirmation of the previous year. See note 35.

[70] Elysio de Carvalho, "Max Stirner", *Renascença*, February 1907, 61–69; and Everardo Backheuser, "Onde moram os pobres", *Renascença*, March 1905, 89–94. On the latter, see Chapter 1.

[71] Rodrigo Octavio was to become extremely influential in Brazilian government, serving as chief attorney (*consultor-geral da República*), between 1911 and 1929, and subsequently as a justice on the Supreme Court, from 1929 to 1934. He was also a member of the Brazilian Academy of Letters from its foundation in 1897.

[72] Henrique Bernardelli was known to produce occasional works of graphic art, such as designs for diplomas. Among the over 500 works on paper by him in the collections of the Pinacoteca do Estado de São Paulo, almost a dozen are studies for graphic design.

[73] Gonzaga Duque, *A arte brasileira* (Campinas: Mercado de Letras, 1995 [1888]), 187–190; and "Bellas-artes", *Gazeta de Notícias*, 31 March 1890, p. 1. See also Camila Dazzi, "Revendo Henrique Bernardelli", *19&20*, 2 (2007).

the workshop training provided in the private studio he shared with his elder brother Rodolpho, director of ENBA from 1890 to 1915.[74]

Renascença's graphic design was ground-breaking. Sharing *Kósmos*'s taste for art nouveau borders, titles and ornaments, it pushed the aesthetic even further, extending it to the covers of its frequent musical supplements and even to advertisements (Fig. 37). More importantly, it set itself apart from its predecessors through modernized page design, including greater attention to typography and fonts, as well as purposeful use of white space in layouts. The aspect in which it departed most markedly from either of its predecessors was the way it employed photography. Differently from *Atheneida*, still heavily illustrated by hand, and *Kósmos*, more densely occupied by text, *Renascença*'s distinguishing feature is the quantity and variety of photographic reproductions. By 1904, printed photographs were a common feature of the Brazilian media landscape, but the magazine made innovative use of them. It was the first publication in Brazil to print colour photographs via a three-colour process (trichromy), in 1904.[75] Another remarkable example is a two-page spread in the January 1908 issue featuring a photograph of the Second Hague Conference (1907). A few pages later, a second spread blows up a detail of the image (Figs. 38–39). It has been retouched to heighten faces and emphasize the role of the Brazilian delegation at the plenary conference. This kind of experimentation with photo manipulation was certainly not standard practice.

Renascença's editors were justifiably proud of their graphic achievements. The retouched photo is marked with the monogram EBC, signature of the magazine's proprietors, E. Bevilacqua & Cia., a major producer of sheet music and musical editions. The firm had much experience in the domain of printing, which they showcased in the magazine via expensive materials like metallic inks and complicated processes of colour reproduction. Bevilacqua's printing services were openly advertised in *Renascença*, which further discussed the technological capabilities of the firm's new machines in its articles.[76] Among the magazine's regular

[74] A steady stream of artists – and, notably, many women artists – passed through the doors of their successive studios in Lapa and in the newly developing beach-front district of Copacabana, where they set up house after 1908. Visconti, Seelinger, Lucilio de Albuquerque and Arthur Timotheo da Costa numbered among Henrique's many pupils. See Costa, *A inquietação das abelhas*, 27–31.

[75] These were reproductions of a watercolour of a Japanese street scene and a painting by Victor Meirelles, respectively in March and June 1904.

[76] João de Barro, "Eugenio Bevilacqua", *Renascença*, February 1907, 54–56. For more on the firm, see Mônica Neves Leme, "Isidoro Bevilacqua e filhos: Radiografia de uma empresa de edição musical", In: Antonio Herculano Lopes, Martha Abreu, Martha Tupinambá de Ûlhoa & Monica Pimenta Velloso, eds., *Música e história no*

FIG. 37 Unidentified author, *Renascença*, August 1905
Fundação Biblioteca Nacional (BN Digital/Hemeroteca Digital Brasileira)

longo século XIX (Rio de Janeiro: Fundação Casa de Rui Barbosa, 2011), pp. 117–160; and Rosa Maria Zamith, *A quadrilha, da partitura aos espaços festivos: Música, dança e sociabilidade no Rio de Janeiro oitocentista* (Rio de Janeiro: E-papers, 2011), 19–38.

FIG. 38 Unidentified author, *Renascença*, January 1908
Fundação Biblioteca Nacional (BN Digital/Hemeroteca Digital Brasileira)

FIG. 39 E. Bevilacqua & Cia., *Renascença*, January 1908
Fundação Biblioteca Nacional (BN Digital/Hemeroteca Digital Brasileira)

advertisers were other companies linked to graphic arts and the printing industry, including the aforementioned A. Niklaus & Co. and Companhia Typographica do Brazil, as well as the photographer L. Musso & Co. whose signature appears on many photo-engravings that illustrate the magazine. Luiz Musso was an active member of the Rio de Janeiro Photo Club.[77] At least one member of the Bevilacqua family, Sylvio Bevilacqua, was also a member; and the exhibitions staged by that society received ample coverage in *Renascença*.[78] These manifold links to the printing industry and the milieu of commercial photography help shed light on the magazine's graphic prowess, which it marketed unabashedly. Captions accompanying images make frequent reference to the quality of photographic reproductions or to breakthroughs in colour printing and even go so far as to name suppliers of special inks.

The interrelationships between artists, authors, editors and publishing firms in these three art nouveau magazines indicate that a vibrant periodical publishing industry was taking shape over the first decade of the twentieth century. It is important to bear in mind that printing was prohibited in Brazil during the colonial period, which means that the periodical press only effectively got underway after 1808. Despite rapid advances and an abundance of publications over the course of the nineteenth century, the publishing trade remained comparatively small, with a handful of entrepreneurs and a limited reading public.[79] Most commercial enterprises were dedicated to putting out a single periodical, as was the case with several of the major newspapers of the time. Between the 1860s and 1890s, even the most influential illustrated magazines – such as

[77] First such organization in Brazil, the Photo-Club do Rio de Janeiro is generally held to have been started in 1910, but the references in *Renascença* leave no doubt that it was already active in 1905; see Maria Teresa Bandeira de Mello, *Arte e fotografia: O movimento pictorialista no Brasil* (Rio de Janeiro: Funarte, 1998), p. 68.

[78] Von Ab. Eff, "Segunda exposição do Photo-Club", *Renascença*, September 1905, 95–101; and Alvaro de Lima, "Terceira exposição artistica do Photo-Club", *Renascença*, December 1907, 246–256. Another member of the family, painter Eduardo Bevilacqua, was obliged to give up the ENBA travel prize in 1907 due to his father's recent demise, according to the magazine; "Exposição de 1907. Salão annual de arte", *Renascença*, November 1907, 222.

[79] On the reading public and editorial practices, see Ana Cláudia Suriani da Silva & Sandra Guardini Vasconcelos, eds., *Books and Periodicals in Brazil 1768–1930: a Transatlantic Perspective* (London: Legenda/MHRA, 2014); Alessandra El Far, *O livro e a leitura no Brasil* (Rio de Janeiro: Jorge Zahar, 2010); Márcia Abreu & Nelson Schapochnik, eds., *Cultura letrada no Brasil: Objetos e práticas* (Campinas: Mercado das Letras/ALB, 2005); and Marisa Lajolo & Regina Zilberman, eds., *A leitura rarefeita: Livro e literatura no Brasil* (São Paulo: Ática, 2002).

Semana Ilustrada, *Revista Ilustrada* or *A Vida Fluminense* – were practically cottage industries, produced by untiring editors who wrote texts, drew illustrations, laid out pages, supervised printing and managed subscriptions in their spare time.[80]

This scenario began to change around 1900 due to shifts in technology, suppliers and business models. Larger graphic establishments bought up smaller ones and consolidated numerous activities into a single organization. Actual conglomerates arose, combining publishing with printing on an industrial scale. The culmination of this process occurred circa 1918, in Rio de Janeiro, when traditional printing firm Pimenta de Mello & Cia. merged with the publishing house Sociedade Anônima O Malho, which already produced some of the most popular magazines in Brazil, such as the weekly satirical magazine *O Malho* and the leading children's publication *O Tico-Tico*. Under the leadership of José Pimenta de Mello, the company would come to dominate magazine publishing in Brazil over the 1920s, with the addition of further titles like *Para Todos* (1918–1958), *Illustração Brasileira* (1920–30) and *Cinearte* (1926–1942).[81]

3.4 FROM LITTLE MAGAZINES TO MASS MEDIA

The spread of illustrated mass periodicals is one of the major signifiers of cultural modernity in Brazil over the early twentieth century – on a par with cinema, automobiles, sports and advertising, phenomena with which it is bound up and which it helped propagate.[82] Despite many technological advances over the latter decades of the nineteenth century, illustrated magazines remained almost exclusively small-scale productions,

[80] See Rafael Cardoso, "Projeto gráfico e meio editorial nas revistas ilustradas do Segundo Reinado", In: Paulo Knauss, Marize Malta, Cláudia de Oliveira & Monica Pimenta Velloso, eds., *Revistas ilustradas: Modos de ler e ver no Segundo Reinado* (Rio de Janeiro: Mauad X/Faperj, 2011), pp. 17–40; and Rafael Cardoso, "Origens do projeto gráfico no Brasil", In: Cardoso, *Impresso no Brasil*, esp. pp. 68–73.

[81] Julieta Sobral, *O desenhista invisível* (Rio de Janeiro: Folha Seca, 2007), pp. 35–38, 129–132; and Cassio Loredano, *O bonde e a linha: Um perfil de J. Carlos* (São Paulo: Capivara, 2002), pp. 43–45.

[82] See Monica Pimenta Velloso, "As distintas retóricas do moderno", In: Oliveira, Pimenta Velloso & Lins, *O moderno em revistas*, pp. 43–50; Marcia Cezar Diogo, "O moderno em revista na cidade do Rio de Janeiro", In: Sidney Chalhoub, Margarida de Souza Neves & Leonardo Affonso de Miranda Pereira, eds., *História em cousas miúdas: Capítulos de história social da crônica no Brasil* (Campinas: Ed. Unicamp, 2005), pp. 459–489; and Ana Luiza Martins, *Revistas em revista: Imprensa e práticas culturais em tempos de República, São Paulo (1890–1922)* (São Paulo: Imprensa Oficial/Edusp, 2001), pp. 38–44.

containing few pages (usually fewer than twelve), lithographic or zinco-graphic images and comparatively little commercial advertising. Popular magazines of the first few years of the century, like *Tagarela* and *O Malho*, still conformed to this model. The earliest photograph printed in a Brazilian periodical dates from 1895, but processes for halftone printing did not become commercially viable until 1900.[83] The breakout publication was *Revista da Semana*, a weekly Sunday edition of newspaper *Jornal do Brasil*, featuring "photographs, instant views, drawings and caricatures" at the affordable price of 300 *réis*. It was equipped with its own printing workshops specialized in photoengraving.[84] However, it remained small (eight pages) and otherwise unremarkable as a departure from prevailing norms of graphic design.

Technologies of photographic reproduction would soon be put to better use by other newer publications. In 1907, Jorge Schmidt, proprietor of the luxurious *Kósmos*, launched *Fon-Fon!*, perhaps the first mass-circulation periodical in Brazil that fits the present-day description of a magazine, with thirty pages or more bound inside a cover, and costing 400 *réis*.[85] It was announced as a "joyful, political, critical and effervescent weekly" and promised in its first editorial to dedicate itself to "elegant jest and polite mockery". Faced with the grave and complicated problems of politics, finance and society, the magazine would simply honk its horn and push them out of the way. The title *Fon-Fon!* is an onomatopoeia for the sound of an automobile horn (equivalent to *honk honk* in English), and its original masthead (drawn by Raul, under the pseudonym OIS) displays the image of a speeding car, the spinning wheels of which fill the two O's in the name. The magazine's editorial voice was embodied in a sinister-looking chauffeur – drawn by K. Lixto – dressed in a tuxedo, black mask and driving cap (Fig. 40). In the first issue, this mascot tells the story of his birth during carnival, and a caricature depicts the baby chauffeur spewing out of a printing press into the waiting hands of Schmidt. The list of friends and

[83] See Joaquim Marçal Ferreira de Andrade, "Processos de reprodução e impressão no Brasil, 1808–1930", In: Cardoso, *Impresso no Brasil*, pp. 62–63; and Joaquim Marçal Ferreira de Andrade, *História da fotorreportagem no Brasil: A fotografia na imprensa do Rio de Janeiro de 1839 a 1900* (Rio de Janeiro: Elsevier/Biblioteca Nacional, 2004), pp. 229–231.

[84] "Trabalhos de luxo", *Revista da Semana*, 27 May 1900, 19.

[85] The distinction between newspaper and magazine is fluid in nineteenth-century Brazil. The names *jornal* and *revista* were used interchangeably and often in ways inconsistent with later distinctions. See Cardoso, "Projeto gráfico e meio editorial nas revistas ilustradas do Segundo Reinado", pp. 17–40.

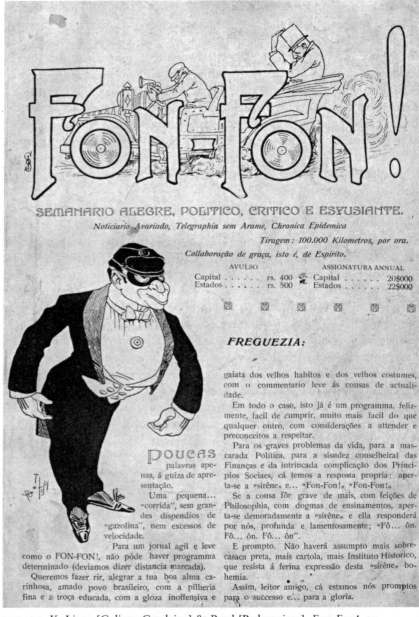

FIG. 40 K. Lixto [Calixto Cordeiro] & Raul [Pederneiras], *Fon-Fon!*, 13 April 1908
Fundação Biblioteca Nacional (BN Digital/Hemeroteca Digital Brasileira)

relatives attending the birth consists largely of regular contributors to the art nouveau publications discussed in the preceding section: Gonzaga Duque, Mario Pederneiras, Mario Behring, Raul and K. Lixto, among others.[86]

For reasons that remain unclear, Schmidt quickly withdrew from *Fon-Fon!* Alexandre Gasparoni took over as one of the proprietors in 1908, joining Giovanni Fogliani and presumably pushing or buying out the former owner.[87] The editors-in-chief were Gonzaga Duque, Lima Campos and Mario Pederneiras, who formed a triumvirate the magazine referred to jokingly as "the three Siamese brothers". K. Lixto was the "artistic director", responsible for numerous early covers and illustrations, with additional support from Raul and Seelinger.[88] Apart from Gonzaga Duque, who passed away in 1911, this core editorial group remained intact until 1915, when K. Lixto's departure put an end to the magazine's most creative phase, visually. Over the following few years, other major names in the history of Brazilian caricature would pass through its pages: Max Yantock, Torquato Tarquino, Fernando Correia Dias, Alfredo Storni and Seth. In 1914, a second magazine, *Selecta*, was spun off from the first. Together, the two publications possessed nearly one hundred employees in 1916, including a complete photographic service with four photoengravers (Luiz Brun, Alfredo Bioleto, J. Garcia, Alois Fabian) who often signed the images they produced.[89] In 1922, *Fon-Fon* was sold and thereafter took a conservative turn, falling under

[86] Eu Mesmo, "O meu carnaval", *Fon-Fon!*, 13 April 1907, n.p. Cf. Monica Pimenta Velloso, *"Fon-Fon!* em Paris: Passaporte para o mundo", In: *Fon-Fon! Buzinando a modernidade*, 11–21; and Pimenta Velloso, *Modernismo no Rio de Janeiro*, 68–69.

[87] "Declaração", *Fon-Fon!*, 9 May 1908, n.p. For more on the magazine's history, see Renata Franqui, *O processo de modernização no Brasil e a educação das mulheres na revista Fon-Fon!* (Curitiba: Editora CRV, 2017), pp. 47–74; Fabiana Francisca Macena, "Além do modernismo paulista: A revista Fon-Fon e os debates sobre a modernidade no Rio de Janeiro da Belle Époque", *Em Tempo de Histórias*, 16 (2010), 131–153; Maria Cecilia Zanon, "A sociedade carioca da Belle Époque nas páginas do Fon-Fon!", *Patrimônio e Memória*, 4 (2009), 217–235; and Semiramis Nahes, *Revista Fon Fon: A imagem da mulher no Estado Novo (1937–1945)* (São Paulo: Arte e Ciência, 2007).

[88] "A familia de 'Fon-Fon!'", *Fon-Fon!*, 10 April 1909, n.p. See also "A familia de 'Fon-Fon!'", *Fon-Fon!*, 22 April 1911, n.p.; and "O anniversario de Fon-Fon!", *Fon-Fon!*, 19 April 1913, n.p. Many of Raul's illustrations in the magazine are signed O.I.S., a pseudonym intended to be read as 'oh, yes!'; see Herman Lima, *História da caricatura no Brasil* (Rio de Janeiro: José Olympio, 1963), pp. 3, 1006.

[89] "Fon-Fon! e Selecta na intimidade", *Fon-Fon!*, 1 January 1916, n.p. See also "Fon-Fon no Fon-Fon", *Fon-Fon!*, 27 December 1919, n.p.

the sway of Gustavo Barroso, one of the leading intellectual lights of Brazilian *integralismo*, who became the magazine's editor-in-chief.[90]

The roll call of editors, authors and illustrators at *Fon-Fon!*, during the phase of peak creativity from 1907 to 1915, is so redolent of *Kósmos* and *Atheneida* that past literary historians have sometimes considered it a late symbolist magazine in the lineage of *Pierrot*, *O Mercúrio*, or *Revista Contemporânea* and others edited between the late 1890s and early 1900s.[91] Such a reading wilfully ignores that it was anything but rarefied or exclusive. Crowd-pleasing to the limit and commercial to a fault, *Fon-Fon!* panders to a mainstream readership that kept it successfully in print for over fifty years. It was, by no means, a magazine for intellectuals. Its stock-in-trade was gossip and society, fashion, health, sports, leisure and entertainment. Its ample photographic coverage spotlighted not only notable figures but also anonymous readers, as well as daily life in the capital, other regions of the country and even foreign lands. Its pages and pages of advertising sometimes exceeded the editorial content, both in size and interest.

Most of all, *Fon-Fon!* worked hard to be entertaining. Though snobbish at times, its humour is crass, delighting in political satire and wallowing in the everyday sexism and racism that were standard fare of the time. An article in the inaugural issue poked fun at Monteiro Lopes, elected the country's first black congressman in 1909 and a source of unbroken mirth in the press.[92] Despite its overt prejudices, the opinions expressed in the magazine did not stray from the median mindset of Brazilian society at the time and could even be perceived as progressive by contemporary standards. A 1908 cover by K. Lixto shows an Afro-descendant man raising his hat and crying "Long live liberty!" in salute to the twentieth anniversary of 13 May 1888, the date slavery was officially

[90] Gustavo Barroso, "Vinte e um annos de vida", *Fon Fon*, 14 April 1928, n.p.; Mario Sette, "Uma visita que me fez recordar", *Fon Fon*, 21 March 1941, 13; and Bastos Portela, "Mario Poppe", *Fon Fon*, 12 December 1942, 3. Under its new management, the magazine dropped the dash in its title, having already lost the exclamation point in 1920. *Fon Fon* was purchased by colonel Sergio Silva, employed as a manager since at least 1912. The general manager at Sociedade Anônima O Malho, from 1919 until August 1922 was also named Sergio Silva (A. Sergio da Silva Junior). They may or may not have been the same person, a worthy topic for further research.

[91] See Lins, "Em revistas, o simbolismo e a virada de século", 16–26.

[92] See Petrônio Domingues, "'Vai tudo ficar preto': Monteiro Lopes e a cor na política", *Novos Estudos (Cebrap)*, 95 (2013), 59–81; and Carolina Vianna Dantas, "Monteiro Lopes (1867–1910): Um 'líder da raça negra' na capital da República", *Afro-Ásia*, 41 (2010), 167–209.

abolished; yet, both his feet are shackled to an iron ring labelled 'oligarchies'.[93] Over its first decade of existence, *Fon-Fon!* took sympathetic positions towards women's suffrage and the plight of the dispossessed. True to its announced editorial policy, though, it mostly steered clear of contentious issues. In a media landscape in which the purpose of periodicals was traditionally to support one or another political party, it was refreshingly nonpartisan.

The arena in which *Fon-Fon!* stands out most prominently is its visual construction and graphic design. Heir to the technological advances that made *Kósmos* an exquisite but expensive publication, its more popular successor managed to replicate some of those improvements at a lower cost, particularly in the domain of photographic reproduction. *Fon-Fon!* was astoundingly modern by the standards of circa 1910 and, on occasion, even given over to experimentation of a sort not usually encountered in mass-market publications. A perusal of the magazine's covers over its first decade reveals a dizzying array of formats and styles (Fig. 41), from conventional cartoons and outmoded painterly scenes, reminiscent of nineteenth-century chromos, to bold visual effects and complex overlays of photography and illustration. A series of covers illustrated by K. Lixto between 1910 and 1913 makes clever use of colour contrasts and framing devices to simulate a photographic aesthetic (Figs. 42–43). Other covers of the same time mix photography and illustration in astonishing composites that belie the commonly held notion that early twentieth-century audiences were not attuned to the possibilities of image manipulation (Fig. 44).

Fon-Fon!'s major competitor was *Careta*, the latter launched by Jorge Schmidt in June 1908, immediately after he lost his proprietorial role at the former magazine.[94] *Careta* was less daring visually, but also managed to keep its price slightly lower, at 300 *réis*. Its inner pages were sober, and its covers stuck to a tried and true format: the same masthead on every issue (though it evolved over the years), always at the top, bearing title and publication information; a cartoon underneath, usually contained within a linear border (though it sometimes burst the frame); a caption

[93] The fact that K. Lixto was himself of Afro-descendant identity lends an additional layer of meaning to the image. For more on this aspect, see Chapter 2.

[94] See Vol-Taire, "Almanach das glorias. Jorge Schmidt", *Careta*, 3 June 1911, n.p.; "Justas referencias", *O Malho*, 11 December 1920, n.p.; and "Jorge Schmidt", *Fon Fon*, 2 November 1935, n.p.

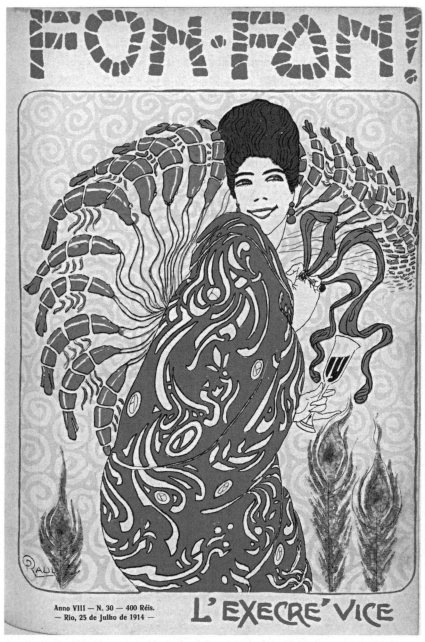

FIG. 41 Raul [Pederneiras], *Fon-Fon!*, 25 July 1914. For color version of this figure, please refer color plate section.
Fundação Biblioteca Nacional (BN Digital/Hemeroteca Digital Brasileira)

FIG. 42 K. Lixto [Calixto Cordeiro], *Fon-Fon!*, 3 September 1910. For color version of this figure, please refer color plate section.
Fundação Biblioteca Nacional (BN Digital/Hemeroteca Digital Brasileira)

FIG. 43 K. Lixto [Calixto Cordeiro], *Fon-Fon!*, 21 January 1911
Fundação Biblioteca Nacional (BN Digital/Hemeroteca Digital Brasileira)

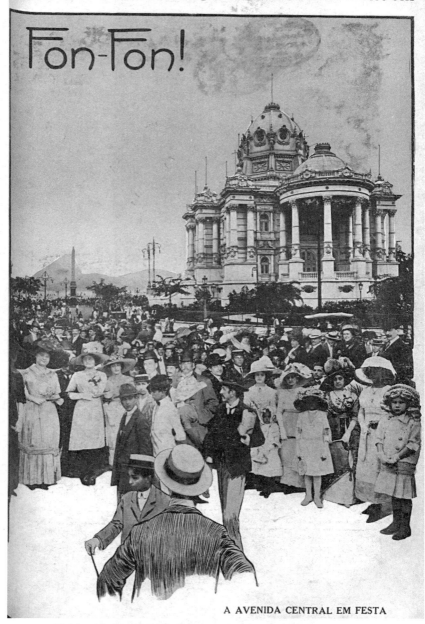

FIG. 44 Unidentified author, *Fon-Fon!*, 5 August 1911
Fundação Biblioteca Nacional (BN Digital/Hemeroteca Digital Brasileira)

at the foot of the page.[95] Though the layout of the inner pages was initially quite elegant, in an art nouveau vein, the magazine eventually declined in visual and material quality, especially after Schmidt's death in 1935. The range of topics covered was similar to *Fon-Fon!*, although *Careta* was more attuned to politics and also discernibly more conservative. Current events and political satire dominated its covers. The magazine's editorial content was closer to *O Malho*, the oldest of the weeklies along with *Revista da Semana*. Over the 1910s, the visual and graphic quality of the latter two publications remained distinctly inferior to their two newer competitors. *Careta* was also much more willing to provoke and even offend than *Fon-Fon!*, often indulging in blatantly racist and xenophobic covers.

One contributor was of key importance to *Careta*: illustrator J. Carlos. Having begun his career at *Tagarela*, under the guidance of K. Lixto and Raul, he continued to work at *A Avenida* and *O Malho* over the early 1900s and subsequently took on a leading role at Schmidt's magazine. At *Careta*, J. Carlos was single-handedly responsible for the majority of covers and illustrations. Between circa 1908 and 1919, he appears to have worked exclusively for Schmidt and even signed many of the early covers of *Careta* with the company name 'Kósmos' underneath his own distinctive signature. The commercial rivalry between the three leading weeklies was intense. Besides the graphic input of J. Carlos, Schmidt also had sole recourse to the talents of Mario Behring, formerly editor of *Kósmos*. In February 1909, the magazines belonging to the Kósmos group announced a radical overhaul of their graphic facilities that would endow them with "model workshops, the likes of which have not yet been seen in South America".[96] Indeed, the quality of printing and design showed noticeable improvement over the first half of 1909, including experiments with colour reproduction of photographs.[97] For unknown

[95] This three-part structure was maintained with remarkable consistency until 1954, when the frame in the middle was abolished and the text integrated with the image. The images continued to be cartoon illustrations, almost never photographs, until the magazine's demise in 1960. For more on its history, see Clara Asperti Nogueira, "Revista Careta (1908–1922): Símbolo da modernização da imprensa no século XX", *Miscelânea*, 8 (2010), 60–80; and Sheila do Nascimento Garcia, *Revista Careta: Um estudo sobre humor visual no Estado Novo (1937–1945)* (unpublished master's thesis, Programa de Pós-graduação em História, Universidade Estadual Paulista, 2005), esp. pp. 45–68.

[96] "Kósmos e Careta", *Careta*, 20 February 1909, n.p. See also Gonzaga Duque, "Bilhete à 'Careta'", *Careta*, 5 June 1909, n.p.

[97] In February 1909, *Kósmos* published a photographic plate of Corcovado mountain, in Rio de Janeiro, in full colour. In the 6 March 1909 issue, *Careta* published two colourized photographs of beach scenes; on 5 June 1909, two colourized photographic portraits of

reasons, these advances were not sustained, and *Careta* soon fell behind *Fon-Fon!* in terms of visual and graphic innovation.

Eventually, *Careta* failed to retain its one competitive edge when it lost exclusive access to the art of J. Carlos. After a decade of astonishing productivity working for Schmidt, the artist resumed activities for *O Malho*, producing several covers in 1919, although he would remain *Careta*'s chief illustrator until March 1922. The extreme popularity he achieved around this time eclipsed the celebrity enjoyed by his mentors, Raul and K. Lixto, and indeed has remained unsurpassed in the history of illustration and graphic arts in Brazil.[98] In April 1922, the revamped Sociedade Anônima O Malho – under the ownership of Pimenta de Mello – announced J. Carlos as "artistic director" of its seven magazine titles, under exclusive contract, a position he would retain until 1931.[99] In his new capacity, he began a fruitful partnership with another offspring of the former *Kósmos* milieu: writer Alvaro Moreyra, who had served as editor at *Fon-Fon!* under Mario Pederneiras and took on the role of editor-in-chief of its competitor *O Malho* in 1918.[100] Together, as art director and editorial director, respectively, the pair would revive the glory years of precursors like *Renascença*, under Henrique Bernardelli and Rodrigo Octavio, or *Fon-Fon!*, under K. Lixto and the triumvirate of Gonzaga Duque, Lima Campos and Mario Pederneiras. After *Fon-Fon!* was sold in 1922, Mario Behring likewise went to work for Pimenta de Mello, further concentrating the human resources of the *Kósmos* period under the corporate oversight of *O Malho*.

The magazines J. Carlos and Alvaro Moreyra produced together between 1922 and 1931 represent the maturity of a process of experimentation and endeavour that altered visual culture in Brazil over the preceding decades. Without the interpersonal and organizational developments arising out of the luxurious literary and artistic magazines of the early

actors; and, on 19 June 1909, the cover of the magazine was exceptionally graced by a photograph – a colourized portrait of recently deceased president Afonso Penna. See "Kósmos", *Careta*, 19 June 1909, n.p.; and also Cardoso, *Impresso no Brasil*, p. 145.

[98] See Loredano, *O bonde e a linha*, pp. 13–15, 54–55. The work of J. Carlos is viscerally bound up with the visual culture of 1920s Brazil. Its distinctive style epitomizes art deco and the jazz age in the Brazilian context. On the enduring legacy of his work, see Loredano, Kovensky & Pires, eds., *J. Carlos: Originais*.

[99] "J. Carlos, director artistico das publicações desta Empeza", *O Malho*, 15 April 1922, n. p. Cf. Sobral, *O desenhista invisível*, 35–38; and Loredano, *O bonde e a linha*, 65–69.

[100] "Fon-Fon! e Selecta na intimidade", *Fon-Fon!*, 1 January 1916, n.p.; "Do mestre e do discipulo", *O Malho*, 14 September 1918, n.p.; "Ecos da sociedade", *O Malho*, 25 December 1918, n.p.

1900s – *Atheneida, Kósmos, Renascença* – and the intense commercial and stylistic rivalry between the leading weeklies of the 1910s – *O Malho, Fon-Fon!, Careta* – conditions would not have existed for the golden age of mass-circulation periodicals ushered in by the pair's collaborative work on *Illustração Brasileira* and *Para Todos*, two of the outstanding visual productions of the 1920s.[101] Moreyra's tenure at *O Malho* possesses the further historical significance of providing the missing link between *paulista* modernism and its broader reception in Brazilian society. It was under the auspices of his editorship that Guilherme de Almeida, Di Cavalcanti and Tarsila do Amaral, among others, burst onto the national stage.[102] Starting in 1919, Di Cavalcanti's intense activity for *O Malho* extended to designing covers that garnered widespread recognition for his work as an illustrator (Fig. 45). After the *Semana de Arte Moderna*, Moreyra lent explicit support to both Mario de Andrade and Oswald de Andrade in the pages of *Para Todos*, at a time when other organs of the national press were unreceptive to the group.[103] He was instrumental in transforming the anthropophagic movement from a hermetic avant-garde into a mainstream phenomenon, as shall be seen in Chapter 4.

As Julieta Sobral has argued, J. Carlos's tenure as art director at *Para Todos* represents a marker of modernity in Brazilian visual culture.[104] For many decades, his contributions in terms of graphic design were overshadowed by his superlative talent as an illustrator. A closer look at the work carried out at the magazine, especially over the late 1920s, reveals unconventional solutions for page layout and innovative uses of

[101] For an analysis of these magazines, see Sobral, *O desenhista invisível*.

[102] See, among others, "Encantadores e melindrosas", *O Malho*, 5 October 1918, n.p.; Olegario Marianno, "Dor de recordar", *O Malho*, 11 January 1919, n.p.; Rodrigo Octavio Filho, "Livros e autores", *O Malho*, 22 March 1919, n.p.; "Encantadores e melindrosas", *O Malho*, 12 April 1919, n.p.; Lima Campos, "Sambanette", *O Malho*, 24 May 1919, n.p.; Rodrigo Octavio Filho, "Meu jardim cheio de sonhos", *O Malho*, 31 May 1919, n.p.; Alvaro Moreyra, "Folha morta", *O Malho*, 7 June 1919, n.p.; "Bagatellas", *O Malho*, 6 September 1919, n.p.; "Bagatellas", *O Malho*, 25 October 1919, n.p.; "Bagatellas", *O Malho*, 24 January 1920, n.p.

[103] Alvaro Moreyra, "Tudo é novo sob o sol", *Para Todos*, 10 February 1923, n.p.; *Para Todos*, 1 March 1924, n.p.; Oswald de Andrade, "Modernismo atrazado", *Para Todos*, 5 July 1924, n.p.; "Oswald de Andrade candidato a uma vaga na Academia Brasileira de Letras", *Para Todos*, 24 October 1925, 27; "Oswald de Andrade candidato a uma vaga na Academia Brasileira de Letras. O que pensa sobre isto Felippe d'Oliveira", *Para Todos*, 31 October 1925, 20. After 1929, Alvaro Moreyra also maintained close ties to the *Antropafagia* group; see Chapter 4.

[104] See Sobral, *O desenhista invisível*; and Julieta Sobral, "J. Carlos designer", In: Rafael Cardoso, ed., *O design brasileiro antes do design: Aspectos da história gráfica, 1870–1960* (São Paulo: Cosac Naify, 2005), pp. 124–159.

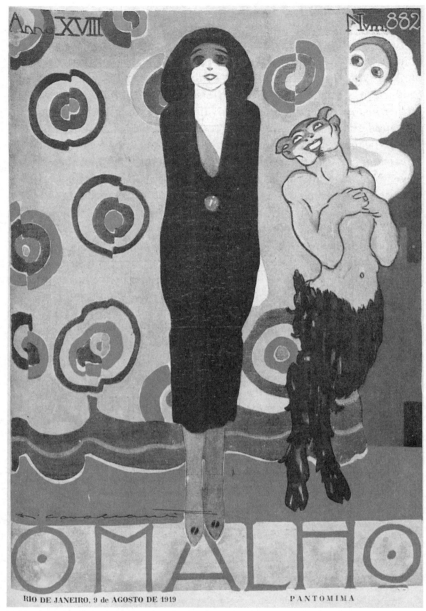

FIG. 45 [Emiliano] Di Cavalcanti, *O Malho*, 9 August 1919. For color version of this figure, please refer color plate section.

Fundação Biblioteca Nacional (BN Digital/Hemeroteca Digital Brasileira)

photography that go beyond the cover art for which he has come to be celebrated and cherished in Brazil. Even less known, however, are the experimental efforts of other graphic artists of the 1920s, such as the ambitious redesign proposals implemented by Andrés Guevara at the men's magazine *A Maçã*, circa 1925, or the exuberant work of Sotero Cosme and João Fahrion at the magazines *Madrugada* and *Revista do Globo*, in Porto Alegre.[105] K. Lixto's efforts as art director of *Fon-Fon!* between 1907 and 1915 are nothing short of astonishing, especially to the extent that they precede and anticipate the more widely known work of the 1920s. Taken in conjunction with the work of J. Carlos, Guevara, Cosme and others, they prove that there was much more to the graphic arts renaissance of the period than can be ascribed to the talent of any single artist.

What needs to be underscored is that the work produced by K. Lixto at *Fon-Fon!* or J. Carlos at *Para Todos* was self-consciously expressive of modernizing aspirations at a time when definitions of modernism remained largely undetermined. Unlike the efforts of artists and intellectuals in the worlds of literature and fine art, these works were accessible to a mass audience which relished the aesthetic they promoted. The fact they have not generally been recognized as expressions of modern art says much about the elitism that historically surrounds the idea of 'high' modernism. Like their turn-of-the-century predecessors who reacted with nervous derision to uppity art nouveau as a symptom of lower-class tastes, the arbiters who canonized the modernist movement in Brazil, between the 1940s and 1960s, remained indifferent to manifestations of modernity occurring in arenas of mass culture not under their control. Their keen attention to the feeble tootle of *Klaxon* and deafness to the horn blast of *Fon-Fon!* bespeaks a perverse unwillingness to see the elephant in the room.

[105] See Aline Haluch, *A Maçã: O design gráfico, as mudanças de comportamento e a representação feminina no início do século XX* (Rio de Janeiro: Ed. Senac, 2016); Aline Haluch, "A Maçã e a renovação do design editorial na década de 1920", In: Cardoso, *O design brasileiro antes do design*, pp. 96–123; and Paula Ramos, *A modernidade impressa: Artistas ilustradores da Livraria do Globo – Porto Alegre* (Porto Alegre: UFRGS Editora, 2016), pp. 129–155.

4

The Cosmopolitan Savage

Modernism, Primitivism and the Anthropophagic Descent

Only the savage will save us.
Revista de Antropofagia, 1929[1]

Cursory accounts of Brazilian modernism often collapse the *Semana de Arte Moderna*, of 1922, and the anthropophagic movement (hereafter, *Antropofagia*), of 1928–1929, into a seamless progression, with the latter as a sort of continuation of the former. According to this widely held but deceptive view, modernists in 1920s São Paulo embraced racial mixture as an emblem of national identity, setting them apart from prior Eurocentric conceptions. Such a reading is neatly encapsulated in visual terms by linking Tarsila do Amaral's two paintings *A Negra* (1923) and *Antropofagia* (1929), which do share evident similarities.[2] However, both points need to be problematized. The purported continuity of intentions between *Semana* and *Antropofagia* does not withstand historical scrutiny. Rather, it reduces a convoluted relationship, full of tensions and contradictions, to a simple teleology.[3] Their espousal of a Brazilian racial identity is even

[1] Oswaldo Costa, "Da antropofagia", *Revista de Antropofagia*, II, 9, In: *Diário de S. Paulo*, 15 May 1929, 10.

[2] See Rafael Cardoso, "White skins, black masks: Antropofagia and the reversal of primitivism", In: Uwe Fleckner & Elena Tolstichin, eds., *Das verirrte Kunstwerk: Bedeutung, Funktion und Manipulation von Bilderfahrzeugen in der Diaspora* (Berlin: De Gruyter, 2019).

[3] See Rafael Cardoso, "Forging the Myth of Brazilian Modernism", In: Larry Silver & Kevin Terraciano, eds., *Canons and Values: Ancient to Modern* (Los Angeles: Getty Research Institute, 2019), pp. 269–287. See also Randal Johnson, "Brazilian modernism:

more deeply contentious, and the present chapter will focus on teasing out some of the complexities of that mythical construct.

Like any avowedly avant-gardist grouping, the inner dynamics of *paulista* modernism were shaped by the conflicts between its members. Foremost among these was the rivalry between Oswald de Andrade and Mário de Andrade for leadership.[4] The encounter between them energized the movement in its early years but degenerated into a rift that separated them permanently after 1929, in large part due to attacks against Mário in the *Revista de Antropofagia*. Unrelated despite the common surname, the two writers were utterly opposed in temperament. Whereas Oswald was brash and entitled, Mário was demure and contriving. Something of a libertine, Oswald became the prototypical alpha male of modernist lore. Mário maintained his homosexuality so deeply hidden that it was only made fully public in recent years.[5] Politically too, they often found themselves on opposite sides, especially after 1937 when Mário collaborated with the Estado Novo dictatorship and Oswald was proscribed as one of its opponents.[6]

Beyond issues of personality, the differences between them can be traced to a pronounced contrast in background and social standing. Oswald descended from a rural slave-holding family in Minas Gerais. His father moved to São Paulo after Abolition, got rich during the *Encilhamento*, became an alderman and one of the largest owners of real estate in what was then, by his son's account, a "small and dusty town".[7]

An idea out of place?", In: Anthomy L. Geist & José B. Monleon, eds., *Modernism and Its Margins: Reinscribing Cultural Modernity from Spain and Latin America* (New York: Garland, 1999), esp. pp. 193–197; and Kenneth David Jackson, "A view on Brazilian literature: Eating the *Revista de Antropofagia*", *Latin American Literary Review*, 7 (1978), 1–9. One of the first commentators to emphasize the point was Augusto de Campos in his introduction to the facsimile edition of the *Revista de Antropofagia*; Augusto de Campos, "Revistas re-vistas: Os antropófagos", *Revista de Antropofagia* (São Paulo: Cia. Lithographica Ypiranga, 1976), n.p.

4 Sérgio Miceli, *Nacional estrangeiro: História social e cultural do modernismo em São Paulo* (São Paulo: Companhia das Letras, 2003), pp. 108–115.

5 Eduardo Jardim, *Mário de Andrade: Eu sou trezentos: Vida e obra* (Rio de Janeiro: Edições de Janeiro, 2015), pp. 128–134.

6 Rafael Cardoso, "O intelectual conformista: Arte, autonomia e política no modernismo brasileiro", *O Que Nos Faz Pensar*, 26 (2017), 179–201.

7 Oswald de Andrade, *Um homem sem profissão: Memórias e confissões. I volume 1890–1919. Sob as ordens da mamãe* (Rio de Janeiro: José Olympio, 1954), pp. 30–34, 69–70. For more on Oswald's biography, see Maria Augusta Fonseca, *Oswald de Andrade: Biografia* (São Paulo: Globo, 2007); and Maria Eugênia Boaventura, *O salão e a selva: Uma biografia ilustrada de Oswald de Andrade* (São Paulo & Campinas: Ex-Libis & Ed. Unicamp, 1995).

Oswald then spent the rest of his life living off the proceeds of properties sold to develop prime sections of the burgeoning city. His 1954 autobiography was self-deprecatingly titled "a man without a profession" and comically subtitled "under the orders of Mama". Mário, on the other hand, came from lower-middle-class origins, attended the musical conservatory and worked his way up as a teacher, critic and cultural administrator.[8] In his memoirs, Oswald narrated the first encounter between them, circa 1917, during a graduation ceremony at the conservatory: "The speaker was a tall student, a mulatto, with a broad grin and glasses. His name was Mário de Andrade. He delivered a speech that struck me as awe-inspiring."[9] Then working as a reporter, Oswald had the text published. This early dynamic of patronage, with Oswald in charge, gave way to competition following Mário's success as a poet after 1922 and eventually to a bitter sense of mutual betrayal after they fell out.

Such interpersonal relationships would hardly seem important as historical explanation except for the outsize role they played in fleshing out the discourses and meanings of *Antropofagia*. Proper contextualization casts doubt upon the status the movement has since acquired as a sort of postcolonial theory, *avant la lettre*.[10] Scholarly readings of *Antropofagia* usually reduce the concept to Oswald's 1928 *Manifesto antropófago* which, like any avant-gardist manifesto, is a literary device and statement of ideas.[11] To take its aphorisms as a theory, much less a praxis, is

[8] See Jardim, *Mário de Andrade*, pp. 17–36.

[9] Andrade, *Um homem sem profissão*, p. 176.

[10] See, among others, Luís Madureira, *Cannibal Modernities: Postcoloniality and the Avant-garde in Caribbean and Brazilian Literature* (Charlottesville: University of Virginia Press, 2005), ch.1; Carlos A. Jáuregui, "Antropofagia (cultural cannibalism)", In: Robert McKee Irwin & Monica Szurmuk, eds., *Dictionary of Latin American Cultural Studies* (Gainesville: University of Florida Press, 2012), pp. 22–28; Antonio Luciano de Andrade Tosta, "Modern and postcolonial?: Oswald de Andrade's Antropofagia and the politics of labelling", *Romance Notes*, 51 (2011), 217–226; Gazi Islam, "Can the subaltern eat?: Anthropophagic culture as a Brazilian lens on post-colonial theory", *Organization*, 19 (2012), 159–180; Kalinca Costa Söderlund, "Antropofagia: an early arrière-garde manifestation in 1920s Brazil", *RIHA Journal*, 132 (2016); and Luis Fellipe Garcia, "Only Anthropophagy unites us – Oswald de Andrade's decolonial project", *Cultural Studies*, 2018, 1–21. On the pitfalls of the comparison with postcolonial theory and the necessity of problematizing *Antropofagia*, see Heloisa Toller Gomes, "The uniqueness of the Brazilian case: a challenge for Postcolonial Studies", *Postcolonial Studies*, 14 (2011), 405–413; and Luiz Costa Lima, "A vanguarda antropófaga", In: João Cezar de Castro Rocha & Jorge Ruffinelli, eds., *Antropofagia hoje?: Oswald de Andrade em cena* (São Paulo: É Realizações, 2011), pp. 363–371.

[11] Oswald de Andrade, "Manifesto antropófago", *Revista de Antropofagia*, I, 1 (May 1928), 3, 7. English translations are available in: Stephen Berg, "The Cannibalist

something of a leap. They also routinely underestimate the centrality of Tarsila do Amaral, often consigned to a supporting role as wife, muse and interpreter of her husband's intellectual propositions into pictorial terms. Oswald himself always insisted on the opposite, granting precedence to Tarsila and asserting that the manifesto put into words ideas that were born in the realm of the visual.[12] To understand what *Antropofagia* represented in its time and place, underlying tensions must be taken into account – of class, race and gender, professional affiliations, social and political positions.

4.1 *ANTROPOFAGIA* IN CONTEXT

Since its rediscovery and reinvention in the late 1960s, *Antropofagia* has usually been interpreted conceptually, as a set of ideas.[13] The movement was both larger and broader in scope than the manifesto, and it should not be forgotten that the discourses it advanced were grounded in a very particular historical context.[14] Its inner workings revolved around a close-knit coterie of friends in São Paulo who congregated as the so-called Clube de Antropofagia, more a series of social gatherings, often in Tarsila's home, than an actual establishment. According to the memoirs of one notable participant, these included banquets catered like a British gentlemen's club with white-gloved waiters.[15] Its main organ of expression and discussion, the *Revista de Antropofagia*, was always the work of a group: Oswald, Tarsila, Antônio de Alcântara Machado

Manifesto", *Third Text*, 13 (2008), 92–95; and Leslie Bary, "Cannibalist Manifesto", *Latin American Literary Review* 19 (1991), 38–47. For reappraisals of the manifesto and its implications, see Castro Rocha & Ruffinelli, *Antropofagia hoje?*; and Madureira, *Cannibal Modernities*, pp. 35–51.

[12] See "De antropofagia", *Revista de Antropofagia*, II, 4, In: *Diário de S. Paulo*, 7 April 1929, n.p.. The claim was later reinforced by one of the members of *Antropofagia*, Raul Bopp, who unambiguously credited Tarsila with being "the chief [*chefa*] of the movement"; Raul Bopp, *Vida e morte da Antropofagia* (Rio de Janeiro: Civilização Brasileira, 1977), p. 69. See also Raul Bopp, *Movimentos modernistas no Brasil, 1922–1928* (Rio de Janeiro: Livraria São José, 1966), p. 97.

[13] On the vogue for *Antropofagia* circa 1967 and Oswald's sudden rise to celebrity, see Marilia de Andrade, "Oswald e Maria Antonieta – Fragmentos memória e fantasia", In: Castro Rocha & Ruffinelli, *Antropofagia hoje?*, pp. 33–45.

[14] The standard source on the movement and its history is Benedito Nunes, "Antropofagia ao alcance de todos", In: Oswald de Andrade, *Do Pau-Brasil à Antropofagia e às Utopias (Obras completas – 6)* (Rio de Janeiro: Civilização Brasileira, 1972), xi–liii. See also Madureira, *Cannibal Modernities*, pp. 23–34.

[15] Bopp, *Movimentos modernistas no Brasil*, pp. 68–73. See also "Antropofagia Piolin Comido", *Para Todos*, 13 April 1929, 23.

(before he fell out with the others), Raul Bopp, Jayme Adour da Câmara, Oswaldo Costa, Geraldo Ferraz and Pagu (Patricia Galvão), as well as a loose network of contributors that included important voices from outside São Paulo (José Américo de Almeida, Manuel Bandeira, Cícero Dias, Ascenso Ferreira, Rosário Fusco, Oswaldo Goeldi, Fabio Luz, Murilo Mendes, Alvaro Moreyra, Benjamin Péret).[16]

Despite its cliquish elitism, the movement was combative and sought to achieve notoriety through carefully staged polemics. Over its brief existence, the *Revista* pointedly antagonized many major names associated with the history of Brazilian modernism. Besides Mário de Andrade, Guilherme de Almeida, Carlos Drummond de Andrade, Victor Brecheret, Graça Aranha, Alceu Amoroso Lima, Menotti del Picchia and Paulo Prado were all singled out for personal abuse in its pages. In a series of articles by Oswaldo Costa (penned under the pseudonym Tamandaré), it also violently denounced the *Semana* itself, repudiating it as false modernism, derivative, imported, academic and merely aesthetic when it should have been transformative.[17] Any interpretation that posits *Antropofagia* as a continuation of the *Semana* does so against the repeatedly expressed views of the anthropophagists themselves.

Through the networks it established, *Antropofagia* achieved greater immediate impact on the national scene than the *Semana* had, a few years earlier. Alvaro Moreyra – one of the most influential journalists of the time and heir to the modernizing currents discussed in Chapter 3 – was instrumental in lifting the movement out of the self-contained world of literary coteries and into the mainstream by devoting sustained coverage to Tarsila, Oswald and company in the pages of the widely read and

[16] The *Revista de Antropofagia* was published in two phases, which the editors dubbed first and second teethings. During the first, lasting from May 1928 to February 1929, it was a four-page monthly, of which ten issues were published. From March to August 1929, it ceased independent circulation and featured as a semi-weekly page in the newspaper *Diário de S. Paulo*, running to a further sixteen instalments. Alcântara Machado was the principal editor during the first phase and Oswaldo Costa during the second, though Oswald de Andrade was always firmly in charge. Geraldo Ferraz was mostly responsible for the design.

[17] Tamandaré, "Moquém. II – Hors d'oeuvre", *Revista de Antropofagia*, II, 5, In: *Diário de S. Paulo*, 14 April 1929, 6; Tamandaré, "Moquém. III – Entradas", *Revista de Antropofagia*, II, 6, In: *Diário de S. Paulo*, 24 April 1929, 10; Tamandaré, "Moquem. IV. Sobremesa", *Revista de Antropofagia*, II, 7, In: *Diário de S. Paulo*, 1 May 1929, 12; Tamandaré, "Moquem. V. Cafezinho", *Revista de Antropofagia*, II, 8, In: *Diário de S. Paulo*, 8 May 1929, 12.

nationally distributed magazine *Para Todos* over 1928 to 1929.[18] In turn, Moreyra was repeatedly cited in the *Revista de Antropofagia* as an ally and representative of the movement in Rio de Janeiro.[19] This proved a bone of contention within the modernist networks deriving from the *Semana*, particularly among allies of Mário de Andrade. In mid-1929, poet Carlos Drummond wrote a letter to Oswald explaining his refusal to join the anthropophagic movement, in which he specifically cited the participation of Moreyra and French surrealist poet Benjamin Péret as motives for his antipathy. Oswald's response was to publish the letter in the *Revista*, despite the fact it had been intended as private correspondence, thereby precipitating a very public split.[20]

Cooperation between Oswald's group and Moreyra represented a crucial turning point in the fortunes of Brazilian modernism. Oswald, who had succeeded in publishing his "Manifesto of Brazilwood Poetry" in the leading Rio daily *Correio da Manhã*, in 1924, was acutely aware of the importance of gaining visibility on a national stage.[21] He further recognized that the modernist movement was at risk of extinguishing itself, mired in infighting. In March 1927, he published a piece in a small magazine extolling Moreyra's "ironic patience" and advocating him as the only person capable of pacifying the various competing factions

[18] See, among others, "De Bellas Artes – Tarsila do Amaral", *Para Todos*, 19 May 1928, 36–37; Raul Bopp, "Coco de Pagu", *Para Todos*, 27 October 1928, 24; Peregrino Junior, "A progenie de Brumell", *Para Todos*, 24 November 1928, 1; "Tarsila por ella mesma", *Para Todos*, 11 August 1928, 29; Oswald de Andrade, "Hip Hip Hoover", *Para Todos*, 12 January 1929, 22; Samuel Tristão, "Futurismo", *Para Todos*, 26 January 1929, 17; Salvador Roberto, "Da terra da garoa", *Para Todos*, 23 March 1929, 27; "Antropofagia Piolin Comido", *Para Todos*, 13 April 1929, 23; "Tarsila", *Para Todos*, 27 July 1929, 14; Bezerra de Freitas, "Antropophagia", *Para Todos*, 27 July 1929, 17; "Pagu", *Para Todos*, 27 July 1929, 21; Clovis de Gusmão, "Na exposição de Tarsila", *Para Todos*, 3 August 1929, 21; "De João da Avenida. Reminiscências", *Para Todos*, 5 April 1930, 27. Cf. Luís Martins, *Um bom sujeito* (São Paulo: Secretaria Municipal de Cultura & Rio de Janeiro: Paz e Terra, 1983), pp. 21–22, who remembered *Para Todos* as a "bastion of modernism" in Rio de Janeiro.

[19] Alvaro Moreyra, "Visita de São Thomé", *Revista de Antropofagia*, I, 1 (May 1928), 8; Freuderico, "Ortodoxia", *Revista de Antropofagia*, II, 3, In: *Diário de S. Paulo*, 31 March 1929, 6; "A propósito do teatro sem nome – entrevista de Alvaro Moreyra", *Revista de Antropofagia*, II, 5, In: *Diário de S. Paulo*, 14 April 1929, 6; "Expansão antropofágica", *Revista de Antropofagia*, II, 10, In: *Diário de S. Paulo*, 12 June 1929, 10. Cf. Raul Bopp's comments on Alvaro Moreyra in: Bopp, *Movimentos modernistas no Brasil*, 32.

[20] "Cartas na mesa (os Andrades se dividem)", *Revista de Antropofagia*, II, 11, In: *Diário de S. Paulo*, 19 June 1929, 10.

[21] See Rafael Cardoso, "Modernismo e contexto político: A recepção da arte moderna no *Correio da Manhã* (1924-1937)", *Revista de História (USP)*, 172 (June 2015), 339.

distributed throughout the country.[22] Moreyra, for his part, would not have been oblivious to the advantages of an alliance with the wealthy and well-connected couple from São Paulo. Tarsila and Oswald's wedding in 1926 was attended by no less than the president of Brazil, Washington Luiz, as well as congressman and future president-elect, Júlio Prestes, both stalwarts of the Partido Republicano Paulista (PRP), who were designated the couple's *padrinhos* (godfathers).

Around the time of his involvement with the anthropophagists, Moreyra was struggling to achieve success with a side project of his own: a modernizing theatrical venture called Teatro de Brinquedo (literally, toy theatre), which he directed along with his wife, poet Eugênia Alvaro Moreyra.[23] The feminist Eugênia then outpaced Tarsila as the fashionable female face of modernity. Her distinctive bobbed hair featured frequently in press photographs and even caricatures that graced the society pages of the capital.[24] In August 1929, the two women appeared together in *Para Todos*, flanking poet Jorge de Lima and adding what the magazine called "a very expressive note" to the occasion (Fig. 46).[25] The bond between Tarsila and Eugênia reaffirmed the status of both as modern artists and reinforced their husbands' mutual ambitions to dominate the scene. Between 1927 and 1929, a budding friendship between the two couples bridged the distance between elites in São Paulo and Rio and threatened to overshadow other competing groupings with its novel

[22] "Alvaro Moreyra e outras questões que não são para todos", In: Oswald de Andrade, *Telefonema (Obras completas – 10)* (Rio de Janeiro: Civilização Brasileira, 1976), pp. 39–43.

[23] "Theatro de brinquedo", *Revista da Semana*, 19 November 1927, 29; Mário Nunes, "De theatro", *Para Todos*, 19 November 1927, 21; Benjamin Lima, "Brincadeira que faz pensar", *Para Todos*, 17 December 1927, 22–24. See also Severino J. Albuquerque, *Tentative Transgressions: Homosexuality, AIDS and the Theater in Brazil* (Madison: University of Wisconsin Press, 2004), pp. 62, 196. For more on the couple, see Joelle Rouchou, "Um arquivo amoroso: Alvaro e Eugênia Moreyra", *XXXII Congresso Brasileiro de Ciências da Comunicação (Intercom)*, 2009.

[24] See, among others, "Poesia brasileira no Theatro Municipal de São Paulo", *Para Todos*, 5 May 1928, 21; Mário de Andrade, 'Senhora Eugenio Alvaro Moreyra", *Para Todos*, 9 June 1928, 21; "Poesia nova do Brasil", *Revista da Semana*, 9 June 1928, 25; "Poesia nova do Brasil", *Para Todos*, 23 June 1928, 22; "Noticias e commentarios", *Revista da Semana*, 23 June 1928, 27; "Noticiario elegante", *Revista da Semana*, 29 June 1929, 27; "Noticiario elegante", *Revista da Semana*, 6 July 1929, 30; "Figuras e factos", *Revista da Semana*, 9 November 1929, 5. See also the extraordinary 1931 portrait of her painted by Dimitri Ismailovitch and exhibited in the so-called Revolutionary Salon of 1931.

[25] "Homenagem a Jorge de Lima", *Para Todos*, 17 August 1929, 28.

HOMENAGEM A JORGE DE LIMA

OS amigos mais intimos de Jorge de Lima, reunidos no Club dos Bandeirantes, quarta-feira penultima, homenagearam, com um almoço de despedida, o illustre poeta de Alagôas, que tambem é nosso, porque é um poeta brasileiro. Jorge de Lima achava-se no Rio ha algumas semanas, tendo vindo até aqui representar seu Estado nos recentes congressos medicos realizados nesta capital. Porque o poeta que tanto admiramos, e que acaba de nos offerecer seus «Novos Poemas», é, tambem, um scientista de grande mérito e um clinico notavel. Mas, terminados os congressos em que tomou parte, Jorge de Lima deixou de lado a medicina para se reunir aos seus amigos literatos e com elles passar os ultimos dias de sua permanencia na terra carioca. O almoço dos Bandeirantes foi, mais do que um simples agape, uma reunião de cordialidade literaria, uma vez que delle participaram apenas homens de letras — poetas, escriptores, jornalistas, etc. — e as sras. Tarsila do Amaral e Eugenia Alvaro Moreyra, cuja presença foi uma nota muito expressiva na homenagem a Jorge de Lima. Ninguem se levantou para fazer discurso, embora todos tenham falado, pois o almoço foi uma palestra «saborosa e bôa», como a poesia de Jorge de Lima, na expressão pittoresca da sra. Tarsila do Amaral.

FILIGRANAS

Aquelle caminho, que sobe para a montanha no fim daquella rua tranquilla que termina o arrabalde, perde-se entre arvoredos e para elle dão casas rusticas, onde ao entardecer gemem violinos. Nos crepusculos de oiro e madreperola, eu tenho uma vontade de ir vêr aquelle caminho, de sentir a voluptuosidade do anoitecer á sombra densa de suas arvores amigas, uma vontade tão grande que muito me custa refrear. Porque aquelle caminho é uma pagina da minha vida, pagina suave e triste, deliciosa, porém, na sua suavidade e na sua tristeza, pagina de ternura e de amor!

FIG. 46 Unidentified author, *Fon Fon*, 17 August 1929
Fundação Biblioteca Nacional (BN Digital/Hemeroteca Digital Brasileira)

FIG. 47 [Emiliano] Di Cavalcanti, *Para Todos*, 27 July 1929
Rio de Janeiro: Instituto Memória Gráfica Brasileira

mixture of modernism, fashion and celebrity, media clout and private money.[26]

The mainstream magazine *Para Todos* and the avant-garde *Revista de Antropofagia* worked in tandem to acclaim Tarsila's first solo exhibition in Brazil, inaugurated in July 1929 in Rio de Janeiro, as a triumph. The 27 July issue of *Para Todos* featured no less than three articles related to *Antropofagia*, one of which covered the opening of Tarsila's exhibition in glowing terms, including a caricature of the artist by Di Cavalcanti (Fig. 47). A photograph shows Tarsila surrounded by some of the leading cultural influencers of the time, including the Alvaro Moreyra couple. The caption informs readers that "all of elegant and intelligent Rio de Janeiro

[26] They shared political affinities, as well, as would be borne out by the increasing leftist militancy of all four over the 1930s. After splitting up from Oswald, Tarsila grew even closer to the Alvaro Moreyra couple, who helped mediate her encounter with and subsequent marriage to Luís Martins. See Martins, *Um bom sujeito*, pp. 25–36. Their friendship with Oswald also endured, as attested by the fact that he dedicated his play "O rei da vela", published 1937, to Eugênia and Alvaro Moreyra; see Oswald de Andrade, *Teatro (Obras completas – 7)* (Rio de Janeiro: Civilização Brasileira, 1973), p. 59.

was present".[27] Of the three major factions that splintered off from the *Semana* – including not only Mário's cohort but also the ardently nationalist *Verde-Amarelo* group – only *Antropofagia* was thus graced with the spotlight of the national press.[28]

The result was unambiguous, launching Tarsila to a new level of public visibility. One week later, the leading daily *Correio da Manhã* reported on a homage to the painter at the Palace Hotel, with songs performed by Elsie Houston; poems declaimed by both Eugênia and Alvaro Moreyra, as well as the prominent Catholic poets Augusto Frederico Schmidt and Murilo Mendes; plus the presence of two congressmen from the PRP, Altino Arantes and Eloy Chaves; a member of the Brazilian Academy of Letters, Claudio de Souza, and the "communist writers" Mário Pedrosa and Antônio Bento.[29] The entire spectrum of cultural influence in the capital was present. Triumph must have seemed certain to Oswald. In August 1929, the headline of the final edition of the *Revista de Antropofagia* proclaimed that "Tarsila do Amaral's exhibition at the Palace Hotel, in Rio de Janeiro, was the first great battle of *Antropofagia*".[30] As luck would have it, the first great battle proved also to be the last.

[27] "Tarsila", *Para Todos*, 27 July 1929, 14. In an article published 15 September 1929, in Recife, Manuel Bandeira also emphasized the large number of people present at the opening, as well as the fact that various groups were represented; Manuel Bandeira, *Crônicas da província do Brasil* (São Paulo: Cosac Naify, 2006 [1937]), p. 294.

[28] The nativist and regionalist Verde-Amarelo (green and yellow) group, founded 1926, included writers and veterans of the *Semana de Arte Moderna*, Plínio Salgado, Cassiano Ricardo, Menotti del Picchia and Cândido Motta Filho. To varying degrees, they would become associated with the Brazilian fascist movement of *Integralismo* after 1932. Salgado went on to become supreme leader of the *Ação Integralista Brasileira* and its candidate for the presidency. See Madureira, *Cannibal Modernities*, pp. 31–33; Monica Pimenta Velloso, "O modernismo e a questão nacional", In: Jorge Ferreira & Lucília de Almeida Neves Delgado, eds., *O Brasil republicano. 1. O tempo do liberalismo excludente: da Proclamação o da Republica a Revolução de 1930* (Rio de Janeiro: Civilização Brasileira, 2003); Monica Pimenta Velloso, "A brasilidade verde-amarela: Nacionalismo e regionalismo paulista", *Estudos Históricos*, 6 (1993), 89–112; Daniel Pécaut, *Entre le peuple et la nation: les intellectuels et la politique au Brésil* (Paris: Ed. de la Maison des Sciences de l'Homme, 1989); and Antonio Arnoni Prado, *1922 – Itinerário de uma falsa vanguarda: Os dissidentes, a Semana e o Integralismo* (São Paulo: Brasiliense, 1983).

[29] "Homenagens", *Correio da Manhã*, 7 August 1929, 7. Eloy Chaves was a staunch defender of *paulista* identity, casting São Paulo as birthplace of the nation; Barbara Weinstein, *The Color of Modernity: São Paulo and the Making of Race and Nation in Brazil* (Durham: Duke University Press, 2015), pp. 45–46.

[30] "A exposição de Tarsila do Amaral no Palace Hotel, do Rio de Janeiro, foi a primeira grande batalha da Antropofagia", *Revista de Antropofagia*, II, 16, In: *Diário de S. Paulo*, 1 August 1929, 10.

In October 1929, the Wall Street crash brought Brazil's coffee export economy to a grinding halt. The fortunes of Tarsila's family – an exorbitantly wealthy clan of rural landowners in São Paulo – were ravaged; and Oswald's finances too were hard hit. His romantic entanglement with the young poet and artist Pagu precipitated the end of the marriage to Tarsila. The network around *Antropofagia* fell apart swiftly and permanently.[31] The political situation too began to unravel in the countdown to the self-proclaimed Revolution of 1930, which would usher Getúlio Vargas into the presidency one year after the stock market crash. Oswald and Tarsila, with their close personal ties to the deposed president and the PRP, suffered a major loss of prestige and influence. On the opposite side, Mário de Andrade, who wrote for the newspaper *Diário Nacional* – organ of the Partido Democrático (PD), which supported Vargas in São Paulo – suddenly saw his professional fortunes take an upswing.[32]

The first half of the 1930s witnessed seismic shifts in politics and society that directly impacted the relationships among modernist groupings.[33] Chief among these was the so-called Constitutionalist Revolution of 1932, in which the state of São Paulo attempted to secede from the federal union and was crushed militarily after three months.[34] One result of this defeat was to deprive São Paulo's elites of their influence, temporarily, and shift the momentum of the modernist movement back to the nation's capital. In 1934, Gustavo Capanema, an ally of Vargas from Minas Gerais, was appointed to head the powerful new Ministry of Education and Health, which came to exercise unprecedented ascendancy over cultural affairs. In his move to Rio, he took along with him poet Carlos Drummond, who rose to new heights of influence as Capanema's chief-of-staff, vying with Catholic leader Alceu Amoroso Lima for sway over the minister's policies.[35] Drummond, in turn, was instrumental in enticing Mário de Andrade to exchange São Paulo for Rio, where he

[31] See Bopp, *Vida e morte da Antropofagia*, pp. 53, 70.
[32] On the PD's challenge to PRP dominance, see Weinstein, *Color of Modernity*, pp. 64–68.
[33] See Cardoso, "Modernismo e contexto político", pp. 354–357.
[34] On the Constitutionalist Revolution and its implications in terms of regional and racial identites, see Weinstein, *Color of Modernity*, chs. 2 & 3.
[35] See Simon Schwartzman, Helena Maria Bousquet Bomeny & Vanda Maria Ribeiro Costa, *Tempos de Capanema* (São Paulo: Paz e Terra, 2000), esp. chs. 5 & 6; Daryle Williams, *Culture Wars in Brazil: the First Vargas Regime, 1930–1945* (Durham: Duke University Press, 2001), esp. ch. 3; and Jerry Dávila, *Diploma of Whiteness: Race and Social Policy in Brazil, 1917–1945* (Durham: Duke University Press, 2003), pp. 62–67. See also Helena Bomeny, ed., *Constelação Capanema: Intelectuais e política* (Rio de Janeiro: Ed. FGV, 2001).

remained between 1938 and 1941.[36] Over the decade and a half after 1930, the *Antropofagia* group was left out in the cold; and Oswald, in particular, would remain a virtual outcast from patronage until the end of the Estado Novo in 1945.[37]

4.2 *ANTROPOFAGIA* AND THE DISCUSSION OF RACE

Given this context in which the relationship between Mário and Oswald de Andrade degenerated from friendship to rivalry to antagonism, it would be ill-advised to presume any sort of continuity between the efforts of the *Semana* and those of *Antropofagia*. Despite the historicist habit of mapping back onto the 1922 movement things that came after it, the artists and works participating in the *Semana* showed little interest in matters of race or blackness, for instance. Tarsila's *A Negra*, often taken as an iconic image of the *Semana* group's supposed recovery of Afro-Brazilian identity from a tradition bent on denying it, was painted later, in 1923, and, even then, in Paris where the painter resided at the time, entirely detached from the São Paulo event. The painting's appeal to *négritude* owes more to the Parisian vogue for primitivism and *negrophilia*, and it was not even exhibited in Brazil until 1933. Further-more, quite apart from the historical facts that situate it outside contem-porary debates on race during the 1920s, *A Negra* can only be viewed as affirmative of Afro-Brazilianness if one is willing to overlook the work's evidently troubling aspects – its depiction of a generic 'negress' as a cartoonish figure, orange in hue, dehumanized by lack of hair and ears, rendered grotesque by her huge lips and dangling breast.[38]

Interest in race is not something that spilled out from modernism to society at large but exactly the opposite. Whereas Oswald's 1924 "Mani-festo of Brazilwood Poetry" makes strategic (though fleeting) nods to African culture, the 1928 *Manifesto antropófago* contains no reference at all, despite its greater length and the fact that it cites influences as disparate as carnival and matriarchy, missionaries and magic, communism and the French Revolution. The manifesto's silence on the legacy of Afro-Brazilian identity is somewhat surprising, considering that

[36] See Jardim, *Mário de Andrade*, ch. 7.
[37] Marilia de Andrade & Ésio Macedo Ribeiro, eds., *Maria Antonieta d'Alkmin e Oswald de Andrade: Marco zero* (São Paulo: Edusp, 2003), pp. 16–18, 66–69.
[38] See Cardoso, "White Skins, Black Masks", pp. 131–138. See also Renata Gomes Car-doso, "*A Negra* de Tarsila do Amaral: Criação, recepção e circulação", *VIS (Revista do Programa de Pós-graduação em Artes da UnB)*, 15 (2016), 90–110.

race was coming to the fore in intellectual debates of the time.[39] The place of blackness in Brazilian culture was an object of concern in artistic circles in Rio de Janeiro since the early 1900s, as has been seen in previous chapters, including the work of black artists such as Arthur Timotheo da Costa, who was attuned to the topic of racial self-representation.[40] By the mid-1920s, the theme was also being unambiguously addressed by an artist well-known to *paulista* modernist circles, Lasar Segall, even if in a more ethnographic vein as evidenced in his paintings *Boy with geckos* (1924) and *Banana grove* (1927).[41]

The topic of race only crops up in the *Revista de Antropofagia* in November 1928, seven months into the journal's existence, and, even then, as a negative trope. A front-page article on the proposed construction of a monument to honour the figure of the black nursemaid, or *mãe preta* – sarcastically titled "Wet nurse contest" and signed by Alcântara Machado – begins by affirming that such a monument was being built "I don't know where (but always in Brazil)."[42] Given the noisy campaign to erect a *mãe preta* monument in Rio de Janeiro in 1926 and subsequent debates regarding a similar initiative in São Paulo, the author's professed ignorance of location can only be understood as facetious.[43] The article

[39] Heloisa Toller Gomes, "A questão racial na gestação da antropofagia oswaldiana", *Nuevo Texto Critico*, 12 (1999), 249–259. See also Darién J. Davis, *Avoiding the Dark: Race and the Forging of National Culture in Modern Brazil* (Aldershot: Ashgate, 1999), ch. 2.

[40] See Alejandro de la Fuente, "Afro-Latin American art", In: Alejandro de la Fuente & George Reid Andrews, eds., *Afro-Latin American Studies: an Introduction* (Cambridge: Cambridge University Press, 2018), pp. 374–375; Rafael Cardoso, "The problem of race in Brazilian painting, c.1850–1920", *Art History*, 38 (2015), 488–511; and Roberto Conduru, "Afromodernidade – representações de afrodescendentes e modernização artística no Brasil", In: Roberto Conduru, *Pérolas negras, primeiros fios: Experiências artísitcas e culturais nos fluxos entre África e Brasil* (Rio de Janeiro: Ed. Uerj, 2013), pp. 301–313.

[41] See Alejandro de la Fuente & Rafael Cardoso, "Race and the Latin American Avant-gardes, 1920s–1930s", In: David Bindman & Alejandro de la Fuente, eds., *The Image of the Black in Latin America and the Caribbean* (Cambridge: Harvard University Press, forthcoming, 2021).

[42] Antônio de Alcântara Machado, "Concurso de lactantes", *Revista de Antropofagia*, I, 7 (November 1928), 1.

[43] See Paulina L. Alberto, *Terms of Inclusion: Black Intellectuals in Twentieth-century Brazil* (Chapel Hill: University of North Carolina Press, 2011), pp. 69–74. See also Weinstein, *Color of Modernity*, pp. 289–293; Marcus Wood, *Black Milk: Imagining Slavery in the Visual Cultures of Brazil and America* (Oxford: Oxford University Press, 2013), pp. 1–4; Isabel Löfgren & Patricia Gouvêa, *Mãe preta* (São Paulo: Frida Projetos Culturais, 2018), esp. pp. 54–55; and Kimberly Cleveland, *Black Women Slaves Who*

warns that building the monument entails the risk that other groups will also demand monuments of their own:

One for each colour. Then one for each nationality. The homage will provoke a competition between races and origins and even types of milk. In the end, the manufacturers of condensed milk will also lay claim to a statue, with good motive. And all hell will break loose when the Dutch government demands a statue for their cows, its subjects. I do not mean to offend, only to give fair warning.[44]

He did mean to offend, of course. Offence was the modus operandi of the *Revista de Antropofagia*, even during its comparatively restrained first phase. The question remains open to whom this rhetorical pretence at not causing offence was directed, since there were likely to be few black readers among the journal's public. Possibly, the author had in mind the offence caused by describing cows as Dutch subjects.

Given that this first extended reference to blackness occurred within the context of debates around the *mãe preta* monument, the absence of *A Negra* from the pages of the journal is worth pondering. Illustrations by Tarsila were a constant feature of the *Revista de Antropofagia*, from the very first issue – in which the *Manifesto antropófago* is accompanied by a line drawing of *Abaporu* (1928), a work Oswald claimed as its inspiration – to the final editions, illustrated with photographs of the paintings *Forest* (1929) and *Antropofagia* (1929). Indeed, if text and image are given equal weight, Tarsila was one of the most frequent contributors to the journal. It would have made perfect sense to reproduce *A Negra* in the context of a discussion about *mãe preta*, particularly since, by the artist's own account, the work was related to the theme of wet nursing.[45] That did not happen. One obvious reason is that the painting was not in Brazil, at the time, but instead in Paris. Yet, it would have been entirely possible to reproduce the composition the way most of Tarsila's works were

Nourished a Nation: Artistic Renderings of Black Wet Nurses of Brazil (Amherst: Cambria Press, 2019).

[44] Alcântara Machado, "Concurso de lactantes", 1.

[45] Later in life, Tarsila explained in interviews that the inspiration for *A Negra* came from childhood memories of women who tied stones to their breasts to stretch them, so that they would be able to nurse children on their backs while working in the fields. See Gilda de Mello e Souza, "Vanguarda e nacionalismo na década de vinte", *Almanaque: Cadernos de literatura e ensaio*, 6 (1978), p. 81; Nádia Battella Gotlib, *Tarsila do Amaral: A musa radiante* (São Paulo: Brasiliense, 1983), p. 37; and Maria José Justino, *O banquete canibal: A modernidade em Tarsila do Amaral* (Curitiba: Ed. UFPR, 2002), p. 42. Extensive documentary evidence on the painter's early life and childhood is available in the volume edited by her granddaughter, also named Tarsila: Tarsila do Amaral, *Tarsila por Tarsila* (São Paulo: Celebris, 2004).

featured in the *Revista de Antropofagia*: as a line drawing (which did exist, having graced the cover of Blaise Cendrars's 1924 book of poems *Feuilles de route*).[46] The omission of *A Negra* from the pages of a journal that served very much as a vehicle for showcasing Tarsila suggests that the artist and/or the editors were not particularly keen on promoting that work.

The *Revista de Antropofagia* persisted in its purportedly light-hearted treatment of race, making occasional jokes but generally skirting the issue over most of its existence. Finally, in May 1929, it saw fit to address the topic head-on, in an article defending the "negro race" against a putative slur in an Italian-language publication that approximated Brazilians to Ethiopians as a negative comparison. The journal affirmed:

> Brazilians are not ashamed of the African blood that courses through their veins. Very much the opposite, they even take pride in it. The negro contributed honourably to our economic greatness. The black mother [*mãe preta*] is in all our hearts.[47]

The slippage between the pronouns *they* and *we* to refer to Brazilians is present in the original Portuguese text and suggestive of a duality in identification with so-called 'African blood'. The article was signed with the pseudonym Menelik – name of the Ethiopian emperor famous for having repulsed the attempted Italian invasions of the 1890s. Its title was "*A pedidos*" – literally, 'by request', old newspaper jargon for articles sent in by outside contributors (who often paid for the space) – and the subtitle purports it was published in conjunction with the Centro Cívico Palmares, a black activist association founded in São Paulo in 1926, deeply involved in the campaign to erect a monument to *mãe preta*.[48] Considering the *Revista de Antropofagia*'s constant and preferential recourse to hyperbole and absurdist humour, it is difficult to assess to what extent this defence of black heritage was ironic or sincere.

[46] See Alexandre Eulalio, *A aventura brasileira de Blaise Cendrars* (São Paulo: Edusp, 2001 [1978]), pp. 23–30, 112–126; and Aracy A. Amaral, *Blaise Cendrars no Brasil e os modernistas* (São Paulo: Ed.34/Fapesp, 1997 [1970]), esp. pp. 21–27, 133–141.

[47] Menelik, "A pedidos. Com o Centro Cívico Palmares", *Revista de Antropofagia*, II, 7, In: *Diário de S. Paulo*, 1 May 1929, 12.

[48] Alberto, *Terms of Inclusion*, 89–101; and Kim D. Butler, *Freedoms Given, Freedoms Won: Afro-Brazilians in Post-Abolition São Paulo and Salvador* (New Brunswick: Rutgers University Press, 1998), pp. 101–107. An early Afro-Brazilian newspaper in São Paulo, founded 1915, was titled *O Menelick*; see Giovana Xavier da Conceição Côrtes, "'Leitoras': Gênero, raça, imagem e discurso em *O Menelik* (São Paulo, 1915–1916)", *Afro-Ásia*, 46 (2012), 163–191.

Nonetheless, its appeal to the black mother and the longsuffering slave is in line with approved bourgeois sentiment since the heyday of abolitionism.

The *Revista de Antropofagia* was not particularly racist, by the standards of its day, but neither can it be construed as a champion of Afro-Brazilian identity. Its attitudes to race were more ambiguous, and that ambiguity can be better understood by assessing the movement's relationship to the slippery trope of primitivism. In one of the series of articles castigating "the *Semana de Arte Moderna* and its derivative currents", Oswaldo Costa criticizes Brazilian modernism for not having created any new and original ideas, but rather perpetuating "the old imported thinking". He expounds on this accusation with an unusual reference to "negro art":

Now, some of these modernists are starting to say that São Paulo is ugly, that Brazil is ugly. Don't be dismayed. They are copying the European, whom ugly-Europe has cast into the arms of negro art and of all exoticisms. This is the psychology of failure.[49]

This negative appraisal of *negrophilia* as "the psychology of failure" is noteworthy. In full Spenglerian mode, probably filtered through *Antropofagia*'s reception of Hermann von Keyserling, the article diagnoses the headlong rush "into the arms of negro art and of all exoticisms" as a symptom of the cultural decline of Europe.[50] If primitivism was a marker of European decadence, then to copy it from the vantage point of a country viewed by Europeans as (quasi-)primitive was doubly decadent.

Yet, appraisals of *Antropofagia* tend rightly to view the movement as an embrace of the native and the savage, against colonialist ideals of civilization. The same Oswaldo Costa, one of the first authors to coin the phrase 'colonial mentality', would state these aims with categorical clarity, one month later:

[49] Tamandaré, "Moquem. II. Hors d'oeuvre", p. 6.
[50] Keyserling visited São Paulo in 1929 and became personally acquainted with Tarsila and Oswald, who cited him in a crucial passage of the "Manifesto Antropófago". See Daniel Faria, "As meditações americanas de Keyserling: Um cosmopolitismo nas incertezas do tempo", *Varia Historia*, 29 (2013), 905–923; and Abilio Guerra, *O primitivismo em Mário de Andrade, Oswald de Andrade e Raul Bopp: Origem e conformação no universo intelectual brasileiro* (São Paulo: Romano Guerra, 2010), pp. 257–263, 270–275, 287–291.

They are mistaken, those who think we are only against the abuses of Western civilization. We are against its uses. [...] Against mental servitude. Against colonial mentality. Against Europe.[51]

The contradiction of being against Europe but also against primitivism is only apparent. Costa was correct, after all, in implying that the idea of 'negro art' is a function of the relationship between colonizer and colonized. Those viewed by colonization as savages did not regard themselves in the same light. The inversion of perspective engendered by looking at Europe from Brazil occasioned a reversal of the primitivist gaze. Through its subversive humour and verbal belligerence, *Antropofagia* succeeded in shifting the valence of categories such as native, savage and primitive. This point is crucial to understanding the radicality of the anthropophagic position but also its fragility.

4.3 PRIMITIVISM AND ITS DISCONTENTS

In April 1929, the *Revista de Antropofagia* ran an article titled "Ethnological manipulations" in which it sought to clarify its position, stating: "The primitivist question is still timely. More than ever. It will only cease to be so when it is substituted by the anthropophagic question."[52] This affirmation is doubly important. Firstly, because it makes clear that the group were aware of debates around primitivism. Secondly, because it sets *Antropofagia* apart from primitivism, as something one step beyond, much as the *Manifesto antropófago* had done when it posited surrealism as a precursor.[53] Primitivism was a stage on the way to achieving a more essential condition, to becoming *natural man* – as the journal termed it, in an article penned under the pseudonym Poronominare – stripped of civilized morals, religion, culture, all rolled into a single negative package. As emphasized in a subsequent article penned under the same pseudonym, this was not a *return* to a pre-existing condition, but an *advance* towards

[51] Costa, "De antropofagia", 10. For more on Costa's relevance to the movement, see Carlos A. Jáuregui, "Oswaldo Costa, Antropofagia and the cannibal critique of colonial modernity", *Culture & History Digital Journal*, 4 (2015), 1–17. See also Carlos Rincón, "Antropofagia, reciclagem, hibridação, tradução ou: como apropriar-se da apropriação", In: Castro Rocha & Ruffinelli, *Antropofagia hoje?*, pp. 551–557.

[52] Poronominare, "Manipulações etnologicas", *Revista de Antropofagia*, II, 6, In: *Diário de S. Paulo*, 24 April 1929, 10.

[53] See Cunhambebinho, "Péret", *Revista de Antropofagia*, II, 1, In: *Diário de S. Paulo*, 17 March 1929, 6; and Adour, "História do Brasil", *Revista de Antropofagia*, II, 4, In: *Diário de S. Paulo*, 7 April 1929, n.p.

a new one. It involved no Romantic gesture of going back to nature or the past. *Antropofagia*, the author explained, refused to renounce any of the material advances on the planet, "such as caviar, the record player, asphyxiating gas and metaphysics".[54] It despised the "indigenist Romanticism" of the nineteenth century and, in its place, espoused the virtues of the savage.[55]

The key to understanding this wilful paradox lies in the distinction made between 'primitive' and 'savage' within the discourses of *Antropofagia*. The savage state the anthropophagists aspired to achieve was unrelated to any specific historical era, cultural identity or traditional way of life. According to Poronominare, it was not determined by ethnicity at all: "The natural man we want can easily be white, wear a tuxedo and ride in an airplane. He can just as well be black or even an Indian".[56] To become savage was instead a process of shedding civilized values and virtues – which the author who wrote under the telling pseudonym Freuderico lumps together as the *taboo* – and embracing the biological essence of humanity. "The transformation of the Taboo into totem," he calls it, closely echoing the *Manifesto antropófago*.[57] Freudian theory was the ground in which such premises were rooted. Oswald de Andrade makes this abundantly clear in one of the few articles published in the *Revista de Antropofagia* under his own name, explaining that the central idea of *Antropofagia* was psychoanalytic.[58] The process of overcoming false morals, false culture, false art, was labelled by the movement as "the anthropophagic descent".[59] This was a descent not in any civilizational sense – that is, the cultural decline they associated with primitivism – but a plunge into the depths of the unconscious self to embrace the savage drives within.

[54] Poronominare, "Uma adesão que não nos interessa", *Revista de Antropofagia*, II, 10, In: *Diário de S. Paulo*, 12 June 1929, 10. Poronominare is the name of a divine hero in the mythology of some peoples of the Amazon region, renowned for his cunning.

[55] Costa, "De antropofagia", 10. See also Tamandaré, "Moquem. II. Hors d'oeuvre", 6, on the deforming gaze cast upon indigenous peoples by Romantic authors like Gonçalves Dias and José de Alencar.

[56] Poronominare, "Uma adesão que não nos interessa", p. 10.

[57] Freuderico, "De antropofagia", *Revista de Antropofagia*, II, 1, In: *Diário de S. Paulo*, 17 March 1929, 6. In the manifesto, this was phrased: "The transfiguration of the Taboo into totem", see Andrade, "Manifesto antropófago", 7.

[58] Oswald de Andrade, "Antropofagia e cultura", *Revista de Antropofagia*, II, 9, In: *Diário de S. Paulo*, 15 May 1929, 10.

[59] Tamandaré, "Moquem. IV. Sobremesa", 12; and Tamandaré, "Moquem. V. Cafezinho", 12. Cf. Bopp, *Vida e morte da antropofagia*, p. 41.

The self-professed biological imperative of anthropophagic thinking helps make sense not only of the movement's permissive attitudes towards sex but also its ambiguous ones towards race. In purporting to move beyond issues of nationality and identity, *Antropofagia* could adopt a stance that pitted itself, at one and the same time, against European colonialism and Brazilian nativism. It is no coincidence that Poronominare's critical discussion of the concept of 'natural man' occurred in an article ostensibly directed at repulsing the nationalist *Verde-Amarelo* group and titled "An endorsement that does not interest us". *Antropofagia* cast itself as standing outside and above political divisions: "We are against fascists of any kind and against bolshevists of any kind too. Whatever exists within these political realities that is favourable to biological man, we consider good. It belongs to us."[60] The anthropophagic descent thus involved thinking outside the usual parameters of right and left, rational and irrational, black and white, national and foreign. This was a convenient vantage point for a group of provincial intellectuals who wished to dismantle all positions but their own. Aware of the mystique of their exoticism as Latin Americans, they could invoke the myths and magic of subaltern groups within Brazil to garner credibility vis-à-vis their European counterparts. Dressing up as shamans for a Parisian audience, so to speak. Wealthy and cosmopolitan, they could, in turn, trade up their newfound European credentials to bypass existing structures of institutional validation in Brazil – passing themselves off as consummately up to date for a cultural sphere in thrall to Parisian models.[61] By playing both sides off one another, they ensured their discourses would always prevail as authentic.

This double-dealing did not go unnoticed among more astute observers. Charged with producing an article about anthropophagy for *Para Todos* – likely at the behest of editor Alvaro Moreyra – journalist Bezerra de Freitas wrote up the movement with smiling derision. The article states, at the outset, that critic José Clemente – then recognized in the Carioca press as an expert on modernism – had informed him it was "the first serious movement that has existed in Brazil"; but the author wonders if that is true, expressing his mistrust of modern intellectuals from São

[60] Freuderico, "De antropofagia", 6.
[61] See Cardoso, "White Skins, Black Masks", 152–154. Interestingly, this position of standing outside prevailing paradigms, in a sort of ideological no-man's-land, bears strong parallels to that occupied by Mattos Pimenta in his repudiation of favelas. It is perhaps a hallmark of the in-between position of Brazilian elites. See Chapter 1.

Paulo, whom he describes as "amiable troglodytes full of intentions". Bezerra goes on to ponder the historical place of anthropophagy, in the literal sense of the term as a mode of cannibalism, paying scant attention to the propositions of the manifesto or the *Revista de Antropofagia*. The article concludes with a dig at the wealth of these latter-day defenders of devouring the enemy:

They do not, however, forget to check the value of stocks, the political exchange and the price of coffee. Some stash away thousand *mil-réis* banknotes; others travel to the banks of the Nile and have their pictures taken on camelback in the middle of the desert. That is why I do not believe in these *paulista* anthropophagists, somewhat sedate epicureans, ironic, subscribers to sun-bathing, who wish to transform us into marionettes. These *paulistas* . . .[62]

Despite Moreyra's editorial offensive in support of the movement, Bezerra was clearly suspicious of the motives of the *paulista* group, whom he posits as a class of rich arrivistes trying to storm the citadel of which he is the guardian.

Nothing in the brief article suggests that Bezerra de Freitas was even aware of the manifesto or its contents. Rather, he sticks to the name of the movement and the insider knowledge he appears to possess of its adherents as a leisure class, living off financial markets and spending their fortunes on tourism and sun-bathing. The unusual reference to having their pictures taken on the banks of the Nile most certainly derives from a photograph published in *Para Todos*, three years earlier, in which Oswald and Tarsila appear in a group posing on camelback in front of the Great Pyramid of Giza (Fig. 48). They are accompanied by Altino Arantes, congressman and former governor of the state of São Paulo, and Claudio de Souza, then recently elected to the Brazilian Academy of Letters, as well as their respective wives, both of whom later attended Tarsila's exhibition at the Palace Hotel. Taken well before *Antropofagia* was conceived, this 1926 photograph places Oswald and Tarsila within a social context far removed from the advanced modernist milieu to which they preferred to be associated in the public mind. The final comment on marionettes suggests Bezerra was alert to the string-pulling going on behind the scenes at the magazine.

[62] Bezerra de Freitas, "Antropophagia", *Para Todos*, 27 July 1929, p. 17. For contemporary opinions on modernism, see José Clemente, "Sobre o modernismo", *Correio da Manhã*, 19 June 1925, 6; and Leoncio Correia, "Arte moderna. José de Lubecki", *Revista da Semana*, 31 December 1921, n.p.

No Egypto: Senhor e Senhora Claudio de Souza, Senhor e Senhora Altino Arantes, a pintora Tarsila do Amaral, Oswald de Andrade e sua Filha

FIG. 48 Unidentified author, *Para Todos*, 22 May 1926
Rio de Janeiro: Instituto Memória Gráfica Brasileira

Bezerra's article is accompanied by a cartoon by J. Carlos – then art director of the magazine – lampooning the followers of *Antropofagia* as a couple of city slickers playing cowboys and Indians (Fig. 49). The one in the foreground wears glasses, a fedora, checked shirt and two-toned shoes but also sports a tomahawk, beads and feathered loincloth straight out of a Hollywood western. His companion, in the background, wears a pork-pie hat with two feathers stuck into the hatband. Both have rings in their noses and ears. Bearing an oversized bow and arrow and a gigantic club, respectively, they advance slack-jawed towards the edge of the page, clearly on the hunt. The page is framed by borders composed of stylized banana leaves on both sides and a geometric pattern underneath in the decorative style of ancient Marajoara ceramics which were then becoming popular as a Brazilian contribution to the international fashion for Art Deco.[63] At the head of the text, under the initial A, a coffee cup makes visual reference to the product that gave São Paulo its vast wealth and which is mentioned in the gibe about eyeing the price of coffee. Together,

[63] Márcio Alves Roiter, "A influência marajoara no Art Déco brasileiro", *Revista UFG*, 12 (2010), 19–27.

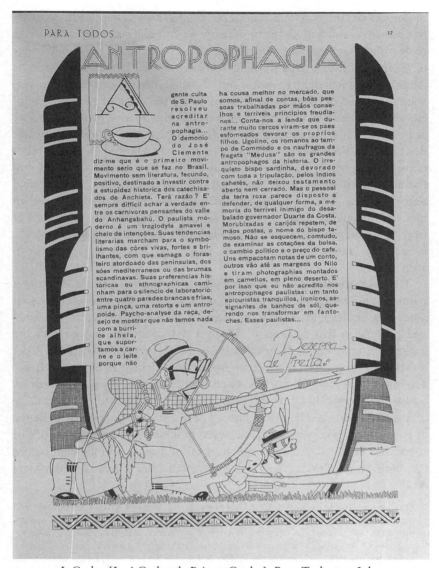

FIG. 49 J. Carlos [José Carlos de Brito e Cunha], *Para Todos*, 27 July 1929
Rio de Janeiro: Instituto Memória Gráfica Brasileira

image and text sum up a cogent critique of a stage-set modernity designed to fool innocents into thinking that *paulista* millionaires were somehow fearful savages.

Emanating as they did from a class of inordinately privileged members of the São Paulo bourgeoisie, the primitivist and anti-primitivist

discourses of *Antropofagia* cannot be taken at face value. The primitiviz-
ing propensities of modernism, already so fraught and contradictory in
the various European and North American contexts, acquired new layers
of meaning through their transculturation onto the Brazilian scene.[64] As
Abilio Guerra has rightly pointed out, Brazilian discussions of primitivism
were grounded in pre-existing debates about the place of race and ethni-
city in the formation of the nation, particularly ideas of racial inferiority
and the so-called 'three sad races' from which the national populace
derived. The preponderance of such discourses allowed Brazilian mod-
ernists to approach primitivism not as a flight from the modern self into
the archaic other but as an embrace of neglected aspects of their own
native culture. Thus, Guerra affirms, primitivism operates in Brazilian
modernist thinking more as a process of assimilation than rupture. Far
from merely reproducing European ideas of a supposed primitive essence,
it actively reworked them into new and competing claims to
authenticity.[65]

The contradiction lies in the fact that *Antropofagia* was essentially a
cosmopolitan movement. Its ability to communicate directly with Parisian
modernist circles allowed it to circumvent the brokers of cultural power
and prestige in Rio de Janeiro. When it did choose to engage with the
national capital, via the alliance with Alvaro Moreyra, it was able to do so
on its own terms, garnering more from the exchange than it gave back.
The movement can be fairly classed as outward looking and even as
harbouring hopes that it might, one day, come to invert the directionality
of influence and reverberate in Paris.[66] If not for the political sea change
of 1930, it might very well have achieved that aim, given the magnitude of
social and financial capital at the disposal of Tarsila and Oswald before
the Wall Street Crash. The final issue of the *Revista de Antropofagia*

[64] On disputes around primitivism, see Uwe Fleckner, "The naked fetish: Carl Einstein and
the Western canon of African art", In: Silver & Terraciano, *Canons and Values*,
pp. 245–268; Daniel J. Sherman, *French Primitivism and the Ends of Empire,
1945–1975* (Berkeley: University of California Press, 2011); Laurick Zerbini, "Sur les
traces des arts africains", In: Oissila Saaïdia & Laurick Zerbini, eds., *La construction du
discours colonial: l'empire français au XIXe et XXe siècles* (Paris: Karthala, 2009),
pp. 63–89; and Uwe Fleckner, *The Invention of the Twentieth Century: Carl Einstein
and the Avant-Gardes* (Madrid: Museu Nacional Centro de Arte Reina Sofia, 2009).

[65] Guerra, *O primitivismo em Mário de Andrade, Oswald de Andrade e Raul Bopp*,
pp. 17–18, 217–219, 244–245. See also Viviana Gelado, *Poéticas da transgressão:
Vanguarda e cultura popular nos anos 20 na América Latina* (Rio de Janeiro: 7 Letras
& São Paulo: Ed. UFSCar/Fapesp, 2006), pp. 132–193.

[66] See Rincón, "Antropofagia, reciclagem, hibridação, tradução", 549–551; and João Cezar
de Castro Rocha, "Uma teoria de exportação? ou: 'Antropofagia como visão de
mundo'", In: Castro Rocha & Ruffinelli, *Antropofagia hoje?*, pp. 647–668.

gloated over having won its *first* great battle, suggesting they expected more and greater battles to come.

Given its cosmopolitanism, *Antropofagia*'s appeal to nativism should be understood more as a clever discursive gambit than a genuine attachment to deeper strata of Brazilian culture and society. Though the anthropophagists spoke forcefully about the Amerindian and (to a lesser extent) African roots of Brazil, they by no means spoke for these subaltern groups. The strategic essentialism of positing all Brazilians as equal heirs to an unequal past involved appropriating the cultures of others in ways that subtly silenced them. Though they might claim to be anti-colonialist, the actions it empowered frequently involved a further usurpation of marginalized groups whose identities were exploited in the name of modernity. Thus, *Antropofagia*'s greatest discursive strength – its deliberate code-switching – is ultimately also its fatal flaw.

4.4 THAT OLD BLACK MAGIC

Before 1930, there is little in Oswald's or Tarsila's works to suggest that they were interested in engaging with the harsh social realities of a country still struggling to emerge from the traumas of slavery and its aftermath. Tarsila's treatment of folklore and rural themes, during her so-called Brazilwood phase, tends toward the naïf and sentimental. Even her *Morro da Favela* (1924) stands out as an incongruously ingenuous depiction of a theme widely perceived as grounds for fear and anguish.[67] As Heloisa Toller Gomes perceptively pointed out, *Antropofagia* was less engaged with issues of race than competing currents, such as the group congregating around Gilberto Freyre and his "Regionalist Manifesto" of 1926, in Recife.[68] They were certainly less focused on Afro-Brazilian culture than European counterparts like Blaise Cendrars, whose outlook on Brazil was conditioned by his prior interest in *négritude*.[69]

If race can be understood as a sort of black hole (a pun Oswald would have appreciated) in anthropophagic discourse – in the sense of being a

[67] See Chapter 1.
[68] Toller Gomes, "A questão racial na gestação da antropofagia oswaldiana", 252–253. See also Weinstein, *Color of Modernity*, 194; and Davis, *Avoiding the Dark*, 62–63. Cf. Manoel Correia de Andrade, "Uma visão autêntica do Nordeste", In: Gilberto Freyre, *Nordeste* (São Paulo: Global, 2013), pp. 9–10.
[69] Eulalio, *A aventura brasileira de Blaise*, pp. 24–43; and Amaral, *Blaise Cendrars no Brasil e os modernistas*, pp. 15–28. Cf. Hermano Vianna, *O mistério do samba* (Rio de Janeiro: Jorge Zahar/Ed. UFRJ, 1995), pp. 95–96, 99–103.

powerful gravitational force but largely unseen and unfathomed – then the case of Benjamin Péret is the supernova that casts light into the darkness. As has been mentioned, Péret contributed to the *Revista de Antropofagia* and was viewed as an ally, if not a member, of the movement. His presence in São Paulo was repeatedly highlighted by the journal, which reviewed a lecture he gave in the following terms: "It was a lesson. The West, which has sent us so much awful stuff, this time sent an exception."[70] A few months later, Péret's affiliation to the movement had grown close enough that Carlos Drummond perceived him as an obstacle to joining up. Though Péret was apparently disliked by many for his ideological intransigence and pugnacious debating style, both these characteristics aligned him squarely with the rhetorical stance of the anthropophagists.[71] The unanswered question is who influenced whom, or whether this was just a meeting of kindred spirits.

Péret married Brazilian singer Elsie Houston in Paris in 1928, and together they moved to Brazil in January 1929.[72] He was already well known as a surrealist poet, with close ties to André Breton, and was further engaged in Trotskyite circles since 1927.[73] Despite the surname (her father was American), Elsie hailed from Rio de Janeiro. Her sister Mary Houston would later marry Mário Pedrosa, who attended Péret's and Elsie's wedding in Paris. Remembered today as Brazil's most renowned art critic of the twentieth century, Pedrosa was then a journalist and rising star of the Brazilian Communist Party (PCB), studying economics and philosophy in Berlin. He also returned to Brazil in early 1929, and, together with Lívio Xavier, Hílcar Leite, Aristides Lobo and others,

[70] "A conferência de Péret", *Revista de Antropofagia*, II, 2, In: *Diário de S. Paulo*, 24 March 1929, n.p. See also Cunhambebinho, "Péret, 6.

[71] See M. Elizabeth Ginway, "Surrealist Benjamin Péret and Brazilian modernism", *Hispania*, 75 (1992), 545; and Carlos Augusto Calil, "Fascínio e rejeição: Blaise Cendrars e Benjamin Péret no Brasil", In: Leyla Perrone-Moisés, ed., *Cinco séculos de presença francesa no Brasil* (São Paulo: Edusp, 2013), pp. 188–189.

[72] On Elsie Houston, see Micol Seigel, *Uneven Encounters: Making Race and Nation in Brazil and the United States* (Durham: Duke University Press, 2009), pp. 166–178. See also Elsie Houston-Péret, *Chants populaires du Brésil* (Paris: Librairie Orientaliste Paul Geuthner, 1930).

[73] On Péret's political affiliations, see Mário Maestri, "Benjamin Péret: Um olhar heterodoxo sobre Palmares, In: Victorien Lavou, ed., *Les noirs et le discours identitaire latino-américain* (Perpignan: Presses Universitaires de Perpignan/Crilaup, 1997), pp. 170–171; and Robert Ponge, "Desse pão, eu não como: Trajetória no Brasil, na França e alhures de Benjamin Péret, militante-e-poeta permanente", *Revista História & Luta de Classes*, 1 (2006), 29–43. On Péret's stay in Mexico from 1941 to 1948, see Fabienne Bradu, *Benjamin Péret y México* (Mexico City: Fondo de Cultura Económica, 2014).

took part in the Trotskyite dissidence from the PCB, whose Stalinist line they opposed. The group went on to form the self-proclaimed International Communist League, in 1931, a schism from the PCB, in which Péret took active part.

In Brazil, Péret was close not only to Pedrosa but also to Antônio Bento – the previously cited 'communist writer', as the *Correio da Manhã* labeled him, who would later gain recognition as an art critic – and to artist Flávio de Carvalho, who also became a member of the PCB. Due to his connection with the Houston family, Péret moved in the same social circles as other noted modernists like poets Jorge de Lima and Murilo Mendes, painter Ismael Nery and critic Annibal Machado, some of whom shared his taste for surrealism though not necessarily his militant anti-clericalism.[74] Péret was friendly with the anthropophagists too, and both he and Elsie appear prominently in photographs taken at the opening of Tarsila's exhibition at the Palace Hotel in 1929. The peculiar bonds that bound surrealism to communism in Paris and later Mexico appear to have extended to Brazil as well and to have spilled over into the circle around *Antropofagia*.[75] In December 1931, Péret was arrested under the accusation of spreading communist propaganda and expelled from Brazil. The direct spur for this move was a study he authored on João Cândido, leader of the 1910 naval mutiny *Revolta da Chibata* (Revolt of the Lash), a figure popularly known as 'the black admiral', which was the title the poet chose for his work.[76] Through personal contacts, Péret managed to research his book directly in military archives, a detail that outraged navy commanders sensitive to the memory of the revolt and its ramifications in public opinion. The book was seized at the press, the entire edition destroyed and Péret deported under a decree signed by no less than

[74] Ginway, "Surrealist Benjamin Péret and Brazilian modernism", 544–546; and Calil, "Fascínio e rejeição", pp. 189–191.

[75] See Pierre Taminiaux, "Breton and Trotsky: the revolutionary memory of surrealism", *Yale French Studies*, 109 (2006), 52–66; Floriano Martins, "El surrealismo en Brasil", *Alpha (Osorno)*, 21 (2005), 187–20; and Diane Scillia, "A world of art, politics, passion and betrayal: Trotsky, Rivera and Breton and manifesto: Towards a Free Revolutionary Art (1938)", In: Anna-Teresa Tymieniecka. ed., *Does the World Exist?: Plurisignificant Ciphering of Reality*, (Dordrecht: Kluwer, 2004), pp. 447–466. See also Michael Löwy, *Morning Star: Surrealism, Marxism, Anarchism, Situationism, Utopia* (Austin: University of Texas Press, 2009).

[76] See Joseph L. Love, *The Revolt of the Whip* (Stanford: Stanford University Press, 2012); and Zachary R. Morgan, *Legacy of the Lash: Race and Corporal Punishment in the Brazilian Navy* (Bloomington: Indiana University Press, 2014).

President Getúlio Vargas and then Minister of Justice and Internal Affairs, Osvaldo Aranha.[77]

At first glance, Péret's profile as a Trotskyite militant, directly involved in labour agitation, would seem to distance him from the insulated milieu frequented by most of the anthropophagists. Oswald and Tarsila were, after all, personally close to major figures of the PRP, which represented the interests of the wealthy coffee-planting bourgeoisie in São Paulo. Yet, these political divisions were never so clearly hewn; and, after the events of 1929 to 1930, a process of radicalization skewed ideological allegiances in unpredictable ways. Following a personal encounter with Luiz Carlos Prestes – the mythical military commander converted to the communist cause, who would later become a member of the Comintern and secretary-general of the PCB – Oswald and Pagu both joined the communist party in 1931 and became active in editing a weekly newspaper titled *O Homem do Povo* ("the man of the people").[78] Tarsila too drew close to communist circles through her romantic liaison with psychiatrist Osório César, with whom she travelled to the Soviet Union in 1931. As the polarization between fascists and anti-fascists grew starker over the 1930s, many other cultural figures would assume leftist or left-leaning positions, including Annibal Machado, Alvaro Moreyra and Flávio de Carvalho, culminating in the activities of the Clube de Artistas Modernos, in São Paulo, after 1932, and the Clube de Cultura Moderna, in Rio de Janeiro, in 1934 to 1935. After the anti-communist backlash of 1935 to 1936, most such endeavours came to a halt or were forced underground.[79]

Given this atmosphere of political ferment, the receptivity of the *Revista de Antropofagia* to Péret's militant propositions is less surprising than it might seem at first. Rather, it was his active interest in Afro-Brazilian culture that diverged more markedly from the main current of

[77] Ginway, "Surrealist Benjamin Péret and Brazilian modernism", 547; Calil, "Fascínio e rejeição", p. 191; and Maestri, "Benjamin Péret", p. 172.

[78] Geraldo Galvão Ferraz, ed., *Paixão Pagu: Uma autobiografia precoce de Patrícia Galvão* (Rio de Janeiro: Agir, 2005), pp. 75–76. See also Valdeci da Silva Cunha, "O Homem do Povo: Oswald de Andrade e o jornalismo engajado", *Em Tese*, 16 (2010), 36–55; and Aurora Cardoso de Quadros, *Oswald de Andrade no jornal O Homem do Povo* (unpublished doctoral dissertation, Programa de Pós-graduação em Teoria Literária e Literatura Comparada, Universidade de São Paulo, 2009), pp. 29–51.

[79] Cardoso, "Modernismo e contexto político", 354–355. See also Gabriela Naclério Forte, *CAM e SPAM: Arte, política e sociabilidade na São Paulo moderna, do início dos anos 30* (unpublished master's thesis, Programa de Pós-graduação em História Social, Universidade de São Paulo, 2008), esp. ch. 2.

the movement.[80] It is no coincidence Péret chose the black admiral João Cândido as the subject of his lost work. Just prior to that study, the surrealist poet published a series of thirteen articles in the São Paulo evening newspaper *Diário da Noite*, between November 1930 and January 1931, on the subject of "*candomblé* and *macumba*" based on first-hand experiences of *terreiros* (ritual spaces) in Rio de Janeiro. They were an early attempt to re-evaluate these rites as valid cultural expression, as Elizabeth Ginway has observed.[81] In the last four articles of the series, Péret developed an analysis of the place of Afro-Brazilian religions in the formation of Brazilian society. In keeping with his political views, he interpreted their survival as proof of a latent spirit of revolt that would eventually manifest itself on the secular plane, as well. Despite his aversion to religion in general, Péret's careful observations and pondered inquiry constitute an important contribution towards what Emerson Giumbelli has labelled an ethnography of Afro-Brazilian religions.[82]

Péret's series was certainly not the first journalistic account of *terreiro* rites and rituals, which date back at least as far as the early 1900s in the writings of Nina Rodrigues or João do Rio. The topic was increasingly present in the Brazilian press in the run-up to the poet's arrival. Over the first half of 1924, journalist Leal de Souza published a series of front-page articles in the evening newspaper *A Noite* covering the spirit world ("*No mundo dos espíritos*"), some of which referenced Afro-Brazilian rites. His fellow journalist Carlos Alberto Nóbrega da Cunha also wrote on the subject, authoring another series of articles titled "The mysteries of macumba", published in the little-known periodical *Vanguarda*, circa 1927, with illustrations by Fernando Correia Dias.[83] Both these journalists were instrumental in assisting the French poet with his research. Péret's articles depart from prevailing clichés and stereotypes in that they do not strike a note of opprobrium, dread or sensationalism. Much less do they relegate Afro-Brazilian religious practices to an inferior cultural

[80] On Péret's links to Afro-Brazilian culture, see Emerson Giumbelli, "Macumba surrealista: Observações de Benjamin Péret em terreiros cariocas nos anos 1930", *Estudos Históricos*, 28 (2015), 87–107; and Maestri, "Benjamin Péret", pp. 159–187.

[81] Ginway, "Surrealist Benjamin Péret and Brazilian modernism", 548–551. For a current appraisal of *terreiros* as visual cultural phenomenon, see Arthur Valle, "Afro-Brazilian religions, visual culture and iconoclasm", *IKON*, 11 (2018), 217–223.

[82] Giumbelli, "Macumba surrealista", 97–100.

[83] Arthur Valle, "Arte sacra afrobrasileira na imprensa: Alguns registros pioneiros, 1904–1932", *19&20*, 13 (2018), n.p.

plane. Anticlerical to the core, Péret deplores them as religion but enthuses openly about what he calls their primitive poetic power.[84]

A revealing, though possibly circumstantial, further connection between Péret and Oswald is the fact that both newspapers – *Diário de S. Paulo*, which published the *Revista de Antropofagia* in its second phase, and *Diário da Noite*, which published Péret's series on *candomblé* and *macumba* – belonged to the same publishing group and were run by one and the same editor, Rubens do Amaral.[85] Without his support, neither of these initiatives would have existed; and, indeed, the *Revista de Antropofagia* came to an abrupt end when he could no longer contain the swell of indignant readers outraged with the anthropophagists's blatantly anti-Catholic provocations.[86] Competition between organs of the press, which made use of sensationalism to vie for readers and of lighter news to mask their often partisan agendas, is an important aspect in understanding the nuances of their coverage of Afro-Brazilian religions.

It is worthy of note that Péret did not publish his articles in a Rio de Janeiro newspaper, much less a major daily like *A Noite* which had run the prior series by Leal de Souza. The subject was of interest in the capital, though, depending how it was packaged. A July 1928 article in *O Malho*, also titled "The mysteries of macumba", is more characteristic of how the mainstream press dealt with Afro-Brazilian rituals, veering in tone between fear, reverence and mockery.[87] It is framed by an illustration by Di Cavalcanti, showing eight figures – one prostrate on the ground, others kneeling or crouching, most visibly agitated, with upturned or staring eyes, furrowed brows, twisted or gaping mouths – amid an assortment of ritual objects: candles, a skull, a chicken, bread and fish, an effigy, a potted plant (Fig. 50). Though cartoonish, especially in its simplification of facial features to almost primitivist masks, the image suggests first-hand observation, which would come as no surprise given the artist's experience of the poorer districts of Rio de Janeiro.

[84] Giumbelli, "Macumba surrealista", 93–98, 105 n17.

[85] After 1932, Rubens do Amaral would prove to be a stalwart of *paulista* regional identity, defender of separatism and the *bandeirante* myth, even going so far as to credit the *bandeirantes* with contributing to Brazilian unity by defeating the "African cyst" of Palmares; Weinstein, *Color of Modernity*, pp. 45, 355–256 n75, 325, 413 n101.

[86] Juliana Neves, *Geraldo Ferraz e Patricia Galvão: A experiência do suplemento literário do Diário de S. Paulo, nos anos 40* (São Paulo: Annablume/Fapesp, 2005), pp. 35–42; and Bopp, *Vida e morte da antropofagia*, p. 53.

[87] "Os mysterios da macumba", *O Malho*, 14 July 1928, n.p.

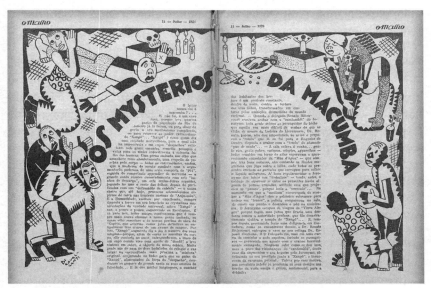

FIG. 50 [Emiliano] Di Cavalcanti, *O Malho*, 14 July 1928
Fundação Biblioteca Nacional (BN Digital/Hemeroteca Digital Brasileira)

Di Cavalcanti became a member of the PCB in 1928. Over the following years, he would develop a new iconography of Brazilian culture, conjugating a distinct vision of racial mixture with issues of social class.[88] His works of 1928 to 1931 verge on Mexican muralism in their ideological and ethnological fusion of identities into an ideal of *brasilidade*, reminiscent of the better-known construct of *la raza* in Mexico. Di's concomitant interest in working-class urban existence, samba and carnival, race and identity, position him within a wider stream of leftist currents embraced by modern artists. Despite the many schisms that divided political parties of the left, subterranean connections united those sympathetic to the aims of class struggle and international revolution. To differing extents, muralism, surrealism and *Antropofagia* all partook of a broader idea of 'social art', which came into its own over the 1930s. It is crucial, however, to bear in mind the subtle distinctions, timescales and shifts that set them apart. Di's affiliation to the PCB was,

[88] See Rafael Cardoso, "Ambivalências políticas de um perfeito modernista: Di Cavalcanti e a arte social", In: José Augusto Ribeiro, ed., *No subúrbio da modernidade – Di Cavalcanti 120 anos* (São Paulo: Pinacoteca do Estado, 2017), pp. 41–53. See Chapter 1, for Di's illustrations of favela themes.

quite possibly, one of the things that kept him aloof from *Antropofagia* at a time when the latter movement still declared itself anti-bolshevist.

Di's 1928 *macumba* illustration is interesting in its use of contrasts of light and dark to create drama in the faces as well as patterns in the clothes. This stark visual opposition is nuanced by the curious mottled grey used for the skin of the woman with spiky hair in the upper right hand corner, as well as patches of skin and clothing on other figures. The jagged black border that compresses the figures around the curved lettering of the title creates a confined pictorial space. Alternation between figurative and geometric elements, black, white and grey, generates visual rhythms that are suggestive of the drums used in rituals, although only two figures in the lower corners actually hold objects resembling percussion instruments. Taking as its subject supposedly archaic forms of popular religious belief, it is an image of modernity in black and white like few others. Akin to his favela illustration of 1923, discussed in Chapter 1, Di is here in engaged in the fabrication of visual archetypes.[89]

Like Di Cavalcanti, Péret was fascinated with a presumed primal essence that both men recognized in the culture of the urban poor and downtrodden, particularly in the black working-class existence of Rio de Janeiro. The *Revista de Antropofagia*, on the contrary, displayed almost no interest in such themes, sharing neither Péret's peculiar fascination with the power of Afro-Brazilian rituals nor his deep hatred of organized religion. The anthropophagists were unmoved by sectarian distinctions, coming out in favour of: "All religions. But no church. And, above all, lots of witchcraft."[90] This flippant attitude towards the sacred derived loosely from Freudian ideas about the origin of religion in totem and taboo, as well as from a quasi-Nietzscheian contempt for the humility professed by Christianity.[91] In the March 1929 article assessing Péret, the journal scorned the "final despair of the Christianized" and exulted over the liberation of man through the dictates of the unconscious: "one of the most vigorous spectacles to warm an anthropophagic heart which has witnessed in recent years the despair of the civilized".[92] Again, religion and civilization are amalgamated as negative tropes.

Antropofagia was not averse, however, to using the faith of others to advance its aims. As Oswald put it in the pages of the journal,

[89] See Conduru, *Pérolas negras, primeiros fios*, pp. 37–47.

[90] Japy-Mirim, "De antropofagia", *Revista de Antropofagia*, II, 2, In: *Diário de S. Paulo*, 24 March 1929, n.p.

[91] See Madureira, *Cannibal Modernities*, p. 34. [92] Cunhambebinho, "Péret", 6.

"Our people possess a superstitious, religious temperament. Let us not contradict it."[93] In this sense, of humouring opposed ideas and debasing them with humour, it is telling that the journal came out in favour of *feitiçaria* (witchcraft) rather than *macumba*, then a popular term for designating Afro-Brazilian religions in general.[94] For many readers at the time, the two terms would have been interchangeable, and the joke remains equally funny (or unfunny, depending on your sense of humour) with the word *macumba*. Even in this minor detail, *Antropofagia* kept a distance from the surge of contemporary interest in Afro-Brazilian religions. Between 1928 and 1929, at a time when the mainstream press, as well as artistic peers like Péret and Di Cavalcanti and even Oswald's great rival Mário de Andrade openly displayed interest in Afro-Brazilian religions, *Antropofagia* maintained an uncharacteristic silence on the subject. This reticence is suggestive of a comparative lack of willingness to engage with the broader issue of race.

4.5 MUSIC AND THE SAVAGE MODERNIST

The be-all and end-all of popular music in Brazil circa 1927 was pianist and composer Sinhô, famously crowned 'the king of samba' in a controversial contest that year. Riding the wave of improved mechanical recordings, he became one of the first household names of the new style and helped popularize it beyond Rio de Janeiro. Readers of Chapter 1 have encountered him before as author of "*A Favela vai abaixo*", a hit during the carnival of 1928. Unlike the *bambas* of the first generation of urban samba – legendary names like Bahiano, China, Donga, Heitor dos Prazeres, João da Baiana, Pixinguinha – Sinhô's identity was not rooted in the 'Little Africa' region of Rio, its *terreiros*, favelas and working-class existence. On the contrary, he used his charm and celebrity to move freely between social classes and musical genres.[95] Upon his early death from tuberculosis in 1930, poet Manuel Bandeira described him as "the most

[93] Oswald de Andrade, "Schema ao Tristão de Athayde", *Revista de Antropofagia*, I, 5 (September 1928), 3.

[94] On distinctions between candomblé and macumba in ethnological writings, see Giumbelli, "Macumba surrealista", 98–99.

[95] Maria Clementina Pereira Cunha, "De sambas e passarinhos: As claves do tempo nas canções de Sinhô", In: Sidney Chalhoub, Margarida de Souza Neves & Leonardo Affonso de Miranda Pereira, eds., *História em cousas miúdas: Capítulos de história social da crônica no Brasil* (Campinas: Ed. Unicamp, 2005), pp. 547–587. See also Marc A. Hertzman, *Making Samba: a New History of Race and Music in Brazil* (Durham: Duke University Press, 2013), 121–125; and Lira Neto, *Uma história do samba: Volume I (As origens)* (São Paulo: Companhia das Letras, 2017), pp. 126–139.

expressive ligature connecting poets, artists, refined and cultured society to the deepest layers of the urban riffraff".[96]

Given Sinhô's undeniable talent for social mobility, it should come as no surprise that he encountered and captivated several of the great names in Brazilian modernism, amidst a profusion of intellectuals with whom he mingled. One such occasion was immortalized by Bandeira in a well-known chronicle in which he recounts Sinhô 'improvising' a song the poet later discovered had been written years before by somebody else.[97] That meeting, in late 1929, took place at a gathering at the home of Eugênia and Alvaro Moreyra. Earlier that same year, Sinhô traveled to São Paulo where he performed, among other venues, at the very Municipal Theatre where the *Semana* had been staged seven years before. The event was the launch of Júlio Prestes's presidential candidacy, and the invitation came from the Clube de Antropofagia. After a reception in his honour, given by Tarsila and Oswald, the shrewd sambista dedicated his song "*Nossa Senhora do Brasil*" (Our Lady of Brazil) to his hostess.[98] Sinhô, it turns out, out-anthropophagized the antropophagists, devouring their influence to make himself stronger. In exchange, the stardust of his celebrity was sprinkled onto them.

With his kingly ambitions and winning ways, Sinhô provided the palatable version of the street-smart *malandro*. The best part of his act was that it was fully self-aware. The lyrics of his final song, recorded posthumously, state:

> "Finally I have seen
> the guitar given its worth.
> To be strummed
> by the flower of the elite.
> Now a black man can sing
> in the house of a senator,
> and garner applause
> from children and father alike."[99]

[96] Bandeira, *Crônicas da província do Brasil*, 98. See also André Gardel, *O encontro entre Bandeira e Sinhô* (Rio de Janeiro: Secretaria Municipal de Cultura/Biblioteca Carioca, 1996), pp. 23–27.

[97] Bandeira, *Crônicas da província do Brasil*, pp. 98, 153.

[98] "Sinhô", *Para Todos*, 15 June 1929, 13; and Pereira Cunha, "De sambas e passarinhos", 559, 584 n23. Cf. Aracy A. Amaral, *Tarsila: Sua obra e seu tempo* (São Paulo: Ed. 34/Edusp, 2003), 474.

[99] José Adriano Fenerick, *Nem do morro, nem da cidade: As transformações do samba e a indústria cultural (1920–1945)* (São Paulo: Annablume/Fapesp, 2005), 207–210; and Pereira Cunha, "De sambas e passarinhos", pp. 559–560, 579–580.

Sinhô's blackness, or relative lack thereof, remains a subject of dispute among aficionados and scholars alike; but there is no doubt his main instrument was the piano, not the guitar. Like many other artists and intellectuals of the period, his outlook was tinged by a double consciousness that he was savvy enough to turn to his advantage whenever he could. The sense of belonging culturally to more than one sphere at once, and of habitually seeing oneself through the eyes of another, is frequently redressed in Brazilian culture by strategies of using humour, play-acting and sham as forms of liberation from impossible social strictures. Thus, the centrality of carnival. As Monica Pimenta Velloso has pointed out, the critical absorption of otherness was a touchstone of sensibilities in Brazil long before Oswald codified it into a manifesto.[100]

In contrast to the enthusiasm of Oswald, Tarsila, Bandeira, the Alvaro Moreyra couple, among others, Mário de Andrade did not embrace Sinhô with quite the same candour of his fellow modernists. Then writing for the *Diário Nacional*, he dedicated a column, dated 11 May 1929, to the sambista upon the latter's visit to São Paulo. Though the text is ostensibly laudatory, it is filled with barbs directed at the composer's Carioca identity:

Sinhô is a poet and a musician. From Brazil? It anguishes me, at present, to imagine Brazil... This country is, I believe, a symbolic entity. [...] However, if Sinhô is not Brazilian, he is Carioca. It does not interest me to know where he was born. Sinhô is Carioca in his music and in his poetry.[101]

Sinhô was, in fact, born in Rio de Janeiro, though Mário's remarks might be taken to imply he was not. The author goes on to explain that "the Carioca exists as a psychological entity" and chastises this presence for its banality, vulgarity and excessive sensuality, all of which he correlates with the music of Sinhô. The contention that the national capital was not a part of Brazil is intriguing in the context of mid-1929 and confirms a grudge the author had vented at greater length, the preceding year, in his essay on the baroque sculptor Aleijadinho, in which he claimed that Aleijadinho was not Brazilian either and pilloried Rio de Janeiro as symbolic of "the bureaucratic tropical instinct of our nationhood".[102]

[100] Monica Pimenta Velloso, "Sensibilidades finisseculares: Intelectuais e cultura boêmia"; In: Carmem Negreiros, Fátima Oliveira & Rosa Gens, eds., *Belle Époque: Crítica, arte e cultura* (São Paulo: Intermeios, 2016), pp. 38, 47.

[101] Mário de Andrade, *Taxi e crônicas no Diário Nacional* (São Paulo: Duas Cidades/ Secretaria de Cultura, Ciência e Tecnologia, 1976), p. 103.

[102] Mário de Andrade, *Aspectos das artes plásticas no Brasil* (Belo Horizonte: Itatiaia, 1984), pp. 11–12. On resentment of *paulista* intellectuals against Rio and its strategic

His rather unhinged attack on the capital in that text – and, by extension, on the very idea of nationhood – demands to be unpacked.

At that specific juncture in 1928–1929 – when *Antropofagia* was at its height and Mário under siege from the movement – his propensity to view himself as the victim of cosmpolitan conspiracies in the capital was nourished to paranoia-inducing heights. The *Revista de Antropofagia*'s attacks began in March 1929, casting him as fussy, feminine and scheming, and hit a low point in July with an article by Oswaldo Costa in which he was ridiculed as "the cosmetic of Northeastern poetry" and reprehended for not allowing "to explode within himself the good negro he wishes vainly to hide for fear of the Holy Mother Church".[103] The unusually phrased latter remark is a veiled allusion both to his homosexuality and his mixed racial background, and its victim undoubtedly picked up on these meanings.[104]

Given that Mário avoided confronting the fact that he was identified as a mulatto by others – as evidenced in Oswald's autobiographical account of the day they met – his emphasis on a conflict between ethnicity and nationality is troubling. It goes against the grain of the then ascendant view, espoused by Gilberto Freyre among others, that racial mixture was the positive defining characteristic of Brazilianness.[105] Mário's thesis that Aleijadinho was not Brazilian was premised on the contention that the sculptor's identity was shaped foremost by his racial condition as a mulatto. He was, according to the author, "more a mestizo than a national" and "is only Brazilian because, by God!, he happened in

manipulation, see Angela de Castro Gomes, *Essa gente do Rio...: Modernismo e nacionalismo* (Rio de Janeiro: Fundação Getúlio Vargas, 1999), pp. 12–13, 48–50; and Tania Regina de Luca, *A Revista do Brasil: Um diagnóstico para a (n)ação* (São Paulo: Ed. Unesp, 1999), ch. 5. See also Weinstein, *Color of Modernity*, pp. 57–59; and Rafael Cardoso, "The Brazilianness of Brazilian art: discourses on art and national identity, c.1850–1930", *Third Text*, 26 (2012), 27–28.

[103] Oswaldo Costa, "Resposta a Ascenso Ferreira", *Revista de Antropofagia*, II, 15, In: *Diário de S. Paulo*, 19 July 1929, 12. For previous attacks, see Tamandaré, "Moquém. II – Hors d'oeuvre", 6; Tamandaré, "Moquem. III. Entradas", *Revista de Antropofagia*, II, 6, In: *Diário de S. Paulo*, 24 April 1929, p.10; Tamandaré, "Moquém. IV. Sobremesa", 12.

[104] See Aracy A. Amaral, ed., *Correspondência Mário de Andrade e Tarsila do Amaral* (São Paulo: Edusp, 2001), p. 106.

[105] This is especially surprising because Mário was then close to Gilberto Freyre; Júlio Castañon Guimarães, "Crônica das Crônicas da província do Brasil", In: Bandeira, *Crônicas da província do Brasil*, pp. 242–243. Cf. Weinstein, *Color of modernity*, pp. 11–14; and George Reid Andrews, "Brazilian racial democracy, 1900–1990: an American counterpoint", *Journal of Contemporary History*, 31 (1996), 487–488.

Brazil".[106] Though Mário exalts Aleijadinho's artistic genius, he attributes it to a condition of deviance from the false social structures by which he was constrained. Tellingly, the same allegation of not being really Brazilian but something else is directed at Sinhô, an iconic figure who happened to self-identify as neither black nor white but something different.[107] The sambista might even be a great Carioca, with all the debased vulgarity that epithet entails for Mário, but does not belong to the same imagined community in which the author situates himself. This unusual position of casting the mestizo and the Brazilian into opposition sugests that Mário acknowledged (or perhaps just feared) some exalted paradigm of ethnic and cultural purity.[108]

Mário's attitudes to music exhibit an insistence on tropes of debasement versus a pristine primitive state. In a column of 10 August 1930 on the subject of recorded music, he wrote: "The Brazilian discography belongs almost exclusively to the domain of urban popular music, I mean to say, that depreciated and rendered banal by the evils of citification." The author expresses the wish that more attention should be paid to recording folkloric music and interesting orchestrations, as opposed to what he dismissively labels the "sound of the little *maxixeira* orchestras of Rio".[109] Similarly, in a subsequent column of January 1931 – written after Sinhô's death – he enthuses about the latter's syncopated style of singing but makes a point of classifying it in comparative ethnological terms, remarking on how: "our *maxixeiro* song of negro origins coincides curiously with the improvisational vocal process of the Afro-Yankee 'blues'".[110] Mário's researches in ethnomusicology, a field in which he achieved no small recognition, bear out his inclination to view the rural past as a disappearing archetype of the *popular*, in the good

[106] Andrade, *Aspectos das artes plásticas no Brasil*, pp. 22–25, 41–42.

[107] In Sinhô's case, he preferred to designate himself as a *caboclo*; Pereira Cunha, "De sambas e passarinhos", 96. On disputes around blackness and authenticity in the world of samba during the 1930s, see Hertzman, *Making Samba*, ch. 5.

[108] Mário's unpublished manuscript "A guerra de São Paulo" reveals that he was not immune to racist ideology and even subscribed to ideas of São Paulo as standard-bearer of a "European Christian civilization" versus the rest of Brazil as semi-civilized; Weinstein, *Color of Modernity*, pp. 148–149.

[109] Andrade, *Taxi e crônicas no Diário Nacional*, 236. On Mário's deafness to urban popular music, see José Miguel Wisnik, "Getúlio da Paixão Cearense", In: Enio Squeff & José Miguel Wisnik, *O nacional e o popular na cultura brasileira* (São Paulo: Brasiliense, 1983), pp. 131–133.

[110] Andrade, *Taxi e crônicas no Diário Nacional*, p. 322.

sense, versus the evils of the urban present and its pandering to the corrupted taste of the masses.[111]

Mário de Andrade's qualified disavowal of Sinhô stands in instructive contrast to *Antropofagia*'s crass embrace of him for his value as a celebrity. The former attitude shares traits with the European primitivist fantasy of seeking purity elsewhere, in the lost past or distant reaches of the earth. The fact that Sinhô is Carioca disqualifies him, in Mário's eyes, because it means he is a sly cosmopolitan, open to outside influences, much as European ethnographers would sometimes rate peoples uncontacted by foreign civilizations as more authentic, for purposes of study, than those who engaged in trade or cultural exchange. Mário, the ethnomusicologist, seeks to preserve the primitive in order to set it apart from the present. On the opposite side of the scale, *Antropofagia*'s entrepreneurial espousal of Sinhô shares ground with the *negrophilia* of Parisian night clubs and the jazz age. It partakes of primitivism too, but of a different sort since its aim is to mix and mingle and incorporate alterity into the self. It is distinctly less prudish and austere, though equally tinged by claims of supremacy. Presumed authority versus de facto entitlement. In both cases, the subaltern is left to fend for itself.

[111] See Martha Abreu & Carolina Vianna Dantas, "Música popular e história, 1890–1920", In: Antônio Herculano Lopes, Martha Abreu, Martha Tupinambá de Ulhôa & Monica Pimenta Velloso, eds., *Música e história no longo século XIX* (Rio de Janeiro: Fundação Casa de Rui Barbosa, 2011), pp. 40–43; Guerra, *O primitivismo em Mário de Andrade, Oswald de Andrade e Raul Bopp*, pp. 248–252; Avelino Romero Pereira, *Música, sociedade e política: Alberto Nepomuceno e a República musical* (Rio de Janeiro: Ed. UFRJ, 2007), 27–28; Carlos Sandroni, "Adeus à MPB", In: Berenice Cavalcante, Heloisa Starling & José Eisenberg, eds., *Decantando a República: Inventário histórico e político da canção popular moderna brasileira* (Rio de Janeiro: Nova Fronteira & São Paulo: Fundação Perseu Abramo, 2004), p. 27; and Vianna, *O mistério do samba*, pp. 106–108.

5

The Face of the Land

Depicting 'Real' Brazilians under Vargas

Studies of miscegenation [*mestiçagem*] in Brazil have yet to be carried out
according to rigorous scientific criteria.

Arthur Ramos, 1947[1]

The idea of the *sertão* looms large in accounts of Brazilian culture and
identity. Variously translated as hinterland, backlands, outback, back
country, among other terms, a rugged and sparsely populated interior is
often cast in opposition to a corrupt coastal civilization. This is the spatial
premise for conceptions of the 'two Brazils' or 'the Brazil that does not
know Brazil', which have been popular tropes since at least the early
twentieth century.[2] Following the triumphant reception of Euclides da
Cunha's *Os sertões*, published 1902, various interpreters came to posit
the interior as the place of the 'real' nation, a territory unfamiliar to
European-fixated elites but home to the deeper currents of national
identity, sometimes encapsulated by the term *Brasil profundo* (deep
Brazil). This imagined non-community reinforces a simplified dichotomy
between authentic values of the rural/natural versus the artificial culture

[1] Arthur Ramos, *Introdução à antropologia brasileira. 2° volume: As culturas européias e os
contatos raciais e culturais* (Rio de Janeiro: Casa do Estudante do Brasil, 1947), p. 361.
[2] Nísia Trindade Lima, *Um sertão chamado Brasil: Intelectuais e representação geográfica
da identidade nacional* (Rio de Janeiro: Revan/Iuperj, 1999), pp. 17–33. See also Rex
Nielsen, "The unmappable sertão", *Portuguese Studies*, 30 (2014), 5–20; and Margarida
de Souza Neves, "O sertão (en)cantado: Cores e sonoridades", In: Berenice Cavalcante,
Heloisa Starling & José Eisenberg, eds., *Decantando a República: Inventário histórico e
poético da canção popular moderna brasileira* (Rio de Janeiro: Nova Fronteira & São
Paulo: Fundação Perseu Abramo, 2004), pp. 93–111.

of cities. It has served as a pretext for various attempts to explore, incorporate or recover a supposed true essence of the nation in fields as diverse as literature, medicine and sociology.[3] The so-called modernist caravans to the historical cities of Minas Gerais and to the northeast, over the 1920s, fit into this pattern just as well as the 'westward march' policy instigated by the Vargas regime after 1940.

The practical difficulty has often been to define exactly where the *sertão* begins and ends. A shifting intellectual construct, the term has been applied to different places over the centuries, although it currently enjoys relative semantic stability as a designation for a specific sub-region of northeast Brazil.[4] The frontier between *sertão* and city has never been fixed. Over the early decades of the twentieth century, as seen in Chapter 1, Rio's favelas were often considered as vestiges of the *sertão* within the nation's capital. In a different vein but still apposite, sculptor Armando Magalhães Corrêa achieved success with a series of illustrated reportages – that came out in the newspaper *Correio da Manhã* between 1932 and 1933 and were published in book form in 1936 – on "the *sertão* Carioca", by which he meant the then semi-rural portions of the city which today correspond to the districts of Jacarepaguá and Barra da Tijuca.[5] Between the 1910s and 1930s, a slippage between *sertão* and city was equally evidenced in the realm of music, with the borders between jazz, samba and *sertanejo* – in the sense of the musical style of the *sertão* – never quite so clear-cut as purists would like to believe. The musical group Oito Batutas, celebrated for taking the characteristic sound of Brazil to international audiences in the early 1920s, crossed over into foxtrot and *sertanejo* as seamlessly as they mashed up *choro* and *maxixe*.[6]

[3] See Trindade Lima, *Um sertão chamado Brasil*, pp. 55–89; and Nicolau Sevcenko, *Literatura como missão: Tensões sociais e criação cultural na primeira República* (São Paulo: Companhia das Letras, 2009 [1983]), esp. ch. 4. See also Vanderlei Sebastião de Souza, "Arthur Neiva e a 'questão nacional' nos anos 1910 e 1920", *História, Ciências, Saúde – Manguinhos*, 16 (2009), 249–264.

[4] Janaína Amado, "Região, sertão, nação", *Estudos Históricos*, 8 (1995), 145–151. See also Janaína Amado, Walter Nugent & Warren Dean, *Frontier in Comparative Perspectives: the United States and Brazil* (Washington, DC: Woodrow Wilson Center for International Scholars, 1990).

[5] Armando Magalhães Corrêa [Marcus Venício Ribeiro, ed.], *O sertão carioca* (Rio de Janeiro: Biblioteca Nacional, 2017 [1936]). See also José Luiz de Andrade Franco & José Augusto Drummond, "Armando Magalhães Corrêa: Gente e natureza de um sertão quase metropolitano", *História, Ciências, Saúde – Manguinhos*, 12 (2005), 1033–1059.

[6] Marc A. Hertzman, *Making Samba: a New History of Race and Music in Brazil* (Durham: Duke University Press, 2013), pp. 107–108; Micol Seigel, *Uneven Encounters: Making Race and Nation in Brazil and the United States* (Durham: Duke University Press, 2009),

The historical construct of the *sertão* is older than Euclides da Cunha's great work on Canudos. Whereas for Euclides, the followers of Antônio Conselheiro were genuine *sertanejos* – or inhabitants of the *sertão* – his contemporary Coelho Netto imagined the *sertanejo* differently from the 'fanatic' *conselheiristas*, as an ideal archetype of Brazilian man, a national hero. His book *O sertão*, of 1897, written in the shadow of the tragic events at Canudos (see Chapter 1), reflects the wish to root the essence of national character in a different environment than the recent slave-holding past or the fevered present of the Federal District.[7] For Affonso Arinos, author of the book *Pelo sertão* (1898), the term is neither tragic nor heroic, but lyrical. His exploration of rural folklore helped spawn a nativist vogue that reached its peak around the time of his death in 1916. The contemporaneity of these two books with the 1890s *caipira* paintings of Almeida Júnior reflects the appeal of rural themes and local types for the construction of a regional *paulista* identity around this time.[8] According to Nicolau Sevcenko, the posthumous staging of Arinos's musical play *O contratador de diamantes* (the diamond contractor), in May 1919 at São Paulo's Municipal Theatre, is the high point of a *caipira* mania that swept up local elites and directly impacted major backers of *paulista* modernism like Paulo Prado and Olívia Guedes Penteado, as well as then mayor and future president Washington Luiz.[9]

Throughout the 1920s, terms like *sertão* and *caipira* were in flux. The fact that someone as well-born and well-connected as Tarsila do Amaral was happy to identify with the latter makes it abundantly clear that by 1923, the date when she painted *A caipirinha* (the little *caipira*), it could no longer be understood simply as a derisive designation. On the contrary, in his 1925 poem "Atelier", penned during their courtship, Oswald

pp. 99–101; Larry Crook, *Focus: Music of Northeast Brazil* (London: Routledge, 2009), pp. 154–157; Rafael José de Menezes Bastos, "Les Batutas, 1922: une anthropologie de la nuit parisienne", *Vibrant*, 4 (2007), 28–55. See also Izomar Lacerda, *Nós somos batutas: Uma antropologia da trajetória musical do grupo Os Oito Batutas e suas articulações com o pensamento musical brasileiro* (unpublished master's thesis, Programa de Pós-graduação em Antropologia Social, Universidade Federal de Santa Catarina, 2011).

[7] Leonardo Affonso de Miranda Pereira, "Cousas do sertão: Coelho Netto e o tipo nacional nos primeiros anos da República", *História Social*, 22/23 (2012), 93–110.

[8] See Maria Cecilia França Lourenço, ed., *Almeida Júnior: Um criador de imaginários* (São Paulo: Pinacoteca do Estado, 2007). The word *caipira* is used to refer to a rural inhabitant and is roughly akin to bumpkin, yokel, hayseed or rube in English-speaking contexts, though not necessarily pejorative.

[9] Nicolau Sevcenko, *Orfeu extático na metrópole: São Paulo, sociedade e cultura nos frementes anos 20* (São Paulo: Companhia das Letras, 1992), pp. 238–248.

de Andrade famously referred to her as a "*caipirinha* dressed in Poiret".[10] The generation to which they belonged had grown up during the 1890s and 1900s, a period when folklore and ethnology were being actively advanced as keystones of a new conception of the 'national' and the 'popular' by authors like Sylvio Romero and Mello Moraes Filho.[11] By the end of the decade, *sertão* mania was old hat. In a 1929 article titled "Poetry of the *sertão*", Manuel Bandeira remarked derisively that Catullo da Paixão Cearense – the elder statesman of *sertanejo* music and poetry, whose song "Luar do sertão" (moonlight of the *sertão*) captured the hearts of multitudes in 1914 and instantly became a standard – was really just as urban as he was. "His is a *sertão* of yearning [*saudade*]," wrote Bandeira.[12]

The inventions and transformations undergone by the term *jeca* (roughly translatable as 'hick') are perhaps the most striking example of how unstable the rural/urban dichotomy had become.[13] The *caboclo* character Jeca Tatu, created by writer and *paulista* regionalist Monteiro Lobato between 1914 and 1916, exploded into a national phenomenon after being cited by presidential candidate Ruy Barbosa, during the electoral campaign of 1919, as an exemplar of the backward mentality that hindered Brazil's progress.[14] The satirical press in Rio was delighted at

[10] Carolina Casarin, "'Caipirinha vestida de Poiret': O traje de Tarsila do Amaral em sua primeira exposição individual", *Anais do Primeiro Seminário em Artes, Cultura e Linguagens (Instituto de Artes e Design/UFJF)* (2014), pp. 139–149. See also Aracy A. Amaral, *Tarsila: Sua obra e seu tempo* (São Paulo: Ed. 34/Edusp, 2003 [1975]), pp. 143–147.

[11] See Avelino Romero Pereira, *Música, sociedade e política: Alberto Nepomuceno e a República musical* (Rio de Janeiro: Ed. UFRJ, 2007), pp. 24–28; Martha Abreu, *O império do divino: Festas religiosas e cultura popular no Rio de Janeiro, 1830–1900* (Rio de Janeiro: Nova Fronteira, 1999), pp. 144–156; and Roberto Ventura, *Estilo tropical: História cultural e polêmicas literárias no Brasil, 1870–1914* (São Paulo: Companhia das Letras, 1991), pp. 47–52. See also Renato Ortiz, *Cultura brasileira e identidade nacional* (São Paulo: Brasiliense, 1986), pp. 127–142.

[12] Manuel Bandeira, *Crônicas da província do Brasil* (São Paulo: Cosac Naify, 2006 [1937]), p. 144. Cf. a drawing by Raul for the cover of *O Malho*, 28 June 1919, titled "Luar do sertão", satirizing the vogue for images of the rural poor.

[13] See Jerry Dávila, *Diploma of Whiteness: Race and Social Policy in Brazil, 1917–1945* (Durham: Duke University Press, 2003), pp. 28–30; Aluizio Alves Filho, *As Metamorfoses do Jeca Tatu (a questão da identidade do brasileiro em Monteiro Lobato)* (Rio de Janeiro: Inverta, 2003); and Márcia Regina Capelari Naxara, *Estrangeiro em sua própria terra: Representações do brasileiro 1870/1920* (São Paulo: Annablume, 1998).

[14] Ruy Barbosa, "A questão social e política no Brasil", In: *Pensamento e ação de Rui Barbosa* (Brasília: Senado Federal, 1999), pp. 367–369. See also Maria Cristina Gomes Machado, *Rui Barbosa: Pensamento e ação: Uma análise do projeto modernizador para a sociedade brasileira com base na questão educacional* (Campinas: Ed. Autores

the magniloquent Ruy's discursive incursion into the backwoods. A cover of *O Malho* by J. Carlos (Fig. 51), one among many cartoons and articles, lampooned him as a latter-day Portuguese navigator discovering, 419 years later, what everyone already knew: a *caipira* figure standing on the shore, fishing, a cigarette dangling from his open mouth. The cartoon places the Jeca character in the foreground, while a wild-eyed Ruy approaches from afar, suggesting how distant the politician was from the everyday concerns of the magazine's readership.

One of the crucial questions emerging out of these discourses of the 1910s and 1920s revolves around the image Brazilians made of themselves. Were typical Brazilians supposed to look more like Ruy, like Jeca Tatu or some other appearance entirely? The illustrated magazines of the period employed different solutions to represent the face of Brazil in cartoons and illustrations. Many used some variation of the Jeca character to depict the common people or the national interest, much as nineteenth-century periodicals had done with allegorical indigenous figures, who were frequently deployed to represent the body of the nation. Such generic *jecas* were, in many ways, successors of the older Zé Povo (literally, 'Joe People') character, of Portuguese origin, occasionally represented as a *caipira* in Brazil. The leading political magazine *O Malho* made extensive use of a mascot named 'Cardoso' – a short, stout, balding figure with a red nose and a straw hat, who often wore checked vests and carried a walking stick. This character was intended as a sort of average man, though it is open to question how far readers identified with his appearance. On occasion, characters like Cardoso and Jeca could even be made to interact, breaking up the imagined collective into component parts that complicated its meaning (Fig. 52).

In a country of such ethnic diversity, how could Brazilianness be represented visually, as well as conceptually? There are many possible answers to that question, and almost all of them are traversed by issues of race and stereotypes.[15] Before the 1930s, there was little chance any such representative figure might be depicted as black. The republican regime of 1889 never really succeeded in enforcing its preferred effigy of the nation:

Associados & Rio de Janeiro: Fundação Casa de Rui Barbosa, 2002). *Caboclo* is another epithet of variable meaning. It can be used to refer to anyone from the backwoods, but in racialist discourses usually refers to a mixture of European and Amerindian ancestries, with a predominance of the latter.

[15] See Monica Pimenta Velloso, "A mulata, o papagaio e a francesa: O jogo dos estereótipos culturais", In: Isabel Lustosa, ed., *Imprensa, humor e caricatura: A questão dos estereótipos culturais* (Belo Horizonte: Ed. UFMG, 2011), pp. 365–387.

FIG. 51 J. Carlos [José Carlos de Brito e Cunha], *O Malho*, 3 May 1919
Fundação Biblioteca Nacional (BN Digital/Hemeroteca Digital Brasileira)

the white female allegory of the Republic consciously derived from the
French Marianne.[16] Nevertheless, the figure of *República* did find its way

[16] José Murilo de Carvalho, *A formação das almas: O imaginário da República do Brasil*
(São Paulo: Companhia das Letras, 1990), pp. 75–107.

FIG. 52 J. Carlos [José Carlos de Brito e Cunha], *O Malho*, 12 July 1924
Fundação Biblioteca Nacional (BN Digital/Hemeroteca Digital Brasileira)

into the public discourse, not only through official representations (e.g., postage stamps) but also in illustrated magazines and cartoons, where it took its place alongside other embodiments of nation and people, such as Zé Povo, Jeca Tatu and Cardoso. The multiplicity of figures

representative of Brazilian identity during those forty years is a testament to the decentralized political culture of the 'old' Republic, dominated by rival oligarchies and competition between regions.

After the Revolution of 1930, and in parallel to the rise of fascism in Europe, the representation of so-called *raciality* and national types became a more sombre concern. The Vargas regime, with its drive towards centralization and attempts to suppress regional power, devoted much thought and resources into establishing a visual paradigm of *brasilidade*. Some of the efforts undertaken will be scrutinized in the present chapter. In parallel to its search for an effigy symbolizing the people, the regime also invested heavily in the image of Vargas himself, who was styled as 'father of the poor' (*pai dos pobres*). Yet, the cult of personality around Vargas only really came into its own after 1939, when the regime's notorious Department of Press and Propaganda (DIP) was created and charged with the specific mission of strengthening the leader's appeal to a mass public.[17] Symbolic disputes in the realm of visual culture before that date are more ambiguous and less understood. One thing is certain: before building up a new image of *brasilidade*, it was necessary to tear down other competing ones.

5.1 VANQUISHING THE BARBAROUS ELEMENT

In May 1929, the *Revista de Antropofagia* claimed an unusual member for the movement. Under the headline "Lampião-Anthropophagist", the journal printed three phrases extracted from a letter sent to the police by Virgulino Ferreira da Silva, the notorious bandit leader known as Lampião.[18] The sentences, written in his signature rustic style contain threats addressed to a sergeant of the Bahian police, one Sergeant Dudu, and were presumably gleaned from newspaper reports. The anthropophagists seem to have identified with the murderous sentiments contained in the outlaw's words, though there is no indication they sought Lampião's permission to number him as one of their own. Such a request would have been in order, considering the bandit's zealous efforts to control his

[17] See Mônica Pimenta Velloso, "Os intelectuais e a política cultural do Estado Novo", *Revista de Sociologia e Política*, 9 (1997), 57–74; and Lucia Lippi Oliveira, "O intelectual do DIP: Lourival Fontes e o Estado Novo", In: Helena Bomeny, ed., *Constelação Capanema: Intelectuais e política* (Rio de Janeiro: Ed. FGV, 2001), pp. 37–58. See also Alejandro Groppo, *The Two Princes: Juan D. Perón and Getulio Vargas: a Comparative Study of Latin American Populism* (Villa María: Eduvim, 2009), ch. 5.

[18] "Lampeão-Antropófago", *Revista de Antropofagia*, II, 8, In: *Diário de S. Paulo*, 8 May 1929, 12.

own image. By the late 1920s, Lampião was already a household name, more famous – or, at least, infamous – even than the sambista Sinhô, though he was not yet as media-savvy as he would grow over the following decade. Upon his death in 1938, Lampião was arguably the biggest celebrity in Brazil, vying with Vargas as the most recognizable face of the nation.

Lampião first rose to prominence in 1926 in connection with the federal government's efforts to contain the rebel military movement known as *Coluna Prestes*, led by Luiz Carlos Prestes, the outlaw's anthithesis as a symbol of political resistance. Already feared as a bandit leader in the northeast of Brazil, Lampião entered a new phase in which he expanded his group – which grew into a small army, at some points – and restructured its organization, including the radical step of admitting women. His legend grew exponentially over the following years, and he became known as 'king of the *cangaço*', leading a lifestyle of raucous luxury and sought after by journalists curious to enquire about which type of perfume he wore and which brand of whisky he drank.[19] In 1930, the state government of Bahia instituted a substantial reward for his capture, soon doubled by funds from a commercial sponsor in Rio de Janeiro. Later that same year, he was the subject of an article in the *New York Times*. In 1931, he became the object of a popular song titled "I'm going to catch Lampião" and, in 1933, of a hit theatrical revue in the nation's capital. By 1934, two biographies of the bandit leader had been published, a feature-length film drama made about his escapades, and his image appeared increasingly in advertisements.[20]

Managing celebrity was a challenge, and it was not one Lampião took lightly. After all, the bandit leader's image was preyed upon by strangers exploiting it for their own ends, commercial, literary or otherwise. During the early 1930s, his band undertook an overhaul of its appearance, introducing a new wardrobe and colourful accessories, designed by one of their members and openly geared to ostentation and aestheticizing self-aggrandizement. They did their own sewing and embroidering, including the men, which intensified prurient interest in their lifestyle. The

[19] The term *cangaço* refers to the system of exercising authority through the employment of armed militias, hired by local landowners to control the disperse population in the rural interior of northeastern Brazil. A *cangaceiro* is a member of one of these groups.

[20] Élise Grunspan-Jasmin, *Lampião, senhor do sertão: Vidas e mortes de um cangaceiro* (São Paulo: Edusp, 2006), pp. 27–30; and Frederico Pernambucano de Mello, *Estrelas de couro: A estética do cangaço* (São Paulo: Escrituras, 2012), pp. 49–50, 82–85, 188–191, 199, 208.

flamboyant outlaws had become such a national obsession by the mid-1930s that an enterprising amateur photographer and filmmaker named Benjamin Abrahão tracked them down with the intention of shooting documentary footage. He not only achieved that intent but was rewarded with an authorization from Lampião granting him exclusive rights as purveyor of his image. Strategically peddled to the national press, Abrahão's journalistic coup intensified an already frenzied coverage. In early 1937, *O Cruzeiro*, by then the biggest national magazine, renowned for its photojournalism, devoted a spread to the images obtained by him. Other headlines hailed the outlaw as a 'movie star'.[21]

On 28 July 1938, a seven-year manhunt by state and federal governments ended in the deaths of Lampião and the core of his group at the hands of a detachment of army troops. A photograph of the severed heads of the leader and ten members of his band was produced, ostensibly with the purpose of proving that he was really dead, since popular superstition credited him with being invincible and immortal.[22] Within a few days, the image began to circulate in local and national newspapers – where the heads were described as "macabre trophies" and "the living image of death" – until the Ministry of the Interior prohibited its reproduction, a little over one week later.[23] It is the epitome and centrepiece of what Élise Jasmin has described as a 'war of images', as she defines the sensationalist coverage of Lampião's exploits that gripped the Brazilian press between 1936 and 1938, much of it orchestrated by the bandit leader himself, who proved to be a shrewd manipulator of his own image.[24]

Over subsequent decades, the photograph of the severed heads became one of the most infamous images in the visual culture of Brazil (Fig. 53). The picture shows a purposefully staged travesty of an altarpiece,

[21] Élise Jasmin, "A guerra das imagens: Quando o cangaço descobre a fotografia", In: Elise Jasmin, ed., *Cangaceiros* (São Paulo: Terceiro Nome, 2006), pp. 23–29; Frederico Pernambucano de Mello, *Benjamin Abrahão: Entre anjos e cangaceiros* (São Paulo: Escrituras, 2012), pp. 136–139, 171–173; and Pernambucano de Mello, *Estrelas de couro*, pp. 189–191.

[22] Authorship of the image is uncertain but has been attributed to João Damasceno Lisboa, a local painter, sculptor and photographer. The photograph was taken on the day of Lampião's death, with the heads displayed on the steps of the town hall of Piranhas, Alagoas; Pernambucano de Mello, *Estrelas de couro*, pp. 205–207.

[23] Grunspan-Jasmin, *Lampião, senhor do sertão*, pp. 286–290.

[24] Jasmin, "A guerra das imagens", pp. 15–32. See also Pernambucano de Mello, *Benjamin Abrahão*, pp. 136–173; and Marcos Edilson de Araújo Clemente, "Cangaço e cangaceiros: Histórias e imagens fotográficas do tempo de Lampião", *Fênix - Revista de História e Estudos Culturais*, 4 (2007), 1–18.

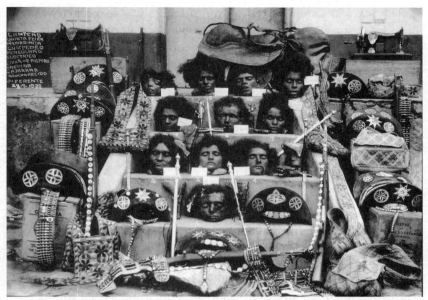

FIG. 53 Unidentified photographer, 28 July 1938 (severed heads of Lampião, Maria Bonita and nine other members of their band, whose names are listed on the tablet in the upper left)
Rio de Janeiro: private collection

designed to desecrate the memory of the dead it represents. Its composition is structured around an inverted pyramid, with two sewing machines in the upper corners defining the base and reaching an apex in the bruised and battered face of Lampião. His head is set apart on the lowest step, between a pair of long knives and two of the decorated hats emblematic of the *cangaceiros*. The heads all have closed eyes. Their hair is unkempt. Some of the mouths gape open. Visible wounds and deformities bespeak the violence of their recent struggle. Surrounding them, and propping up the centre of the composition, paraphernalia of the *cangaço* lifestyle fill the foreground and both sides of the image – rifles, cartridges, knives, leather hats, embroidered bags, straps made out of gold coins – a wealth of accessories looted from the corpses of the vanquished. At first glance, the clutter of the image can be disorienting; but its knowing use of symmetry, perspective and contrast of light and shade finally thrust the spectacle of the decapitated outlaw into the foreground of both picture and imagination. This carefully staged and crafted photograph can only be understood as the final volley in a pitched battle for symbolic power.

The years of Lampião's ascension to fame were no ordinary time in Brazilian history. Following a failed communist uprising in November 1935, the Vargas regime intensified repressive measures, persecuted political opponents and finally descended into a full-blown dictatorship in November 1937 – the *Estado Novo*, or 'new state', which lasted until 1945. As Frederico Pernambucano de Mello has argued, the federal government's campaign against Lampião worked into a larger strategy of effacing regional power structures and crushing opposition in the name of a fight against subversion and extremism. In its fusion of archaic myths of supernatural power with the most sophisticated instruments of modern propaganda, the legend of Lampião grew to be a thorn in the side of the dictatorial regime, forcing the government to devote ever more violence to its suppression. Such a context of political strife explains the brutality with which the *cangaceiros* were hunted down and the contempt with which their corpses were desecrated. There was a clear intent to prove not only that the outlaws were dead but also that the forces of insurgence and autonomy they represented had been definitively vanquished.[25]

Death did not put an end to Lampião. Rather, his legend continued to grow over subsequent decades, to the point where the myth has come almost to efface the historical figure. However, the mythical Lampião is less threatening than the man with all his quirks and foibles. At once folk hero and media celebrity, the outlaw came as close as anyone to personifying a Brazilian cultural identity in the 1930s. In a country characterized by ethnic and regional diversity, as well as extreme contrasts between urban and rural, rich and poor, unifying figures are hard to come by. Luiz Carlos Prestes played something of that role in his early years in the *tenentista* movement and subsequently as leader of the military column that marched over 25,000 kilometres through the Brazilian countryside, between 1925 and 1927, preaching insurrection. The ultimate failure of that movement to effect political change, as well as Prestes's espousal of communism after 1931, altered public perceptions of him. After his imprisonment in 1936, he seemed contained as a force for channelling something as abstract as 'the will of the people'. Suggestively, Lampião's ascent in the public eye runs roughly parallel to the undoing of Prestes as folk hero.

The notoriety achieved by Lampião between circa 1930 and 1938 is indicative of the sway mass media had already achieved in focusing

[25] Pernambucano de Mello, *Estrelas de couro*, 190–192. See also, Jasmin, "A guerra das imagens", 29–31.

popular attention at a national level. The legendary status of the bandit leader within his lifetime challenges Renato Ortiz's enduring argument to the effect that mass culture only came to exist in Brazil over the 1940s, with the advent of commercial radio.[26] Indeed, the evidence in print, photographs and even film suggests that coverage around the manhunt for Lampião and his ensuing death echoed throughout regions and social classes, gripping public opinion in a manner that made it aware of its own might. The media construct of Lampião as public enemy is arguably a watershed in the imagined communality of the nation. It marks a turning point at which the older illustrated magazines were overtaken by the newer power of photojournalism.[27] The idea of a war of images reinforces the fact that the battleground had shifted from words to pictures. At a time when the rate of adult illiteracy was well over 50 per cent and the medium of radio was still in its early stages, only visual culture could provide the resources necessary to manipulate the masses at all effectively. The fact that it did so is demonstrated by the political events of 1930 and 1932, in which 'the image of the people' was very definitely out in force.[28]

5.2 IMAGES OF BRAZILIAN MAN

Considering the fascination that the figure of Lampião exercised over the popular imagination, it is intriguing that the timing of his demise coincides with efforts by the Vargas regime to forge an official image of Brazilian identity through works of art. Foremost among these is construction of the building known today as *Palácio Capanema*, in Rio de Janeiro, the most renowned architectural product of the Vargas era. Designed by a team of architects including Lúcio Costa and Oscar

[26] Renato Ortiz, *A moderna tradição brasileira: Cultura brasileira e indústria cultural* (São Paulo: Brasiliense, 1988), pp. 38–49. In all fairness, most of the research on printed media and photojournalism that contradicts Ortiz's thesis had not yet been produced at the time of his writing. For a recent perspective on his pioneering contributions, see Paul Schlesinger, "Cultural industries, nation and state in the work of Renato Ortiz: a view from the anglosphere", *Ciências Sociais Unisinos*, 54 (2018), 172–177.

[27] See Nadja Peregrino, *O Cruzeiro: A revolução da fotorreportagem* (Rio de Janeiro: Dazibao, 1991); and Daniela Queiroz Campos, "Um fazer imagem: A produção gráfica da revista O Cruzeiro", *Diálogos*, 20 (2016), 102–116. See also Joaquim Marçal Ferreira de Andrade, *História da fotorreportagem no Brasil: A fotografia na imprensa do Rio de Janeiro de 1839 a 1900* (Rio de Janeiro: Elsevier, 2004).

[28] See Angela Alonso & Heloisa Espada, eds., *Conflitos: Fotografia e violência política no Brasil, 1889–1964* (São Paulo: Instituto Moreira Salles, 2017), pp. 214–262.

Niemeyer, working from studies by Le Corbusier, it is widely recognized as a landmark in the history of modernist architecture.[29] It was purpose built to house the then Ministry of Education and Health (MES) and commissioned by minister Gustavo Capanema, who oversaw the long and convoluted process of its construction, lasting from 1936 to 1945 and spanning the entire existence of the *Estado Novo.*

An important component of the original building programme, often forgotten because never executed, was a monumental sculpture celebrating the theme of 'Brazilian man' (*o homem brasileiro*). Intended for the courtyard in front of the building, the statue was supposed to be twelve metres high, made of granite and depict a nude seated man. The conception was Capanema's own, and he guided its development closely. In a letter of June 1937 presenting the proposal to Vargas, the minister compared it to Rodin's *Thinker*, as well as the Colossi of Memnon or the statues at Karnak. It would be a symbol of the Ministry's mission to shape the Brazilian people and, according to surviving letters and memoranda, would seek to establish the "Brazilian racial type".[30] Capanema took the latter aspect so seriously that he resorted to a committee of scientific advisers to determine what exactly that type might be. Among the experts he consulted were physicians Álvaro Fróes da Fonseca, Juvenil da Rocha Vaz and Edgard Roquette Pinto, leading lights of physical anthropology, as well as law professor and eugenicist Francisco José de Oliveira Vianna.

The monument was an integral part of the project, appearing repeatedly in preparatory sketches by Le Corbusier, and became the focus of a protracted effort during which Capanema commissioned two different

[29] On the building and its place in architectural history, see Mauricio Lissovsky & Paulo Sérgio Moraes de Sá, *Colunas da educação: A construção do Ministério da Educação e Saúde, 1935–1945* (Rio de Janeiro: Iphan/MinC & CPDOC/FGV, 1996); Lauro Cavalcanti, *Moderno e brasileiro: A história de uma nova linguagem na arquitetura (1930–1960)* (Rio de Janeiro: Jorge Zahar, 2010); Carlos Eduardo Dias Comas, "Protótipo e monumento, um ministério, o Ministério", In: Abilio Guerra, ed., *Textos fundamentais sobre a história da arquitetura moderna brasileira. Parte 1* (São Paulo: Romano Guerra, 2010), pp. 79–108; and Roberto Segre, *Ministério da Educação e Saúde – Ícone urbano da modernidade brasileira* (São Paulo: Romano Guerra, 2013). In English, see Lauro Cavalcanti, *When Brazil Was Modern: Guide to Architecture, 1928–1960* (Princeton: Princeton Architectural Press, 2003).

[30] Paulo Knauss, "O homem brasileiro possível: Monumento da juventude brasileira", In: Paulo Knauss, ed., *Cidade vaidosa: Imagens urbanas do Rio de Janeiro* (Rio de Janeiro: Sette Letras, 1999), pp. 29–30. See also Dávila, *Diploma of Whiteness*, ch.1; and Darien J. Davis, *Avoiding the Dark: Race and the Forging of National Culture in Modern Brazil* (Aldershot: Ashgate, 1999), pp. 101–103.

sculptors, Celso Antônio and Ernesto de Fiori, and attempted to engage a third, Victor Brecheret, finally failing to approve either of the two designs actually submitted. The task of condensing a concept as abstract and complex as 'Brazilian man' into a figurative symbol was certainly a difficult one. The minister's interest in identifying anthropometric criteria that would ground the ideal of racial type in scientific truth is revealing of the underlying issues at stake. The project was eventually abandoned, foiled by Capanema's aesthetic objections and bogged down in theoretical disagreements.[31] The fact of its failure is significant in terms of thinking about the inability of the regime, and the artists it employed, to compose a convincing image of national identity.

An article in the daily *Correio da Manhã*, penned by no less than the newspaper's director M. Paulo Filho, sheds light on developments behind the scenes. Published in September 1938, it recounts a visit to the workshop, set up on the construction site, where Celso Antônio was at work on his version of the sculpture. Paulo Filho details the sculptor's credentials as a former pupil of Antoine Bourdelle and relates that he was appointed to the task upon the recommendation of Lúcio Costa, duly vetted by Le Corbusier, before being hired by Capanema. He then narrates the conflict of opinions that led to the sculptor's falling out with the minister. The text is worth citing at length:

According to the account of Celso Antonio, Mr. Capanema suggested an Aryan type. So exact and rigorous in its lines that a commission of aesthetes and biotypologists, nominated by him after the fact, would decide if it was worthy of approval or not. The sculptor did not agree. He alleged there were no pure Aryans in Brazil. Adhering strictly to the principles of plastic art, he would model the *Man* as he saw him from the Amazon to Rio Grande do Sul. And he would not submit himself to the judgment of physicians and anthropologists upon whom the minister wished to rely. This *Man*, underscored Celso Antonio, is not the immigrant. He is the one from here. Mr. Capanema replied that he could not conceive of a work of art without beauty and truth, that he was repulsed by the stiff lines and protruding lips [*beiçola pendente*] of the mestizo that was taking shape in the workshop.[32]

[31] Rafael Alves Pinto Júnior, "Memórias de um monumento impossível", *19&20*, 9 (2014), n.p.; José Barki, José Kós & Naylor Vilas Boas, "O Ministério da Educação e Saúde (1936–1945): Museu 'vivo' da arte moderna brasileira", *Arquitetxos*, 6 (2006), n.p.; Cláudia Piantá Costa Cabral, "Arquitetura moderna e escultura figurativa: A representação naturalista no espaço moderno", *Arquitextos*, 10 (2010), n.p.; and Annateresa Fabris, *Fragmentos urbanos: Representações culturais* (São Paulo: Studio Nobel, 2000), pp. 171–172.

[32] M. Paulo Filho, "Homem brasileiro", *Correio da Manhã*, 23 September 1938, 4. Cf. Dávila, *Diploma of Whiteness*, pp. 23–24.

Paulo Filho concludes that neither sculptor nor minister was correct in his appraisal of the complex question of racial type. Citing the social scientific authority of Sylvio Romero, whom he references in a long excursus, the editor argues that a true 'Brazilian man' did not yet exist and would only come into being in another two or three centuries through further mixture of the multiple ethnic groups that made up the population.

Celso Antônio's account, as reported by the *Correio da Manhã*, differs in one crucial respect from surviving correspondence between Capanema and his scientific advisers. According to the sculptor, the minister suggested an Aryan type and expressed contempt for the mestizo. In his letters, Capanema stated that his intention was to establish, "I wouldn't say the Brazilian type (which does not yet exist), but the ideal figure we could permit ourselves to imagine as representative of the future Brazilian man." He emphasized that he was interested not in "the vulgar or inferior man, but [...] the finest exemplar of the race".[33] In their replies, the scientific advisers fretted about the lack of uniformity and homogeneity of the Brazilian population, but both Roquette Pinto and Rocha Vaz came out in favour of the *moreno*, an ambiguous term in the context of purportedly scientific racial distinctions.[34] In another letter, to writer Mário de Andrade, the minister echoed that verdict, describing the figure he wanted as a "*moreno* type, of good quality, with the countenance displaying intelligence, high-mindedness, courage, and the capacity to create and achieve".[35] Those familiar with the discourses of physical anthropology, at the time, will recognize in these terms coded references to what were perceived as essentialist racial characteristics.

It is possible that Celso Antônio may have distorted Capanema's position intentionally, out of spite at having his sculpture rejected and not being paid for his work, or even that he simply misunderstood it. Equally plausibly, the minister's coded language may have served to hedge his real meaning. Capanema's insistence on an ideal racial type taking shape in an indefinite future may well have been a way of dissembling his preference for a European-looking figure. According to the

[33] Knauss, "O homem brasileiro possível", pp. 31–33.

[34] The term *moreno* bears an extremely wide range of meanings, including tanned, brown, olive-skinned, coppertone, swarthy and brunette. In this context of ethnological classification, it can be taken as indicating generally southern European features with traces of Amerindian descent. Celso Antônio's appraisal that the sculpture should not represent 'the immigrant' refers to recent arrivals of the late nineteenth and early twentieth centuries, as opposed to the preexisting 'three races': Amerindian, Portuguese and African.

[35] Knauss, "O homem brasileiro possível", p. 36.

pseudo-science that undergirded much of the debate, a finest exemplar of the race would likely be whiter in the future anyway, given the eugenicist premise that the 'superior' blood would prevail over 'inferior' ones in subsequent mixtures.[36] In the event the minister really did express a preference for the so-called 'Aryan', the sculptor's revelation of it would have been politically sensitive. In the charged international atmosphere of 1938, the connotations of the term were inescapable and might be taken as implying that Capanema was sympathetic to the wing of Vargas's government aligned with Nazi Germany. Someone in the position of Paulo Filho would, of course, be aware of that fact; and the newspaper he ran was firm in its repudiation of Nazi racial ideology as alien to Brazilian culture and traditions.[37] His attribution of the overtly racist phrasing *"beiçola pendente"* to Capanema suggests a subtle intention to cast the minister in a negative light.[38]

5.3 THE 'NEGRO' AS SYMBOL

The question of how to depict a *moreno* complexion in a monochrome sculpture presents a technical challenge and helps make sense of the emphasis on 'type', a category that encompasses other physical character-istics such as stature and features. In painting, on the contrary, skin colour is the simplest means of conveying racial identities. Capanema's purported objection to a mestizo figure is somewhat out of keeping with his choice of Candido Portinari, in 1936, for the prestigious job of painting a series of murals for the MES building. At the time, Portinari was renowned for paintings depicting social and racial themes, including one titled precisely *Mestiço* (*Mestizo*), of 1934, one of his best-known works (Fig. 54). Other related paintings of the period 1933 to 1935 include *Morro* (or 'hill'), *Dispossessed*, *Coffee growers* and *Black man with a hoe* (better known today under the title *Coffee labourer*), all of which featured black figures prominently. The twinned themes of labour and ethnicity would continue to play a major part in his paintings throughout the 1930s and 1940s.

[36] See Dávila, *Diploma of Whiteness*, pp. 24–27; and Nancy Stepan, *The Idea of Race in Science: Great Britain 1800–1960* (London: Macmillan, 1982), ch. 5.

[37] Another article on the same page makes this argument unequivocally; Americo Silvado, "As raças humanas e o Brasil", *Correio da Manhã*, 23 September 1938, 4.

[38] The only known photograph of Celso Antônio's proposal does not show the facial features of the statue clearly and thus sheds little light on the discussion; see Alves Pinto Júnior, "Memórias de um monumento impossível", n.p.

FIG. 54 Candido Portinari, *Mestiço*, 1934, oil on canvas, 81 × 65 cm
São Paulo: Pinacoteca do Estado de São Paulo (purchased by the state government of São
Paulo, 1935) (photo: Isabella Matheus)

The Ministry began to display interest in Portinari in 1935 when it
purchased the large oil painting *Coffee*, the composition and treatment of
which announced the painter's interest in muralism. The following year,
he received the commission for the MES murals, which were to revolve
around the successive cycles of commodities that made up Brazil's eco-
nomic history.[39] From that moment onwards, his career entered a period
of steep ascendancy, due in no small part to the favour he enjoyed under
Vargas, so pronounced that it led antagonists to dub him the 'official'
painter of the regime. There is no doubt that his close collaboration on the
building project, over a period of eight years, placed him at the heart of
Capanema's educational mission of shaping Brazilian identity through art
and culture.[40] In 1939, he was further tasked with producing three panels
for the Brazilian pavilion at the New York World's Fair. That same year,

[39] Though commissioned in 1936, the murals were actually painted between 1939 and
1943; see Annateresa Fabris, *Portinari, pintor social* (São Paulo: Perspectiva, 1990).
[40] Fabris, *Portinari*, pp. 29–36; and Annateresa Fabris, *Cândido Portinari* (São Paulo:
Edusp, 1996), pp. 51–87. See also Carlos Zilio, *A querela do Brasil: A questão da
identidade da arte brasileira: A obra de Tarsila, Di Cavalcanti e Portinari, 1922–1945*
(Rio de Janeiro: Relume-Dumará, 1997 [1982]), pp. 90–118.

his favela-themed painting *Morro* was purchased for the collection of the Museum of Modern Art, in New York.[41]

Portinari's rise to prominence over the 1930s cannot be dissociated from contemporary debates around the issue of 'social art'. Upon returning to Brazil in 1931, after two years studying in Europe, he came to be perceived as a specialist in portraiture, a genre in which he achieved considerable success.[42] The critical acclaim he craved eluded him, however, until he began to work on themes of ethnicity and labour. Upon the occasion of his exhibition in São Paulo in December 1934, two such works – *Mestizo* and *Black man with a hoe* – were both lauded for their perceived depiction of deeper currents in Brazilian society. Mário de Andrade acclaimed *Mestizo* as a masterpiece, singling out the statuesque quality of the figure, and linked it to the German *neue Sachlichkeit* for not shying away from depicting even the subject's dirty fingernails. Oswald de Andrade agreed about the merit of the pictures, though he preferred to associate their qualities with Mexican muralism. Then a member of the PCB, Oswald enthused about the mural potential of both paintings and praised Portinari for aligning himself with the revolutionary artists of the time. As black working men, he affirmed, the depicted subjects were "splendid raw material of the class struggle". The young Trotskyite critic Mário Pedrosa, an early enthusiast of mural painting, also praised the "monumental plasticity of the figure" in *Black man with a hoe*.[43]

Despite such interpretations, Portinari's works of the period 1933 to 1935 are far from unambiguous in terms of political affiliation or even in their adherence to prevailing conceptions about modern art. Both *Mestizo* and *Black man with a hoe* display a tension between an almost niggling attention to detail in the figures and the self-consciously naïve, dreamlike

[41] See Aleca Le Blanc, "Building the tropical world of tomorrow: the construction of *brasilidade* at the 1939 New York World's Fair", *Hemisphere: Visual Culture of the Americas*, 2 (2009), 27–45; and Marcelo Mari, "Controvérsias sobre a arte brasileira na Feira Mundial de Nova York, 1939", *Anais do 26º Encontro da Anpap* (2017), 3961–3871. See also Daryle Williams, *Culture Wars in Brazil: the First Vargas Regime, 1930–1945* (Durham: Duke University Press, 2001), pp. 215–220.

[42] See Sérgio Miceli, *Imagens negociadas: Retratos da elite brasileira (1920–1940)* (São Paulo: Companhia das Letras, 1996), pp. 57–110. Cf. Florence Horn, "Portinari of Brazil", In: *Portinari of Brazil* (Detroit: The Detroit Institute of Arts, 1940), p. 7. For Portinari's place in the discourses surrounding social art, see Raúl Antelo, ed., *Parque de diversões – Aníbal Machado* (Belo Horizonte: UFMG & Florianópolis: UFSC, 1994), pp. 150–154.

[43] Quoted in Fabris, *Portinari, pintor social*, pp. 8–9, 85–86; and Fabris, *Cândido Portinari*, pp. 34–36.

quality of the colourful landscapes. Despite the enthusiasm he expressed for the works, Oswald de Andrade perceptively noted that the spirit of class struggle had not yet penetrated to Portinari's idyllic depictions of the countryside. Another communist critic and former anthropophagist, Geraldo Ferraz, was so bothered by the disjunction between background and figure that he decried the paintings as "pantomime".[44] With their hieratic figures, set against backdrops of an almost programmatic return to order, these and other works of the period are reminiscent of artistic currents coming out of fascist Italy – in particular, the *Novecento* movement. Unsurprisingly, the artist visited Italy during the years 1928 to 1930, and, upon his return to Brazil, effusively praised the cultural politics of Mussolini in interviews. As Annateresa Fabris has pointed out, depictions of workers and discussions of social art were not a prerogative of the left, at that time, but stretched across a troubling and often turbulent ideological spectrum.[45]

Overcoming his initial infatuation with Mussolini, Portinari soon fell into line with the left-leaning circles of modern art in Rio de Janeiro, growing close to the Associação dos Artistas Brasileiros and the Clube de Artistas Modernos, where he exhibited repeatedly over the first half of the 1930s. In 1936, he was employed as a teacher at the Arts Institute of the Universidade do Distrito Federal (UDF), directed by Celso Kelly, prime mover of the former association and an active leftist. UDF was the target of an anti-communist purge in 1936 to 1937; and, notably, Portinari was one of the few modern artists to be spared. In 1938, he was promoted to full professor under the conservative directorship that replaced Kelly.[46] Given the artist's extensive collaboration with the *Estado Novo* dictatorship at its height, plus his fluctuations between modernists and traditionalists, it would be foolhardy to cast Portinari as some sort of uncompromising defender of the oppressed. Rather, he was a political survivor. By 1939, Oswald de Andrade was ready to disown him as a reactionary, and other former admirers grew resentful of his proximity with the regime.[47] After 1945, when the *Estado Novo* came to an end,

[44] Ibid., pp. 34, 37.

[45] Ibid., pp. 44–48, 81–82; and "Um pintor que volta da Europa", *Correio da Manhã*, 31 January 1931, 3.

[46] "Nomeações e designações para a Universidade do Districto Federal", *Correio da Manhã*, 18 June 1938, 2. See also Rafael Cardoso, "Modernismo e contexto político: A recepção da arte moderna no *Correio da Manhã* (1924–1937)", *Revista de História (USP)*, 172 (2015), 358–362.

[47] Fabris, *Portinari, pintor social*, pp. 26–36.

he flipped back to the left, joined the PCB and even ran for congress on the party ticket.

The premise that Portinari's depictions of black and indigenous figures approximated him to the Mexican muralists gained wider currency through an essay historian Robert C. Smith wrote for the catalogue of a solo exhibition at the Detroit Institute of Arts in 1940. The first paragraphs of the text establish a mythical teleology that has proven as enduring as it is false:

> The debt that modern Brazilian culture owes to the folklore, the dances, the music, the cult art of the negro was acknowledged by the intellectuals of São Paulo in that Week of Modern Art of 1922 which was the first public recognition of indigenous and regional art in Brazil. Since then a school of startling vigor inspired to a large extent by the negro has grown up. Forswearing the artificial picturesqueness of their francophile predecessors the modern Brazilians have tried to understand the negro and his relation to themselves, and upon the resulting conceptions they have based their art.[48]

Nearly every claim in those few sentences is misleading or factually incorrect. Lumping together artists and intellectuals as diverse and even opposed as Gilberto Freyre, Mário de Andrade, Arthur Ramos, José Lins do Rego, Jorge Amado, Cícero Dias, Lasar Segall and Portinari, Smith cobbles together a 'school of startling vigour' – startling indeed, that these names could ever be construed as a unified group – supposedly organized around the "mystery of the negro".[49] Only an audience with little firsthand knowledge of Brazil and no idea of the inner dynamics of the modernist movement could have bought into such a premise. Yet, despite the inaccuracies, the conclusion Smith derives from it deserves consideration: "But Candido Portinari has shown the negro of all Brazil as a solid symbol in the vigorous, changing life of his country."[50] The conjunction *but* at the start of the sentence is by no means unimportant. Smith's text casts Portinari in opposition to the regionalist efforts of other painters

[48] Robert C. Smith, "The art of Candido Portinari", In: *Portinari of Brazil*, 10–11. Cf. Williams, *Culture Wars in Brazil*, pp. 220–222. Smith's criticism was strategic in positioning Brazilian modern art in the USA; see Renata Gomes Cardoso, "As exposições de arte latino-americana no Riverside Museum de Nova York em 1939 e 1940: Trâmites da organização da seção brasileira", *Modos: Revista de História da Arte*, 3 (2019), 9–24.

[49] Smith, "The art of Candido Portinari", p. 11. On the impact on modernism of Smith's writings on Brazilian colonial heritage, see Sabrina Fernandes Melo, *Robert Chester Smith e o colonial na modernidade brasileira: Entre história da arte e patrimônio* (unpublished doctoral dissertation, Universidade Federal de Santa Catarina, Programa de Pós-graduação em História, 2018), see ch. 4.

[50] Smith, "The art of Cândido Portinari", p. 11.

belonging to his imaginary school. The 'negro of all Brazil' he evokes is an essentialist and unifying trope, corresponding not to an individual but to the realm of type and archetype.

There can be little doubt that Portinari's *Mestizo* operates powerfully as a symbol, even today when the life of the country has changed so much. The question is: a symbol of what? Certainly not of the agency of Afro-Brazilians. The cultural policies of the first Vargas era were far from affirmative of racial difference but instead geared towards ensuring conformity to an abstract ideal of the collective, embodied in the nation and its leader. The regime actively suppressed political rights, religious freedoms and regional identities – an effort perhaps most powerfully symbolized by the ritual burning of state flags that took place in Rio de Janeiro in November 1937.[51] Ethnic identities fared little better. The civic holiday *Dia da Raça*, instituted in 1939, was intended to celebrate *the race* (akin to the idea of *la raza* in Mexico), meaning a unified Brazilian race and not any subordinate groupings. Racial distinctions, when recognized, provided a pretext for controlling individuals and policing deviance, not for organizing resistance or laying claim to representation.[52]

The regime of 1937 to 1945 sought systematically to root out its enemies, labelling them as communists, foreigners or archaic elements, forces that demanded to be purged in the name of preserving the social body of the nation.[53] Those who challenged the sanctioned order had to be eradicated. The severed head of the popular anti-hero Lampião stands in instructive contrast to the idealized portrait of the 'mestizo', not a person but an imaginary racial type. Ironically, from the standpoint of today, the 'archaic' Lampião appears somewhat modern, at least in his enterprising strategies of visual representation, while the 'modern'

[51] See Daryle Williams, "Civicscape and memoryscape: the first Vargas regime and Rio de Janeiro", In: Jens R. Hentschke, ed., *Vargas and Brazil: New Perspectives* (New York: Palgrave Macmillan, 2006), pp. 63–66; and Ruben George Oliven, "Cultura brasileira: Retratos de uma identidade", In: Elisa Reis & Regina Zilberman, eds., *Retratos do Brasil* (Porto Alegre: EDIPUCRS, 2004), pp. 120–121. On the repression of Afro-Brazilian religions, see Nathália Fernandes de Oliveira, *A repressão policial às religiões de matriz afro-brasileira no Estado Novo (1937–1945)* (unpublished master's thesis, Universidade Federal Fluminense, Programa de Pós-graduação em História Social, 2014).

[52] See Dávila, *Diploma of Whiteness*, 27; Olívia Maria Gomes da Cunha, "Sua alma em sua palma: Identificando a 'raça' e inventando a nação", In: Dulce Pandolfi, ed., *Repensando o Estado Novo* (Rio de Janeiro: Fundação Getúlio Vargas, 1999), pp. 257–288; Giralda Seyferth, "Os imigrantes e a campanha de nacionalização do Estado Novo", In: Pandolfi, *Repensando o Estado Novo*, pp. 199–228; and Davis, *Avoiding the Dark*, ch. 3.

[53] Pernambucano de Mello, *Benjamin Abrahão*, pp. 175–176.

Mestizo looks increasingly like a throwback to pictorial dispensations of a bygone era – oil on canvas, and figurative at that, at a time when parameters of visual culture were being tested in movies, magazines and muralism. Rarely was the phrase *return to order*, in vogue among art critics of the time, so redolent with meaning. The model of *brasilidade* it posits is a normative one, exclusive of all difference in its homogenizing claim to be regarded as archetype.

5.4 MAKING FACES AND CATALOGUING TYPES

Portinari's early works on ethnic and labour themes were painted between 1933 and 1935, well before the *Estado Novo*. To the wary reader, referencing them in the context of discussions of *brasilidade* under Capanema and the MES may seem historicist and therefore misguided. That would be true, except for the fact that these images were subsequently appropriated by the regime as part of its drive to establish a unified view of Brazilian culture based on racial archetypes. Eight pictures by Portinari – including *Mestizo*, *Coffee* and a work of the same period titled *Negro* (known today under the alternate title *Head of a negro*) – were used to illustrate Fernando de Azevedo's epochal book, *A cultura brasileira*, first published 1943. This broad-ranging study of Brazilian culture originated in a commission to write an introduction for the 1940 census, put forward by the government's revamped bureau of statistics, *Instituto Brasileiro de Geografia e Estatística* (IBGE), itself an integral part of the drive towards centralization of political power.[54] As a professor at the University of São Paulo and leading figure in educational administration, Azevedo saw this project as an opportunity to promote his vision of education and its role in forging a unified national identity.[55]

The book is illustrated with 418 plates – mostly photographs, but also drawings, paintings and maps – and Portinari is uniquely well represented

[54] An English edition was later published: Fernando de Azevedo, *Brazilian Culture: an Introduction to the Study of Culture in Brazil* (New York: Macmillan, 1950). On the inception and history of IBGE, see Eli Alves Penha, *A criação do IBGE no contexto da centralização política do Estado Novo* (Rio de Janeiro: IBGE/Centro de Documentação e Disseminação de Informações, 1993), esp. pp. 65–84. See also Dávila, *Diploma of Whiteness*, pp. 58–60.

[55] See Libânea Nacif Xavier, "Retrato de corpo inteiro do Brasil: A cultura brasileira por Fernando de Azevedo", *Revista da Faculdade de Educação*, 24 (1998), 70–86. The frontispiece of the book is a portrait of Vargas.

among modern artists.[56] A reproduction of *Mestizo* appears near the section on the racial composition of Brazil. There is no attempt to couch it as a work of the imagination. Rather, it is inserted into the fabric of the verbal/visual discourse as an illustration, a specimen, in the same manner that photographs of a church or a cowherd are used to illustrate sections on architecture and rural life. This slippage between the painted depiction of an imaginary archetype and photographic examples of actual people and places is problematic. It becomes even more disturbing given that it was no lapse on the part of a guileless editor or even the author, but a deliberate choice guided by someone used to thinking about art – Mário de Andrade, who suggested the choice of images and even loaned works from his own collection.[57] The decision to use Portinari's paintings to illustrate abstract concepts like race and racial mixture lends them a scholarly credence distinct from their earlier reception as affirmations of the cause of 'social art'. In Azevedo's book, imagined depictions of the 'mestizo', the 'negro' and the 'Indian' appear more as substantiation of cultural truisms than as expressions of an artistic vision. The chromatic intensity that lent them painterly meaning is lost in their black and white reproduction, and they are reduced to markers of so-called 'raciality'. In other words, they are offered up as visual proof that the categories they purport to illustrate really do exist.

In terms of visual discourse, the function Portinari's works exercise in Azevedo's book is midway between personification and allegory. Their use aligns itself closely with illustrations produced by Percy Lau for the volume *Tipos e aspectos do Brasil* (types and aspects of Brazil), also published by IBGE, consisting of representations of regional scenes and types – such as the 'cowherd of the Northeast', 'alligator harpooners', 'Bahian negresses', among many other themes.[58] These highly finished

[56] The other living artists whose works appear in the book are Celso Antônio, José Wasth Rodrigues and Percy Lau, who is not credited.

[57] Annateresa Fabris, ed., *Portinari, amico mio: Cartas de Mário de Andrade e Candido Portinari* (Campinas: Mercado de Letras, 1995), pp. 109, 111. Two of the works are credited in the book as belonging to Mário's collection and a third to that of Carlos Drummond de Andrade.

[58] See Alexandre de Paiva Camargo, "A Revista Brasileira de Geografia e a organização do campo geográfico no Brasil (1939–1980)", *Revista Brasileira de História da Ciência*, 2 (2009), 23–39; Ana Maria Daou, "Tipos e Aspectos do Brasil: Imagens e imagem do Brasil por meio da iconografia de Percy Lau", In: Zeny Rosendahl & Roberto Corrêa, eds., *Paisagem, imaginário e espaço* (Rio de Janeiro: Ed.Uerj, 2001); and Licia Rubenstein, *O censo vai contar para você: Design gráfico e propaganda no Estado Novo* (unpublished master's thesis, Programa de Pós-graduação em Design, Pontifícia Universidade Católica do Rio de Janeiro, 2007). A few of Lau's illustrations reappear in Azevedo's book.

drawings in pen and ink, accompanying short texts by a specialist on the given subject, first began to appear in the *Revista Brasileira de Geografia* in 1939. The idea to compile and publish them separately as a volume arose in 1940 as IBGE's contribution to a trade fair (*XIII Feira Internacional de Amostras*). Subsequent small print runs were produced in 1942 and 1943 for other special occasions, and a larger edition in 1944 for the Second Pan-American Consultative Meeting on Geography and Cartography. Translations into English and Esperanto were printed in 1945 and into Spanish in 1946.[59] The fifth expanded edition of 1949 consolidated the format that would continue to be produced as an official IBGE publication through the mid-1970s, running to over ten editions. Like Portinari, Lau's figures are vivid and detailed enough to suggest portraits of specific individuals, yet their titles and captions consign them to the realm of the general and the typical. In both cases, the artist's rendering provides a plausible physiognomy for a faceless abstraction.

The problem of how to depict racial archetypes for purposes of study and classification was certainly not new. The annals of anthropology abound in anonymous faces used to illustrate ethnic categories. In the context of the 1940s, it is worth asking why take recourse to paintings and drawings at all, as opposed to the widely available option of using photographs. A factor that should not be underestimated is cost. At a time when photographs were still comparatively expensive to print, line drawings (such as Lau's) were a cheaper option. Yet, this rationale does not apply to Azevedo's book, in which the paintings were printed as photographic reproductions. Certainly, one effect of the decision to use paintings as examples was to shift the regime of representation away from the perceived indexical nature of the photographic towards a timelessness and universality associated with traditionalist ideas about art. Another motive is that imagined representations nimbly sidestepped the issue of deciding exactly what was meant by normative racial categories like 'mestizo', which applied to many people in general but almost no one in particular. In a culture with hundreds of terms for every shade and variation of skin colour, few people, if asked, would spontaneously self-identify with that label.[60] For the specific purpose of unifying a diverse

[59] Christovam Leite de Castro, "Nota explicativa", *Tipos e aspectos do Brasil* (Rio de Janeiro: Instituto Brasileiro de Geografia e Estatística/Conselho Nacional de Geografia, 1949), pp .v–vi.

[60] See Mara Loveman, Jeronimo O. Muniz & Stanley R. Bailey, "Brazil in black and white? Race categories, the census, and the study of inequality", *Ethnic and Racial Studies*, 35 (2012), 1466–1483; and Peter Fry, "The politics of 'racial' classification in Brazil",

and unruly population into an imagined national community, broad categories and ideal figures were more effective than real individuals.

Outside the official arena of government organs, the closest contemporary counterpart to the IBGE publications is the two-volume study *Introdução à antropologia brasileira*, by physician, psychiatrist and anthropologist Arthur Ramos. Intended as a textbook on Brazilian anthropology, the work was published by the Casa do Estudante do Brasil, the representative organ of students under the Vargas regime, as part of its Brazilian Studies Collection. The first volume of the work, on "non-European cultures", appeared in 1943, numbering over 500 pages; and the second, on "European cultures and racial and cultural contacts", in 1947, nearly 650 pages long. Their author was, by then, recognized nationally and internationally as the leading expert on Afro-Brazilian culture, having risen to prominence with the studies *O negro brasileiro*, in 1934 (published in English, 1939), and *O folk-lore negro do Brasil*, in 1935. An admirer of Nina Rodrigues, Ramos is sometimes written off as a holdover from the scientific racialism of an earlier generation or, contradictorily, as an apologist for the loaded concept of 'racial democracy', but his relationship to such terms is more complex than usually presumed.[61] During the 1930s, he was one of the few prominent intellectuals to voice support for black activism, a position he stated in no uncertain terms in the preface to his study on folklore, where he railed against the ignorance of white society about the problems of Afro-Brazilians, its effacement of their history and enthused about a new spirit of "protest and demands".[62]

Journal de la Société des Américanistes, 95 (2009), 261–282. On the place of the mestizo in Brazilian society, see Yuko Miki, *Frontiers of Citizenship: a Black and Indigenous History of Postcolonial Brazil* (Cambridge: Cambridge University Press, 2018), ch. 3.

[61] Paulina L. Alberto & Jesse Hoffnung-Garskof, "'Racial democracy' and racial inclusion", In: Alejandro de la Fuente & George Reid Andrews, eds., *Afro-Latin American Studies: an Introduction* (Cambridge: Cambridge University Press, 2018), pp. 287–288; and Maria José Campos, *Arthur Ramos: Luz e sombra na antropologia brasileira: Uma versão da democracia racial no Brasil nas décadas de 1930 e 1940* (Rio de Janeiro: Edições da Biblioteca Nacional, 2004), pp. 57–72. See also Antonio Sérgio Alfredo Guimarães, "Africanism and racial democracy: the correspondence between Herskovits and Arthur Ramos (1935–1949)", *EIAL – Estudios Interdisciplinares de América Latina y el Caribe*, 19 (2008), pp. 53–79; Kevin A. Yelvington, "The invention of Africa in Latin America and the Caribbean: political discourse and anthropological praxis, 1920–1940", In: Kevin A. Yelvington, ed., *Afro-Atlantic Dialogues: Anthropology in the Diaspora* (Santa Fé: School of American Research Press & Oxford: James Currey, 2006), pp. 51, 65–67; and George Reid Andrews, "Brazilian racial democracy, 1900–1990: an American counterpoint", *Journal of Contemporary History*, 31 (1996), 483–507.

[62] Arthur Ramos, *O folk-lore negro do Brasil: Demopsychologia e psychanalyse* (Rio de Janeiro: Civilização Brasileira, 1935), p. 7. On Ramos's relationship to the *escolanovista*

Though *Introdução à antropologia brasileira* is not a publication by a government organ, it can be viewed as part of a network of officially sanctioned opinion on race and racial harmony.[63] The most relevant feature the work shares with the IBGE publications is its attempt to produce convincing visualizations of racial categories and ultimately to define a 'Brazilian type'. One of Ramos's main concerns in the first volume was to exhibit the variety of ethnic origins making up the non-European portions of the population and thus to combat the reductionist homogeneity of ideas about 'the Black' and 'the Indian'.[64] The second volume displays similar concerns with regard to European origins, but its main focus is on ideas of miscegenation and the concept of *mestiçagem*, a subject to which it devotes no less than four chapters. Ramos recapitulates the entire literature on the subject, seeking to shift analysis of racial mixture onto supposedly scientific ground.[65]

Significantly, like the work's IBGE counterparts, both volumes switch back and forth between the reproduction of photographs and drawings. The photographs in Ramos's volumes were produced by a range of individuals – including the author himself, other amateur photographers and respected professionals like Jean Manzon – as well as archival photographs from institutions such as the Instituto Nina Rodrigues or the Serviço Médico Legal da Bahia. The drawings, with only a few exceptions, are the work of Ukrainian-born artist Dimitri Ismailovitch.[66] They comprise more than half of the total illustrations. The first volume contains 23 plates, of which ten are drawings by Ismailovitch. Of the 23 plates in the second volume, twelve are drawings by Ismailovitch and two reproductions of paintings by his disciple Maria Margarida de Lima Soutello. In the first volume, the illustrations focus exclusively on displaying representative types of ethnic groupings, with titles like: 'Curuaia Indian', 'Apinagé adolescent' or 'Urban type. Old negro woman from Rio Grande do Sul'. The second volume also contains types – e.g. 'Second generation Luso-Brazilian; rural type of Minas', 'German type of Rio',

educational project, see Fabíola Sircilli, "Arthur Ramos e Anísio Teixeira na década de 1930", *Paidéia (Ribeirão Preto)*, 15 (2005), 185–193; and Dávila, *Diploma of Whiteness*, pp. 34–40.

[63] Ramos was in constant contact with Christovam Leite de Castro, secretary-general of the Conselho Nacional de Geografia, which published Lau's illustrations; see Campos, *Arthur Ramos*, pp. 309–310, 313 n6.

[64] Campos, *Arthur Ramos*, p. 274 and ch. 3.

[65] Ramos, *Introdução à antropologia brasileira. 2° volume*, pp. 361–462.

[66] The illustrations are reproduced and discussed in Campos, *Arthur Ramos*, pp. 263–286.

FIG. 55 Maria Margarida [Soutello], *Três Meninas da Mesma Rua*, circa 1942
Fundação Biblioteca Nacional (BN Digital/Coleção Arthur Ramos)

'Chinese boy of Rio' – but the illustrations extend their remit to the subject of racial harmony, represented through photographs depicting black and white children together, as well as the two works by Maria Margarida. These paintings, respectively titled *Três Meninas da Mesma Rua* (*Three girls from the same street*) (Fig. 55) and *First communion*, are reproduced in the book alongside the disingenuous caption "Race relations in Brazil".

The presence of Maria Margarida's paintings is revealing of the ulterior ambitions of Ramos's project. They are the only images in the book to stray from the presumed indexical quality of photographs – or, at least, of carefully observed portraiture in a naturalist vein – into the arena of openly idealized representation. With their symmetrical compositions, high contrast between sketchiness and finish, and the stiff hieratic poses of the figures, they border on religious icons. Their inclusion betrays the difficulty of achieving a valid visualization of a concept as reified as racial mixture. They deflate Ramos's pretence to move the study of *mestiçagem* onto solid scientific ground and, instead, approximate his argument to the shifting sands of Azevedo's culturalism. Their insertion into the discursive fabric of Ramos's book is important for understanding how images contribute to the persuasiveness of his arguments.[67] The book's recourse

[67] Cf. Campos, *Arthur Ramos*, p. 265.

to the same structures of visual discourse as the IBGE publications is no coincidence. In reducing the immense variety of a multi-ethnic and multi-coloured population, spread out over eight million square kilometres, to forty-six black-and-white plates, *Introdução à antropologia brasileira* achieves the author's intent of imposing a unified narrative and a semblance of order onto an amorphous mass.

5.5 AN OUTSIDER GAZE UPON THE NATIVE

The choice of Dimitri Ismailovitch to illustrate Ramos's magnum opus is an intriguing one. In the overheated climate of nationalism and nativism that gripped Brazil during the *Estado Novo*, why charge a foreign-born artist with the task of depicting the racial and cultural components of nationhood? Ismailovitch was no newcomer to official publications. The first book ever published by the new *Serviço do Patrimônio Histórico e Artístico Nacional* (SPHAN, the national heritage service, created in 1937) – Gilberto Freyre's *Mucambos do nordeste* – contained seven illustrations by him, painted landscape scenes with houses, which complemented the more technical drawings of building structures by painter Manoel Bandeira. Ismailovitch's precise and highly finished drawing style must certainly have appealed to Ramos. At a time when black and white photographs were still predominant – and their printed reproduction in books often less than good quality – the subtlety with which the artist rendered gradations of skin tone would have been considered an advantage. Add to that the fact that drawings allowed the possibility of selectively heightening specific features and downplaying others, by leaving them sketchy or unfinished, and there are solid perceptual reasons behind the choice to favour their use over photographs. Differently from the works of Portinari or Percy Lau, Ismailovitch's studies of faces for the Ramos volumes are doubtlessly drawn from the life, portraits of individuals rather than types. They nonetheless share the IBGE publications' option for a traditionalist regime of representation.

In the case of Ismailovitch, the tradition was a very specific one. Press coverage in Brazil often associated his work with Russian and Byzantine icons, as well as with religious mysticism.[68] Born in Kiev and trained at

[68] See, among others, "Dimitri Ismailovitch e sua arte", *Vida Doméstica*, February 1932, n.p.; "Dimitri Ismailovitch", *Vida Doméstica*, February 1934, n.p.; "Da Russia czarista ao Solar de S. Clemente", *Revista da Semana*, 27 October 1945, 9–12; "A arte de Dimitri Ismailovitch", *Vida Doméstica*, August 1956, n.p.; and Carlos Drummond de Andrade, "O pintor, a cidade, o santo", *Correio da Manhã*, 26 April 1964, 6.

the Ukrainian State Academy of Arts, the artist lived in Turkey for a period of about eight years before moving to Brazil in late 1927.[69] He quickly achieved recognition as a society portraitist and, by the early 1930s, was much in demand. His painted portrait of Eugênia Alvaro Moreyra, exhibited at the 'revolutionary' Salon of 1931, captures fashionable modernity with such flair that it has since become an iconic image of both the woman and the event. From 1932 onwards, the women's magazine *Vida Doméstica* took uncommon interest in his career, writing articles about him, publishing reproductions of his works, dedicating extensive photographic coverage to his many exhibitions and appearances at society functions. In one article, the magazine classed him alongside Picasso and Foujita.[70] Ismailovitch soon acquired a group of artistic followers, the most faithful of whom was Maria Margarida, a Portuguese painter routinely presented as his disciple. He began to portray her in works from the early 1930s, and the pair exhibited together regularly between at least 1943 and 1951.[71]

Over his long lifetime (he died in 1976), Ismailovitch painted likenesses of numerous influential figures – politicians, socialites, artists and intellectuals. Many of these ended up gracing the pages and even covers of *Vida Doméstica*, to which he was a contributor for over a decade. In August 1937, at the Salão dos Artistas Brasileiros, one of his portraits was purchased by none other than Getúlio Vargas. In October of that year, a little over a month before the *Estado Novo* was decreed, he became a naturalized Brazilian citizen. His 1937 portrait drawing of Mário de Andrade can be found in the writer's art collection, alongside a painting of a church. His 1939 group portrait centred around the legendary

[69] Very little has been published on the life of Dimitri Ismailovitch, and even his birth date is uncertain (1890 or 1892). The artist seems to have spun a personal mythology that requires archival verification. The Museu Villa-Lobos, in Rio de Janeiro, dedicated an exhibition to him in 2013/2014, curated by Eduardo Mendes Cavalcanti: *A ceia brasileira de Ismailovitch: Homenagem ao Aleijadinho* (Rio de Janeiro: Museu Villa-Lobos, 2014). On his passage through Turkey, see Ayşenur Güler, "Tale of an émigré artist in Istanbul: the impact of Alexis Gritchenko on the 1914 Generation of Turkish artists", In: Christoph Flamm, Roland Marti & Ada Raev, eds., *Transcending the Borders of Countries, Languages and Disciplines in Russian Émigré Culture* (Newcastle upon Tyne: Cambridge Scholars Publishing, 2018), p. 124.

[70] "Quartos de creança", *Vida Doméstica*, March 1933, n.p. See also "O sonho imperial da gloriosa cidade de São Sebastião (Sobre motivos pictóricos do admiravel artista Dimitri Ismailovitch)", *Vida Doméstica*, August 1933, n.p.; and "Retratos de D. Ismailovitch", *Vida Doméstica*, October 1935, n.p.

[71] Oscar D'Alva, "Notas de arte. Grupo Ismailovitch", *Fon Fon*, 12 December 1935, 50–51.

FIG. 56 Dimitri Ismailovitch, *Sodade do Cordão* (triptych), 1940, oil on canvas, 60.5 × 224.9 cm. For color version of this figure, please refer color plate section. Rio de Janeiro: Museu Nacional de Belas Artes/Ibram (photo: Museu Nacional de Belas Artes/Ibram)

sertanejo bard Catullo da Paixão Cearense – accompanied by actor Procópio Ferreira, playwright Joracy Camargo, writer Gastão Pereira da Silva, young singer and songwriter Dorival Caymmi, as well as the painter himself in a self-portrait – challenges commonly held assumptions about who got along with whom in the artistic networks of the time. Despite his reclusiveness and relative obscurity today, Ismailovitch seems to have known and portrayed pretty much everyone who mattered in the cultural life of Rio de Janeiro over the 1930s and 1940s. His career survived the end of the *Estado Novo* intact; and, in August 1946, his photograph appeared once again in *Vida Doméstica*, alongside a freshly painted portrait of the new president, Eurico Gaspar Dutra.

Portraiture may have been Ismailovitch's bread and butter, but it was not his only pursuit as a painter. The mysterious émigré produced architectural and landscape scenes, including a series on churches and convents in Bahia, circa 1936, and further devoted his talents to a few works difficult to categorize in terms of genre. One is the 1945 painting *Supper – Hommage to Aleijadinho*, a large canvas depicting Jesus Christ and the twelve disciples, the faces modelled on the sculptural works of Aleijadinho, which mixes religious painting with portraiture and iconographic study.[72] Another, of more immediate interest to the subject at hand, is a 1940 work titled *Sodade do cordão* (Fig. 56). The seemingly cryptic title requires explanation. 'Sodade' is a debased form of *saudade* (yearning or pining or longing, especially for people, places and the past), spelled incorrectly to mimic the way it might have been pronounced by poor uneducated folk (somewhat equivalent to using a form like *yurnin'*,

[72] See Cavalcanti, *A ceia brasileira de Ismailovitch*.

instead of yearning, in an English-language context). A *cordão* is a kind of carnival group, akin to a *rancho* or a *bloco*, but emphasizing specific forms of presentation and dance.[73] "*Sodade do cordão*" was the name chosen for a historicizing carnival presentation staged under the leadership of celebrated composer and maestro Heitor Villa-Lobos in 1940.

Already an international celebrity and revered in Brazil, Villa-Lobos was then employed as director of the musical department of the Federal District's Secretariat of Education and Culture. His deep involvement with the Vargas regime, since the early 1930s, gradually encroached from promoting musical education, properly speaking, to the use of music as a means of mass propaganda and indoctrination. Accordingly, his speeches and writings became ever more stridently nationalistic and bound to the interests of the *Estado Novo*.[74] By 1940, his political power was so entrenched that he could indulge in even the most whimsical pet projects – among them, "*Sodade do cordão*", which was approved and fully funded by the powerful DIP. Widely reported in the press in January 1940, the idea of the project was to re-enact an old-fashioned *cordão* in laborious detail, with music, choreography and costumes researched to revive folkloric traditions perceived to be dying out. In order to ensure authenticity, Villa-Lobos enlisted the help of Zé Espinguela (artistic name of José Gomes da Costa) – a legendary musician, carnival enthusiast (one of the founders of the Mangueira samba school) and *alufá*, or religious leader of the Afro-Brazilian *malê* ritual, derived from Islamic traditions – who was tasked with gathering the requisite personnel and organizing the festivities.[75]

[73] The three terms are used almost interchangeably today. Within studies of carnival folklore and ethnography, however, there are subtle differences between them. These were the subject of much dispute among the authors who codified and classified the history of carnival between the 1950s and 1960s, such as Eneida de Moraes, Jota Efegê and Edigar de Alencar.

[74] The bibliography on Villa-Lobos and the Estado Novo is extensive. For recent appraisals, among many others, see Mauricio Barreto Alvarez Parada, "O maestro da ordem: Villa-Lobos e a cultura cívica nos anos 1930/1940", *Artcultura*, 10 (2008), 173–189; and Rita de Cássia Fucci Amato, "Villa-Lobos, nacionalismo e canto orfeônico: Projetos musicais e educativos no governo Vargas", *Revista HISTEDBR Online*, 27 (2007), 210–220. In English, see Carmen Nava, "Lessons in patriotism and good citizenship: Nationalism and national identity in public schools during the Vargas administration, 1937–1945", *Luso-Brazilian Review*, 35 (1998), 39–63.

[75] Lira Neto, *Uma história do samba: Volume I (as origens)* (São Paulo: Companhia das Letras, 2017), pp. 11–18; and Ermelinda A. Paz, *Sôdade do cordão* (Rio de Janeiro: ELF/Fundação Universitária José Bonifácio, 2000), pp. 25–55.

The result was a highly acclaimed presentation on 5 February 1940 before a select audience at the *Feira Internacional de Amostras* and, the next day, Shrove Tuesday, a public procession starting out from Praça Tiradentes and parading through the centre of Rio. A report in *Correio da Manhã* (the day before the public procession) struck a tone of official approval, describing it as as "a bit of that delightful carnival, naïve, fragrant, lively, that the baton in recess of the Brazilian maestro has resuscitated for the Carioca of today".[76] Press coverage was intense and highly laudatory, as befits an effort supported by DIP, including a photo-reportage in *O Cruzeiro* on 17 February. A detail that inevitably drew attention was the live lizard carried by Zé Espinguela in his role as chief of the group of 'Indians and *caboclos*', which he repeatedly kissed on the head. The performative aspect of the *cordão*, based on folkloric tradition, consisted of a ritual clash between that group and another, the group of 'old folks' (*velhos e velhas*), each bearing their own carnival standard, which met and engaged in an elaborate contest of choreography and dance.[77] Presumably due to personal ties to Villa-Lobos, whose portrait he painted in 1940, Ismailovitch and Maria Margarida were recruited to design the carnival banners and masks that played a central part in the choreography of the *cordão*.

The painting *Sodade do cordão* was not part of the carnival event and was likely painted afterwards by Ismailovitch as a tribute to the project and its participants. It consists of three panels of equal size framed together to form a triptych. The panel on the lift contains a self-portrait of Ismailovitch, flanked by three older Afro-descendant men, against a backdrop of huge masks of a clown and a lizard and foregrounded by a mask of a Pulcinella character in profile. The middle panel contains a portrait of Villa-Lobos, surrounded by four Afro-descendant men and a woman, against a backdrop of two grotesque masks (one of which appears to be a frontal view of the Pulcinella in the left panel) and a narrowly visible section of a tambourine. The third panel depicts a group of five Amerindian-looking people, one clearly a woman, two of whom are decked out in feathered headdresses and two wearing necklaces with distinctive ornaments. A single arrow is visible behind them, along with

[76] "'Sodade do cordão'- embaixada que veiu lembrar o Momo dos bons tempos", *Correio da Manhã*, 6 February 1940, 1.

[77] Paz, *Sôdade do cordão*, pp. 34–43. Cf. "Ao som dos clarins, numa expansão que faz esquecer muita coisa em quatro dias, a população carioca affluiu ao centro, para demonstrar que o Carnaval do Rio não morreu", *Correio da Manhã*, 4 February 1940, 1.

what appears to be a section of a bow. Apart from these props, the background is a uniform cobalt blue. The figures are all compressed tightly into their respective pictorial spaces, and no more than head and shoulders are visible of even the most prominent ones. Several of them are dressed in colourful outfits, reminiscent of carnival costumes, with the significant detail of a green jacket and yellow vest – in the exact tones of the national flag – on the man in the lower right-hand corner of the middle panel. The weirdness of the picture derives from the fact that all the characters stare off into the distance, most bearing serious or even grim facial expressions. Despite the proximity with which their bodies overlap on the canvas, they do not interact at all, nor even seem to be particularly aware of each other.

As the syntax of group portraits goes, *Sodade do cordão* gives the impression of being an assemblage of individual portraits combined after the fact, as opposed to representing an actual assembly of people in one place and time. That was precisely the case, as archival evidence demonstrates. A collection of drawings belonging to Arthur Ramos, housed today in Brazil's National Library (BN), in Rio de Janeiro, contains the originals of Ismailovitch's illustrations for the two volumes of *Introdução à antropologia brasileira*.[78] Of the fifteen figures that make up the composition of *Sodade do Cordão*, ten are derived from portrait drawings produced for that series and some also appear in the book itself. The self-portrait and portrait of Villa-Lobos are adapted from other extant solo portraits, leaving three figures who remain unidentified. The group portrait is, therefore, a mix of recognizable portraits of well-known personalities and portraits of anonymous individuals representing ethnic or social types, as well as possibly a couple of invented or hybrid portraits.

Very noticeably, to a viewer from the present, the composition inserts the two white artists – Villa-Lobos and Ismailovitch himself, who both stare frontally outwards at the viewer – into the mixed ethnic currents of the nation. In this very basic sense, it could be read as an artistic exercise in going native; but there is so much more to *Sodade do cordão* that such a reading would be reductionist. The lizard and clowns are direct

[78] These were sold to the Biblioteca Nacional by Ramos's widow in 1956 and are held in the Divisão de Iconografia under the call number ARC.30-E:j:III-Ismailovtich, Dimitri. They can all be viewed online at the website BN Digital: http://acervo.bndigital.bn.br. The collection contains over one hundred drawings by Ismailovitch, mostly signed and dated and often labelled "Col. Arthur Ramos" or dedicated to him. Many bear titles, sometimes visible on the front but mostly annotated on the backs, which cannot be viewed online. These are duly referenced in the website's listings.

references to characters in the procession and would have been recognizable as such to a contemporary audience that either took part in the event or read about it in the press. The spatial division of the triptych also corresponds to the choreography of the *cordão*, with 'Indians and *caboclos*' on one side and '*velhos*' on the other, coming together in the middle panel where the two main players in the endeavour – Villa-Lobos and Zé Espinguela, in a green skullcap with golden stars – are portrayed. In a touch of self-effacing humour, the artist chose to portray himself among the old guard rather than among the organizers.

The unstable relationship between the figures in the painting and the portraits drawn for Ramos's book deserves to be explored further. It is useful to go figure by figure, starting with the left panel. The figure on the far left, in profile, is reminiscent of an untitled portrait in the BN's Arthur Ramos collection (manuscript no. 299136), with the crucial difference that the drawing does not indicate unambiguously that the subject's skin colour would be painted so dark. Sketchier in finish than most of the portrait drawings in the collection, its shading suggests a lighter complexion and wavier, less closely cropped hair, though the features are the same. The figure just behind the first, with silver hair and an elaborate white and gold collar, is similarly reminiscent of a portrait in the BN collection (no. 299090) titled *"Negro Rio, Yoruba type"*, though the features are slightly different. In both these cases, the figures in the painting appear to be loosely based on an existing portrait sketch but modified and adapted. The face of the third figure in the left panel, with a large handlebar moustache and blue tunic with a white stripe, is an almost exact rendering of a portrait titled *"Mulato (Português × Negro)"* (Fig. 57) in the BN collection (no. 299132) and later published in the second volume of Ramos's book with the caption "Mulatto of Rio de Janeiro with characteristics of Lusitanian phenotype". These titles provide new insight into his coppery complexion in the painting, slightly lighter than the two preceding figures. The fourth member of the left-hand panel is Ismailovitch in self-portrait, conspicuously not dressed up for carnival.

The middle panel is even more unstable in its relationships to the drawings. The face of the woman in a pink dress with lace collar, in the lower left-hand corner, is rendered precisely from a portrait in the BN collection (no. 299093) titled *"Filha de santo (Rio)"* (Fig. 58), a term designating a female devotee of an Afro-Brazilian religion, especially *candomblé*. Next to her, in the foreground, is Villa-Lobos, in the same pose and dress as the solo portrait of him by Ismailovitch. In the lower

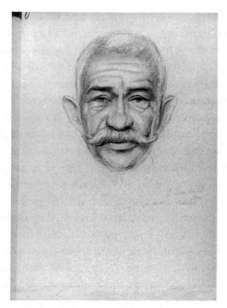

FIG. 57 Dimitri Ismailovitch, *Mulato (Português × Negro)*, circa 1940
Fundação Biblioteca Nacional (BN Digital/Coleção Arthur Ramos)

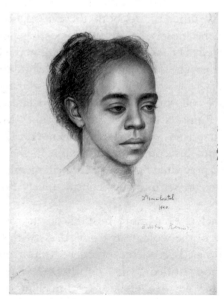

FIG. 58 Dimitri Ismailovitch, *Filha de Santo*, circa 1940
Fundação Biblioteca Nacional (BN Digital/Coleção Arthur Ramos)

right-hand corner, the face of the man in the green jacket and yellow vest, with a bow tie, derives from a portrait in the BN collection (no. 299087) titled *"Yoruba type"*. The contour of a bow tie is just visible in the drawing, suggesting that the costumes in the painting are not entirely imagined. Behind him and Villa-Lobos, wearing a red collarless pullover, is a face that derives from a drawing in the BN collection (no. 299082) titled *"King of the devils (macumba of Rio)"*. The title possibly refers to a role in the *cordão* presentation. The painted figure differs slightly from the sketch, however, suggesting that the artist's intention was less of portraying the person who played the part and more of appropriating his features to depict a type.

Moving further back, the upper left-hand of the middle panel is occupied by two faces in extreme proximity, almost as if they were two facets of one Janus-type head. The lighter-skinned, older man on the right is a portrait of Zé Espinguela, charged by Villa-Lobos with leading the *cordão*. His position behind and above Villa-Lobos, scowling down at the maestro, is suggestive of his importance. His is the face highest up in the middle panel, and he occupies a strategic place in the entire composition – visually, the power behind the throne. Yet, the juxtaposition of his head and expression to the giant Pulcinella mask immediately to the right is troubling. The sinister-looking, blue-eyed mask seems almost to bite into Villa-Lobos's scalp, and this is perhaps an inside joke or an allusion to some aspect of their relationship that has been lost to posterity. A portrait (no. 299124) titled *"Pai Alujá"* does exist in the BN collection, depicting very much the same features as the Zé Espinguela figure in the painting. This is a misspelling (or alternate version) of *alufá* and confirms the identity of the sitter. Curiously, Ismailovitch did not feel moved to record the subject's name on the drawing, as he did with a few of the portrait sketches, preferring instead to consign him to his religious function. The face on Zé Espinguela's left, just behind his, does not correspond to any surviving sketch. It is one of the two figures that remains unidentified.

The right-hand panel, representing the 'Indians and *caboclos*' group, contains four portraits from the BN collection. The face of the woman in the lower left-hand corner derives from a drawing (no. 299127) titled *"Arená"* and subsequently reproduced in the first volume of Ramos's book under the alternate title *"Curuaia Indian (Tupi of the River Tapajós)"*. In the painting, she is clearly a female figure, with earrings and long flowing hair; but, in the book, the same face is listed as an *índio*, masculine, rather than the equally current *índia*. Standing next to her in the foreground, with an elaborate necklace bearing a blue-and-red

feather-work ornament, is another face from the BN collection
(no. 299133), bearing the title "*José Atalion*". In the painting, his hair
has become wavier, and he has acquired a broad chest and muscular
shoulders that provide the perfect backdrop for setting off the pendant
dangling from his neck. Immediately behind the two foreground figures, a
face decked out in colourful headdress and tunic corresponds to the BN
collection's "*Kupinaré*" (no. 299102). Again, as in the left-hand panel,
these three figures have been adapted and slightly made over to acquire
not only colour but also strength and regularity of features.

Though not ideal types, in the same sense as Portinari's or Lau's
figures, neither are they the kind of depictions that could be described
as 'warts and all'. The face in the background, on the left, is rendered
faithfully from an illustration appearing in the first volume of Ramos's
book, under the title "*Canela Indian (Gê-Timbira of Maranhão)*", but
absent from the BN collection. Finally, the figure on the far-right of the
painting, wearing a feathered headdress and a necklace of bones or teeth,
is the other unidentified presence. Lighter-skinned than the others and
slightly androgynous, it is difficult to situate precisely. Perhaps, s/he is
representative of the *caboclo*, encompassing the idea of a mixture between
Amerindian and European. Without further documentary evidence, it is
difficult to say for sure. The slippage between genders in this panel is
suggestive of the play-acting characteristic of carnival, in which men often
dress up as women and, more rarely, vice-versa.

Independently of the few points that remain in doubt, this iconograph-
ical dissection of *Sodade do cordão* makes the artist's message clearer.
This weird and wonderful painting is an homage to a project in which he
took part and was evidently close to his heart. It is also a celebration of
the ethnic origins and cultural diversity of Brazil, as well as an attempt by
the artist to situate himself within the invented tradition of 'authentic'
carnival. He and Villa-Lobos – both dressed in white, as befits a follower
of Oxalá, the orisha of creation in *candomblé* – are the only white men
included in the picture, and they have been admitted into the inner
sanctum via their art, under the watchful eye and moral authority of Zé
Espinguela. The very prominent masks, designed by the painter's disciple
Maria Margarida, subtly admit her artistic presence into the scene too.
The painting has a votive quality to it, reinforced by its condition as a
triptych, a format used almost exclusively for religious paintings in the
Russian Orthodox context in which Ismailovitch was raised. It is his
personal altarpiece to the new Brazilian religion of the carnivalesque.
Here we are, the painter says to his viewers (among them, his patron

Villa-Lobos), arrayed among the gods and saints. Ismailovitch has seen the face of Brazil, and its great lizard eye stares back at him like an image in a mirror.

As a naturalized citizen of Brazil and figurative citizen of the world, Ismailovitch embodied the conundrum of defining *brasilidade*. The spurious concepts of 'raciality' and racial purity are particularly risible in a society composed largely from the progeny of immigrants and forced migrants and notorious for its pliancy in fusing them into every possible permutation of commixture and hybridization. The 'real' face of Brazil is every face and no face at all. As a last resort for those who insist on a pure source for the nation, there is always the appeal to the population's Amerindian roots – a constant from Romanticism to *Antropofagia* to the *Estado Novo* – but the continent's first peoples are rarely called upon to endorse their involuntary induction into a national project based on the spoliation and murder of their ancestors. Discounting this one group (in actuality, many groups) that could lay claim to authenticity, all else is triumphalist bluster. Ismailovitch, plunging into the swirling anthropological currents paddled by Arthur Ramos and allowing himself to be swept up by the whirlwind of artistic nationalism agitated by Villa-Lobos, manages to come out the other side. His triptych transforms types, characters and individuals into the commonality of so many masks in a carnival parade.

Epilogue

Images of a Culture at War with Itself

> Each and every day, poetry crops up where you least expect it: in the crime
> pages of the newspapers, on the signboard of a factory, in the name of a
> hotel in Rua Marechal Floriano, in advertisements for Casa Mathias ...
> Manuel Bandeira, undated fragment, 1930s[1]

Manuel Bandeira is one of the great Brazilian poets of the twentieth
century and certainly ranks among the most revered names in modernism.
Almost every word he wrote has been collated and pored over by literary
scholars, even to the point that a fragment like the one cited in epigraph
has found its way into publication. The reference to Casa Mathias would,
however, elude all but the most dedicated student of Bandeira. Located in
the centre of Rio de Janeiro, in Avenida Passos, Casa Mathias was a shop
selling textiles, carnival supplies and household items. Its proprietor was
Mathias da Silva, a pioneer of advertising strategies like creating a
madcap self-personification and using low humour to target the buying
public. Over the early 1930s, he routinely took out large advertisments –
one third, one half or even two thirds of a page – in the back of leading
daily newspaper *Correio da Manhã*, especially in January and February,
May and June, months when demand for his goods would have been
highest due to carnival and other popular festivities. Written and illus-
trated in a distinctive style, these advertisements became a sensation.
Upon the occasion of the shop's seventeenth anniversary, the newspaper

[1] Manuel Bandeira, *Crônicas da província do Brasil* (São Paulo: Cosac Naify, 2006 [1937]),
p. 208.

dedicated an article to its advertiser which began with the following words: "Casa Mathias ranks incontestably among the best-known shops in Carioca retail, standing out for its unusual methods of sales and, even more so, of advertising."[2]

The advertisements for Casa Mathias followed a simple visual structure. They were usually headed by a bombastic or intriguing phrase at the top, splashed out in large bold type. Underneath it, an illustration conjured up some eye-catching or unusual scene, often involving the figure of Mathias himself, who was usually caricatured as a grinning white man with a big head and hair neatly parted down the middle. The bottom half of the layout was filled with humorous text, heavily laced with current slang and interspersed with the name "Casa Mathias", repeatedly printed in large bold lettering.[3] The headline might reference a hit song: "*Com que roupa, sim, com que roupa*" ('what clothes shall I wear'), asked one on 7 February 1931, citing the refrain of Noel Rosa's "*Com que roupa eu vou?*" Or, it might simply address itself to the respectable public, often in less than respectable terms: "*êpa, êpa, negrada*" ('hey, hey, black folk'), screamed another on 18 January 1931.[4] The illustration might nod to a current event: on 12 June 1932, one shows a Zeppelin, named *Graf Melancia* ('Graf Watermelon') hovering over the shop and unloading parcels filled with cheap goods. Often, it depicted the caricatural Mathias engaged in some uncontrolled or surprising situation, such as galloping wild-eyed on a griffin while clutching the hair of his black girlfriend Josephina (19 January 1930) or else hanging over the edge of the roof of the shop and urging his rapacious customers not to ransack the place (9 November 1930). The humour was always crass and often blatantly racist, casting the white Mathias as a foil to the *negrada* he puported to serve and endearingly berated in his advertising.

The advertising campaign appears to have reached its height between 1930 and 1932. As it progressed, its authors hit upon the idea of telling the story of Mathias's love life. On 17 October 1931, under the headline "I don't like *crioulas* anymore", Mathias takes leave of his former girlfriends in the series, Josephina and Zuleika, and embarks on a new adventure with Virgulina, whose complexion is described as *trigueira*, a

[2] "Uma data auspiciosa para o commercio carioca", *Correio da Manhã*, 8 November 1931, 9.

[3] A variety of fonts was employed, creating a conspicuous visual arragement on the page, in the typical style of broadsheet advertising since the nineteenth century.

[4] The term *negrada* can be used colloquially to refer to a group of people, almost independently of its racial composition. Its roots are, nonetheless, explicitly racial.

designation indicating she is brown or mulatta.[5] Their love story reappears in several subsequent instalments, culminating in a trip together to Europe (10 April 1932) and finally their marriage (27 September 1932). Early on in the courtship, during carnival of 1932, one particular scene is worthy of note for the concision with which it ties together several strands discussed in this book.

In an illustration by Seth (Alvaro Marins), whose studio drew most of the campaign, a dishevelled Virgulina reclines awkwardly on a single bed, wearing a flimsy slip, high heels, hoop earrings and a bracelet (Fig. 59).[6] What seems to be a rumpled hat (though it somewhat resembles an ice pack), of a pattern matching her dress which hangs at the foot of the bed, rests precariously on her head. She looks distinctly pained, quite possibly hung over. Copious tears stream down her face, though it is also plausible to interpret the drops as sweat. A used ampule of *lança-perfume* (an ether 'popper' widely consumed during carnival) lies by her side on the bed, also occupied by a black cat licking a sleeping white dog. Feet on the bed, lying on the floor, propped up on a pillow, is an equally dishevelled Mathias, his usually neat hair a tousled mess, his collar open and tie untied, a rumpled top hat at his side. He throws his arms up in the air, pontificating with one finger, and his mouth hangs open as in a scream. The finger points upwards at the headline: "Get out, Virgulina! It's time to think only of Casa Mathias." This rude awakening is spelled out further in the caption below: "Gather your rags together, pack your trunk and go search for 'Lampião' out in the backwoods of the torrid zone. The party is over."[7]

The immediate reference was to the reward for the capture of bandit leader Lampião, but the juxtaposition of text and image also operates on a deeper level.[8] The scene of a white man awakening from carnival revelry embarrassed to find himself in the company of a black woman is a visual trope of the period, as exemplified in a 1923 cover of *Careta* magazine drawn by Storni (Fig. 60). It references the common presumption that white men would use black and brown women for sex but subsequently rebuff them. Further along in the dialogue, Virgulina pleads with Mathias that she is afraid of the *caatinga* (scrubland) of the Northeast. Mathias replies derisively that she is no stranger to *catinga* (a slang word for body

[5] The term *crioulo* possesses varied meanings in different regional contexts. In Rio de Janeiro, it is a mostly pejorative designation for a black person.

[6] On Seth (Álvaro Marins), see Herman Lima, *História da caricatura no Brasil* (Rio de Janeiro: José Olympio, 1963), pp. IV, 1330–1343.

[7] *Correio da Manhã*, 16 February 1932, 7.

[8] On the manhunt for Lampião, see Chapter 5.

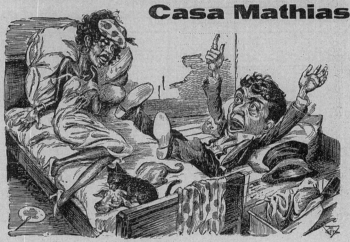

Cáe fóra, Virgulina!

Chegou a hora de só pensar na
Casa Mathias

Ajunta os teus trapinhos, arruma o bahú e vae procurar o "Lampeão" lá nos cafundós da zona torrida
A Folia acabou. Agora é na enxada e no machado. Arranja dois retratinhos e uma estampilha, que eu vou ver o que posso fazer por você.
Você bem viu o que foi o Carnaval na popular

Casa Mathias

O rei Momo ainda vinha longe e já a farra tinha começado. Vamos, toca p'ra Pernambuco !
— Mas, meu querido MATHIAS, eu tenho medo das CAATINGAS do Nordeste.
— Qual medo de CATINGA. O teu cheirinho não nega. Você tem raça de capivara. Va cobrir esse esqueleto que já está muito descarnado.
— Agora é que você está achando que eu sou um osso...
— Bem, vamos acabar com a choradeira. Chôro na

Casa Mathias

só com pandeiro, cavaquinho e réco-réco. Isso aqui sempre foi, é e continuará a ser a CASA DA ALEGRIA. Vê só o Povo como sáe daqui contente e satisfeito. Por que ? Porque só ha uma casa em todo orbe terraqueo que lhe offerece reaes vantagens na excellencia dos artigos e na modicidade dos preços. E' a invencivel

Casa Mathias

O resto é conversa

Povo amigo ! Freguezes de sempre ! Mais uma vez venho reverente á vossa presença agradecer a especial preferencia por esta vossa casa na acquisição do que vos era preciso para brilhar no Carnaval. Obrigado, meu Povo ! Muito obrigado !...
Mathias da Silva

Casa Mathias
101 ~ AVENIDA PASSOS ~ 103
Filiaes, uma óva! A CASA MATHIAS é uma só. Não se divide.

FIG. 59 Seth [Alvaro Marins], *Correio da Manhã*, 16 February 1932
Fundação Biblioteca Nacional (BN Digital/Hemeroteca Digital Brasileira)

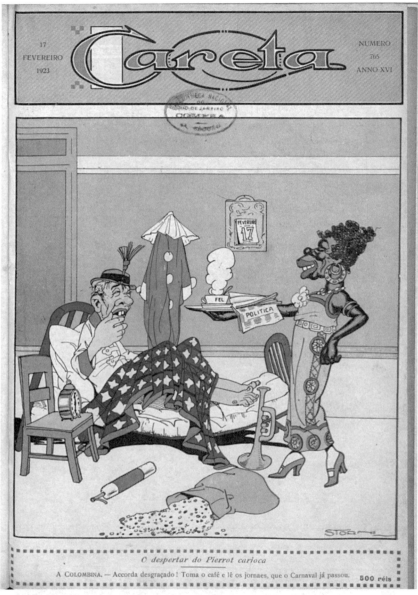

FIG. 60 Alfredo Storni, *Careta*, 17 February 1923
Fundação Biblioteca Nacional (BN Digital/Hemeroteca Digital Brasileira)

odour and often used to disparage black people): "your smell does not deny [that] you are of the capybara race". The most shocking aspect of this contemptible dialogue is that it was seen as fit for publication in a respectable newspaper like *Correio da Manhã* and, indeed, must have been perceived as funny or entertaining. No matter how crazy the real-life Mathias da Silva purported to be, he would certainly not want to alienate potential customers.

The unusual choice of the name Virgulina for Mathias's bride-to-be adds a further layer of meaning to the text. The outlaw Lampião's given name was Virgulino, and that association would have been evident to the reading public even without the explicit reference to him. In his rejection of the brown-skinned Virgulina, Mathias embodies the white self-image of the middle-class readers of *Correio da Manhã*. Independently of their own skin colour, they would be disposed to view both Virgulina and Virgulino with a mixture of fascination and contempt, as residues of an ancient blight on the social body. The contrast between the prosperous, fast-talking Mathias and the depleted scrawny body of Virgulina is instructive. Further into the dialogue, he refers to her as skeletal, and she is distressed that he should think of her as bony. The discursive trope of the malnourished and physically underdeveloped *sertanejo* seeps through the cracks of their relationship, echoed visually in the stained and crumbling plaster of the wall behind his raised right hand.

In light of all that has been discussed in the preceding chapters, the fictional coupling of Mathias and Virgulina is a powerful symbol of Brazilian society's relationship to its non-European components. Mathias's treatment of her is scornful and degrading, yet must have been motivated by desire on the eve of the depicted scene. He wants her, and ends up marrying her, but is violent and abusive nonetheless. She is longsuffering and puts up with his manhandling, presumably out of a lack of self-esteem. He is the owner of shop and story, after all. It is easy enough to recognize traces of the *sertão* and favelas in Virgulina's awkward body and fate. It is not that hard to see through the bluster of Mathias's banter and identify the bullying nature of his humour. The tone has much in common with the entitled brashness of *Antropofagia*. That the vehicle for conveying these complex discourses was an organ of the press, and its language commercial illustration, says much about the modernity that was taking shape by the 1930s. That their purpose was to sell articles and supplies for carnival says even more about the conflicted nature of a society content to wring pleasure out of its deepest pain.

Index